Reading Joan Nestle's prose as _____
much I always drew myself to h__ _____
bians in it. Joan's language is beautiful. Her analysis—of sexual history, life in the West Village, the Barnard conference, her struggle against lesbian sexual orthodoxy, and her struggle to defeat cancer—is brilliant. Joan Nestle is a warrior. Yes.

—Cheryl Clarke, poet, essayist, scholar

Reading these collected essays and talks, I have fallen in love with Joan Nestle all over again – her heart and her passionate belief that history is both created and found in the rich specifics of lives as they have been lived. *A Sturdy Yes of a People* brought me back to the Lesbian Herstory Archives' original home where I first met Joan, whose generosity of vision and spirit continue to sing throughout this brilliant compilation. The Archives offered an entire history that had been hidden from me up until the moment I walked in the doors of the 92nd Street apartment. This was not my first library, but in the most important ways, the Archives was the first library that documented the history and culture of *my* people – those of us who broke the strict gender codes of the dominant culture, lesbian, queer, and those who found fierce and creative ways to survive in the face of violence and oppression. It is through Nestle's commitment to the personal that she gifts us her extraordinarily nuanced narratives about family, lovers, sex, politics, and a deep devotion to the freedom of gender expression.

—Samuel Ace, author of *Our Weather Our Sea* and *Meet Me There: Normal Sex & Home in three days. Don't wash.*

Where would I be without Joan Nestle? I can't imagine my life without the fierce generosity of her writing on erotic pleasure, lesbian archives, Jewish working-class wisdom, and, above all, femme ways of knowing and being. For decades, she has gathered others together through her archival and editorial activism, now *A Sturdy Yes of a People* showcases the passionate force of her own words.

—Ann Cvetkovich, author of *An Archive of Feelings: Trauma, Sexuality, and Lesbian Public Cultures*

A Sturdy Yes of a People:
Selected Writings

A Sturdy Yes of a People: Selected Writings

Joan Nestle

A Sapphic Classic from
Sinister Wisdom

Sinister Wisdom, Inc.
2333 McIntosh Road
Dover, FL 33527
info@sinisterwisdom.org
www.sinisterwisdom.org
Thank you to all the donors and supporters of *Sinister Wisdom* who made this book possible.
Designed by Nieves Guerra.

Cover photograph, Joan Nestle at the Lesbian Smut Writer's Conference 1987 © Susan Fleischmann 2022.
Used with Permission.

First edition, December 2022

ISBN-13: 978-1-944981-52-5

Printed in the U.S.

Contents

Foreword: In Bed with Joan Nestle

Carolyn D'Cruz

While Naarm/Melbourne became the most locked down city in the world during the COVID-19 pandemic, I went to bed with Joan Nestle several nights a week. If you hook up with her here, she'll also touch you. Every time I read her erotica (or is porn the better word?), I relive the joy of legs spreading and lips parting, of feeling hot and getting wet, of bodies opening, holding on, and letting go. A lover of words, even as language fails, Joan Nestle finds enough space for flesh to speak. Besides taking us through bars and streets to all that steamy sex, Joan gifts us a political and scholarly heritage. She shares her methods for collecting archives, recording history, and commemorating places, events, and those people we need to listen to if we want to build a more just world. She guides us through the heritage of solidarity building between social movements. Her words beckon us to pay attention to how narratives of desire, power, and justice are told—or not. Our work is to learn how to tell what's missing and amplify those voices that have been too readily suppressed. Working from the margins, or "history from below," Nestle is a shape-shifting storyteller who gracefully reminds us of "what we are in danger of forgetting" (p. 331).

The first Joan Nestle article I read was "Butch- Fem Relationships: Sexual Courage in the 1950s." It was 1989. My girlfriend at the time wanted to discuss it. She didn't call herself butch, but like Joan's Emma in "Lesbian Memories 3," she had cropped hair, wore tight white T-shirts and Levi 501s.[1] She was much

1 Joan Nestle, *A Restricted Country* (Ithaca, NY: Firebrand Books, 1987), 147.

hungrier than I was to find a feminism that was not swallowed up by heterosexuality. "Butch-Fem Relationships" captured so much of what we were debating in our own lives: the categories we used to name ourselves, the entanglements between sexuality and gender identity, our reckonings with pornography, even the politics of what we did with one another in bed. Decades later, I would come to appreciate how Nestle's heartfelt tone in that piece betrayed the level of political and historical complexity she prompted us to wrestle with.

Fighting our way to sense: shifting definitions and challenging acceptable history

For Joan Nestle, it's not just a quest to articulate what *butch-fem* means or had first meant to her, living through the oppressive conditions of McCarthy's 1950s. It's also what butch and fem *look* and *feel* like for those who have some attachment to these categories. Throughout her own work, Joan marks the significance of the minutiae of dress and style, as do so many of the writers she gathered into her collections of lesbian fiction and the 1992 anthology *Persistent Desire: A Femme-Butch Reader*. Butch-fem relations are primarily about sex, rituals around wooing one another, and community; they show us a heritage where fucking and kinship, aesthetics and politics, meet in the zigzag history of a counterculture.

Many of us will recognize in these pages what we understand as "butch," with its historical relations to passing women in the nineteenth and twentieth centuries, through to what some of us call "masc," among other things, today: the short, slicked-back hair (what Joan calls the DA style, which till now I didn't

know stood for duck's arse, or duck's ass, depending on your accent); the white shirt; the black pants; the tough body and dexterous hands, which have learned to touch and fuck with care and competence. I'm taking these details from "Esther's Story," of course; but the beauty of Joan's writing allows us to substitute her proper names with our own. So many of us gasp when we utter the name of the Puerto Rican taxi driver, Esther, because we too have played the role of one of the main characters in that story: "I was standing between her legs as she sat with the lights of the bar at her back. Her knees jutted around me, and I worried that I could not hold her attention" (p. 201). From the bar to the drive home, there is erotic charge right down to the point of holding a cigarette (probably a soft pack, Camels) and steering "with ease, one hand on the wheel." I bet Esther could have lit a Zippo with a one-handed flick of their wrist as well. The situation and context give us the switch that turns so many of us on when instructed to "raise our hips" or "to be a good girl." These repeated codes of style and behavior can be understood through what Judith Butler calls "gender performativity,"[2] a concept that confirms Nestle's belief that it is politically and socially important to explain why this erotic play is not reducible to the heterosexualized models of man and woman.

Joan Nestle's writing showed me how to exit the kind of feminism that could not see this, without losing my politics. My own eighties' feminist experience was loaded with a uniformity in dress, style, and politically correct fucking that inadvertently took away my right to sexiness and liberated sex. When I passed from the straight to lesbian and queer world, Joan's writing

2 Judith Butler, *Gender Trouble: Feminism and the Subversion of Identity* (New York: Routledge, 1990).

helped me find a new kind of freedom, a freedom that allowed me to feel within my own skin when I put on short dresses, V-neck sweaters, and made up my face with heavy eyeliner and lipstick. Like Joan, I've got my own black slip that can summon sex like magic. I'm yet to wear it on a panel like Joan did, though; and it will never be, and nor should it, as famous as hers. Joan is the Queen of Fems. She's given so many of us a lifeline and the simple permission to flaunt it. Her pages are littered with joyful sexual communication through putting one's self on: not submissively, as stereotype, or dismissively, as parody—but powerfully, as flamboyance. On rereading what Joan gathers in her own and others' writing, I can better see how erotic taste connects with what is also a politics of style and a style of politics—a politics that underscores our own bent right "to be."

Flaunting is one way of telling one another and the rest of the world who we want to attract and what we want to repel. It's not a simple case of dividing one column for butch and one for fem, or any two markers we may contrast through inadequate understandings of masculinity and femininity. In Joan's day there was also "butchy fem," "femmy butch," or "feeling kiki (going both ways)" (p. 103). The language has expanded today, while the mix-and-match-y style of bending rigid categories of gender through sexuality and sexuality through gender continues to be expressed through tattoos, flannel shirts, chunky watches, leather wristbands, and baseball caps. In other spaces there are bow ties, suits, and kooky cuff links (sexier with painted, manicured fingernails). Some of us still have our generic leather and denim jackets, surviving with their unique markings of wear and tear, badges and brooches, and sewn-on patches; it's not just our hearts but our politics that are worn on our sleeves. I'm pausing so long on the politics of dress, for these are the

signifiers that also attract street harassment and police profiling (which heightens when intersecting with markers of race and class). Joan Nestle reminds us that our "erotic heritage" (as she so beautifully puts it) includes police raids in bars, as was the case with the working-class Sea Colony in Greenwich Village that she frequented in the 1950s and 1960s. As she documents, in those days it was legal to arrest a person if they did not have three items of clothing that belonged to the gender they were presumed to be.

Nestle discusses these raids in "Lesbian Sex and Surveillance," taking us through the intersection of her own working-class lesbian and queer history against the institutional forces that confined, patrolled, and violated the expression of nonnormative sexuality and gender. Looking at the number of times she has revisited her "fem quest" within a broader history of surveillance gives us some idea of the urgency in which she believed feminists needed to sort the telling of this stuff out. "Butch-Fem Relationships" was first published in *Heresies: A Feminist Publication on Art and Politics* in 1981 and appeared in the anthology *Pleasure and Danger: Exploring Female Sexuality*, which emerged from the notorious 1982 Scholar and Feminist Conference IX at Barnard College, New York City. That conference marked a significant moment of the "sex wars" *within* feminism, and we had our own versions of those debates across the ocean, where Joan would later come to live with her partner Di, in so-called Australia. Joan's endnote accompanying the essay's republication in *A Restricted Country* says, "It took me forty years to write this essay" (p. 109). The same issues are raised in "My Fem Quest" in *A Fragile Union* as well as "The Fem Question" in *Persistent Desire*. Each of these iterations underscore the recurring problem of how to tell a history that can remain true to those whose

experiences are at the center of it. Alarmingly, the fights staged at and surrounding the 1982 Barnard conference remain within feminism and beyond, gathering force in public debates over the years where certain feminists are happy to form alliances with conservative and right-wing bodies intent on squeezing some of our folk out of existence.

Over twenty years ago, Joan reflected on how her friend Chelsea Elisabeth Goodwin, a transgender woman volunteering at the Lesbian Herstory Archives, opened the space for "another layer of lesbian history" (p. 209). Chelsea and her partner Rusty were housing Sylvia Rivera, whose name has now become eminently connected to the Stonewall insurrection of 1969, but at the time was "left behind by the mainstream respectable gay liberation movement" (p. 209). If the gay liberation movement and lesbian-feminist movement had "done things differently," Joan argues, then "Chelsea and her comrades would not have to be fighting for their most basic rights in the 1990s" (p. 210). The alarm bells ringing through these words should have been loud enough to warn the same kind of feminists and respectable gay and lesbian lobbies how far under the bus trans, nonbinary, and gender-diverse folk would be thrown in the twenty-first century. When Joan rereads Esther's story for the occasion of speaking to the trans community group Metropolitan Gender Network in 1997, she once again shares lessons in the constraints and possibilities for building solidarity: "If I know the dreams of only my own, then I will never understand where my impulse for freedom impinges on another history, where my interpretation of someone's life is weakened by my own limits of language, imagination, or desire" (p. 213).

Somehow, Joan Nestle manages to hold together the contradictory positions that come with the experience of having

"fought our way to sense" at the same time as learning to live through "shifting definitions" and "let[ing] go of certainty" (p. 281). How does she do it? How does Joan maintain her love for women while also navigating those situations when "the opposition between women and men stops being pertinent"?[3] How does she maintain a lesbian herstory as she simultaneously navigates an historical terrain when lesbian, passing women, butch, and even our ideas of what is the "same" in a same-sex relationship keep shifting? Rereading Esther through her encounters with Chelsea and looking back at a time when the resonance of Esther's own sense of self, gender, and desire would have been too easily dismissed through the particularity of how Esther, "want[ing] to be a man," would have been read in a certain lesbian world, Joan manages to claim a lesbian-feminist perspective at the same time in which she "pushe[s] against lesbian-feminist boundaries of acceptable history" (p. 211). As some of us reread, or read for the first time, texts like Radclyffe Hall's *The Well of Loneliness* or Leslie Feinberg's *Stone Butch Blues*, Joan's rereading of Esther is like a guiding star for navigating what we can and cannot see and say about the intersections of gender, sexuality, class, and race in a particular time, place, or genre of expression. Without using fancy academic jargon (not that there is anything inherently wrong with that), Joan's own grappling with the history of desire shows how we are caught within struggles where identity categories are ineluctably politicized. Her first-rate scholarship on "[fighting] our way to sense" gives us clues for working on what is to be done and how we go about doing it (p. 281).

3 Jacques Derrida with Kate Doyle, James Adner, and Glenn Hendler, "Women in the Beehive: A Seminar with Jacques Derrida," *Differences* (Bloomington, Indiana, 2005 [1987]), vol 16 (3), 139-157. This quotation, 146.

Keeper of memory

Throughout her work, Nestle shares ways to combat state surveillance, oppression, and violence while also rallying against the oppressive effects of policing thought and action within and between our connected communities. She introduces her "fragile unions" at the end of the twentieth century as a "fifty-eight-year-old, white Jewish fem lesbian woman with cancer living in New York City,"[4] but not in the perfunctory way in which movements of the seventies and eighties had been, and many today still are, accustomed to operating. For Joan it is a mistake to think "if we laid out our particulars, we had cleared away all ambiguity about our lives." She shares these identity markers "precisely for the opposite reason." Such labels hold space for "huge worlds of shifting meaning, unending searches for what can keep [her] love and what has to be let go."[5] For Joan, decisions about what and how to hold go hand in hand with learning how to let go. Yet if there is one thing that Joan will always hold on to—not as a selfish hoarder, but as a generous sharer—it is an archive.

I would never have guessed that my Catholic-raised self would one day become thankful to those who keep records on the politics of where we piss and shit. "The Will to Remember: My Journey with the Lesbian Herstory Archives" begins with an extract from "The Bathroom Line," a short essay where Joan describes the rituals of lesbian women at the Sea Colony having to wait for "permission to urinate, to shit" (p. 183). This ablutionary detail of memory prepares us for claiming marginalized peoples' right to history. It would be worth considering how the policing

4 Joan Nestle, *A Fragile Union* (San Francisco: Cleis Press, 1998), 9.

5 Joan Nestle, *A Fragile Union* (San Francisco: Cleis Press, 1998), 9–10.

of sexuality and gender nonconformity in Joan's recording of "The Bathroom Line" shares an underlying grid of surveillance that anchors the debates of those public commentators who scoff at access issues regarding bathrooms today. Nestle's critical lens for documenting surveillance was widened further for me when I attended a paper where Professor of African American Studies Alexander Weheliye asked us to compare today's public focus on bathroom gender segregation with the racial segregation of bathrooms in the Jim Crow era. Through the allegedly trivial site of bathrooms, we can learn how identity markers slip and slide to suit the maintenance of power relations under the guise of a supposed natural order of things. Nestle's approach to history calls us to remain vigilant about this. Her writing is an "act of outrage at the unquestioned assumptions of those used to power, privilege and entitlement."[6] No doubt there are others who are joining the dots between bathroom policing over time and space, and across various markers of identity. Without the keepers of archives and resurrectors of memory, it is near impossible to conceive that such dots await someone to connect them.

Through the creation of the Lesbian Herstory Archives in 1973, founded with her then lover, Deborah Edel, Joan Nestle gives us access to another heritage not readily accessible in the mainstream: the memory of a people's history for those who have been deemed incapable or unworthy of having one. Drawing inspiration from French-Tunisian Jewish writer Albert Memmi's *The Colonizer and the Colonized* (1957 [1965 English translation]), Joan saw how the Archives project could house material to write a history from the perspectives of those who had been thus far unrecognized as having heroes, leaders, sages, and

6 Nestle, *A Restricted Country*, 2.

memories worth passing on to future generations. In her essay "The Politics of Thinking," Nestle notes similar sentiments in African American abolitionist Frederick Douglass's suggestion in 1845 to approach American history from the "bottom up" (p. 283), a point also captured in her essay "When the Lions Write History." These ideas for the Archives were fed into and by the consciousness-raising group attached to the Gay Academic Union that Joan and Deborah were a part of at the City University system of New York in the sixties and seventies. If the perspective was to tell history from below, the content would emphasize the full range of what came into the Archives' domain and "not become a handpicked collection of respectable lesbian role models" (p. 369).

With the task to hold on to anything and everything that could tell a lesbian story, the Lesbian Herstory Archives is a living home for all sorts of personal and historical cultural records and ephemera that might have been otherwise left to pass away. In "transforming what this society considered garbage into a people's history" (p. 365), the Archives make room for those voices that acceptable forms of feminist and gay and lesbian history have tried to expel: the sex workers (with historical relations to queers), S/M groups, prisoners, and those caught on the wrong side of a border or law. Letters, diaries, pornography, broadsheets, posters, novels, and boxes of personal documents have all found a home in the three-story limestone building in Brooklyn, New York. The Archives' vision stretches to include anecdotes attached to big histories—as in the case of "the young Jewish woman who had read *The Well of Loneliness* in Polish before she was taken into the concentration camps" (p. 370). There is also room for smaller personal memories, as in the case of the broken-hearted lesbian asking the Archives to store letters exchanged between herself and

her lover so she did not destroy them (*Archivettes*).[7] When Joan describes such stories as filling her heart and changing "forever that which [she] would call history" (p. 370), she draws our attention to the fact that we do not have to forgo emotional attachments or our positionality in the name of objectivity. Rather, such investments make us ever more vigilant in giving accounts of how we make our claims.

On crafting a history from below

When students ask me where they can find good examples of history from below, I say read Joan Nestle. While they are always impressed with Nestle's work, I sometimes feel the complexity of her ethical, political, and theoretical layering can be hard to articulate. Perhaps the sweeping beauty of her prose makes it more difficult to extract her conceptual and methodological toolkit, which she shifts accordingly with changing times and debates. Yet I suspect the main reason it can be hard to outline Nestle's methods and situate her conceptual framing is because she stays within the concrete mess of everyday life more often than she turns to summarizing what she is doing through theoretical abstraction. While I rely on theoretical abstraction to guide much of what I do as a learner and lecturer, it is only in recent rereadings of Nestle that I have noticed how deeply she thinks and how deftly she navigates the conceptual conundrums that lie at the heart of any inquiry that gives itself the task of passing on a heritage.

There are so many genres of writing that apply to and underpin Joan Nestle's work: life writing, oral history, gender and

7 Megan Rossman (dir), *The Archivettes* (Women Make Movies, 2018).

sexuality studies, pornography, poetry, and creative nonfiction, to name a few. I'm using "history from below," because it captures what Marcus Rediker calls the ability "to tell a big story within a little story."[8] The essay "A Restricted Country," which is also the title of Nestle's 1987 collection, is not only a story about a working-class Jewish family from the Bronx taking a trip to Arizona. It is also an essay that enables us to hear the resonance between "exclusion unto death" in Nazi Germany and the meaning of a restricted country expressed as "No Jews allowed" in an American hotel in 1956 (p. 98). The essay "John Preston and Myself" is not just a story of friendship between Joan and her kindred pornographer. This piece also prompts us to think of how singular stories of people living with AIDS can get lost or saturated in volumes of history, and how the complications of "simplification of our own erotic histories" (p. 176) and "weigh[ing] the consequences of [one's] words" (p. 174) become a prerequisite for speaking about erotic desire in public.

When Nestle does speak through generalities, it is usually to take us on a deeper dive into detail. Oral historian Studs Terkel quotes her opening line to "The Huge Light of Yours" before talking about a nation's historical amnesia: "The sixties is a favourite target of those who take delight in the failure of dreams."[9] Joan smashes the "mockery and disdain" captured in that sentiment by turning our attention to Selma, Alabama, 1965. The difficulty of summarizing the breadth and depth of coverage in such an essay comes from Nestle shifting the emphasis of the big story into little stories (many of which are already lost) through which generalities about history could not otherwise be

8 Marcus Rediker, "The Poetics of History from Below," *Perspectives on History* (September 2010).

9 Studs Terkel, *The Studs Terkel Reader: My American Century* (New York: The New Press, 1997).

made. The condensation of historical events into a proper name like Selma, for example, will connote the killings, beatings, jailings of African American people, which prompted the activism around Black voter registration and the march into Montgomery. (Perhaps you've seen the film *Selma*, made in 2014.) Reading Joan Nestle's experience of participating as an ally in this struggle is a footnote in this history. It is good practice to read footnotes. They usually take us on a detour through a point of view that might not belong at the center of the main text but can nonetheless mark entangled issues along the way. In this case it is the "contradiction between kept silences and new honesties" (p. 132) that affect any of us engaged with solidarity building and social change.

If I had to choose one "big story within a small story" to demonstrate the painstaking work undertaken by those with a passion for a people's history, it would be Joan Nestle's essay on the life of Mabel Hampton, " 'I Lift My Eyes to the Hill.' " The essay shows us what kind of work can be crafted from seemingly random collections of archives. We learn more than the biographical content of Ms. Hampton's "material struggle to survive" and her "cultural struggle for beauty," the pairing captured, Joan reminds us, in the working-class slogan for Bread and Roses. Reading this account of Ms. Hampton is like attending a master class on how to situate a singular life within interlocking relations of power, which are themselves entangled in histories of race, class, gender, and sexuality. This essay is also about the responsibility of the researcher; Joan takes us on a journey of trial and error in historical methods. She situates her authorial position through learning from Ms. Hampton's own archival clues for "how [Ms. Hampton's] story should be told" (p. 332). Adjusting her training from oral history workshops to meet Ms. Hampton's demand to "extend

our historical perspective until she is at its center" (p. 334), Nestle makes a crucial shift in focus from "lesbian history" to "lesbians *in* history" (Nestle's emphasis, p. 334). This move widens gay and lesbian oral history questions that are focused on sexuality to include race and class.

From all the bureaucratic documents regarding births and deaths, Nestle singles out a typewritten list of Ms. Hampton's that records where she went to school and where she worked and lived from 1915 to 1955. This tells a story that goes way beyond reading a resume. The list, "so bare and yet so eloquent" (p. 333), sets a tone that commands respect for an African American working woman's lesbian life in history—a life that against the odds refused "messages of self-hatred" (p. 356). Throughout the essay, Nestle weaves Ms. Hampton's preserved newspaper clippings, programs from the opera and theatre, and her own oral history interviews into what she gleans from reading deeper histories. The smaller, singular story of Ms. Hampton is stamped into the bigger historical narratives of the Triangular Slave Trade, "the history of Black working women in the sharecropping system" (p. 337), post-slavery mutual aid societies, the Harlem Renaissance, the prison system, and the Jim Crow era. The politics of aesthetics once again emerge alongside struggles for social transformation, where the "fortitude and flamboyance" that Nestle highlights in *Persistent Desire* is brought to life within the one person of Ms. Hampton.[10]

10 In her book, *Wayward Lives, Beautiful Experiments, Intimate Histories of Riotous Black Girls, Troublesome Women and Queer Radicals*, Saidiya Hartman includes a stunning portrayal of Mabel Hampton, in which she acknowledges Joan's essay and the special collection of Ms Hampton's oral history interviews and archives held at the Lesbian Herstory Archives.

Learning, activism, and solidarity building

Joan Nestle's interdisciplinary style of writing also makes it difficult to delineate hard and fast boundaries between her learning and teaching, activism and thought, socializing and politicking. From her days at Queens College, CUNY, first as a student and then as a teacher for thirty years, Joan shares her stories of solidarity building and the specific mutual learning that takes place when students are not from privileged backgrounds. While her instrumental work in the Lesbian Herstory Archives project opens us to a praxis situated in one of Joan's own communities, the stories she shares about her life as a student and teacher show us a way of connecting to communities to which we do not necessarily belong or in which we share an opposition toward the same national atrocities. In "Narratives of Liberation," we hear how her student cohort of "working-class 'queers' " joined forces with "battles against nuclear arms, battles against the House of Un-American Activities Committee, against the Vietnam War, and against segregation" (p. 139).

I wish I could have read this essay in the 1980s, when I was crying about the university grooming me into a white middle-class straight man (I'm the kind of brown that bears some privileges of whiteness, now middle class, and still a queer woman). As I was learning the canon and becoming more adept at using what African American lesbian-feminist writer and activist Audre Lorde calls "the master's tools," this piece would have allowed me to keep more of what I was losing on my way to becoming an academic.[11] I would have formed a more productive engagement with how "nontraditional" students and teachers

11 Audre Lorde, "The Master's Tools Will Never Dismantle the Master's House," in *Sister Outsider: Essays and Speeches* (Berkeley, CA: Crossing Press, 2007), 110–114.

have challenged the university. Nestle could see then what so many still cannot see now in higher education: that those who historically "had neither the skin color nor the accent nor the money to qualify for being heard" could push the canon to be more truthful, comprehensive, and just (p. 142). Nestle stages the case for how higher education could be both more learned and egalitarian if the guardians of the ivory tower were not so condescending toward minoritarian programs, were not so dismissive of what they deemed unscholarly texts, and were not so threatened by new theories and interpretations of knowledge. Written at a different moment of the "culture wars," in the late eighties and nineties, this essay provokes a protected tradition to become a more just and "intellectually honest" heritage. While the sector has become uglier and more corporate in the twenty-first century, this essay is as relevant to today's culture wars as it was when Nestle first wrote it. Detailing the opportunities for transforming the curriculum with the aim of demarginalizing those lives upon which the lies of settler-colonial nations like the USA and Australia have been built, "Narratives of Liberation" resonates with the activist-scholars whose calls for decolonizing the academy are more audible today.

Joan's own writing and reflections on establishing the Lesbian Herstory Archives show her lesbian feminism as also committed to overturning colonial projects. Living the first sixty or so years of her life on the lands of the Lenape peoples and now living on the lands of the Wurundjeri people of the Kulin nations (as I do), Joan has also responded to the specific task of opposing the national cruelties of settler colonialism. This brings us to the side of Joan Nestle that cannot be captured in this book, as her words and actions have been tied to speeches at rallies and keynotes at conferences that have not found their way into publication. There are archives yet to be collated that will

tie Joan's "Words for Palestine" at a Naarm/Melbourne rally in 2009 to her calls for Treaty and Justice on the Aboriginal lands she lives on now in the address she delivered to the Queer Legacies, New Solidarities Conference in November 2018. No doubt, much more can be collated on the life, activism, thought, and writing of Joan Nestle, and I hope that this volume is the beginning of more to come.

Follow the proper names of people, places, and events in her work, and you will have a lifetime of reading and calls to action cut out for you. The works I've highlighted reflect my own stakes in sending Joan's work forward to new generations. If you love her sexy stories like I do, you will find some of her best pieces here, and there is no need for commentary on that. Yet we are on repeat in history, and we must again situate these stories within our erotic heritage against the current moral panics, which call for our measure and action. In sharing her heritage, in playing a fundamental role in building the Lesbian Herstory Archives, in writing about people, places, and events that we are in danger of forgetting, Joan invites us to join the task of solidarity building to eradicating oppression. Confronting the concrete conundrums Joan recounts in her own grappling with lesbian feminism is possibly the best guiding tool I have for approaching the worst elements of the culture wars taking place in the public sphere today.

Joan Nestle brought me into a delightful world of pleasure at the same time as she opened new doors to thinking and doing politics when I was in my early twenties. I met her for the first time in 2012, and like many a fem has done before me, I thanked her for her nourishing words and for showing me a way "to be" that had room for both bread and roses, struggle and dignity, survival and beauty. A few years later, we became friends in real life. A student I was working with, Katie Moore, was painting a

portrait of Joan and allowed me to come to a couple of the sessions where Joan shared her warmth and wisdom while sitting in her black slip and robe. The times we have shared have been few and precious, while also feeling vast and familiar. Her mind darts so fast that she can move a conversation from what's going on in our own lives to a story about her mother Regina to sharing the brilliance of Mahmoud Darwish's poetry in one short visit. She gave me a subscription to the lesbian journal *Sinister Wisdom*, which maintains a space for figuring out how a lesbian community may still articulate itself through literature, art, and politics—and whose current editor, Julie Enszer, has opened the space for us to read Joan Nestle again in this book. I walked out of Joan's house with the *Sinister Wisdom* issue titled "Lesbians and Exile," reminding me again of the lives and stories that warrant greater audibility and attention. I would never have guessed that Joan would be there for me in real life when I needed it, as she has been there for me for over thirty years with her words. I am so honored that I have been given the space to write about the world's greatest memory keeper and advocate for the small story of fem and butch culture in the bigger story of fighting for justice.

Carolyn D'Cruz
Naarm/Melbourne, December 2021

Having been constantly called to explain herself to strangers, **Carolyn D'Cruz** has become an expert on entanglements between personal, professional and political life. She is author of *Identity Politics in Deconstruction: Calculating with the Incalculable* and *Democracy in Difference: Debating key terms in gender, sexuality, race and identity*. She is also co-editor of *After homosexual: Legacies of Gay*

Liberation. D'Cruz is a Senior lecturer in Gender Sexuality and Diversity Studies at La Trobe University.

Additional References

Derrida, Jacques with Kate Doyle, James Adner, and Glenn Hendler. "Women in the Beehive: A Seminar with Jacques Derrida." *Differences* (Bloomington, Indiana, 2005 [1987]), vol 16 (3), 139-157.

Hartman, Saidiya, W*ayward Lives, Beautiful Experiments. Intimate Histories of Riotous Black Girls, Troublesome Women and Queer Radicals*. London: The Serpent's Tail, 2019.

Lorde, Audre. "The Master's Tools Will Never Dismantle the Master's House." In *Sister Outsider: Essays and Speeches*. 1984. Ed. Berkeley, CA: Crossing Press, 2007.

Rediker, Marcus. "The Poetics of History from Below." *Perspectives of History* (September 2010). https://www.historians. org/publications-and-directories/perspectives-on-history/ september-2010/the-poetics-of-history-from-below.

Rossman, Megan (dir). *The Archivettes*. Women Make Movies, 2018.

Terkel, Studs. *The Studs Terkel Reader: My American Century*. New York: The New Press, 1997.

Introduction: Invitation to a Feast

Yeva Johnson

Joan Nestle's writings are wide-ranging with something to challenge, delight, or spark the imagination for a variety of lesbians: well-read lesbians, nonbinary lesbians, academic lesbians, lesbians of color, queer folk, activist lesbians, women-loving lesbians, trans lesbians, Jewish lesbians, feminists, women, womxn, people of all genders or none, and people of all races, religions, ages, classes and political persuasions. Nestle writes about everyday lesbians and the people who travel with them in all their diversity. Her stories, essays, speeches, and treatises energize the past as a vibrant part of our present political understanding and welcome an ever-more-liberated future where people can glory in their full selves and identities, whichever way they overlap. Joan Nestle shows us how lesbians made social change from the second half of the twentieth century to the first quarter of the twenty-first and inspires readers to imagine expanded possibilities for freedom in the new millennium.

As a queer lesbian who came to writing late in life, it is both daunting and exhilarating to invite new and familiar audiences to enjoy Joan Nestle's work. Born in the mid–twentieth century, I came out in the 1980s during a time that was not as open to varied forms of lesbian expression. In the community where I came out, there was a right way and a wrong way to be a lesbian. Never one to follow someone else's right way, I ended up making my own circuitous queer path in life. Medical training and practice, then raising children meant that for years, I was lucky to be able to read a few short stories or an occasional novel about lesbians, let alone eke out the time to put pen to paper. Around 2014, I started to write poetry and to read more widely,

with a particular emphasis on poetry and literature about people of color, feminists, queer people, and Jewish people. I set out to become a well-read Black Jewish queer lesbian.

Prior to the 2020 coronavirus pandemic, I had never heard of Joan Nestle. Lockdowns and quarantines brought me in touch electronically with so many more literary lesbians than I had ever encountered before. In November of 2020, amid COVID-19's initial waves, *Sinister Wisdom* sponsored an online celebration of Joan Nestle's life and work. Many people came to sing her praises, and some repeatedly mentioned *The Persistent Desire: A Femme-Butch Reader*, a book Nestle edited. Other participants were familiar with her earlier works, *A Restricted Country* and *A Fragile Union*. At this occasion to honor her, Joan Nestle was kind, her words generous and filled with gratitude. The event made it clear that younger and future generations of lesbians, queer people, and allies would benefit from exposure to Nestle's work. Joan inspired me so much at that gathering that we soon were sending direct chat messages to each other, and she sent me a lovely email after I sent her a fan thank-you message the following week. I learned that *Sinister Wisdom* was planning to continue the celebration by publishing Joan Nestle's selected works. When Julie Enszer asked if I was interested in joining the project, I jumped at the chance.

Picture a feast celebrating Joan Nestle's life and work. Discover a huge variety of covered subject matter in Joan Nestle's essays, nonfiction, poetry, and fiction, all decked out on themed tables where Joan imbues every selection with the political and the personal, braiding these two visions repeatedly throughout her work to tap into the myriad ways the struggle for lesbian rights is integral to struggles for all human rights. In *A Sturdy Yes of a People: Selected Writings*, Nestle offers portraits of lesbian life long before Stonewall in 1969. Many queer people today might

be surprised to know that "cross-dressing" against rigid gender norms was a crime. Most anyone these days would find it difficult to name three pieces of gender-appropriate clothing or to identify the difference between male and female socks. Joan explores all of this in "Lesbian Sex and Surveillance" and "Lesbians and Prostitutes: An Historical Sisterhood." Other stories delve into being queer during the civil rights movement of the sixties and what life was like during a more openly antisemitic period in the forties and fifties. Nestle shares the complexities and dilemmas of being a lesbian civil rights marcher in Selma, Alabama, in the 1960s in "This Huge Light of Yours," from negotiating having to share a bed with a straight woman to deciding to leave out "lesbian" in her self-description as Jewish and feminist. Joan deftly reveals the blatant antisemitism her family encountered on their first vacation so that the reader learns alongside a teenage Joan what "A Restricted Country" means.

Nestle's writing and thinking vibrate at the center of contentious disagreements in feminist communities and lesbian communities. Throughout the collection, women celebrate their full sexuality without shame. Joan reaches for openness, for acceptance of expansive views of gender, of lesbians, of what it means to be a woman, or a woman and feminist and a lesbian, and how those meanings might vary depending on race, class, religion, and other identities. As Nestle recounts in "Who Were We to Do Such a Thing?," "These people, these projects, were the golden riches of my time," and her work celebrates "the sheer womanness of it all, the sheer lesbianism of it all, all the variations of woman and lesbian welcomed." Joan embraces the "tensions of lesbian difference" and includes butch women, passing women, fem women, adolescent women, women sex workers, women academics, nonbinary women, working class women, and women of color, rejecting

the idea of "lesbian purity" or "role-model lesbian history" so that "lesbian" becomes a "noun that stands for all possibilities of queerness, for all possibilities of deviations." Open *A Sturdy Yes of a People: Selected Writings* and let the feast begin.

Enter a great party hall where lavish tables are adorned with literary delights. The first table holds a banquet of Liberation. Unabashedly in-your-face works at this table include "My Mother Liked to Fuck" and "My Fem Quest," where Joan assures readers "All is possible, she says as she surges into me, and now finally, all is." Linger to sample complex and multilayered fem views of the past. Celebrate people speaking up to free themselves in all ways possible. Further into the hall, sample delicacies from the History table featuring important moments during Joan's life. Take "Butch-Fem Relationships: Sexual Courage in the 1950s" and discover how, as Joan says, "As a fem, I did what was natural for me, what felt right. I did not learn a part: I perfected a way of loving." Serve up "A Fragile Union" and see how a colleague in the civil rights movement both inspires and disappoints, and why "songs, like our bodies, carry history in a fragile yet enduring way." Savor the History table's wonderful overview of Joan Nestle's decades of activism, where in "Narratives of Liberation: Pluralities of Hope" she invites readers to "find common ground on which to protect the dignity of difference and the possibility of hope."

Appetite whetted, head to the Sex table. No feast of Joan Nestle's work would be complete without a Sex table. Enjoy Joan's classic "Esther's Story" and her thoughtful reconsideration in "On Rereading 'Esther's Story' " demonstrating vulnerability in rethinking the narratives she created and how she might write those narratives in a more gender-inclusive and gender-open society. Celebrate the sexual enjoyment of women with cancer who don't obfuscate the difficulties of navigating

required adaptations to living life in a body transformed by side effects from medications, treatment, illness, and recovery, and the sexual enjoyment of women of a certain age or of a certain size in "A Feeling Comes" and "My Cancer Travels." Further back, the lectern has been pushed aside to make room for the Education table. Serve up provocative portrayals of the travails of studying and teaching about lesbians and queer life in post-secondary education settings and the ways in which academic freedom of expression might differ between public and private colleges in pieces like "The Politics of Thinking" and "Lesbian Sex and Surveillance." Joan fearlessly interrogates and liberates sex discussions in all settings, including the academic.

Find the last table at the back of the hall, the Archives table. Treat yourself to a variety of Joan's writings that exemplify the goal of the Lesbian Herstory Archives, of which Joan Nestle is a founder. Sample narratives and documents that are more inclusive of all types of everyday lesbian lives, such as the fascinating account of overlapping marginal statuses in "Lesbians and Prostitutes: An Historical Sisterhood." Take " 'I Lift My Eyes to the Hill': The Life of Mabel Hampton as Told by a White Woman." Imagine this story serving as the spark for a writer to pen a biography of Black lesbian Mabel Hampton. Let the Archives table stimulate your appetite for more lesbian history after you've finished the feast of this book and sampled Joan's generous offerings.

Read *A Sturdy Yes of a People: Selected Writings* from cover to cover, or enjoy each piece alone, separate tastes of Joan's glorious prismatic work. Nestle offers this wonderful feast of so many illuminating morsels from her oeuvre to provide the reader glimpses into what life was like for lesbians and queer people and queer and lesbian communities over a more than sixty-year period. From a landscape where Radclyffe Hall's *Well*

of Loneliness was one of the few readily available books that described lesbian life to the current day, where there are children's books for child lesbians and children's books for children of lesbians and romance novels for Black lesbians and wonderful fiction by and about all kinds of lesbians and a multitude of studies about lesbians, Nestle's extraordinary collection of writings takes its rightful place in the lesbian literary canon.

Joan Nestle's *A Sturdy Yes of a People: Selected Writings* showcases her body of work as a writer, academic, activist, and mentor who has contributed so much to the liberation of lesbians, queer people and their allies, and many other peoples. In this twenty-first century when rights gained can never be taken for granted, Nestle's work is more important than ever. Joan reifies the depth and breadth of queer life with all its ups and downs, freedoms and hindrances, past trials and successes, and never leaves out the class, race, gender, and other lenses that are critical to understanding everyday lesbian lives.

A Sturdy Yes of a People: Selected Writings invites readers to explore more of Nestle's legacy, including preserving the history of everyday lesbians and struggles for lesbian liberation. Delve deeply and enjoy the feast!

Yeva Johnson, a Pushcart Prize-nominated poet and musician whose work appears in *Bellingham Review, Essential Truths: The Bay Area in Color Anthology, Sinister Wisdom, Yemassee,* and elsewhere, explores interlocking caste systems and possibilities for human co-existence in our biosphere. Yeva is a past Show Us Your Spines Artist-in-Residence (RADAR Productions/SF Public Library), winner of the 2020 Mostly Water Art & Poetry Splash Contest, and poet in QTPOC4SHO, a San Francisco Bay Area artists' collective. Yeva's first chapbook, *Analog Poet Blues*, will be published by Nomadic Press in 2023.

Liberation

My Mother Liked to Fuck

My mother, Regina, was not a matriarchal goddess or a spiritual advisor. She worshipped at no altars and many times scorned the label *mother*. She was a Jewish working-class widowed woman who, from the age of fourteen, worked as a bookkeeper in New York's garment district. My father died before I was born, when my mother was twenty-nine, and left her with two children to raise. My mother liked sex and let me know throughout the years both the punishments and rewards she earned because she dared to be clear about enjoying fucking.

Regina was in my mind that October afternoon I sat in the front row of 1199's union auditorium to tape the panel discussion on pornography and eros. When my mother died, she left no money, no possessions, no property, no insurance policies. She left me only a sheaf of writings, scrawled letters and poems written on the back of ledger sheets. I have written a longer piece about her and me that incorporates these letters,[1] but for now I only want to talk about the courage of her sexual legacy and the sexual secrets I found in her writings and how she stood in my mind, the mind of her lesbian daughter who has loved women for over twenty years, on the afternoon of that panel.

At age thirteen, my mother allowed herself to be picked up on a Coney Island beach and have sex with a good-looking

1 See "Two Women: Regina Nestle, 1910–1978, and Her Daughter, Joan," p. 149.

young Jewish man in his twenties; three weeks later he invited her to his apartment, where she was gang-raped by three of his friends. She became pregnant and had an abortion at age fourteen. The year was 1924. Her German father threatened to kill her, and she left school in the ninth grade to go to work. When my mother writes of these experiences she tells of her sexual passions, of how she wanted sex:

> I remember as a little girl, the impatience with my own youth. I recognized that I was someone, someone to be reckoned with. I sensed the sexual order of life. I felt its pull. I wanted to be quickly and passionately involved. God, so young and yet so old. I recognized my youth only in the physical sense, as when I exposed my own body to my own vision, saw the beautiful breasts, the flat stomach, the sturdy limbs, the eyes that hid sadness, needed love—a hell of a lot of grit and already acknowledging this to be one hell of a life. I was going to find the key. I knew the hunger but I did not know how to appease it.

She goes on to speak of her shock, pain, and hurt, and later of her anger, at the rape, but she ends the narrative with a sexual credo: she would not let this ugliness take away her right to sexual freedom, her enjoyment of "the penis and the vagina," as she puts it.

Respectable ladies did not speak to my mother for most of her widowed life. She picked up men at the racetrack and at OTB offices, slept with them, had affairs with her bosses, and generally lived a sexualized life. Several times she was beaten by the men she brought home. In her fifties, she was beaten unconscious by a merchant seaman when she refused to hand over her paycheck. My mother, in short, was both a sexual victim and a sexual ad-

venturer; her courage grew as the voices of condemnation and threats of violence increased against her. I watched it all, and her belief in a woman's undeniable right to enjoy sex, to actively seek it, became a part of me. But I chose women. I wanted to kill the men who beat her, who took her week's pay. I wanted her not to need them and to come into my world of lesbian friendship and passion, but she chose not to. We faced each other as two women for whom sex was important, and after initial skirmishes, she accepted my world of adventure as I did hers.

The week before she died, she was sexually challenging her doctor in the hospital, telling him he probably did it too quick for a woman like her. He, red-faced and young, hurriedly drew the curtain around her. At sixty-seven, my mother still wanted sex and made jokes about what she could do when she didn't have her teeth in. My mother was not a goddess, not a matriarchal figure who looms over my life big-bellied with womyn rituals. She was a working woman who liked to fuck, who believed she had the right to have a penis inside of her if she liked it, and who sought deeply for love but knew that it was much harder to find.

As Andrea Dworkin's litany against the penis rang out that afternoon, I saw my mother's small figure with her ink-stained, callused hands, never without a cigarette held out toward me, and I saw her face with a slight smile: "So *nu*, Joan, is this the world you wanted me to have, where I should feel shame and guilt for what I like? I did for all the years of my life. I fought the rapist and the batterer and didn't give up my knowledge of what I liked. I looked at those dirty pictures, and I saw lonely people. Sometimes I did those things they do in dirty pictures, and wives would not speak to me. Their husbands fucked me first and then went home for *Shabbas*. I made lots of mistakes, but one thing I never did—I never allowed anyone to bully me out of my sexual

needs. Just like you, Joan, when in the 1950s I took you to doctors to see if you were a lesbian and they said you had too much hair on your face, you were a freak, they never stopped you either. They called you *freak* and me *whore* and maybe they always will, but we fight them best when we keep on doing what they say we should not want or need for the joy we find in doing it. I fucked because I liked it, and Joan, the ugly ones, the ones who beat me or fucked me too hard, they didn't run me out of town, and neither can the women who don't walk my streets of loneliness or need. Don't scream penis at me, but help to change the world so no woman feels shame or fear because she likes to fuck."

Liberties Not Taken

Mac was a big man, a square-jawed engineer who built bridges and looked like he could shove them into place. He was lying stretched out on our couch with my mother sitting alongside him, as if he were ill. I could tell she was impressed that a person such as he—what she called a professional—was listening to her. Standing quietly before him, answering his questions and looking mainly at the soles of his shoes, I realized I had been summoned to pass some unknown test. His questions seemed to come from far away, and he barely moved his head to acknowledge that my voice was reaching him. I understood then that he was not ill, but that it was his power over us, the two women, that kept him so regally immobile. I did not know who he was or why he had this power, but I had learned by this, my thirteenth year (1953), that men were my mother's secret.

After the interrogation, he asked me if I would like to spend a summer in the country helping his wife Jean care for their five children: "a mother's helper," he said. I knew then some of the talk that had gone on between the two of them: the sad tale of our circumstances, my mother's worry that I was getting into trouble. I had already been in a fight at school. Here was a chance for me to see what a real family was like. I accepted and prepared for a journey into other people's lives.

Early the next week, we left for the cottage in a battered blue station wagon. I was packed in among the twins and the older boy and could barely hold my own among the tumbling duffel

bags filled with T-shirts and sneakers. Mac and Jean were invisible to me, and I was not sure how I could help make some order out of this family chaos. The house was flat with small rooms, musty and bare. Somehow it swallowed all of us up each night and then in the day turned us loose on its screened-in porch and shaded lakefront.

The first day Jean and I were alone with the children, I learned quickly that she knew exactly what she wanted from me. I was to help with the cooking and cleaning, and in the afternoons watch the kids as they played on the lake's edge. All of this was told to me in a quick, crisp voice while she never took her eyes off me, and then she said, "Want to swim?"

I followed her down to the lake, walking behind her tall, lean body and quietly wondering at what was to come. She strode into the water, swam powerfully out to the floating raft, and, ignoring the wooden ladder, hauled herself up. I was still knee-deep in the lake's shallows, frightened by the muddy bottom. This was the first time I had felt dying leaves, soft sticks, and small shelled creatures under my feet. I kept my eyes on her as she looked toward me, and then she walked across the raft until she was balanced on the extreme edge, facing the water. She raised her arms straight above her head, stood perfectly tall and still, a long unbroken line, and then, almost too quick for me to be sure I had seen it, she sprang high up into the air and did a deep dive into the gray water. So clean, so sharp, so strong. I had never before seen a woman do such a thing, except for Esther Williams in the movies. I had known only the tired women of the cities, women who like my mother dragged their bodies to work, stuffed them into too-tight shoes and full-line bras. I knew women's bodies were for sex, but I did not know they could cut through the water or leap straight up into the air. Jean surfaced not far from me, waved me on, and then walked quickly out

of the water up the hill and back to the house. I stood silently, knowing I had seen a wonderful thing, knowing that a woman brave enough to do that was going to teach me things I would never forget.

As the days went by, I washed the dishes, cleaned the little square rooms, tended the four boys and the little girl who all had a California enthusiasm for the outdoors that left me exhausted, and, most of all, listened to Jean talk. I learned that she had met Mac when she was in the WAVES and he was in the navy. Even after their marriage, her favorite weekends out were with her women buddies, spending long weekends in San Francisco bars. She had a special girlfriend, a woman who delighted in dropping her glass eye into her Scotch and watching other patrons turn away in disgust. The eye would sit there in the amber liquid, staring up at them as the evening wore on. Eventually Mac would storm into the place, drag Jean out, and fuck her hard that night as if he could drive their deep women's laughter out of her belly. But Jean would keep returning to the bars and to her one special friend. Five children later, to save her from herself, Mac got a new job in New York, moved the family, and for a short time ended up in the same square, desolate housing development as we had.

She told me these things as if I would understand them, and I did. She taught me to play poker and got angry when I made a mistake, but it was anger that made me feel proud. She let me drive the old station wagon down the dirt roads, and one night she took me to a drive-in and let me lie with my head in her lap and dangle my feet out the window. She made me laugh until I couldn't stop, and looking down at me, she started laughing too. I felt it deep in her bones; she had no belly, just taut skin stretched over her bones. My head rolled with her laughter. Then I felt her hands on my face, on my hair,

and a sweetness overcame me. I wanted never to take my head out of her lap, wanted her laughter pouring out over me for always because with it came a caring and an indulgence too sweet, too grand, to let time take away.

She introduced me to her gay nephew who visited irregularly throughout the summer. Mac hated this young man who wore his suit jacket over his shoulders, smelled of perfume, and read Anaïs Nin. She arranged a date between us, and we sat in the borrowed car for a respectable amount of time before returning, aware that we were thrown together for a purpose but not yet having words to share our longings. I didn't call myself gay yet. For three years I had been making love to my best friend Roz Rabinowitz with my mouth, and I knew the word *lesbian*, but I was terrified of its implications and could not say it.

With Jean it was different; I was not afraid of being anything she was—except Mac's wife. We spent the long weekday nights playing cards with the older women who shared a cabin down the road. Every night before we went to bed she asked me to massage her back. I would straddle her, marveling at her body that was her ally, the muscles lying lean on her bones. I longed to slip my hands around her, to catch her small, pointed breasts in my hands, to extend the travel of my fingers down the small of her back to her buttocks, to slip gently into her, and to give her all the pleasure there was in my thirteen-year-old imagination to give. I wanted to lie beside her, hoping that she would wrap her long legs around me and carry me with her in her leaps for freedom. I never had the courage to do these things. I just whispered, "I love you," as she stretched under my hands.

When Mac arrived for the weekends, they moved into the double bed on the porch, and I could hear their arguments, hear Jean saying, "I don't want to, leave me alone!" Then I would hear her being fucked, a hard rushing sound that silenced her.

I wondered where the strength went that I saw all week until I pictured Mac, a huge man who was sure he knew what was good for her.

One weekend, after they had fought particularly hard, we were all in the lake together. I was out over my head, but I wasn't afraid, because Jean was there. All of a sudden, Mac, whose head was only a few feet away from me, said, "You have never been kissed by a father. I will show you what it is like." And he swam toward me, a large moving head with an open mouth and a power hidden beneath the surface. I tried to swim to land, but he grabbed me and held my head while he pushed his tongue deep into my mouth. I churned my arms and legs to keep from drowning; finally, he let me go. I swam desperately for shore, not wanting to see Jean's face, not wanting to see her failure.

I had been kissed like this before, by the lonely fireman whose wife had just brought home their new baby. While she was upstairs showing it off to the other little girls, he sat beside me on the sofa, showing me a picture of a naked Hawaiian woman. Then he kissed me, pushed his tongue into my mouth. I was ten years old. And then again, two years later, my mother's lover forcing me to give him a "real kiss goodnight," the same tongue this time joined by a knee between my twelve-year-old legs and his hand squeezing my breasts. And it was to happen many years later when a renowned young doctor kissed me in front of my woman lover to show me what I really needed. Always it was done to save me, to show me something I did not know, and always it resulted in near drowning. It was not that I lacked desire; I longed for Jean's lips. But because I did not tell her clearly that it was my yearning, my choice, my passion that wanted her, a thirteen-year-old knowledge that was deep and fine, she and I did nothing, and Mac kissed me and fucked her.

As the summer wore on, Jean gave me more freedom from my chores, and I made friends with the teenage counselors who worked in the Jewish socialist camp a few yards down the lakefront. I quickly found myself in their world of summer-camp romances. The summer was dying and Stanley, the City College freshman who had become my halfhearted pursuer, convinced me to have a party on the beach near our cabin. It started late, a late-summer night, a night of teenage scents—beer, cigarettes, Scotch—of wet kisses, fumblings, twisting in the blankets, the fire blazing up; couples, the young men lying on the young women, rubbing their swollen needs. I did not want it and retreated from my young man to sit in the gently rocking canoe, knowing the summer was going to end and wondering if my deliverance would come. Stanley followed me, angry that I had deserted our chance to open our mouths to each other. I sat still in the night air, seeing his lips move but not hearing his words.

My whole body was tuned for another sound. I knew she would come, and I wanted to show her I recognized my difference. I will bide my time until she touches me. I want her hands on me, her tongue in my mouth. I want to hold her head against me and throw my legs around her. And then I heard her canoe coming, the slow dipping of the paddle. I saw her flashlight search for me among the coupled bodies. Sooner than I thought possible her light found me, and I saw her eyes dark in her small face. The others in the canoe sat in the shadows behind her, but she must have forgotten they were there. I answered her before she spoke. "I am here. I am only talking, waiting."

"I would have killed you if you were there," she said, flashing her light over the entangled bodies as if she were a general surveying a field of fallen opponents.

No, Jean. You gave me the freedom to choose, but you feared that freedom more than you knew. I showed you in the best way

I could that it was your touch I sought, and in the end all you could give me was the suspicion that I had not listened, had not heard your stories, not recognized your gifts of woman difference. You heard their voices, not mine, because I was a girl-woman and it was a dangerous thing to touch me, and yet I had been touched so many times before by men who did not pause to think of innocence. Your touch would have healed me. But we had been judged unclean, and you would not harm me with the power of what they called our sin.

The summer ended. My mother lost the apartment, and I went back to live with my childless aunt and uncle in their gray rooms. I never saw Jean again, but my mother must have, because she told me five years later that Jean was dead of breast cancer. My high deep diver, I would have touched you so.

Lesbian Memories 1: Riis Park, 1960

I may never change my name to nouns of sea or land or air, but I have loved this earth in all the ways she let me get close to her.[1] Even the earth beneath the city streets sang to me as I strode around this city, watching the sun glint off windows, looking up at the West Side sky, immense as it reached from the river to the hills of Central Park. Not a Kansas sky paralleled by a flat earth, but a sky forcing its blue between the water towers and the ornate peaks that tried to catch it.

And then my deepest joy, when the hot weekends came, sometimes as early as May but surely by June, I would leave East Ninth Street early on Saturday morning, wearing my bathing suit under my shorts, and head for the BMT, the start of a two-hour subway and bus trip that would take me to Riis Park—my Riviera, my Fire Island, my gay beach—where I could spread my blanket and watch strong butches challenge each other by weightlifting garbage cans, where I could see tattoos bulge with womanly effort and hear the shouts of the softball game come floating over the fence.

The subway wound its way through Lower Manhattan, out to Brooklyn, and finally reached its last stop, Flatbush Avenue. I always had a book to read but would periodically cruise the

1 In the 1970s and eighties, lesbian-feminists often changed their given names to names reflecting their commitment to spirituality and their connection to nature.

car, becoming adept at picking out the gay passengers, the ones with longing faces turned toward the sun waiting for them at the end of the line. Sometimes I would find my lesbian couple, older women, wide-hipped, shoulders touching, sitting with their cooler filled with beer and cold chicken.

The last stop was a long, one-way station, but I could already smell the sea air. We crushed through the turnstiles, up onto Flatbush Avenue, which stretched like a royal highway to the temple of the sea. We would wait in line for the bus to pull in, a very gay line, and then as we moved down Flatbush, teenagers loud with their own lust poured into the bus. There were hostile encounters, the usual stares at the freaks, whispered taunts of *faggot, lezzie, is that a man or a woman?*, but we did not care. We were heading to the sun, to our piece of the beach where we could kiss and hug and enjoy looking at each other.

The bus rolled down Flatbush, past low two-story family houses, neighborhoods with their beauty parlors and pizza joints. These were the only times that I, born in the Bronx, loved Brooklyn. I knew that at the end of that residential hegemony was the ocean I loved to dive into, that I watched turn purple in the late-afternoon sun, that made me feel clean and young and strong, ready for a night of loving, my body reaching to give to my lover's hands the fullness I had been given by the sea.

I would sit on the edge of my blanket, watching every touch, every flirtatious move around me, noting every curve of flesh, every erection, every nipple hard with irritation or desire. I drank in the spectacle of lesbian and gay men's sensuality, always looking for that tall dark butch who would walk over and stand above me, her shadow breaking the sun, asking my name.

And the times I came with my lover, the wonder of kissing on the hot blanket in the sunlight, the joy of laying my head in

her lap as we sat and watched the waves grow small in the dusk. The wonderful joy of my lover's body stretched over me, rolling me into the sand, our wrestling, our laughter, chases leading into the cooling water. I would wrap my legs around her, and she would bounce me on the sea, or I would duck below the surface and suck her nipples, pulling them into the ocean.

Whenever I turned away from the ocean to face the low cement wall that ran along the back of our beach, I was forced to remember that we were always watched: by teenagers on bikes, pointing and laughing, and by more serious voyeurs who used telescopes to focus in on us. But we were undaunted. Even the cops, who decided to clean up the beach by arresting men whose suits were judged too minimal, hauling them over the sand into police wagons, did not destroy our sun.

Only once do I remember the potential power of our people becoming a visible thing, like a mighty arm threatening revenge if respect was not paid. A lifeless young man was brought ashore by the exhausted lifeguards, and his lover fell to his knees, keening for his loss. A terrible quiet fell on our beach, and like the moon drawing the tides, we formed an ever-growing circle around the lovers, opening a path only wide enough for the police carrying the stretcher, our silence threatening our anger if this grief was not respected. The police, sinking into the sand under the weight of their uniforms, looked around and stopped joking. Silently they placed the dead youth on the stretcher and started the long walk away from the ocean. His lover, supported by friends, followed behind, and then, like a thick human rope, we all marched after them, our near-naked bodies shining with palm oil and sweat, men and women walking in a bursting silence behind the body, escorting it to the ambulance, past the staring interlopers. The freaks had turned into a people to whom respect must be paid.

Later in my life I learned the glories of Fire Island, the luxury of Cherry Grove. But this tired beach, filled with the children of the boroughs, was my first free place where I could face the ocean that had claimed me as its daughter and kiss in blazing sunlight the salt-tinged lips of the woman I loved.

My Fem Quest

For Barbara Cruikshank and Dianne Otto

The large hall of New York's Lesbian and Gay Community Center was dark in preparation for the night of benefit readings for ILGO (Irish Lesbian Gay Organization). After climbing up four flights of stairs, I quietly slipped into the room and introduced myself to the young woman behind the table as one of the readers. "Oh, I know you, Joan," she whispered. "Look," she said, coming from behind the welcoming table and holding up her stockinged leg. "I wore these in your honor." Green pumps flashed in the darkness. How beautiful she was, in her short black dress, its hem hitting just above her knees.

Later in the evening, just as intermission was coming to an end and the room was darkening once again, a young woman appeared before me. Bending down so she could whisper her words to me, she said, "I had to come speak to you and thank you for what you have written about fems. You gave me the right to be myself." I looked up at her, at her neckline swinging away from her body, at her softly swelling breasts, such tender assertions, rising above a black lace bra, her dark curly hair framing

This essay uses as its starting point a conversation with Barbara Cruikshank entitled "I'll Be the Girl: Generations of Fem," which appears in *Femme: Feminists, Lesbians and Bad Girls,* eds. Laura Karris and Elizabeth Crocker (New York: Routledge, 1997).

her face so earnestly turned toward me. For one moment—I felt we were making love, the whispered voices, the darkened room, the revelation of the body—but this time I was the one struck by the gift of what she could offer. "Thank you," I mumbled, "but you are beautiful. You did not need any permission to be yourself."

The tensions between artifice and self, between enacting and being, between alienation and integration, between innocence and judgment were all present in those whispered words. I have emphasized youth in the retelling because two fem generations were represented that evening. How strange it was to be thanked for permission to return to the "natural" state of celebrating a young woman's body, adorning it in celebratory clothing. I think these younger women take play for granted, but it was "self" that was now the exciting creation.

I, on the other hand, am just beginning to understand that my fem desire, born in the 1950s—or better said, expressed in the 1950s—can be explored in terms of performance as well as gut-wrenching need. My fem self is both an identity and a performance because I have outlived my own decades of risking it all for a touch—meaning the vice squads, the police, the doctors—and now have the breathing space of some autonomy, both intellectually and politically, though I know how precarious this relief is. Because of my history, I have both a fem identity and a fem persona. And now I have something even more.

When I first started writing about my own sexual history, I thought being fem was as natural as breathing. While I also had a beginning understanding that all systems of desire have artifice built in—the glance, the body stance, the courtly gesture—it was the historical weight, the communal and yet somehow lonely courage of the butches and fems who stood with me in the darkness that was most real. Now I live and struggle in a world where

nothing feels natural, where reality is constructed almost every day. I am still a little uneasy with the sometimes too glib and highly abstract language of postmodern theory, and I am grateful for a past that taught me early on when to be humble in the face of the sincerity of lives lived with so little protection and so much need. However, I am also learning that new positionings are a good thing.

In my introduction to *A Persistent Desire: A Femme-Butch Reader* (1992), I had naively suggested that the decade of the fem was upon us. I was wrong; I had not counted on the tremendous appeal of lesbian masculinity. I should have known better. In 1997, I attended two "cutting-edge" events on the subject of lesbian genders: one at the prestigious Whitney Museum, which had clearly discovered the chic in butch, and the other in the book-lined parlor of the Lesbian Herstory Archives. It soon became clear, however, at both of these events, that only one gender was in full sight, the one I had taken delight in for so many years—butch and all its versions. At one of the events, a participant stated the familiar belief that a fem image by itself does not read as subversive; it would be perceived only as "woman." No matter how many times the groundbreaking work of Judith Butler and that of Sue-Ellen Case were referenced, I still felt that something was sadly familiar about this erasure of significance.

When I try to speak about what is missing from the postmodern discussion of lesbian genders, I find I have no language that feels comfortable, given all I know. For me, "fem" has a very problematic relationship to "femininity"; perhaps because I have spent my early lesbian years as a butchy-looking fem, perhaps because I have lived my whole adult life within lesbian communities, or perhaps because my mother wanted me to be more her missing husband than her sexually competitive daughter and

thus gave me only rudimentary instruction in how to be a girl—wear a girdle or your ass will look like the side of a barn, wear lipstick so you don't look like death, always be a good fuck.

For whatever reason, "femininity" carried a heterosexual marker that does not signify what I mean when I speak of my femness. I have only the word *woman* to work with, but I do not know what this word means. I know I do not mean *woman* as in "woman-identified woman," or as in "lesbian woman" or as in the heterosexual term "woman." Somewhere in my construct of fem stands the full-bodied, big-breasted, big-assed woman, firm on her feet, taking in her lover's desire in the fulfillment of her own while she "works and works and works" (to quote Judy Grahn). It was always working-class clear to me that I had to earn my living in a very concrete way to make my erotic survival possible. Economics and my version of gender were inextricably tied.

(As I write these words, a shadow falls on me, the shadow of the Woman who toils in fields and factories, who walks endless miles for her family's water, who sits in the dust outside the clinic, her baby already exhausted with its struggle to live, the Woman "who has no place in Paradise" because she is too poor, too dark, too *woman*. I must never allow my pleasure with shifting terrains of meaning to carry me too far from her life or else I, too, become her tormentor.)

This questioning of all my layers of gender and sexual experience was forced upon me, in a wonderful way, by my friendship with brave younger fems who are comfortable with discourse of all kinds. One woman in particular, Barbara Cruikshank, pursued me for a year to have a good sit-down with her and a tape recorder as we wrestled with our different fem histories. Barbara, whom I first met in San Diego when I was touring with *Persistent Desire*, is a compelling woman. Beautiful and sharp, she carries

her own history of class deprivation into all her work without sacrificing her dreams of future accomplishment, her love affair with ideas, or her need for good hot butch-fem sex. When she suggested we collaborate on an intergenerational discussion of our fem lives, I knew I would be challenged by a different language and a less romantic vision of everything. I also knew that I would learn more about my fem self and how it would travel into the next century, if I am that lucky.

Barbara did not disappoint me. Her questions made me sort out the different threads of performance that created my experience of gender. "Are we making fems sound schizophrenic, girls with multiple personalities? Is that fem self different from what you call your woman self, and at what point in your day is this transition marked?" she relentlessly queried. For the first time, I looked at my actions and desires from a self-consciously postmodern point of view. I discovered layers of garments, of actions, of shifting terrains. When I moved through my day at school I did it as a "woman," professionally competent and loving to my students; my femmself was employed in the privacy of my relationship, in the security of my bed, under the gaze of my community. I said to Barbara that afternoon, "In my earlier years, being a fem made it bearable for me to be a woman."

We passed that afternoon, two women, with our heads bent low over the tape recorder, trying to pick out the threads of our fem lives. Barbara talked about our relationship to straight women and asked if we betrayed them when we took refuge in our fem selves. She wanted to know how fem transgressiveness is created, how we can make "being the girl" as hot as "being the boy." I gave my answers as best I could—not answers really, just words of exploration. My recognition of the complexity of my own erotic narrative could be a bridge between myself and straight women; it forced me to never conclude

all was simple in any woman's story of her erotic choices and personas. We had no mutually agreed-upon answer for how we could imbue the fem image with the same kind of "cutting-edge" popularity the boygirl stance was engendering.

The weeks passed, and I grew a little uneasy with all the playing Barbara and I had done with our lives. I felt I had been seduced into an intellectual performance and while crucial, heartfelt ideas were raised, I was no more at ease with the central issue—how to honor, in the closing of this century, the woman who calls herself a fem. The more I think about it, the more it becomes clear to me that it is the concept of "woman" that is the sticking point. What to do with it? Is fem the performance, woman the essence? Is fem the parody, woman the false original category? Something is wrong with this whole discussion. My concern now is that behind all the sophisticated discussion of lesbian genders is a devaluing of the fem woman, not because she is fem but because she is a woman.

What kind of fem am I becoming? One who does not need to be on the arm of a butch-daddy-boygirl to have meaning and value in our world. One who takes great pleasure in the body of Bette Midler, in the memory of Simone Signoret, in the audacity of Gypsy Rose Lee, in the arms of another fem woman, in my own softness. I am the fem woman who has lived through the queer days, the butch-fem days, the lesbian-feminist days, and the queer days again; they are all part of this woman-fem that I am now. Now I stand alone, holding my body in my own hands, knowing that when I lie down with a butch lover, she is getting something precious, and when I take her cock in my mouth or her hand in my cunt, I do it as much to honor my own dreams as hers.

And to my woman-fem lover, who allowed me to love both her breasts and my own, whose body was so round like mine and

as strong in its desire as mine, who allowed me to finally hold in my arms the world I had given to my butch lovers, I give the deepest kiss of recognition and of desire. All is possible, she says as she surges into me, and now finally, all is.

Doesn't She Ever Stop Talking

With a nod to Jesse B. Semple and his creator,
Langston Hughes

1. Her Death Was Not Unexpected

Her death was not unexpected, but the weather was. A blustery wind sneaking in under the heat, bending the silver gums almost to their knees. She had been lying up in her little bedroom for several weeks, books piled all around her as if they were her family come to say goodbye—all kinds, all the sorts of books that had befriended her during her wayward life: a life of Robert Browning, a novel by a Turkish writer, an Australian detective story, a thick collection of poetry, a book about drawing with colored pencils, the story of Sydney's dance halls and picture palaces, a four-generational history of a Vietnamese family, a journal of queer thinking. Glasses of water had to find their balance on these stacks, pills and tissues slipped into the crevices between these edifices of The Word. That was where she was going, she used to say—into the great Black Word, not the word that was in the beginning, whatever that might have been, long ago in some old man's tyrannical mind, but maybe the

Originally published on the online lesbian journal ReadTheseLips.com (Volume 3, 2009). I would like to thank Evecho, editor-in-chief, for her careful and caring editing.

Word in the middle of a dirty joke or in a garbled dream or best of all, a Word sung by Ethel Waters when she wasn't allowed to be magnificent on the white stage—that was where she was going.

We didn't think she missed her family, never having had much of one; in a way, she lived without family or nation, the two anchors of Vietnamese life, she told us one particularly difficult day. "Unanchored" was how she put it: not devoid of loyalties, just not the usual kind—not to gods or anthems or sports teams or free enterprise, which so often, she said, was neither free nor particularly enterprising, unless you call having old Harvard chums in high places acts of the economic imagination.

In some ways our friend seemed most alive in her last days; she was preoccupied with shadows, and they carried a hefty weight. In fact, one night as we sat in her small living room sipping Mount Gay Rum and tea, we overheard bits of her ongoing conversation with one David Brooks, a *New York Times* columnist with a boyish grin, who must have been appearing nightly right above her bed, not on his wishes it would seem because she spent a good fifteen minutes reassuring him that his time in her bedroom would be short and he would soon return to his son, baseball, and friends at West Point who could always make him feel good about war. How she conjured up this unlikely apparition we had no idea; our friend was steadfastly closed to spiritual endeavors—just the smell of lavender—or apricot-scented candles was enough to slam her door. She did enjoy delightful contradictions, and he, shining down from her bedroom ceiling, loaded as he was with phobias about the chattering classes, women going down on each other, and "really radical people" at peace marches, must have been a seductive diversion from dying. That was our friend—conjuring up ghosts so she could see right through them.

Another visitor she entertained quite regularly, or thought she did, was Ethel Merman. "Ethel," we heard her say one very hot morning, "You're not even Jewish." But what they really wanted to talk about was girdles, the old-fashioned kind that rubberized your whole body. "That was the real secret of that voice," we heard our friend say. "That never-ending O that brought down the fake stars in the Lowe's on Jerome Avenue was forced out of your mouth by body made into stone, one unbroken column of flesh, flesh made stone."

"Yep, that was me," said Ethel.

Sometimes Ethel Merman made our friend cry—not in sadness but in longing for a sound. And then they would talk about women, their language growing fouler and fouler with each tit for tat. Our friend loved to regale us, when she was in this world, with stories from the golden days of lesbian gossip—like the night Ethel almost bit off Tallulah's nipple in a fit of drunken grand passion that ended in the Bellevue emergency room. Ethel, we were told, swore like the sailor she was. It was at times like these, when there's no business like show business or the business of war was being touted in the sickroom, that the little black dog with his impenetrable black eyes would throw his ruffled head back and howl like a foghorn, a small black beacon for wayward ships and dreams.

Our pal was not dying alone literally. We were there, a motley collection of old and new friends: librarians waiting to take back overdue books; old lovers and lovers of the old; the woman from down the street who had shared her collection of the Harmonics, delighting in the tuneful way Jews could sing a cappella before being shipped off to unknown destinations; and most of all, right outside her door sat the little dog, day and night, sometimes licking our hands, sometimes snapping at our fingers— don't worry, she would say, he never draws blood. And then of

course, no one really dies alone; billions of people are dying all at the same time all over the world, an endless stream passing from one dimension to another. Every day she lived, our friend wondered at those who had been standing on the wrong side of the street in Baghdad—was there a right one, she said out loud, outside the green zone, and why *the green zone*, green for grass or money or go ahead, and was the rest *the red zone*, for blood, for stop now? Accidents of fate some called it, but our friend refused such dismissals—she could not work out how starvation or untreated disease or war or exile from enough could be called accidents when so many seemed involved in making it all happen. She never accepted the belief that history was an accident. In fact, one of her favorite sayings toward the end was a loud "That was no accident," shouted with her old Bronx verve. It sounded a lot like "You're out!"

Besides, our friend always knew dying was part of life; she didn't belong to a community of faith, our friend. And that was good because we didn't have to either and if we did, it didn't enter the equation. Like Einstein said. When he wasn't being the Jewish genius. In fact, our friend, over the seventy years of her life, had been dying for a long time. She never took a trip without calling one of us to say goodbye—and she didn't mean a little goodbye; she meant the whole shebang. We all had stock phrases like "You will be home before you know it" or "You know, they have doctors there too." She left her latest last will and testament tucked into her chest of drawers—she loved that phrase, how it conjured up breasts and cunt all in one image of storage—or under her pillow or between the pages of one of those precariously balanced books. We imagine once we have to empty her rooms, we will find endless goodbyes and notices of who gets what—not that there is a lot of what but there are the books and of course, that little dog, the sen-

tinel of her dreams. Maybe we could even say that for our friend, dying was her life—and boy, did she kick up her heels the whole way.

How do you say goodbye to a ghost in these days when so many apparitions are on the scene, but this one was special, she was our friend? Maybe all ghosts have friends who think they are real, that blood flows in those shattered veins, that nights should bring pillows for tired heads and not concrete floors or armored vehicles. Sorry to slip into diatribe, one of the dangers of our times, the rich baroque language of ghosts, but our friend used to say, don't worry about being over the top, they don't allow it for long anyway. She was a good bottom, she was, that woman lying in there, always had her best conversations looking up at the ceiling.

We shifted in our seats, feeling the wind about our ankles, the little dog curling up in front of the bedroom door. The poet among us spoke Browning, something about "the dangerous edge of things."

2. There She Goes Again

"There she goes again, dreaming of better days," says the gray-haired, gray-eyed Midwesterner sitting in the corner. "I would know that moan anywhere and this time—it sure ain't pain. Oh, she sure did like her woman poppas." Again the moan, and this time the little dog rolled over and spread his legs. "Nothing to show off there," the schoolteacher cracked. The night was long and our knees ached. We needed this change of subject. The tennis player from the back of the room contributed, "What she most loved was a good forearm." A few of us laughed fondly. "Yep, it was the promise of all that thrust; she sure did love that thrust."

"You're making her sound like Cape Canaveral," said the historian sitting next to our friend's bust of Eleanor Roosevelt.

Then the redhead twanged: "You know I come from a timber mill family; for three generations we have hewn and stacked slabs of Antipodean hardwoods, our hands callused and our noses large. That was what she saw in my arms, I believe, my veins made large by hauling big ideas around. The thrust of big ideas, I wore them on every knuckle, and she took them all in."

"Thrust is an interesting thing in a woman," said the Midwesterner. Like our friend, we were a mixed bag, geographically speaking. "I remember the afternoon she watched me whip up an angel-food cake, my arm bulging with the effort of making froth hard; she was sighing with every whip, worrying, I found out later, that there would be nothing left for her." And as we knew she would, the Midwesterner laughed low and, with a charming kind of Kansas modesty, said, "Of course, she had nothing to worry about." Thrusting, our friend always said, is a two-way street.

A good thirty of us were packed into that small room, listening for changes in breathing, lapses in dreams. And here we were, filling in the hours with our own special moments of remembered, desired, intrusions.

A thirty-year-old auburn-haired friend who spoke in the soft drawl of a Louisiana delta girl started to sing a Cajun song about cowgirl boots treading the boards of a bar in the lowlands. "As the moon came up," she added once the song was finished and we were sitting very still, "I kindly, with my red-nailed fingers and perfumed ways, made my way deep inside of her."

Late into the night we told our stories, cave painters all, our hands dipped in our vocations—printers' hands, old fashioned bookkeepers' hands rough with ink-stained calluses, peach-smeared child-carer hands, carpenters' hands with nails bitten

low because that is how we had all learned to do it. Horse riders' hands, poets' hands pausing to shape sound from the air, and at the end, one of the oldest friends, though not around much anymore, told of her soldier's hands, on a weekend leave back in the early sixties, fleeing into our friend. "Oh, did she grip me, the best AWOL I ever had. I remember it like it was yesterday, or maybe tomorrow, another war, but the same pull between one intrusion and another—how I wanted to stay, one hand buried in that warm place, my dog tags bouncing on her breasts, she whispering freedoms in my ear, but I had to go. She, in there, knew the difference between one kind of invasion and another." Our heads nodded in the darkness, no oil wells in there, no prisons or medals or god's will, no lands to own, no people to subjugate, no axes to grind, no profits, no nations wanting the world's all without giving anything back, no gated communities or walled-in territories, no manifest destinies—"Wait, stop, it's just our friend's sexual pleasures we are talking about, not the United Nations, all you needed was her open-door policy and a little thrust."

As we took in this call to reason, we noticed that the little black dog had left its usual position and now stood on the threshold of our gathering. "Hey, look at that—he's got something for us." Knowing our fear of him, he dropped the small tooth-marked piece of paper at the foot of the most patient of us. "It's from her," she said in a hushed voice. "I can die without god, but I can't live without Marx," she read out. Well, there you go. She sure is going to need a lot of thrust to get where she is going.

3. Among Us Was

Among us was a fat older woman who had flown in just for our vigil, not knowing whether she would arrive before or after

our friend's departure, but we quickly reassured her that even we who had been gathered for many months now were never sure what was happening in that small bedroom. We had to do a lot of shifting to make room for her large body, which smelled of pepper trees and corn. The little dog made himself even smaller as she carefully stepped over him, after putting her ear to her friend's door and calling out, "No worries, doll, I made it." Satisfied with her new position among us, she took out a small embroidery from her ever-present travel sack, pushed her needle through, straight and true. After a few minutes of tight stitching, the newcomer looked up, smiled at the leather-clad bookkeeper sitting to her left, and, exhaling a soft, red desert–warmed breeze, settled in for the duration.

"Where do you think our friend is residing tonight—which world is she in, she's been so quiet, no messages, no thumps, and the TV is almost dumb." We all turned to the closed door, bounded as ever by that cheeky dog who had never warmed up to us. "Looks to me as if he is guarding the border," said the fat woman, never missing a stitch.

Ever watchful for a new subject to while away the hours, we turned to her. "And what do you know about borders," gently questioned the lawyer, her next-seat neighbor. We knew when to be careful with our free-floating inquiries; borders were nothing to fool with, not now, maybe not ever, except—and here the questioner inclined her head in the direction of the now silent bedroom. "Well, circumstance, you know Circumstance, can be anything from a bill collector to a love affair to a government's certainty to a tank coming through your bedroom window, Circumstance causing all kinds of changes in a person's life, changes that can just pick you up from all you know and deposit you right smack down in some other godforsaken place." Here we kept

our mouths shut; we didn't want her to know that where she was sitting was literally a place that had forsaken god.

The bus driver among us, still dressed in her blues and whites, passed around a bowl of cherries, and Fannie, as the Circumstance lady came to be known, delicately took a handful, putting down on her ample lap her piece of linen with its carefully emerging cross-stitched green-and-red grevilleas. "Now I have had to learn to live with borders, learn how to twist and turn so one place wouldn't send me back to another place. I'm so used to it now that I can occupy two places at the same time. But no place—and all its brothers—could keep me away from being here. You just keep an eye on me as the night goes by and if you see me fade a little, don't worry, I'm just stepping over the border to my other place. I got to keep my hand in, you know, got to stay in touch with that other sky, with that other light, got to keep the officials on their toes, trying to catch a fat lady slipping through procedures. You know, when I am there, over the years, I have actually in my own way walked through my lounge-room wall and found myself on old Broadway—yep, I'm an old song-and-dance girl. Borders, particularly borders with histories—maybe there is no other kind—are sad, miserable misconceptions, not attuned to Circumstances of Life, if you know what I mean."

At that point, the soldier who had sat among us for as long as she could rose to leave. "You tell my friend in there to give it a good fight—let me know what happens, will you," she said to the most patient of us. "You can find me at the nearest border; I'm on twilight patrol. She knew me before I was a soldier, and those kinds of buddies are hard to come by. Sorry I didn't get to tell you some of the things we did in the old Village, me with my rookie way and shined-to-a-star boots under her day bed that never rose off the floor. I took her home with me one afternoon

back to my Bronx, not hers, mine, the Italian Bronx—wanted her to meet my mom and dad and my messed-up brother, see the house I had grown up in. My mother thought I was bringing home my wife. That's the kind of daughter I was. Well, nice meeting you all—I know what you mean about borders and guns and permissions to cross over—dangerous territory, that. At least I got my education; now I'm a nurse who can carry a rifle—that's the kind of thing that happens at borders. Thanks for the unguarded days." She nodded to the bedroom and before we could stop her, she bent over to take leave of the dog. Our warning words died on our lips as that nasty, fervent fellow just lifted his muzzle, now a little gray, and gave her a long look—no teeth, no snarl, just a good deep look out of those black eyes. Fannie sighed and something shifted in the room.

Some Understandings

In these painful and challenging times, we must not run out on gay men and leave them holding the sexuality bag. It is tempting to some lesbians to see themselves as the clean sex deviant, to dissociate themselves from public sexual activity, multiple partners, and intergenerational sex. While this may be the choice for some of us, it is not the reality of many others, not now and not in the past. Lesbian purity, a public image that drapes us in the cloak of monogamous long-term relationships, discreet at-home social gatherings, and a basic urge to recreate the family, helps no one. It does justice to neither the choices it supposedly venerates nor our sexual independence. Long-term couples are often struggling with huge issues of lust and changes in sexual patterns. Discreet social gatherings were and often are the way close-knit sexual communities found a safe place to play. Public bathrooms have been social bedrooms through the years for young lesbians who had no safe home to take their lovers back to, and we have long documented the lustful crushes of young lesbians on older women, many more of which have been consummated than we encourage to be discussed.

Thus, by allowing ourselves to be portrayed as the good deviant, the respectable deviant, we lose more than we will ever

This talk was delivered during an evening in the early 1980s celebrating the publication of *Powers of Desire*, edited by Ann Snitow, Christine Stansell, and Sharon Thompson (Monthly Review Press, 1983).

gain. We lose the complexity of our own lives, and we lose what for me has been a lifelong lesson: you do not betray your comrades when the scapegoating begins. If, as lesbians, we declare ourselves a people under attack for our sexual difference while at the same time we say, "But we are not as different as they are," then our assertion that we are victims of sexual judgement is self-serving. We cannot be sexual deviants only when it is safe to do so. Gay men, in large measure because of the onslaught of AIDS, are in danger of bearing the brunt of both private and public retaliations. We must not allow them to become isolated as a public sexual community. Historically, bigotry fueled by terror has led to mass exterminations of the offending human beings.

Another thorny issue that needs attention is the relationship between lesbians and straight feminists. If we are to be comrades in the days of battle ahead, it is essential that we clear the air between us. The best way we can work together is suggested by some of the discussions in *Powers of Desire*. I think the phrase "Every woman is a potential lesbian" is no longer useful. It trivializes my own history and the history of a community I was part of, just as it trivializes the history of individual straight women. It once served the rhetorical purpose of carrying the discussion of lesbian feminism into more respectable places, but all my knowledge of the 1950s tells me that my sexual journey was not a rhetorical device.

The police and the doctors and the red lights in the bars, the broken faces and the cruising cars full of hate, the head between my legs in a place I had never seen before and would never again, the leaving of homes to seek one's comrades in the streets, the pronoun deceptions used at work so that telephone calls to lovers would not label one a public freak, the flash of a knife in the hands of a mother who did not want her daughter to go

out the door with a lesbian—these were not the experiences of all women. So, too, I will never feel the push of childbirth or endure the balancing act between autonomy and intimacy that many women are trying to work out in their relationships with men.

We must face each other knowing that we have made different choices, and that each choice opens us up to a different history. We each have an integrity of experience that can keep us from being the victims of our lives. This does not mean that I will ever accept lesbian-hating or disguised shame or sweeping heterosexual assumptions. The other part of the commitment, however, is to stop bullying women into sexual stances, to end the assumption that only lesbians make choices.

We must stand together, realizing the complexity of our histories, both personal and social, choosing when we can tolerate each other's company and when we cannot. We must never pretend to be experts on each other's lives, never belittle the deep differences that do exist or pretend that we do not see the places of exposed pain.

I have dedicated my life to creating a memorial to the specialness of lesbian lives, but so deeply do I know the way I have come that I can now join with comrades who are different, join to fight the terrors of coercive sex on the one hand and the dangers of state-regulated sex on the other. These two forces leave us a fragile piece of land on which to make our stand. It is the place where a woman's voice says simply, "Touch me here because it feels so good," or "Yes, I will take you now," to whomever she chooses. Such a simple thing, and yet all the oppressions in the world conspire against it.

We must make our stand now as government and religious groups begin family-preservation and sex-reform campaigns.

The headline "Urge Sex Ed for JHS" can signal a new respect for teenage sexuality or an attempt to threaten and punish sexually active young women. We must monitor these programs, and even more importantly, we must start giving young women a forum to tell us what their sexuality means.

The battle for reproductive freedom is another battle we must wage together to make sure that class and race do not determine who will be allowed to have sexual pleasure.

Even to raise the issue of women's sexual freedom in the time of our government's invasion of Grenada may seem a bourgeois activity, but I have learned from the historical essays in *Powers of Desire* that times of governmental aggression set up a legacy of sexual repression for decades to come. Our government is now mobilizing this country for further assaults on governments it deems variant. I believe that as celebrants of passion, we must become vocal antigovernment activists. When American rifles bring down the chosen governments of other countries, when bodies hit the earth never to rise again, what also dies is their history of desire. If we do not battle as open sexual radicals fighting the forces of death, all the small freedoms we have won will disappear. These freedoms are crucial not only for this country but for all the countries of the world. In all its different cultural settings, the issue of women's sexual freedom will eventually become the test of how women are surviving in that culture.

Finally, to use the cadences of Frederick Douglass:

Until all women, young and old, black, red, yellow, and white, poor and middle-class, gay and straight, have the power to announce and control their sexual pleasures, this struggle will go on.

Until all women have equal access to abortion, this struggle will go on.

Until we have a government that uses compassion in the place of power, that recognizes a changed social order as the only way to stop the sufferings of the hungry, the homeless, the poor, the aged, the physically challenged; until we have a government that supports the freedom movements of the world and not the regimes that rule by hatred and police force, this struggle will go on.

Until the power of sexual joy has replaced the power of sexual fear, this struggle will go on.

Passion in Our Politics

Today we are a people who once again have taken our anger and our courage into the streets because once again we have been told that our desire, that our sexual celebration, is our sin. This week we have been told by Mayor Koch, while he stood in front of the Lesbian and Gay Community Center, that he would not march in our commemorative parade because we desecrate the steps of a church, because religious bigotry is the right of the powerful but the outrage of queers is an insult to the divine being. The irony of all of this is heightened by the congratulatory messages we give each other on this day—we have come a long way, we have political clout, but in this fifteenth year of our taking to the streets when the slogan is "Unity and More in '84," I find myself needing to remember small things.

I need to remember that the resistance of lesbians and gay men, of queer people, did not start with the courage of Stonewall, that gay pride did not start with marches in the street, but in the collective steps of courage that were taken by thousands of gay men and women when they did such things as go to drag balls in Harlem in the late thirties; when they walked hand in hand in hand down the hate-filled streets of the McCarthy period; when they left small towns all around this country and came to cities like this one, determined to survive their own de-

This speech was given on June 24, 1984, at New York City's gay and lesbian pride celebration.

sires; when they organized homophile groups like DOB and the Mattachine Society; when they danced close together in lesbian bars under the intruding eye of the red light that signaled police surveillance.

I need to remember how in 1958, I endured and played on the bathroom line in the Sea Colony, a working-class lesbian bar, where we were carefully given our allotted amount of toilet paper, abiding by the guideline for bathroom use by deviants that had carefully been set down by the vice squad. I need to remember how we endured and survived the police raids and the police wagons filled with our friends, how the policemen thrust their hands down the pants of our butch women to humiliate them in front of their friends and lovers, and how we nursed battered faces after street assaults. I need to remember the Women's House of Detention, where poor lesbians, mostly Black women, bore the brunt of deviant punishment, the hot summer nights when women called to women, their assertions of love piercing the red brick walls and narrow windows. Before Stonewall, we fought for the right to our love in a hundred different ways, and always this battle took its strength from our need to be part of a sexual community.

Our history is the history of desire and all the wonders that desire can give birth to—out of fragments and out of fear, out of shame and out of judgement, we have built a history of resistance: we have told the tale of loving and then worked hard to give our passion a place in this world. We have built institutions around it, we have become attractive to political candidates because of it, we now talk of a million dollars needed for a gay center, but the deepest memory I want to keep alive is the image of a frightened eighteen-year-old lesbian who in 1958, knowing the world scorned her both as a woman and as a bull dyke, found the places she needed and the women she loved on the dan-

gerous but life-giving streets of this city. It is the courage to be different because of a passion, and then a conviction about the right to that passion, that is at the heart of our history.

This affirmation of the dignity of desire is also our gift to the world's history, and it is one of the ways that we become part of the human struggle against governmental oppression. Desire begins as a personal voice but when we as a people assemble in the name of that desire, we are a political community forcing a new understanding of the complexities of human choice. It is no accident that times of governmental oppression set up a legacy of sexual repression for decades to come. Our government has now mobilized this country for further assaults on other governments it deems deviant. I believe that as celebrants of our passion, we must become vocal anti-Reagan activists. When American rifles bring down the chosen governments of other countries, when bodies hit the earth never to rise again, what also dies with each one is their history of desire. In Grenada, in Central America, in South Africa, in the Middle East, on our own streets, desire is murdered every day. If we do not battle as open sexual radicals fighting the forces of death by judgment, all the small freedoms we have won will disappear or exist only for a small group of us—a group selected because of its connections to power and privilege. But these freedoms, this announcement that a people's sexual identity is part of all the battles for the liberation of the human spirit, are crucial not only for this country but for all the countries of the world.

When we march in the streets, hundreds of thousands strong, we carry with us the lonelier courage of those who risked all because they said to someone of their own sex, "touch me here." This small voice is still enough to rule us out of heaven, but whatever power comes to us in 1984 and beyond, we must not forget that for us passion is our politics.

Letter to My Community:
A Sturdy Yes of a People

These are not easy times, but they are times that must *be*. All around us, institutional heads debate our humanity as if we were not there, as if we were human objects to be moved around as their small minds and smaller hearts grapple with "the gay problem." Other people, working people, fierce in the protection of their children and in adherence to their religious leaders, pledge closed-mindedness. Devout Catholic, Orthodox Jew, fundamental Christian know what God has said about us. The powerful and the powerless join hands in judgment.

But we come now a full-handed people. We come knowing our history, knowing our poets, knowing our communities from the past who built worlds for us to inherit. We come as women who refused to be ideal or childlike or fettered; we come as men who endured the loss of all for the love of some. We are the watchers of their sad shows; we can be the builders of new times.

For over four decades, I have made my way in this world as a lover of women. I have spread my legs and lowered my lips for the love of women at night and taught my students during

This public letter was written in 1993, after viewing the Senate hearings on gays in the military, after watching a 60 Minutes segment on the debate over the Rainbow Curriculum, and after months of reading debates over the humanity of gay people in the *New York Times*.

the day. The way I loved filled the way I taught, the way I loved shaped the books I wrote, the way I loved shaped the politics of change I fought for. Hundreds of thousands of us held our passions close as we created public beauty in this country.

Offers will come to us: be silent, do not announce, tell no one and you will have a place. Silence wins no honest or safe place. Disclosures make us impossible; silence makes us possible. But our heritage demands sound—Radclyffe Hall shouts at her lawyer, "I mean this to be a book about inverts, not just friends." Oscar Wilde chides, "You cannot kill my love of young men by putting me in prison." Pat Parker asks in warning, "Where will you be when they come for you?" Mabel Hampton flaunts, "What do you mean, when did I come out? I was never *in*." Audre Lorde chants, "Silence will never save anyone." They cannot force silence into our mouths; we take lovers into our mouths, we take breasts and cock into our mouths, we take wetness and fullness into our mouths, but never their silence—for that will choke us.

Devout parents and family experts say we are inappropriate for children, that understanding is inappropriate for children, that meeting lesbian parents is harmful for children. Let them find out about these kinds of people when they are older, they say, as if we were a strange food for which only adults can have a taste. Let my child be beaten into manhood in the schoolyard, let my daughter lose her heart in the pursuit of a woman's life— but never let them know that gender is not a prison, that love is not always doled out to the same few. These people who wish to keep us from children battle to protect a killing ground.

Other excluded people have told us that perspective is all; Frederick Douglass wrote, "That which he most loved, I most hated, that which gave him life was death to me." The dying masters have built a house of cards, a full deck of hatreds, and

are caught in its reflected images. We must know ourselves, know the solidity of our history and our gift of love, so we can walk through their mirrored house into the challenge waiting for us: the creation of a more just world.

Cohesion in the killing forces will be destroyed if we appear with our names full on our lips, say the military experts, all-powerful men sitting in the same chairs as the other men who judged what was real in other times—the House Un-American Activities Committee men, the Irangate men, the Anita Hill men. Hollow voices they have become as we move forward; like ghosts they sit upon those chairs, mouthing the credos of a losing world; but even in their airy flailings, they maim hope.

Think of what they fear from us—love and desire, rebellion and difference, play, tenderness, touch, freer children who do not call each other faggot, girls who strive for their own glory, men who do not have to hate softness. All their words and reasons for exclusions, all the tumult of their *No*, will fall into the shadows of history.

You—my queer comrades—have given me a world where my words could live, where my love was kissed by the sun, where my anger turned to visions of possibilities. These are hard times, but necessary ones. These are times when we BE, a sturdy Yes of a people.

History

A Restricted Country

1.

When the plane landed on the blazing tar strip, I knew Arizona was a new world. My mother and brother stared out with me at the mountain-fringed field of blue. The three Nestles, on their first vacation together, had crossed the Mississippi and entered the shining new land of the American West. The desert air hit us with its startling clarity: this was not the intimate heat of New York, the heat that penetrated flesh and transformed itself into our sweat and earned our curses. We walked through it, with the others, and stood waiting for the station wagon to pick us up.

I should have known from the skeptical look on my mother's face that we were in for trouble, but I chalked it up to the fact that she had never traveled further west than New Jersey. My brother's new job at American Airlines had made this trip possible: the company compensated for low wages by offering its employees special cut-rate vacation packages, and many of his fellow workers had recommended this one-week stay at Shining Star Guest Ranch as the best bargain. From the moment he had told us of the possibility to the time we were standing in front of the Tucson Airport, I could not believe the trip was really going to happen. I had dreamed horses all my sixteen years, played wild stallion in the Bronx vacant lots that were my childhood fields, had read every book about wild horses, mustangs, rangy colts that I could find, and through all the splintering agonies of my

family, I galloped on plains that were smooth and never-ending. For my brother, who had seldom been with my mother and me, this trip was both a reunion and an offering. After years of turmoil, mistakes, and rage, he was giving us the spoils of his manhood. He laid this vacation at the feet of our fatherless family as if it were a long-awaited homecoming gift. For my mother, it was a simple thing: her week's vacation from the office, her first trip in over twenty years.

We finally spotted the deep-purple station wagon that bore the ranch's name and hurried to it. A large man in a cowboy hat asked if we were the Nestle family, looked at us intently, and then fell silent as he loaded our suitcases into the wagon. We rode through the outskirts of Tucson and continued into the desert. The man never said another word to us, and feeling the strangeness of the desert, we too fell silent. Cacti rose around us, twisted strong creatures that, like the untouching heat, seemed only to tolerate the temporary intrusion of roads into their world. I felt the desert clumps of tufted grass under my feet. In my mind I was already moving my horse's haunches, for now it was only a sheet of glass that separated me from Annie Oakley. Dusk came suddenly and the heat fled.

We pulled into the ranch, and another man poked his head into the front window and stared at the three of us. "Do you want fish or meat for dinner?" were his only words. My mother answered that it made no difference, meat would be fine. Everything was still in the blue-black night as we were shown our rooms and then led to the dining room. The room was long, low-roofed with heavy beams; a fireplace glowed at one end. All the other guests were seated at the same table, ladling out huge portions of food from communal platters. We were seated at the last long table, a far distance from the rest, near the large stone fireplace. As our places were being set, the waitress placed

a small white card near each of our plates. I picked up mine and read, *Because this guest ranch is run like a family, we are restricted to members of the Gentile faith only.* I could now envision the chain of events that our arrival had set in motion. The man who peered in at us must have realized we were Jewish and rushed in to tell his boss, who pulled out the appropriate cards to be served with our dinner. My brother and I sat stunned; my mother said we would talk to the manager after dinner.

As I tried to eat, the voices of the other guests caught in my throat. I had grown up with the language of New York's Garment District. I knew the word *goy*, but this was my introduction to *Gentiles*. "We can't stay here," my mother said. My brother kept saying he was sorry, he didn't know. How could his co-workers recommend this place? How could American Airlines have a working agreement with such a place? When we finished eating, my mother asked to speak to the manager. She and my brother were led to his office. I stayed outside in what seemed to be a reading room. I paced the room, looking at the books lining the wall. Finally, I found what I knew had to be there: a finely bound volume of *Mein Kampf.* For one moment it wasn't 1956 but another time, a time of flaming torches and forced marches. It wasn't just my Jewishness that I learned at that moment: it was also the stunning reality of exclusion unto death. It was the history lesson of those judged not to be human, and I knew our number was legion and so were our dyings.

Huddled in the privacy of our room, my mother and brother told me what the manager had said. Since it was off-season, he was willing to compromise. If we told no one that we were Jewish, if we left and entered through the back door, and if we ate our meals by ourselves, we could stay. We looked at each other. Here was an offer to the Nestles to pass as Gentiles. To eat and walk in shame.

We waited until the morning to tell the manager our decision. I stayed in our room while my mother and brother went in for breakfast. In a strange twist of feeling, my anger had turned to shyness. I thought of the priest I had noticed sitting at the table the night before, and I could not bear the challenge to his geniality that we would represent. After breakfast, the three of us entered the manager's office to tell him we would not stay under his conditions.

I stared at the man as my mother spoke for us, looking for his embarrassment, waiting for the moment when he would say this was all a joke. His answer was that he was sure we would not want to stay someplace we were not wanted, but there was a Jewish dude ranch several miles away. Perhaps the owners would consider allowing us to stay there for the same price. He made the call for us, saying, "By mistake some of your people came here." The voice on the other end agreed to take us. Once again, we were ushered into the station wagon and driven to a parking lot in downtown Tucson. We sat on the curb waiting for the station wagon to pick us up. The men walking by wore big brown belts with turquoise stones embedded in the leather, pointed boots, and wide-brimmed hats. The sun shone with that same impersonal heat, and the shimmering mountains were still waiting for us in the distance.

2.

When the station wagon pulled into our new destination, we were greeted by a small circle of elderly guests who welcomed us with hugs and low-voiced comments to my mother about "the *kinder*." After the novelty of our sad mistake wore off, the three of us were left to our own devices. As the youngest person at the ranch, I was indulged in my unladylike ways. Riding clothes were lent to me, and my desire to smell as much

like a horse as possible was humorously accepted. My brother spent his time playing tennis and dating the young woman who cleaned the rooms. As soon as it grew dark, they would take off for the nearest town. My mother, however, had a harder time in our Jewish haven. All the other guests were retired, wealthy married couples who moved with ease in this sunlit world. While they were sympathetic to my mother, a woman alone raising two kids, they were also embarrassed by her. She dressed wrong and did not know how to enjoy herself.

My mother was a dedicated gin-and-poker player. Shortly after our arrival she tried to join the nightly card game, but here under the Arizona sun, the stakes had multiplied beyond her resources. I watched her as she approached the table of cigar-smoking men. She sat for one round, growing smaller in her seat while the pile of chips grew bigger and bigger in the center of the table. She was a working-class gambler who played with her week's salary while these men played with their retired riches. Her Seventh Avenue bravado could not cover her cards. For the first time in my life, I saw my mother defeated by the people she said she despised. She could not fight the combination of a strange country, high fashion, pity, money, and physical pride.

One afternoon I noticed a crowd of guests gesturing and laughing at something in the center of the riding ring. I pushed through and saw it was my mother. Dressed in her checked polyester suit, she sat on top of a large brown gelding, attempting to move it. She rocked back and forth in the saddle as if she were on a rocking horse, or making love, while voices cried out to her, "Come on, Regina, kick him. You can do it." The intimate spectacle of my mother's awkwardness, the one-sided laughter, and the desperate look on her face pushed me back from the railing. These people were my people; they had been kind to me.

But something terrible was going on here. We were Jewish, but we were different.

Toward evening, at the end of our stay, I went in search of my mother. I looked by the pool, in the lounge, and everywhere else the other guests habitually gathered, but I could not find her. I wandered to the far end of the ranch and saw her in the distance. She was sitting on a child's swing, trailing one leg in the dust. A small round woman whose belly bulged in her too tight, too cheap pants. Her head was lowered, and the air shimmered around her as if loneliness had turned to heat. Where were Seventh Avenue, the coffee shops, the crowded subways, the city that covered her aloneness because she had work to do there? Arizona was not for Regina Nestle, not this resort with its well-married ladies. While I scrambled over this new earth, my mother sat in the desert, a silent exile.

3.

Bill, the tired, aging cowboy who ran the corral, was my date for the evening. My brother, Elliot, was with Mary, a woman in her twenties who worked at the ranch. We had been to see a movie and were now parked behind the ranch house. Bill kissed me as we twisted around in the front seat. His bony hand pushed into my crotch, while his tongue opened my mouth. I pushed his hand away, sure of what I wanted and what I did not. I did not want his fingers in me, but I did want to see his cheek against my breast. My brother and Mary gave up their squirming in the back seat and left the two of us alone. Bill was respectful. One word from me was enough to get him to stop his efforts at penetration. "Lie in my arms," I told him. He slipped his long legs through the open window at one end of the front seat and leaned back into my arms. His lips pulled at my nipples. We sat that way for a long time as the Arizona sky grew darker and darker. Right

before he fell asleep, he said, "Best thing that's happened to me in twenty years." I knew this did not have very much to do with me, but a lot to do with my sixteen-year-old breasts. I sat there holding him for what seemed like hours, afraid to move because I did not want to wake him, when suddenly he jerked in his sleep and knocked into the steering wheel, setting off the horn. The desert stillness was split by its harsh alarm, and I knew my idyll was coming to an end.

One by one the lights came on in the guest cottages. My brother was the first to reach the car, his pajamas shining in the moonlight. "I'm all right, I'm all right," I whispered as I maneuvered my body away from Bill's. I wanted to escape before the other guests came pouring out, to save Bill from having to explain what we were doing. He would be held responsible for breaking the boundaries between guests and workers, between young girls and old men, and I would never be able to convince them that I knew exactly what I was doing, that tenderness was my joy that night, that I danced in the moonlight knowing my body could be a home in the freezing desert air.

4.

I spent most of my time around the horses, following Bill on his daily chores. He eventually gave me his chaps to wear because I was constantly riding into the cholla cacti and ending up with their needles sticking into my thighs. My horse for the week was not the sleek stallion I had dreamed of, but a fat, wide-backed white mare that was safe. Ruby and I were always on the tail end of the rides, but I did not care: the Bronx streets had disappeared, and I could bend over and talk to my steed while I stroked her powerful neck.

Each day we rode up into the mountains, the same mountains that had looked so distant from the airport. Our party was usually

Elliot and myself, and Bill and Elizabeth. Elizabeth was a small muscular woman in her fifties whose husband was dying of Parkinson's disease. She had made my riding possible by lending me a pair of boots. Each morning her husband, a large burly man who walked in tiny trembling steps, would stand in the doorway of their cottage and slowly raise his hand to wave goodbye. Elizabeth loved him deeply, and each morning I saw the grief on her face. She would ride her horse like a demon far up into the mountains, leaving the rest of us behind. As the week passed, I slowly realized that she and Bill were lovers. I saw the tenderness between them as if it were an invisible rope that kept them both from falling off the rocky hills. Like two aging warriors, both gray and lean, they fought off sadness with sharp, quick actions. We would ride up into the mountain clefts, find a grassy spot to stretch out on in the afternoon sun, and silently be glad for each other's company. I never spoke or intruded on their moments together. I just watched and learned from their sad, tough, erotic connection all I could bear about illness and love and sexuality. One the way home, stumbling down the stony trails, I would ride as close as I could to these two silent adults.

Then it was our last ride together. We had come down from the mountains on a different path. We found a dirt road, smooth enough for cars, and I started to see real-estate signs announcing that this area was the most restricted country in Arizona. I pushed my horse closer to Elizabeth and Bill and asked, "What does *restricted* mean?"

"No Jews allowed," Elizabeth answered. I looked around again in wonder at this land we were moving through. The distant hills had become known, and I loved this earth so different from my own. I silently rode beside my two older friends, wanting to be protected by their gentle toughness and not understanding how the beauty of the land could be owned by such ugliness.

Butch-Fem Relationships:
Sexual Courage in the 1950s

For many years now, I have been trying to figure out how to explain the special nature of butch-fem relationships to lesbian feminists who consider butch-fem a reproduction of heterosexual models. My own roots lie deep in the earth of this lesbian custom, and what follows is one lesbian's understanding of her own experience.

In the late 1950s I walked the streets looking so butch that straight teenagers called me a bull dyke; however, when I went to the Sea Colony, a working-class lesbian bar in Greenwich Village, looking for my friends and sometimes for a lover, I was a fem, a woman who loved and wanted to nurture the butch strength in other women. I am now forty years old (1981). Although I have been a lesbian for over twenty years and I embrace feminism as a worldview, I can spot a butch thirty feet away and still feel the thrill of her power. Contrary to belief, this power was not bought at the expense of the fem's identity. Butch-fem relationships, as I experienced them, were complex erotic statements, not phony heterosexual replicas. They were filled with a deeply lesbian language of stance, dress, gesture, loving, courage, and autonomy. None of the butch women I was with, and this included a passing woman, ever presented themselves to me as men: they did announce themselves as tabooed women who were willing to identify their passion for other women by wearing clothes

that symbolized the taking of responsibility. Part of this responsibility was sexual expertise. In the 1950s this courage to feel comfortable with arousing other women became a political act.

Butch-fem was an erotic partnership serving both as a conspicuous flag of rebellion and as an intimate exploration of women's sexuality. It was not an accident that butch-fem couples suffered the most street abuse and provoked more assimilated or closeted lesbians to plead with them not to be so obvious. An excerpt from a letter by Lorraine Hansberry, published in *The Ladder* in 1957, shows the political implications of the butch-fem statement.[1] The letter is a plea for discretion because of, I believe, the erotic clarity of the butch-fem visual image.

> Someday I expect the "discreet" lesbian will not turn her head on the streets at the sight of the "butch" strolling hand in hand with her friend in their trousers and definitive haircuts. But for the moment it still disturbs. It creates an impossible area for discussion with one's most enlightened (to use a hopeful term) heterosexual friends.[2]

A critic of a draft of this essay has suggested that what was really the problem here was that "many other lesbians at that time felt the adoption of culturally defined roles by the butch-fem couple was not a true picture of the majority of lesbians. They found these socialized roles as a limiting reality and therefore did not wish to have the butch-fem viewpoint applied or

1 *The Ladder*, published from 1956 to 1972, was the most sustaining lesbian cultural creation of this period. As a street fem living on the Lower East Side, I desperately searched newspaper stands and drugstore racks for this small slim journal with a lesbian on its cover. A complete set is now available at the Lesbian Herstory Archives in New York.

2 *The Ladder*, no. 1 (May 1957): 28.

expressed as their own."[3] My sense of the time says this was not the reason. Butch-fem couples embarrassed other lesbians (and still do) because they made lesbians culturally visible, a terrifying act for the 1950s. Hansberry's language—the words *discreet* and *definitive*—is the key, for it speaks of what some wanted to keep hidden: the clearly sexual implications of two women together. *The Ladder* advocated "a mode of behavior and dress acceptable to society," and it was this policy Hansberry was praising. The desire for passing, combined with the radical work of survival that *The Ladder* was undertaking, was a paradox created by the America of the fifties. The writing in *The Ladder* was bringing to the surface years of pain, opening a door on an intensely private experience, giving a voice to an "obscene" population in a decade of McCarthy witch hunts. To survive meant to take a public stance of societal cleanliness. But in the pages of the journal itself, all dimensions of lesbian life were explored, including butch-fem relationships. *The Ladder* brought off a unique balancing act for the 1950s. It gave nourishment to a secret and subversive life while it flew the flag of assimilation.

However, it was not the rejection by our own that taught the most powerful lesson about sex, gender, and class that butch-fem represented, but the anger we provoked on the streets. Since at times fems dressed similarly to their butch lovers, the aping of heterosexual roles was not always visually apparent, yet the sight of us was enraging. My understanding of why we angered straight spectators so is not that they saw us modeling ourselves after them, but just the opposite: we were a symbol of women's erotic autonomy, a sexual accomplishment that did not include them. The physical attacks were a direct attempt to break into this self-sufficient erotic partnership. The most fre-

3 Letter from Sandy DeSando, August 1980.

quently shouted taunt was, "Which one of you is the man?" This was not a reflection of our lesbian experience as much as it was a testimony to the lack of erotic categories in straight culture. In the fifties, when we walked in the Village holding hands, we knew we were courting violence, but we also knew the political implications of how we were courting each other and chose not to sacrifice our need to their anger.[4]

The irony of social change has made a radical, sexual political statement of the 1950s appear today as a reactionary, nonfeminist experience. This is one reason I feel I must write about the old times—not to romanticize butch-fem relationships but to salvage a period of lesbian culture that I know to be important, a time that has been too easily dismissed as the decade of self-hatred.

Two summers ago in Kansas, at the first National Women's Studies Association Conference, a slideshow was presented to the lesbian caucus in which a series of myths about lesbians was entertainingly debunked. The show was to be used in straight sex-education classrooms. One of the slides was a comic representation of the "myth" of butch-fem relationships with a voiceover saying something like, "In the past, lesbians copied

4 An article in *Journal of Homosexuality* (Summer 1980), "Sexual Preference or Personal Style? Why Lesbians Are Disliked," by Mary Reige Laner and Roy H. Laner, documented the anger and rejection of 511 straight college students toward lesbians who were clearly defined as butch-fem. These results led the Laners to celebrate the withering away of butch-fem styles and to advocate androgyny as the safest road to heterosexual acceptance, a new plea for passing. This is the liberal voice turned conservative, the frightened voice that warns Blacks not to be too Black, Jews not to be too Jewish, and lesbians not to be too lesbian. Ironically, this advice can become the basis for a truly destructive kind of role-playing, a self-denial of natural style so the oppressor will not wake up to the different one in his or her midst.

heterosexual styles, calling themselves butch and fem, but they no longer do so." I waited until the end to make my statement, but I sat there feeling that we were so anxious to clean up our lives for heterosexual acceptance that we were ready to force our own people into a denial of some deep parts of their lives. I knew what a butch or fem woman would feel seeing this slideshow, and I realized that the price for social or superficial feminist acceptance was too high. If we deny the subject of butch-fem relationships, we deny the women who lived them, and still do.

Because of the complexity and authenticity of the butch-fem experience, I think we must take another look at the term *role-playing*, used primarily to summarize this way of loving. I do not think the term serves a purpose either as a label or a description of the experience. As a fem, I did what was natural for me, what felt right. I did not learn a part: I perfected a way of loving. The artificial labels stood waiting for us as we discovered our sexualities.

We labeled ourselves as a part of our cultural ritual, and the language reflected our time in history, but the words which seem so one-dimensional now stood for complex sexual and emotional exchanges. Women who were new to the life and entered bars have reported they were asked, "Well, what are you—butch or fem?" Many fled rather than answer the question. The real questions behind this discourse were, "Are you sexual?" and "Are you safe?" When one moved beyond the opening gambits, a whole range of sexuality was possible. We joked about being a butchy fem or a femmy butch or feeling kiki (going both ways). We joked about a reversal of expectations: "Get a butch home and she turns over on her back." We had a code of language for a courageous world for which many paid dearly. It is hard to recreate for the 1980s what lesbian sexual play meant in the

1950s, but I think it is essential for lesbian feminists to understand, without shame, this part of their erotic heritage. I also think the erotic for us, as a colonized people, is part of our social struggle to survive and change the world.

A year ago some friends of mine were discussing their experiences in talking about butch-fem relationships to a women's studies class. Both had been gay since the 1950s and were active in the early gay-liberation struggles. "I tried to explain the complex nature of butch sexuality, its balance of strength and delicacy," Madeline said. "The commitment to please each other was totally different from that in heterosexual relationships in which the woman existed to please the man."

As she spoke, I realized that not only was there the erotic statement made by two women together, but there was and still is a butch sexuality and a fem sexuality—not a woman-acting-like-a-man or a woman-acting-like-a-woman sexuality, but a developed lesbian-specific sexuality that has a historical setting and a cultural function. For instance, as a fem I enjoyed strong, fierce lovemaking; deep, strong givings and takings; erotic play challenges; calculated teasings that called forth the butch-fem encounter. But the essential pleasure was that we were two women, not masqueraders. When a woman said, "Give it to me, baby!" as I strained to take more of her hand inside of me, I never heard the voice of a man or of socially conditioned roles. I heard the call of a woman world-traveler, a brave woman, whose hands challenged every denial laid on a woman's life.

For me, the erotic essence of the butch-fem relationship was the external difference of women's textures and the bond of knowledgeable caring. I loved my lover for how she stood as well as for what she did. Dress was part of it: the erotic signal of her hair at the nape of her neck, touching the shirt collar; how she held a cigarette; the symbolic pinky ring flashing as she waved

her hand. I know this sounds superficial, but all these gestures were a style of self-presentation that made erotic competence a political statement in the 1950s. A deep partnership could be formed, with as many shared tasks as there are today and with an encouragement of the style that made the woman I loved feel most comfortable. In bed, the erotic implications of the total relationship only became clearer. My hands and lips did what felt comfortable for me to do. I did not limit my sexual responses because I was a fem. I went down on my lovers to catch them in my mouth and to celebrate their strength, their caring for me. Deeper than the sexual positioning was the overwhelming love I felt for their courage, the bravery of their erotic independence.

As a way of ignoring what butch-fem meant and means, feminism is often viewed as the validating starting point of healthy lesbian culture. I believe, however, that while many pre-Stonewall lesbians were feminists, the primary way this feminism—this autonomy of sexual and social identities— was expressed was precisely in the form of sexual adventuring that now appears so oppressive. If butch-fem represented an erotically autonomous world, it also symbolized many other forms of independence. Most of the women I knew at the Sea Colony were working women who either had never married or had left their husbands and were thus responsible for their own economic survival. Family connections had been severed, or the families were poorer than the women themselves. These were women who knew they were going to work for the rest of their lesbian days to support themselves and the homes they chose to create. They were hairdressers, taxi drivers, telephone operators who were also butch-fem women. Their feminism was not an articulated theory; it was a lived set of options based on erotic choices.

We lesbians from the fifties made a mistake in the early seventies: we allowed our lives to be trivialized and reinterpreted by feminists who did not share our culture. The slogan "lesbianism is the practice and feminism is the theory" was a good rallying cry, but it cheated our history. The early writings need to be reexamined to see why so many of us dedicated ourselves to understanding the homophobia of straight feminists rather than the life-realities of lesbian women "who were not feminists" (an empty phrase that comes too easily to the lips). Why did we expect and need lesbians of earlier generations and differing backgrounds to call their struggle by our name? I am afraid of the answer because I shared both worlds and know how respectable feminism made me feel, how much less dirty, less ugly, less butch and fem. But the pain and anger at hearing so much of my past judged unacceptable have begun to surface. I believe that lesbians are a people, that we live as all people do, affected by the economic and social forces of our times. As a people, we have struggled to preserve our people's ways, the culture of women-loving women. In some sense, lesbians have always opposed the patriarchy—in the past, perhaps most when we looked most like men.

As you can tell by now, this essay is an attempt to shake up our prevailing judgments. We disowned the near-past too quickly, and since it was a quiet past—the women at the Sea Colony did not write books—it would be easy not to hear it. Many women have said to me, "I could never have come out when you did." But I am a lesbian of the fifties, and that world created me. I sit bemused at lesbian conferences, wondering at the academic course listings, and know I would have been totally intimidated by the respectability of some parts of our current lesbian world. When Monique Wittig said at the Modern Language Conference several years ago, "I am not a woman,

I am a lesbian," there was a gasp from the audience, but the statement made sense to me. Of course, I am a woman, but I belong to another geography as well, and the two worlds are complicated and unique.

The more I think of the implications of the butch-fem world, the more I understand some of my discomfort with the customs of the late 1970s. Once, when the Lesbian Herstory Archives presented a slideshow on pre-1970 lesbian images, I asked the women how many would feel comfortable using the word *lesbian* alone without the adjunct *feminism*. I was curious about the power of the hyphenated word when so few women have an understanding of the lesbian fifties. Several of the women could not accept the word *lesbian* alone, and yet it stood for women who did stand alone.

I suggest that the term *lesbian feminist* is a butch-fem relationship, as it has been judged, not as it was, with *lesbian* bearing the emotional weight the butch bears in modern judgment and *feminist* becoming the emotional equivalent of the stereotyped fem, the image that can stand the light of day. Lesbianism was theory in a different historical setting. We sat in bars and talked about the challenge of knowing what we were not permitted to do and how to go beyond that; we took on police harassment and became families for each other. Many of us were active in political-change struggles, fed by the energy of our hidden butch-fem lives that even our most liberal-left friends could not tolerate. Articulated feminism added another layer of analysis and understanding, a profound one, one that felt so good and made such wonderful allies that for me it was a gateway to another world—until I realized I was saying *radical feminist* when I could not say *lesbian*.

My butch-fem days have gifted me with sensitivities I can never disown. They make me wonder why there is such a con-

suming interest in the butch-fem lives of upper-class women, usually the more removed literary figures, while real-life, working butch and fem women are seen as imitative and culturally backward. Vita Sackville-West, Jane Heap, Missy, Gertrude Stein, and Radclyffe Hall are all figures who shine with audacious self-presentation, and yet the reality of passing women, usually a working-class lesbian's method of survival, has provoked very little academic lesbian-feminist interest.

Grassroots lesbian history research projects are beginning to change this, however. The San Francisco Lesbian and Gay Men's History Research Project has created a slideshow called ". . . And She Also Chewed Tobacco," which discusses passing women in San Francisco at the turn of the twentieth century. The Buffalo Lesbian Oral History Project (Madeline Davis and Liz Kennedy) is focusing on the lives of pre-1970 working-class lesbians.[5] The Lesbian Herstory Archives of New York has a slideshow in progress called "Lesbian Courage, Pre-1970," and there are groups in Boston, Washington, DC, and Philadelphia attempting to be more inclusive of the lesbian experience.

Because I quickly got the message in my first lesbian-feminist consciousness-raising group that such topics as butch-fem relationships and the use of dildos were lower-class, I was forced to understand that sexual style is a rich mixture of class, history, and personal integrity. My butch-fem sensibility also incorporated the wisdom of freaks. When we broke gender lines in the 1950s, we fell off the biologically charted maps. One day many years ago, as I was walking through Central Park, a group of cheerful straight people walked past me and said, "What shall we feed it?" The *it* has never left my con-

5 Later published under the title *Boots of Leather, Slippers of Gold*, by Elizabeth Lapovsky Kennedy and Madeline D. Davis.

sciousness. A butch woman in her fifties reminisced the other day about when she was stoned in Washington Square Park for wearing men's clothes. These searing experiences of marginality because of sexual style inform my feminism.

Butch-fem women made lesbians visible in a terrifyingly clear way in a historical period when there was no Movement protection for them. Their appearance spoke of erotic independence, and they often provoked rage and censure from both their own community and straight society. Now it is time to stop judging and to begin asking questions, to begin listening. Listening not only to words that may be the wrong ones for the 1980s, but also to gestures, sadnesses in the eyes, gleams of victories, movements of hands, stories told with self-dismissal yet stubbornness. There is a silence among us, the voices of the 1950s, and this silence will continue until some of us are ready to listen. If we do, we may begin to understand how our lesbian people survived and created an erotic heritage.

It took me forty years to write this essay. The following women helped make it possible: Frances Taylor, Naomi Holoch, Eleanor Batchelder, Paula Grant, and Judith Schwarz, as well as the Heresies 12 collective, especially Paula Webster, who said "Do it" for years. Most deeply I thank Deborah Edel, my butchy feminist former lover who never thought I was a freak. When this essay was first published in Heresies *12, 1981, it was titled "Butch-Fem Relationships: Sexual Courage in the 1950s."*

A Fragile Union

She stood in front of us, holding her clipboard close to her full breasts, counting us off as we settled into our seats. We had another long bus trip ahead of us, from the gates of this lonely college deep in Flushing, New York, to a Senate meeting room in Washington, DC. I always felt secure when Carol was in charge. A daughter of labor organizers who had paid dearly for their dreams in the red-hating forties, she was a captivating combination of Emma Goldman and Molly Goldberg. Carol led us into political action with a fierce sense of organization that made us feel invincible. When Carol was in charge, the spit never hit us; the invectives lost their sting.

> Solidarity forever, solidarity forever,
> solidarity forever,
> for the Union makes us strong.[1+]

"Subversives" is what some in this country called us, what they called those who traveled on endless early-morning bus trips, walked endless miles, tirelessly handing out the leaflets that called attention to a social wrong. I was lucky enough, gloriously lucky, to have found my way to their encampment, to have had

1 + The songs quoted or echoed here come from the thirty-fifth edition of a small red book entitled *IWW Songs—To Fan the Flames of Discontent*, which was first handed out to would-be union members in 1909.

the chance to see the early-morning sunlight hit the ever-hopeful aged faces of the women who had grown old from marching once again. In 1959, in her matronly yet combative stance, Carol became for me the younger face of this determined courage.

Carol stood, swaying slightly, as the bus lurched its way down the avenue, her blouse tucked neatly into her tweed skirt, her slightly heeled pumps adding to her authority over us. When she turned to speak to the driver, bending slightly, the skirt pulled over her hips, forming that rounded, controlled curve for which girdles were invented. This is my first lesbian memory of Carol, the first time her body broke through the political armor she wore into my own body. This image marks a decade for me: the curve of a woman's hip in 1959, controlled by a man-made garment. I think of that curve now with all its contradictions—Carol held in a latex tightness, while she fought for freedom—but at the time I simply sat in the darkened bus and wondered at the desire that flooded me.

Carol was straight, the steady date of Mike, another grown-up veteran of the red-baiting days, who had sultry lips and a slightly muscled body. So I remained a follower, an admirer from afar, a foot soldier in this small army going full tilt against the vestiges of the McCarthy era. The others, Carol and Mike and Carl and Howard, knew the words to all the anthems that had once called people together to form an international movement for a classless, warless world. From them, I learned to sing those songs, and I believed, perhaps even more deeply than they did, in the power of those melodies to carry us forward to a new day.

I also traveled by night, to places whose history was not yet written, to the dark bars that paled before the marble columns of national capitals. In these years, my secret was not my support of socialism, nor my resistance to nuclear arms, nor my

battle against the House Un-American Activities Committee. My secret lay deeper, in the recesses of butch-fem communities, in the other subversive life I lived, where only women touched women. Here I journeyed—here, where police and social hatred formed a hard crust around our erotic territories. By the mid-sixties, I was a full citizen of these two tainted communities, living in the neighborhood of immigrants, the Lower East Side. From my small, dilapidated apartment on East Sixth Street, I ventured forth to join my comrades by day and my lovers by night.

My political comrades were curious about my apartment. Not only was I the first woman of our group to be living on my own, but rumors of my sexual deviation had floated back to them. Over the ensuing years, I learned that while my friends spoke passionately of the class struggle, most of them kept close to their middle-class harbors. My queer life on a dark avenue below Fourteenth Street had dramatic appeal. This is how Carol came to me. After one political meeting that lasted late into the night, she asked if she could come over to see my place.

The apartment had no saving graces. A large hole gaped in the ceiling; the thin walls carried my neighbors' screams of frustration, of despair. The cries of babies, already living under the curse of hopeless anger, pierced whatever peace I had found there. Living on Sixth Street was not a chosen adventure; it was the place I had to live, the place I could afford.

> The banks are made of marble
> with a guard at every door
> and the vaults are stuffed with silver
> that the workers sweated for.

The walk to my apartment was short, but I panted with nervousness. Carol tapped alongside me, still wearing her small

heels, her skirt, her hair done up in the same tight twist she had worn on all those bus rides. We climbed the four flights of tenement stairs, narrow, crumbling steps that led us to floors soaked in years of human habitation. When I was alone, I did not romanticize my street, but now, leading the way for this properly dressed woman—I always saw Carol as a woman, while my own gender slipped and slid all over the place—I was proud of my battered territory.

The apartment itself had only one room with two windows facing the street. A couch under the windows, a fold-out bed, and a desk were the major pieces of furniture. A galley kitchen ran down one side of the room. On the walls I had hung the inexpensive reproductions that museums had waiting for students who had just discovered the wonders of art. Picasso's *Guernica* arched over my desk.

Kicking off her shoes, Carol made herself comfortable on the couch, drawing her nyloned legs up under her, while I poured us both small tumblers of Scotch.

"What is it like, being a lesbian?" she ventured, as I sat down beside her.

Now I held the clipboard, but my acute sense of her body, wrapped in its functional clothing, robbed me of any authority. I talked, words came out, but touch, the need to touch, was a shimmering presence over me. She had led me into battle, but now, I thought, now there is no enemy. Even today, as I try to make a story of this memory, I feel lost in my desire for her, for the touch of her blouse against my cheek, for her hand on my breast. She was not expected; she came, I thought, as a gift.

I was lying with my head on her lap. She had unpinned her hair. The words had stopped. I was no longer afraid but joyous at the feel of her thighs beneath my head, her breasts within reach of my mouth.

"I always just wanted to do one thing," she said, bending over me so her hair veiled my face.

"Do it," I said. She bent down and kissed me. I remember a long, deep kiss, with my heart breaking at the impossibility of it. I remember her tongue full in my mouth, my hand going up to the back of her neck. I wanted to hold it all in place. Only one kiss, only one time of touch.

"You are so soft, so soft," she murmured, as her breath touched my face.

I want to tell you more, to extend the poised moment into years of feeling. I want this moment in this story to have no ending, to have no loss.

But what I do remember next is touched with endings. Carol stands, fixing her hair, pulling it back into its French roll, replacing the bobby pins with determined jobs, bending a little so she can see her face more clearly in the small mirror. I stand behind her. She is speaking to me, to my image in the mirror, with a bobby pin gripped between her lips, her hands competently swirling her hair back into place.

"You know," she says, her eyes locking onto mine in the mirror, "you must never tell anyone about this."

My hands, poised to rest on her shoulders, dropped to my sides. All we had been through together, all the shouts and tiredness, all the fear and exuberance, all the hope and anger, froze into loss.

I watched her put herself back together again. This was not the first time I had stood before this mirror, caught in its reflections. A few months earlier, Paul, a man who wanted to be my lover, had sneered at me as I put lipstick on in front of this same mirror. "Who are you kidding?" he said. None of this made sense to me. I was young. Why couldn't I want to feel beautiful, why couldn't I speak about a kiss? I knew the world outside

thought I was ugly and immoral, but this was my home and these were my friends. I was young and wanted both the beauty of the moment and the passion of my sex.

That was the last time I saw Carol. The sixties swept me up, and I learned other songs of liberation, rode on other buses, found new comrades with the light upon their faces. But I had learned my lesson and kept my touch close to my side. Solidarity is not forever; it shatters on the rocks of difference, on the fear of exile. But passion burns a place in memory, reserving for itself an inner life, biding its time, waiting for reclamation. Songs still fed a movement's dreams, and I was honored to sing them as we marched along, but my life was a secret.

This little light of mine,
I'm going let it shine, let it shine.

Songs, like our bodies, carry history in a fragile yet enduring way. Made of breath and born of flesh, they ask us to remember the sweetnesses that once they brought and the strength that once they gave. I have lived long enough now to know what I must sing about, and so I claim this kiss.

This Huge Light of Yours

For Arisa Reed, for whom I did not keep the porch light burning bright enough

The sixties are a favorite target of those who take delight in the failure of dreams. For those who dabbled in social change or who stayed aloof from the passion of the times, the sixties have become a playground for nostalgia, a pot-filled room of counterculture adolescents playing with anger. But it is a sad cynicism that jeers at the defeat of courage and commitment, and a selfish one too.

There is one group of Americans that cannot play with the sixties, cannot give those years to mockery and disdain. In Alabama and Mississippi and Arkansas, in Watts and Harlem and Philadelphia, in luncheonettes and in movie theaters, on beaches, on school steps, and on buses, Black Americans took history into their own work-worn hands, carried it on their tired feet, until it became a different thing.

> Monday, March 15, 1965, was a notable day. . . . In Alabama early this morning, Wilcox County's first black voter of the twentieth century was registered. (David Garrow, *Protest at Selma,* New Haven: Yale University Press, 1978.)

This was after Jimmie Lee Jackson was murdered, after Rev. Reeb was killed, after hundreds were clubbed and beaten in Sel-

ma and Montgomery, after thousands were jailed, after endless months of children walking in hate-filled streets, after mothers and fathers and sons and daughters stood against guns, tear gas, horses, whips, water hoses, against city police, state police, and the National Guard. A country that does not know how to honor this heritage becomes a nightmare to its own people and to the world, becomes Reagan's America.

Selma, Alabama
1422 Washington Street
April 9, 1965

Hi Joan,

It was a great pleasure to receive a sweet letter from you and Ramona was so thrilled to have a letter of her own.

Monday I went to the Court House to get registered, but I didn't get in before closing time so I'll try again on the 19th.

Judy doesn't live with us now. She has a room in the project near the Church, but we keep in touch with each other and we all miss you very much. It was a pleasure to have had you with us.

Things here now are not as strong as they were when you were here, but they are going to pick up in a day or so. We still have mass meetings and sing all those Freedom Songs.

I didn't have any stationary paper, but I wasn't going to let that stop me from writing.

Everybody here is doing just fine. We are still praying the same prayer and that one day We Shall Overcome.

We will be glad to have you at any time. I'll start burning the porch light on the last day of May looking for you.

We Shall Overcome,

Mrs. M. Washington

The Lower East Side, NYC, 1965

Carol has left me. I found a small one-room apartment on East Sixth Street between Avenues A and B. Here in this compressed tenement, guarded day and night by a huge Polish man who sat framed in the always-open door of his ground-floor apartment in a chair that disappeared under his gout-stricken legs stretched in front of him, I took refuge. I joined the others who were also much reduced in circumstances. Black and white, young and old, children and adults, we crammed the sorrows and angers of our lives into the hard squareness of those small rooms.

My fire escape was a gift both to me and to the neighborhood junkies. It provided me with another room in the hot evenings, and it gave them a freeway into my apartment. Clock, radio, television, phonograph all disappeared with a regularity that became less frightening each time. Once, I came home and saw the record albums strewn across the floor. A careful selection had been made; I felt I was in the middle of a conversation with people I had never met.

I would not give up access to the open air, however, and one afternoon my faith was proved right. I was sitting at my table in front of the open window, typing a paper for school. I looked up to think for a moment and saw a tiny gray head poking into the room. It was Catly, as I came to call her. She looked around, looked at me and the small room, then turned and disappeared. I went back to work but stopped in amazement a short time later.

The small gray cat had returned, only this time she had a smaller cat dangling from her mouth, the first of six kittens she would bring through the open window and deposit on the floor of my room. Catly never gave up her wandering ways, and I became the foster mother of her squirming brood. The Lower East Side, with its shabbiness and wonders, its freedoms and reductions, its tough little joys and unexpected havens, was much like my open window.

Because my television had disappeared in one of the earlier forays of my unknown visitors, I had not seen the images of hatred that were pouring out of Alabama that March: the Black men, women, and children beaten with the flailing clubs of Jim Clark's men; the hoses turned full force on the peaceful marchers, washing away the grip of tightly held hands, slamming people against the earth, the trees, each other; the dogs' teeth bared in never-ending snarls—all these forces marshaled against a band of would-be voters.

But I had ridden freedom buses into Philadelphia and Baltimore, had hidden from thrown rocks, had washed spit from my face and hair, had sat with CORE (Congress of Racial Equality) comrades at soda fountains while the no-trespassing laws were read to us, and had been dragged out of restaurants that Black CORE members could not even enter. We, the white protestors, acted as a fifth column. Usually under the leadership of a minister, we would enter one of the segregated restaurants, pretending to be quiet couples. Then we would join each other at a table, remembering never to eat or drink anything that was on the table, not even the water. At a given signal, we would all rise, and the respectable air of the restaurant would be broken by the minister reading a statement announcing who we were and that we would not leave until our Black comrades, who were now picketing and shouting outside the restaurant, were allowed

to join us. The simple act of opening the door to all Americans never happened during those early years. Instead, the police were called, we were read our warnings, and then we were dragged out to join the demonstration. As whites, we were useful for infiltration, but what we learned was the unforgettable curse of our privilege.

I wore a double mask in these early sixties' years, in those white restaurants. My first deception was to the enemy: the pose of a nice white person who could be let in and would sit down and eat in quiet tones, ignoring the battle for human dignity that was happening outside the windows. The second was to my friends: the pose of straightness, the invisibility of my queerness. They did not know that when the police entered, with their sneers and itchy fingers, I was meeting an old antagonist. Perhaps their uniforms were a different color, but in the lesbian bars of my other world I had met these forces of the state. I never told my comrades that I was different, because a secret seemed a little thing in such a time of history.

Although I did not have the images flickering across a black-and-white screen, I had seen the photographs in the papers, the large Black woman held to the ground by three white sheriffs, a nightstick across her throat, her skirt pushed up above her knees. All of us had seen and heard what was happening in Selma. There was no place to hide. The night of the first attempt to cross the Edmund Pettus Bridge—the night of the brutal attack on a citizen's army—Judith, a straight friend, called to tell me what she had seen on television, and to ask me if I would go with her to Selma, Alabama, to do voter registration work.

I looked around me, at the loss of love my life had become, at the hate that threatened all love, and I wanted to go, to do battle with another enemy besides my own despair, to use my body not for lovemaking but for filling the ranks in the struggle to change history.

The next day Judith and I joined the small exodus that was taking place all over America. We both had never traveled to the Deep South before. We first flew to Atlanta to make connections for the flight to Selma. Once in the airport, our backpacks and Northern white faces loudly proclaimed us as the new breed of hated carpetbaggers. The Atlanta airport was like a troop station during a war, except that both sides were visible and in close contact with each other. Scattered throughout the terminal were groups of young people with their sleeping bags, nuns and priests in larger groups talking quietly, small suitcases resting against their legs.

We milled around, drawing closer to each other as the anger around us grew more distinct. Trapped into serving people they despised, the ticket agents could only load their responses with veiled verbal threats. As the young man handed us our tickets to Selma, he slowly looked us over and said, "Going to Selma, huh. Well, we'll make sure you have a reeeel gooooood tiiiiime," the words dragged out with controlled rage. This small taste of belligerence in the face of threatened change was the beginning of my understanding of what Black Southern Americans had been enduring, and of the courage of the civil rights workers who had been living with threats against their lives every day. Like the other travelers bound for Selma, we discovered that we had to spend the night in the airport, and so we attached ourselves to a group of nuns, sticking closely to them like the long-necked birds that walk in the shadows of elephants. The one place that seemed safe to sleep in was the women's bathroom, and for the next six hours we huddled on the tile floor waiting for the morning light.

Early the next day our flight was announced, a small propeller plane that bounced its way to Selma. Nauseated by the mixture of fear and motion, I vomited during the flight, hold-

ing the white bag over my face as the reddish flats of the Selma countryside angled up toward us. Once on the ground, we were greeted by Jim Bevel, his head covered by an embroidered skull-cap, his clear, direct eyes looking straight at us, the small group of Northern do-gooders. He said, "I hope you will be there when we come to New York." We knew immediately we were no more than what we were, still part of the killing problem, and he treated us as if we were tourists who had signed up for some offbeat adventure vacation. His gait and the lines around his eyes told us that for him this was a war he could not walk away from: he would make do with whatever troops he had.

We were taken to a small caravan of cars and driven to the African Methodist Episcopal Church, which would become known to us as Brown's Chapel, to be welcomed and gathered up by the Black families who would house us and show us the ways of surviving white hatred while we were there. The church was packed with families and civil rights workers, many fanning themselves as they looked over the new arrivals. Judith and I were called up to the stage and introduced to the congregation. The minister asked who would like to give us a place to stay, and Mr. and Mrs. Washington raised their hands. So did Ramona, their eight-year-old daughter. We went to meet them and were introduced to their older son, Walt, who quietly and courageous-ly was to save our lives several weeks later. We went to their house, a white house with a wraparound porch and tree in the front yard, on a block of similar houses not far from the church, but beyond the housing project where many of the other workers would be staying.

We entered their home quietly, feeling the wonder of what had happened in this small Southern town. Mrs. Washington brought us to their main bedroom at the front of the house and told Judith and me that this was where we would sleep. We said

no, that we had sleeping bags and that the floor or a couch was fine. Mrs. Washington insisted. We must sleep in their big, comfortable bed while we were guests in their home. We picked you, she added, because you look clean. Her kindness and the domestic serenity of the bedroom again reminded me of the secret that I carried, my queerness, and I feared I would not have been taken into this home if my lesbian self had stood in the church with me. But I accepted the weight of my disguise because I was so honored to be in this home and so moved to be even an infinitesimal part of this history. The room was peaceful, filled with the life of a long marriage. White ruffled curtains framed the small windows, photographs sat on the worn dresser, and the bed creaked comfortably with layers of shared sleep. The whole moment, as I sat on my side of the bed with Judith changing for the night, was filled with the awe of what events can do, with an awe for the graciousness and beauty of the human spirit, of the Washingtons, who in the midst of this terrible battle turned over their comfort and their most intimate place to two white Jewish women from New York whom they had never seen before. It was as if hatred had caused the usual flow of events to unravel and reveal another world of possibilities below.

The night was not peaceful. Judith, while knowing I was a lesbian, had never slept in the same bed with me before. Every time our bodies accidentally touched, she leaped to the other side of the bed. But the coming events were to make this discomfort with each other insignificant. Our assignments for the next two weeks separated us, and Judith never slept with me in the Washingtons' home again.

All our days started at Brown's Chapel, and it was there that we learned where we would be needed for the week's activities. I was assigned to a group doing voter registration work in the poor, flat farmsides surrounding Selma. We moved around

the countryside in a car covered with red dust, a cadre of workers led by Bill, an older SNCC (Student Nonviolent Coordinating Committee) worker who was well-known to the families we visited. We were two white male ministers, and Ajax, a Black divinity student who was to become a special friend, and myself, the only woman. On our first ride out, I watched the male interaction closely, realizing I had to learn the language of this new world.

In the beginning, I felt like a foreigner in many ways: to the religious discussions, to the land we were moving through, in the homes of the tenant farmers who stopped their work to listen to us, in the small, bare Baptist churches we visited to encourage community organizing and to give hope to the isolated groups that had already formed and were facing the anger of the whites around them. But we had work to do, and eventually my differences just became part of the pack I carried. I soon learned that while Bloody Sunday had shocked some of us into involvement, the struggle to gain voting rights had been going on in these counties for almost a year. The men, women, and children who had responded to the call for action by the SNCC and SCLC (Southern Christian Leadership Conference) workers were now a family of peaceful resisters who were wise in their knowledge of the forces arrayed against them, and who knew they would not be turned around. However isolated, however small the gathering, the sense of unity was dazzling.

One day our car pulled onto a dirt road in front of a small wooden church, and inside waiting for us was a group of young Black women and men standing in a circle to greet us. We joined the circle, the March sun streaming in through the high windows and making patches of light on the bare wood floor. Around the circle we went, saying our names and, for the new workers, why we were there and where we had come from. When it came to Ajax,

he told us his real name and then added his nickname, saying, "I heard you had some dirt down here, and I came to help clean it up." The congregation of grassroots activists laughed, and everything seemed possible.

Later in the day, as we were driving away from a visit to a tenant farmer's home on a dirt road that lined a newly tilled field, a trooper's car appeared behind us, coming out of the dust we had stirred up along the road. Our driver, Bill, turned his head and told us to be careful and quiet. All around us stretched lonely, featureless earth in never-ending barren squares. We came to a stop, and the trooper pulled in behind us. I turned my head, peering out the dust-covered back window, and saw a figure walking toward us who looked like a caricature of all I had heard about Southern sheriffs, except this was a real person. The sun glinted off the silver discs of his glasses; his hand rested on top of his gun, which he wore low over his wide stomach. He was big and square, and his face was tight with anger.

Reaching the side of our car, he bent over and said to Bill, "Get out of that car, boy." The SNCC worker was a gray-haired man, lean and tall. Bill moved out of the car, almost as if he were bored. The trooper made him stand spread-eagled with his hands flat on the roof of the car as he frisked him, lecturing Bill about getting his passengers out of the country if he knew what was good for him and to stop stirring up trouble. We, the white Northern visitors to this landscape, sat in a silence that choked us, a silence Bill had demanded. We knew we could go back home, back to a world where troopers didn't appear from nowhere and put a gun to your head. But this man, our teacher and protector, would not leave; his life and his family's life would be shadowed by this hunk of hatred. After this encounter, Bill slowly pulled his long body back into our little car and said it

was time to call it a day. We returned in silence to the haven of Brown's Chapel.

That afternoon was the first time I learned that fear had a taste, that terror could make you clench your ass muscles to keep from soiling yourself. All in one day—the circle of sunlight and hope and courage, and the dryness of brutality. The days and nights settled into a routine. I would rise early and help prepare Mr. Washington's breakfast, learning to make his coffee the way he liked it. He was a big, gentle man, always dressed in the blue dungaree overalls that he wore for work and that the male civil rights workers wore for uniforms. We would sit together in the large kitchen at the back of the house, with Ramona running around getting ready for school and for her time at Brown's Chapel. All my fantasies about what a father would be like found a home in Mr. Washington, and his protective kindness became the symbol of the world I had discovered in Black Selma. Not that he couldn't get angry. He was—at the beatings, at the dangers his children faced, at the way his wife was treated by the white women she worked for, at how their livelihood was endangered because he believed in his people's right to vote—but to me he was a tree of kindness.

The mornings would be spent in front of Brown's Chapel, greeting the hundreds that were arriving every day: the nuns, young and strong looking, the clean-cut blond ministers, the scruffy hippies, and the students from all over, Jewish and Christian, Black and white. The SNCC and SCLC workers moved among us, organizing the new arrivals, caucusing in small groups, mapping the goals and dangers of each day. For several days there were marches into downtown Selma. During one of them, Ajax was clubbed in the head as he bent his body over a fallen woman. I saw him the next day with his head swathed in bandages, the ever-present paperback on a philosophical theme

protruding from his back pocket. His spirit was not daunted, but a seriousness seemed to anchor his short solid body closer to the ground.

We all gathered back at the church as soon as it got dark, hundreds of us pouring in there through the double wooden doors, coming home after the tensions of the day. As the night sky grew darker, the troopers gathered their cars around the chapel, turning their bright lights on its white wood walls, sitting or standing by their cars with their rifles cradled in their arms. Sometimes we would hear the voice of Bull Moose Clark come booming out over his loudspeaker. Every night, hundreds of workers and families packed into the church built for fifty or sixty people, knowing the enemy had an easy target if his rage spilled over and he refused to respect the sanctuary of the church. This was America in 1965, and as we stood in our rows singing "This Little Light of Mine," we knew a mighty battle was raging and would rage long after the church's lights had been shut off for the night. It would rage on into the years, and above the shouted ugliness of the bull-horns would soar the sweet shining voices of the youngsters who always sat in front of the chapel, right under the altar, their heads rocking from side to side, their hands swinging in big claps from side to side, giving the rest of us the beat of hope.

Some nights after we left the church but had too much nervous energy to go to bed, we gathered in a large one-room grocery store and restaurant that served as a social center for the Black community. We filled the room, a tired crowd of dusty and rumpled workers, downing beers and Cokes while we listened to anyone who felt the need to speak out about the day's events. Here in this room was one version of the living flesh of the sixties. We were a mass of differences.

Even our voices spoke in the accents of different geographies—the sharp New England twang, the harsher, fuller vowels of the Bronx and Brooklyn, the soft drawls of the South and West—but here we put aside the places we had come from and listened to the place we were in. Here we heard stories about daily life in Selma if you were Black and involved in the civil rights struggle.

In quiet voices we were told about friends who disappeared off the streets and were never seen again, about the bodies found floating in back-country rivers, about the beatings. We sat with our arms around each other, laid our heads on shoulders, just rested and felt safe for the few hours we were there. In the face of this history, and in that large worn room, we shared a tenderness perhaps only warriors without weapons know.

One evening I sat at one of the few tables across from a short, curly-haired young man from New York, who was questioning the meaning of the world in that special way some New Yorkers have. He was filled with personal doubt and sounded as if he were sitting in a Greenwich Village café throwing existential challenges to the world. Next to me sat a young minister, his arm draped across my shoulders. Ajax stood leaning on the counter, and all the others, in their overalls and tired faces, were listening gently to the New Yorker's self-involved monologue. We all knew that he was a new arrival, holding on to what he had come with and not yet seeing what Selma would ask of him. The minister waited till he finished, then reached out and smoothed the young man's lowered head. "We have all come with secrets," he said. His words raced inside of me and I wanted to shout mine, but one neurotic New Yorker was enough for any movement that night, I laughingly said to myself.

The contrast between the safety of that room and the world outside became terribly clear one night when Judith and I lin-

gered too long at the store. We had been warned to be off the streets by nine o'clock, but lulled by the camaraderie we felt, we stayed until after ten. We put on a brave face and refused escorts home, stepping into the night air and walking quickly until we came to the highway we had to cross. All of a sudden a pickup truck filled with men, their faces shining like white moons, roared toward us. We saw the rifles cradled in their arms, and their voices came loud and clear: "We're going to get you, you nigger lovers." Judith and I started to run across the highway, down the long sidewalk, pushing at the limbs of the full trees to clear our way. In our panic, we soon became aware that someone was running after us, and we looked desperately for the porch light that Mrs. Washington always kept shining for us. With a final burst of speed, we made it to the safety of the light. Out of the night we soon saw who our pursuer was. Walter, the Washingtons' oldest son, had waited for us outside the store to make sure we made it home all right. Judith and I collapsed into nervous giggles, like schoolgirls afraid of being caught in some slight offense, but the sight of Walter standing there, thin and shy, quickly silenced us. This was no game, no prank: this was a time and a place where Black children died because they wanted to be free.

While we spent the week doing voter registration work, plans were proceeding for another march over the Edmund Pettus Bridge. One night in the church, white index cards were given out to the visitors who wanted to be a part of the new assault via Highway 80. We were asked to identify ourselves, list our organizational affiliations, religion, and place of birth, and write a short statement about why we wanted to march to Montgomery. We knew that only a small number of the hundreds who had poured into Selma would be selected, and we sat in concentrated silence, writing our best historical selves,

while the families fanned themselves and chatted. How ironic it must have seemed to them, to watch us vying for the honor of doing what they had done out of desperation and anger. Of course, we now had media protection. The wounds of three weeks earlier had been inflicted on plain folks; now the ranks of would-be marchers were swollen with politicians, newspeople, celebrities, clerics of many denominations, and Northern students like myself. Even the federal government was promising protection. The eyes of the nation would be on the fifty-four-mile march to Montgomery.

I did not put the word *lesbian* on my card. I put Jewish and feminist. I wrote about SANE and CORE. I did not talk about the bars I went to and the knowledge about bigotry I had gained from being queer. I had no expectation of being selected, but the next night when the names were read, mine was among them. I was honored beyond belief. My friends kissed me, neighbors hugged me, Ramona jumped with delight and led me to the row of doctors and nurses who would accompany us. The final test was a brief physical exam to make sure the chosen ones were healthy enough for the walk. I stood next to a thin, freckle-faced nun who rolled up her habit's sleeve to have her blood pressure taken. We grinned at each other. Three hundred of us would eventually make the whole trip, led by those who risked their lives earlier in the month. The fear would come later, but that night and the next morning were filled with celebration and preparation.

The morning of the march, the Washingtons and I had a big breakfast together. Prayers were said asking for the safety of the marchers, and Mr. Washington announced that he and Ramona would march with me for a little ways. We made plans to reunite the night before the final march into Montgomery, the night of the mass rally on the grounds of the St. Jude Convent.

The sun shone brightly as 3,200 people set out from Brown's Chapel and followed the same route that had turned bloody three weeks before. We walked down Selma's main street, the jeering whites almost blocked from our vision by the phalanx of police that walked and rode alongside us. As we crossed over the small bridge, the leaders stopped the march to commemorate the courage of those who had come before. "You beat up on a hundred, and a thousand return," one of them said. What I remember most of those early hours was the feel of my hand in Mr. Washington's, the sight of his big farmer's body, and Ramona, chanting and singing on his other side. He and Ramona left me soon after we reached Highway 80, and then I settled into the rhythm of the walk. Singing, always singing, with the red clay banks on one side of us, and across the highway the newly tilled cotton fields. We walked only seven miles that first day before we put up the big tents that would prove flimsy protection against the night cold. The first night we all slept together, men and women, in whatever space we found. I shared a piece of cardboard with a Black minister from New Jersey. Cardboard became a much sought-after commodity, the only covering for the ground we had. The trucks with our sleeping bags had gone ahead, and because of a confusion, we would not see them until the march was over.

The next day we did better. Our ranks were now pared down to the three hundred marchers who would go the whole way. We had a walking rhythm and covered sixteen miles that Monday. For some of us the walk was easy; we were young and strong. But there were others who struggled with the miles. That night, we were told we had to sleep in sex-segregated tents because the nation's newspapers were reporting that sex orgies were going on in the night. We laughed at the rumors, but now I find it particularly interesting that sex and race were so immediately

highlighted. My lesbian self wondered at the futility of the pre-
cautions, and I became even more careful about my actions.

The March winds turned cold after dark, a bitter cold that few
of us were prepared for. I spent long hours standing around the
improvised heaters, large metal garbage cans filled with wood
that we fed throughout the night. Like hobos, we surrounded the
crackling fires, Black and white women and men trying to find
some warmth in that Southern night. Tiredness eventually over-
came me, and I walked into the huge women's tent, feeling lonely
and careful. "Joan, Joan, over here." It was one of the young
women I had met on a church visit. She was lying on pieces
of cardboard with three of her friends. A thin blanket covered
them, and she offered to share it with me. I lay down with them.
We huddled close together, trying to squeeze out what warmth
we could.

On Tuesday the weather turned against us, but we had
reached our destination, the large grounds of St. Jude. We spent
the day erecting tents and building the stage out of wooden
caskets turned upside down. I remember especially a small,
hunchbacked white man who spent the day crawling over the
coffins, hammering hour after hour. I helped prepare drinks for
the workers and the incoming demonstrators. We set up huge
kettles of lemonade in the middle of the field and ladled out
hundreds of cups. Then Frank, a middle-aged Black man, and
I walked the boundaries of the convent, serving the security
guards. He told me about his wife and how he wanted to leave
the South. I told him about the Lower East Side but not about
my women lovers. Again I felt the contradiction between kept
silences and new honesties.

When we had quenched the thirst of the workers, we found
the convent's kitchen. The huge kettles had to be washed out,
and we needed running water. The large institutional kitchen

was in the back of the building, and sitting in the open doorway were six older Black women wearing starched white uniforms and small white caps—the domestic staff for the convent. All the nuns we had met were white. We asked permission to use the sink, and without a word, they nodded their heads, staring at Frank and me the whole time. They had never seen a white woman do this work, Frank said, as we practically climbed into the pots.

Later that day, as I was helping Ajax pull on one of the heavy tent lines, I heard my name called out. It was Judith, running across the field. We hugged, laughed, and promised to find each other when the march was over. She was to stay many more months than I.

I spent the rest of the day working with Ajax, and then we were given shelter in the convent. The nuns were particularly attentive when they discovered I was Jewish; one young woman gave me a pair of pajamas to change into and led me to a hidden cupboard so I could change without being seen. One of the male marchers was having tea in a small parlor right outside my improvised dressing room, and the nun was especially concerned that he did not see me. The pajamas had small hearts on them and were of a light seersucker fabric. I had not worn pajamas like these since I was a little girl. I was given the one available cot while my comrades slept on the floor, on chairs pulled together, and on couches. I woke the next morning to a sweet-faced nun bending over me, her cross swaying before my eyes. For one minute I did not know where I was, and then I saw our muddy boots and I remembered.

That night, thousands poured into the campgrounds. I rejoined Judith and we stayed busy trying to keep an eye on Ramona and get some sleep for the next day. Rain had turned the campground into a muddy swamp, but the big show with stars

like Joan Baez and Shelley Winters still went on. We all sat in little wooden chairs sinking into mud as the coffins became the stage. At some point, the huge spotlights went out. An argument broke out between the civil rights workers and the police, who refused to help. I was standing next to a mobile home, one of the many that housed the more famous marchers, when I saw a small group of workers, police, and National Guardsmen approach the trailer. One of the workers pounded on the door, and a very drunk, very voluptuous Shelley Winters opened it. "Help us, please, Ms. Winters," the worker pleaded. "We need the lights from the military trucks to light up the stage." Winters was leaning out over the doorway of the van, her low-cut dress getting wet in the pouring rain. "Honey, come here," she said in a slurred, amused voice, motioning to the National Guard big shot. He approached, and she whispered something in his ear. He laughed and cupped his hand over her full breast. "Okay, give them the lights," he shouted to the gathered crowd.

When I got back to the tent, Judith had secured a sleeping spot for us, our number now grown by one. A tall, rawboned blond woman had joined us. We slept that night, along with thousands of others, on a bed of warm mud. The morning light came slowly, and marchers stumbled out into the gray, glad the night was over and anxious for the final stage of the march to begin. Everywhere cries of recognition rang out, for people had kept arriving throughout the night, and old friends ran to greet each other. From under one of the tent flaps appeared Susan, my first woman lover. We just had time to shout hello to each other before we had to line up. Ajax joined me, and we waited for what seemed like days for the thousands to assemble. At some point the sun came out, and then we moved, a huge rope of people, hands joined in long lines that stretched from one side of the road to the other. We turned a corner, and there

was the dome of the Alabama Capitol shining at the end of the broad street, a Confederate flag flying high above the national banner. Jeering white faces greeted us: the gesture I remember the most was man after man grabbing his crotch as the inter-racial lines marched by. Those last minutes seemed to fly. Dr. King spoke to us, helicopters flew overhead, ambulances and trucks with our gear roared up and down the streets. We had made it to the forbidden spot. What had started with blood and raw courage ended in an interracial community of 25,000 people besieging the Alabama state capital in the full glare of live television coverage.

But while the speeches went on, we were told over and over again by the SNCC and SCLC workers to get out of town fast. The fury that had lined the streets was beginning to spill over. As the sun went down on that day, we lost the protection of the media, the illusion of a transforming victory. At eight o'clock that night, as marchers were being transported back to Selma, Viola Gregg Liuzzo, a volunteer driver, was shot to death by a carload of KKK men on the same Highway 80 that we had sung and clapped our way down two days before. Ajax and I were among the thousands trucked to the airport only to discover that many of the major airlines were refusing to take us. We finally found room on a charter flight belonging to a large group of Black Baptist ministers who were flying home to Philadelphia.

We were numb with both tiredness and emotional exhaus-tion, but we knew that he was coming home with me. I put out of my mind his words to me back in Montgomery when we were waiting to be picked up: "The only group of people I can't stand are homosexuals." We had been through so much together, and his goodness, his fine toughness, drew me to him. Once we reached Philadelphia we spent another night on the ground, this time on the marble floor of the bus terminal, waiting for

our connection back to New York. In the morning, we were treated like soldiers returning from a courageous or traitorous battle, depending on the racial politics of the spectator. Some people shouted obscenities at us; one Black taxi driver gave us two silver dollars to commemorate the Selma march. We were dirty, marked by that red clay, our sleeping bags hung low on our backs, but when we finally emerged onto Forty-Second Street, with the New York sun welcoming us home, all the grandeur of that time soared within us.

Ajax stayed with me for a week in my Lower East Side apartment. We made love, and he cried when he came in me. I held him tight to me and wondered at my own stillness. We talked of marriage, of opening an interracial orphanage. All of this was still the legacy of Selma. Then it was time for him to return home, to his studies at divinity school. For another week we wrote to one another, and then I finally had to tell him I was a lesbian, that I did not know what I could be in the future, but that he had to know that about me. I never heard from him again. I wrote two more letters, begging him just to talk to me, but I am sure Ajax felt a dream had been smashed.

But not the larger dream, Ajax, not the dream you had in that small, brave church somewhere in Lowndes County, Alabama. And I have carried Selma with me all these years as well, not to prove my civil rights credentials, for I know more than anyone how little I really did in the face of lives that were committed to that struggle every day, but because Selma is to me the wonder of history marked on a people's face and on their soul. Now all the secrets are out, and I can march against apartheid with the Lesbian Herstory Archives banner carried proudly in the open air, and all around me are other gay women and men joining voices with the thousands more to say no to a killing racism and yes to a new world of liberated lives. I carry with me the belief

that Mr. and Mrs. Washington would still greet me at their front door.

Selma, Alabama
Washington Street
April 9, 1965

Dear Joan,

Judy has moved to the projects so she can be closer to the Church. And I enjoyed reading your letter. And we enjoyed you and Judy staying with us. This mite be a short letter but I am glad mother reminded me to write you because I was getting ready for Easter program. I hope that you can come back and visit us again and I just mite have a surprise for you. Come back.

With love,
Ramona

Narratives of Liberation:
Pluralities of Hope

A Syllabus for Sickos
—The measured words of Roger Kimball, editor of
the *New Criterion*, published in the *Wall Street Journal*, No-
vember 5, 1997

In the presence of [us], Wing Biddlebaum, who for twenty years
had been the town mystery, lost something of his timidity, and his
shadowy personality, submerged in a sea of doubts, came forth to
look at the world.
—Sherwood Anderson, *Winesburg, Ohio*

A s is true for many lesbian and gay people, my college years
were also my coming-out years. In the 1950s, my only mo-
ments of erotic and emotional freedom were in shadowy places,
places haunted by police and vice squads, flashing red lights and
swirling nightsticks. I found wonders of community and touch
in these places, but I also learned the scorching limitations of
social exile.

In 1958, I entered Queens College, a then-free component
of the City University system of New York and the campus
where I was later to teach for nearly thirty years. Here, I and
other working-class "queers," as we called ourselves then, met
at a small table in the cafeteria, bolstering our fragile self-images

with insiders' gossip about the gay or lesbian author we had just read in English class. Surrounded by homophobic students and teachers, by cultural references to faggots and bull dykes, by the McCarthy-fueled hatred of subversives, we worked very hard to convince ourselves that we were not the grotesques of our campus world. We never thought then that we had the right to ask the university to care about us, our minds, our imaginations, our lives.

Some of us found a home in other struggles for social change that were finding a voice on the campuses. We knew that while we could not tell our fellow demonstrators where we spent our Friday and Saturday nights, we could draw hope and strength from the battles against nuclear arms, against the House Un-American Activities Committee, against the Vietnam War, and against segregation. Every mile on every march, every hour spent at endless meetings, every endured taunt and thrown bottle, every arrest carried an embedded hope that when we changed this society, there would be a place for queers. Then as now, college campuses were both a place of exile and a refuge.

By the end of the 1960s, the gay liberation movement had found its own feet alongside the civil rights and women's movements, changing the social expectations of this country. People were on the move, shaping history with their bodies, and I moved with them. First in 1970, when I joined the Gay Activist Alliance, a rowdy gathering of queers that met weekly in an abandoned firehouse on Wooster Street in New York City to plan zaps against homophobic institutions and individuals. Then in 1973, when I was part of a group of gay men and women who formed the Gay Academic Union. Our goals were to challenge the homophobia and sexism that flourished on college campuses, to end the isolation of gay and lesbian students and teachers, to share our research and writing, and to inspire curriculum changes that would

reflect the contributions of gays and lesbians to our culture. We met for two years, held conferences, published monographs, helped launch other chapters, and supported one another in our research and writing. I remember the 1973 conference for two reasons: it was the first conference of gay academic people "in the history of civilization," as Richard Gustafson asserted in his welcoming remarks, and we had to empty the hall in the midst of an impassioned speech by Edgar Z. Friedenberg, a renowned writer on education in America and Canada, because a bomb threat had been phoned in to the police. There we stood, out in the cold November night, half pleased that a meeting of two hundred gay academics could cause such a disturbance. It was at these early gatherings that I met Jonathan Katz, Julia Penelope Stanley, Martin Duberman, Gayle Rubin, and Deborah Edel—writers and activists who played a major role in shaping the next twenty years of lesbian and gay culture.

Also in 1973, the Lesbian Herstory Archives was born, and for twenty wonderful and exhausting years it occupied my apartment. Now I realize the Archives were necessary because of what was *not* happening on college campuses: the stories that were not being told, the histories that were not being chronicled, the connections that were not being made, the richness of thought that was not being encouraged. In those days, I walked through my apartment late at night, gazing in wonder at the plentitude of lesbian cultural work, at the photographs of vibrant women from the forties, the boxes and boxes of letters and diaries, books, films, photographs, and special collections, struck by the paradox of the external cultural silence that surrounded us and this fullness of a community's self-expression. I knew we were not the first community to challenge enforced amnesia. Fifty years earlier a young man, Arthur Schomburg, had begun collecting every document of Caribbean and African American culture he

could find after a teacher said to him that Blacks had no history. Thus, the Schomburg Center for Research in Black Culture was born, a center that now enriches the world's scholarship. I remember the first time a college class came to tour the Lesbian Herstory Archives in the fall of 1980 as a visit of special meaning. The students were amazed at the vastness of materials pouring out over each other in a private home; they wanted to hear about the passion that could create such a collection, and they were angry at what had been kept from them.

In 1966, I went back to Queens College as a teacher of writing in the SEEK Program, an educational opportunity born out of the social anger of young Black and Puerto Rican women and men who believed higher education had turned its back on them. For the next twenty-nine years, I was to be educated by these "nontraditional" students in the courage of the heart and mind when confronted with what academics now call "the hegemonic power of the colonizer." I have read hundreds of memoirs written by students depicting flights from countries that were no longer safe, describing their battle with a language that represents to them the loneliness of exile, and expressing their need for hope. It was these students, hundreds of thousands of them, who changed the face of American education, who gave back to our educational institutions a hope for all of us—the hope that the story of human culture would for the first time reflect the complexity and richness of all our differences, of all our narratives of liberation.

As honored as I was to teach the English Department's first official gay and lesbian literature course in 1993 and to co-teach a similar course at the CUNY Graduate Center the following year, I have long realized that I learned my deepest lessons about education and social change from the resistance and insistence of my SEEK students. What I learned was that

the finest writing and thinking can happen only when there is hope in the mind and the heart of the student: hope that her life is of some importance, that her ideas will be honored with a hearing, that her choice of language will be respected with a response, that the risks she takes will be valued. Some students can take this minimal academic encouragement for granted, but the students I worked with for all these years could not. Many of them had neither the skin color nor the accent nor the money to qualify for being heard. A gay and lesbian struggle for academic inclusion and respect is part of this larger discussion: How do we create the possibilities of hope embodied in narratives of liberation, narratives that are, according to Caribbean social thinker Patrick Taylor, "the stories of lived freedom, the stories of individuals and groups pushing up from below to reveal the ambiguity and multilayeredness of reality"?[1]

The movement that started in 1973 both in the academy and in grassroots community projects transformed the cultural and social possibilities for queer people. The courage of gay and lesbian students to ask for what they needed was backed by the courage of lesbian and gay teachers to risk their jobs by responding with gay inclusion in the curriculum. Our cultural workers—the writers, theorists, historians, philosophers, and political and social thinkers—created new texts, re-visioned old ones, and ended the conspiracy of silence surrounding the nature of the desire that had cloaked so many of the canon's classic authors. Lesbian and gay archives, specialized collections, bibliographic guides, study centers all now stand behind the student who proposes a queer exploration. No longer can

1 Patrick Taylor, *The Narrative of Liberation: Perspectives on Afro-Caribbean Literature, Popular Culture, and Politics* (Ithaca: Cornell University Press), 1989), 15.

a senior professor douse a student's enthusiasm with the words "It sounds interesting, but I doubt you will find enough information to complete your project."

The bookshelves are overflowing with our texts; the language of our inquiry has spilled over both into popular culture and into the ivory towers of think tanks and exclusive universities. We are a hot cultural item, with major university presses jockeying for their lesbian and gay multivolume series and major publishers trying to cast their net over the more sellable authors. In short, we have become a community from whom money can be made, but we must continue to be an intellectual community from whom changes can be expected—changes in how gender is thought about, how power is conceptualized, how desire becomes resistance. Publishers have their reasons for calling for our manuscripts, but we must have our reasons for creating them. We must ask ourselves as we pursue our demands for inclusion in the places that still turn away from our cultural richness: What are the stories we want to tell? What narratives are we piecing together from communal pain and strength, from professional and personal excellence of thought and imagination, and how do they join with the stories of others who are fighting for the right to tell their stories in their own words from the fullness of their own histories?

Almost every discipline included in a contemporary college catalogue has been touched by new interpretations, the new information provided by the gay cultural workers of the last twenty years. Anthropology's beginnings must be seen in a different light. The patriarchal figure of Franz Boas, birthing the new science in his wood-lined Columbia University study, must now confront the mothers of anthropology: the bisexual Margaret Mead, who insisted that sexual development in different cultural settings suggested that desire was a constructed value, long be-

fore we had heard a French word on the topic; the lesbian Ruth Benedict, who transformed thinking about culture with her plea for a multicultural understanding of difference; and the free-spirited Zora Neale Hurston, who found a way to use the skills of anthropology to commemorate a people rather than objectify them. Surely students have a right to ponder the connections among gender, sexual desire, and race, as well as the production of original thinking that the lives of these three women represent.

Think of the missed teaching opportunity in computer courses if the paradox of Alan Turing's life is not discussed with the students—how he was forced to lead an encoded life while he imagined a machine that would break codes. Think of the opportunity an educator has to give technology a human face, to place its creation and use back in the narrative of the human need for touch.

The work of Liz Kennedy and Madeline Davis in their sociological and historical study of a Buffalo working-class lesbian bar community, *Boots of Leather, Slippers of Gold: The History of a Lesbian Community*, has ensured that sweeping descriptions of any decade not be trusted. Thanks to historians like them, stultifying national norms are routinely subverted by communities of outsiders, and queer history is tense with contradictions, rich with examples of communal refusal of predetermined historical categories. Because of the work of gay and lesbian historians, every historical period is being reexamined for its other histories, the underbellies of the known stories. Students embarking on the journeys of their own lives should be given the gift of complex knowledge, the insight and encouragement to find the text not spoken, to piece together the bones of hidden histories so they may more fully live their own.

Perhaps it is the study of literature that has been most liberated by the ending of silence and the emergence of multiple readings.

Years of misrepresentation have been swept away by the possibility of open discussion of the roles of gender, sexuality, and passion in the formation of a text. More and more biographies are giving us fuller portraits for understanding the relationship between desire and creation. "Not until 1952, when she set up a stable and happy life in the household of Lota de Macedo Soares, could Elizabeth Bishop take objective account and make direct artistic use of her difficult childhood."[2] When Mary Renault writes in a 1966 letter, "All through those years my inner personae occupied two sexes, too indiscriminately to take part in a sex war," she helps us understand one of the sources of the vitality of her Greek homoerotic fictional world.[3]

And when Lillian Smith sadly writes about her inability to be open about her forty-year love affair with Paula Snelling, she throws her other work, the documenting of the spiritual bankruptcy of Southern racism, into stark relief. She was, she says, held back in her honesty about her life by her shame, "my shame about something different and completely good. It has been that shame that has destroyed the keen edge of a pattern of love that was creative and good."[4]

Emily Dickinson, Amy Lowell, Willa Cather, Sarah Orne Jewett, Sara Teasdale, H.D., Elizabeth Bishop, Nella Larsen, May Swenson, Muriel Rukeyser, Audre Lorde, Adrienne Rich, Mary Oliver all have markings in their work of the imaginative complexity of same-sex desire and their innovative struggles with the confines of gender. Their choice of language, of images, of

2 Brett C. Millier, *Elizabeth Bishop: Life and the Memory of It* (Berkeley: University of California Press, 1993), 1.

3 David Sweetman, *Mary Renault: A Biography* (New York: Harcourt Brace, 1993), 252.

4 Margaret Rose Gladney, ed., *How Am I to Be Heard? Letters of Lillian Smith* (Chapel Hill: University of North Carolina Press, 1993), 136.

vision, the very formation of their texts—like those of Shake-speare, Herman Melville, Henry James, Walt Whitman, Countee Cullen, James Baldwin, Federico García Lorca, Langston Hughes, Allen Ginsberg, and Richard Howard—challenge us to new readings of how desire is encoded or announced in a text, how this private discourse affects the public themes of the work, allowing us to get glimpses of how the hope of self-disclosure, or the fear of it, lives deep in the mystery of literary language and structure. With these insights, students have the chance to read all the stories a text can tell, without shame, without restrictions.

Our narratives of liberation begin with a touch, begin with the body asking for a pleasure that has no social place; out of this quiet moment, a cultural transformation takes place. With this touch come the questions—about the permanence of gender, the cultural power of desire, the relationship between parody and what we think is real.

In America today—or perhaps I should say in the world today—these are dangerous questions to be asking. When we join them to the inquiries of feminism, of postcolonialism, of economic determinism, we can see that a huge moment of questioning is at hand. Narratives of liberation "lift human agents out of their closed realms to bring them into universal history, insisting on the fundamental unity, even in diversity, of all humanity."[5] Any social system or ideology that attempts to deny or negate this human possibility is a destroyer of human hope.

Gay and lesbian studies and the "frivolities of deconstruction" have become the symbol of the loss of America to uncivilized and ungendered masses. When Harold Bloom agonizes over the loss of the traditional canon (an interesting phrase),

5 Patrick Taylor, *The Narrative of Liberation*, 22.

when authors make millions of dollars proving how illiterate some Americans are because they do not know what others have decided is the correct sum of our cultural knowledge, when theories of the biological inferiority of whole groups of people again make front-page news, when educators announce that reform schools are the only answer to hopelessness, when fundamentalism calls for the killing of difference in the protection of sacred truth, then we have some sense of the power of our new readings and of the terror of destabilization they inspire. Of all the reasons I can name why gay and lesbian studies should be part of the college curriculum across disciplines—because it would be intellectually honest and conceptually challenging, because it would serve to demarginalize the lives of a good number of the students we are paid to teach, because the resources now exist to do this easily and interestingly, because it would make for more lively and involving classroom discussions and writing, because it would give the academy a chance to involve communities of activists and cultural workers from beyond the limited world of the campus—there is one reason that stands out as the most compelling.

People are moving all around this globe in unprecedented numbers—following jobs, fleeing catastrophes, finding new air to breathe. There is a great intermingling of ideas, religions, languages, desires. Some are comfortable with this multitude of choices; others are rushing to shore up the boundaries of the known world by reasserting a politics of exclusion and deprivation. When all else fails, they reach for guns. Teachers and students will not be able to hide from this tension. Gay and lesbian studies are often dismissed as being trivial, faddish, a hocus-pocus of language and an inconsequential expression of attitude: read our books, listen to our poets, touch your lover. Think of shame and self-disclosure, of ostracism and communal creation,

of difference and coalitions, of hatred and beauty, of exile and love, of conformity and independent thought, of performance and wit, of the body and all its ideas. This is what gay and lesbian studies can offer.

Gay and lesbian people are not alone in wanting the hope of a new narrative of education; now is the time to form alliances among the communities who see the importance of bringing Wing Biddlebaum out of the shadows, draped in the mysteries of his suppressed story. This shadowy figure will appear differently in different histories; the stories he brings to the surface will be spoken in many tongues; he may be a woman or a man or both in the same body—but this emergence, while something frightening because it is unexpected and uncontrolled, will call to us to find common ground on which to protect the dignity of difference and the possibility of hope.

Bibliography

Gay Academic Union. *The Universities and the Gay Experience: Proceedings of the Conference Sponsored by the Women and Men of the Gay Academic Union.* November 23 and 24, 1973. New York: Publications Committee. Gay Academic Union, 1974.

Gladney, Margaret Rose, ed. *How Am I to Be Heard? Letters of Lillian Smith.* Chapel Hill: University of North Carolina Press, 1993.

Millier, Brett C. *Elizabeth Bishop: Life and the Memory of It.* Berkeley: University of California Press, 1993.

Sweetman, David. *Mary Renault: A Biography.* New York: Harcourt Brace, 1993.

Taylor, Patrick. *The Narrative of Liberation: Perspectives on Afro-Caribbean Literature, Popular Culture, and Politics.* Ithaca, NY: Cornell University Press, 1989.

Two Women: Regina Nestle, 1910–1978, and Her Daughter, Joan

When my mother died, she left me two satchels of scribbled writings. Many of these fragments were written on the back of long yellow ledger sheets, the artifacts of a bookkeeper. She had started writing in the last years of her life, sitting in apartments empty except for a bed, a television set, a table and chairs. Dressed in a housecoat, her work clothes put away for that day, she would sit on the edge of the bed, using the chair as her table. Scattered on one side of her would be the day's racing forms and OTB stubs; on the other side would be her writings. An overflowing ashtray shared the chair seat with her pad, and a few feet away the television spoke to her, bringing the smooth voice of the public broadcasting system into the room. She would sit with her legs spread apart, her glasses low on her nose, a cigarette burning in one hand, and write messages to her daughter, her son, her lover at the time, or to the psychiatrist she had met at Bellevue when she was found wandering the city streets not quite remembering who she was.

Regina Nestle was born into a poor Jewish family in 1910 and raised in Manhattan. She left school at fourteen to work in the Garment District as a bookkeeper, married Jonas Nestle in 1928, was widowed in 1939 and left with a five-year-old son, Elliot, and a daughter yet to be born. Our family of three was pared down by the psychological dictates of the late forties and early

fifties. My brother, unhappy and confused by his father's death, screamed out his anger in frightening tantrums. Get him away from home, the doctors said, away from the family of women. At age fourteen, he fled our family; he entered the army at sixteen to make the final break. Through the years, I too wanted to flee this woman whose passions overflowed, making whatever security we had achieved so impermanent. Her sexual longings, her uncontrollable gambling, her continuous need for money to stave off the eviction notices, the loans come due, the liens on her salary seemed to endanger my life. In 1959, I took refuge on the Lower East Side where apartments were cheap.

Over the years, I learned much more about Regina Nestle: about her strength, her ability to keep coming back, her laughter, and her courage. And then time collapsed. In 1978 she had a massive heart attack. She had been stricken just as I left for work. When she called a doctor, he told her to put herself in a cab, but she had no money, she was unable to dress herself. So she waited those hours for me to come home. Again it was just the two of us, with the same mixture of desperation and absurdity. I dressed her. I couldn't get an ambulance to take her to the hospital her doctor wanted. I hailed a gypsy taxi driver and we sped through New York. My mother was shouting, "Hurry up please hurry up oh God," almost as if she were giving birth. And then I was standing by her bed in the hospital, stroking her cheek, telling her I loved her, taking her scribbled notes begging for release from the respirator. She turned her face into my hand, and I realized how small she was, how my hand reached from her forehead to her chin, how alone we were—no husband, father, son—only me, her daughter and, when she could, Deborah, my lover. Ten days later, my mother died. The last time we saw Regina, she was sitting on the edge of her hospital bed, head

bent, reading Deborah and me the poem she wrote to thank the nurses for bringing her back to life.

Why have I had to write about my mother's life, Regina's life? The rules she broke, the knowledge she had of her difference, the things she told me that mothers were not supposed to tell their daughters—as if she knew I needed this to survive in my life of sexual difference—all this is one reason. And I want to give her a final gift, one she wanted desperately: that her writing move beyond the bed and the chair. Finally, I want to take back something that was denied me by the medical and psychological world that told me lesbianism was a sickness, that my feelings about my mother were distorted, infantile, mannish. So I ran, like my brother did, driven by the doctors' threats. Some will read this and say, "No wonder she is a lesbian." This is the voice I have fought my whole life. It is for the others that I write, in the hope that some part of this will make it easier for us to stop running.

My mother was a bookkeeper. She had kept the books of men ever since she was thrown out of the protective circle of married women by the death of her husband in her twenty-ninth year, 1939. I was born five months after my father's death, so I never knew my mother when she was not the keeper of someone's books. The week before she died, in her sixty-eighth year, she had gotten a part-time job keeping the books for women weavers; she was sure this job would be different.

Joe's death was quick, painful, and not merciful. He wanted to live; he was young, vital, had a son he adored and a wife that sufficed. He tried so hard to survive and when we parted at the hospital, knowing he could not make it, he asked me how I was going to manage. I told him to let go. I would make it but more importantly,

151

his child and the child to come surely would. The last words between two who had created life.

Joan was born five months later, and in those five months, all values, all images of family, compassion were destroyed. The desertion by the families brought to me the realization that all were frightened people. I got along, and the coin of life was money. I accepted their law and rejected them. I picked up the challenge. The people I had contact with were mostly my own tribe, Jews, and I saw them battling the world to make it.

In my early years, when we were still together, my mother would get up early every morning, put on a well-made dress and matching shoes, have several Chesterfields and cups of black coffee, and then disappear out the door to go to the office. *The Office* was a magic word, one of the powerful nouns I grew up with. *Wholesale* was another, a word that meant having something. My mother's clothes were bought wholesale; she bemoaned the fact that I was too fat for the small sizes that hung on the showroom racks. Other creatures that I knew by name were *the line, the cutters, the showroom,* and always *the buyers.* I had images of huge scissors hanging from the ceiling, long wooden tables, and the hulking figure of the buyer stalking through endless rooms of floating dresses. My mother was part of the long tradition of women who toiled behind the showroom in windowless rooms, behind desks piled high with blue ledger books and overflowing metal mail cages. She lived with invoices, yellow perforated sheets spilling out all around her like uncontrollable tongues. In the office, my mother controlled in and out—the journeyings of endless pieces of paper that meant money for the boss and survival for her.

On the third finger of my mother's right hand was a bookkeeper's callus, a hard, raised yellow cushion of skin formed by

the pressure of her pen over the years as she listed figure after figure. The opposite of erosion, day after day, work had built up a plateau on my mother's hand.

The garment industry is run by illusionists, magicians, panderers to the world. The buyers are prostitutes. Give them what will please their customers, you own them. Displease their customers, you have lost security. Season after season, I was part of the cycle, saw the struggle, became part of it, dipped into the excitement of money, power, physical attraction, adornment, flattery, sensuality. Sex was like the afternoon cocktails, the theater tickets, the "black market" bribery, the procuring of nylons—all trivialities but of paramount importance. You had something that someone else could not get. You had it made. It was easy and pathetic after paying off your first IRS man. How sometimes I wished they would set me free. You see, I didn't have the strength to do it myself. I was guilty and so was the world. They had no values and neither did I, or so it seemed.

I saw less and less of my children. I had a housekeeper, efficient. I was with the children on weekends. The total transition from one world to another began to show its effects. It became more difficult for me to live. Loneliness became my friend and dreams became reality. The war, business, good food, clothes, even the beauty of the children were dim.

The Bronx, 1948: My mother, strong and beautiful, stands in front of the foyer mirror, straightening the veil of a smart dark hat, in a checkered dress, perfumed. I sit on the floor, looking up at her, knowing already in my little girl's head that this is a woman who is glorying in not being a mother, and also knowing that she is preparing for lovemaking. The housekeeper, who keeps me clean and fed, sleeps with me while I lie awake waiting for Regina to come home and take me to her bed, but always the dawn comes before she does.

153

And then in a swirl of failure for reasons not explained to me it all changes; the hat disappears, the housekeeper no longer comes. Other caretakers keep me until my mother returns from work. I sit in other children's homes, on their couches, watch them eat dinner, see two parents, who, for a small fee, will keep me until my mother comes to pick me up. The money has disappeared, the job is a grinding everyday ordeal. We are evicted from the Bronx apartment; a relative turns us away; we have no place to live. My mother goes to the Hotel Dixie. I go my aunt Miriam and uncle Murray in Queens to sleep on their gray couch in a gray room, grateful for the food and security, believing that I have terribly betrayed my mother. I wished for her alluring time to come again. Even at the end when she walked Broadway in her bedroom slippers, I wanted to remind her of the veil with its black stars, her upswept hair, arms firm and strong, fastening on her hat. I wanted the mother back who was a woman who did not want to be a mother.

As soon as I was old enough, I went to the office with my mother on Saturdays. When I asked her why she had to work six days a week, she replied, "The books have to get done." The books ruled her life like religious texts; they prescribed her actions and contained the markings of her life. Before I was old enough to help her, she would give me pieces of paper to draw on to keep me away from my favorite toy, the metal racks with their iron wheels that I could ride across the waxed showroom floors. Poor men still pushed these racks through the Garment District's congested streets, their arms bulging with the weight of each season's new line.

As I grew older, I would come to the office after school and sit watching Regina at work. How proud I was of this woman who could answer telephone calls, drink coffee, smoke a cigarette, turn the pages of her ledger sheets, and joke with her girls

all at the same time. I was safe here and so was my mother, I thought then. No eviction notices, no one calling her a whore, no bill collectors shining their flashlights through the windows. It was Regina holding the world together. At some point she would take me around to meet everybody—the operators, the cutters, the shipping clerks, and finally the boss. I knew it was very important that I be good on these tours, that I show the boss my mother could work a fifty-hour week and still raise a good kid. Through the years and the jobs, the tours of introduction continued but with some changes. I now knew my mother was sleeping with her bosses, and they and the women my mother worked with knew I was a lesbian. I no longer cared about being a good kid, but I did care about how shabby her office was, how she called the men who were fucking her *Mister*.

I lived with the garment industry the way other children lived with grandparents. At age eleven, I watched a call girl entertain a buyer and his drunken friends on an afternoon outing to a New Jersey beach. She sat, a beautiful young woman wearing a halter that fell low on her breasts, looking bored, waiting for one of the men to lurch up to her and take her into the tiny bungalow. I came closer to her and just watched. I wanted to break into her bored look, her placid tiredness, into the place that made her breasts swell. For one instant before she disappeared for another quick lay, she looked back at me. I understood she was a working woman, like my mother.

The firm names of the garment industry are cute: Young Togs, Mira Belle Fashions, Wendy Girl Dresses. They mask the desperate battle to survive each year. Every house has a genealogy in the market. My mother knew their lineage like the back of her hand. One of her jobs was to check credit ratings in Dun & Bradstreet. For a long time I thought this was a street out of a Dickens novel, a twisting, narrow road where quaint characters

sat in front of their shops, shouting their worth. My mother worked fifteen years for a firm called Bon Dana, pulling her bosses through the "black market" years, making the figures tell lies that earned thousands for her firm. Bon Dana sounded to me like the name of a small country with shady beaches, a country that demanded complete dedication from its citizens. Why and how my mother left Bon Dana I do not know, but it was the office that molded her, sharpened her manipulative skills, and let her know the range of greed she would have to find room for on her ledger sheets.

My mother, famous for her ability to pull the books together so the accountant had little to do on his yearly visit, laughed at the CPAs who made the big money while they marveled at her talent. The women were *bookkeepers*; the men were *accountants*. She taught me what a mixture of arrogance and failure her business world was, the class structure of its compact society, with the factory shop at one end (before they moved south) and the showroom at the other. Bookkeepers lived in the middle, not good enough to walk through the showroom but more powerful than the shopworkers because they did the payroll and controlled petty cash. In later years, my mother tried to be a workers' fifth column: she fought the bosses for raises for her girls and ran interference for the shopworkers who needed cash advances. It was a war fought by a woman against a man, the keeper of the books against the owner of the books. Like all those in bondage, my mother laughed at the master's dependency, at his vanities. She recorded his tax write-offs, his stealings from the business, his use of call girls to pleasure out-of-town buyers. While she was scorned as a social equal, she was feared as a woman who knew too much. My mother's whole life was marked by knowledge women were not supposed to have.

Did I love my husband? Such a definite question. Who was this husband? I had never considered the man who was the father of my children as my husband. I only knew the man. Did I love this man? Don't you see, Doctor, if I could answer you in one word yes I don't think I would have to be here. I remember as a little girl, the impatience with my own youth. I recognized that I was someone, someone to be reckoned with. I sensed the sexual order of life. I wanted to be quickly and passionately involved. I recognized my youth only in the physical sense as when I looked at my own body, saw the beautiful breasts, the flat stomach, the sturdy limbs, the piquant face, the eyes that hid sadness, needed love—a hell of a lot of grit, and already acknowledging this to be one hell of a life. I was going to find the key. I knew the hunger but I did not know how to appease it. I have not yet appeased it or reconciled myself. Therefore, Doctor, did I love my husband—yes but not as I wanted to, but I was a good wife, a passionate wife, a fearing wife.

My mother always said she had to be a man in a man's world, but she wasn't. She was a different kind of woman, one for whom there was no vocabulary. She was a widow who, out of the necessity to support herself and her two children, developed a craftswoman's skill—the manipulation of endless figures. Her apprenticeship started in 1924, when she left school at fourteen to work in a furrier's office. The boss, Jonas Nestle, liked the smart young girl and married her. But my mother was already damaged goods. In that same fourteenth year, she had been raped by a group of men and a pregnancy developed. She succeeded in finding a woman doctor to perform an abortion. My mother realized that Jonas would not marry her if he knew she was not a virgin. Desperate for her right to a safe life, she faked purity and managed to shed the right amount of blood. For a few years my mother kept no books. She was the glowing young

wife and, in a few years, the mother of a son, Elliot. She had girlfriends, Yetta and Rose the vegetarian, went to Coney Island with other young couples, smoked cigarettes on the roof of her Bronx apartment house so her husband would not yell at her. But then came the night of pain, and Jonas the strong young man died.

I started high school a ball of fire, with my twin sister. I believed we were God-sent. it was conveyed to us by the teachers, by our mother dressing us alike. All external. You know, Doctor, it was all bullshit. I never felt it. I was angry. I was unique. My twin sister, Miriam, had infantile paralysis at the age of three. Her lack of activity became my way of life. I sat, I knitted, I read. If I did anything physical that she could not I felt I was a selfish, ugly kid. Then I rebelled. At fourteen. I left school and went out into the business world. At fourteen, I had my first sexual relationship.

Oh my mama, the things you liked to do
fuck and suck cock
one customer knocked your teeth out
but you would not let your woman friend in to help you
because he might come back and she would get hurt
so you lay in a pool of blood and teeth until the
police broke your door down.
You were evicted once again for being an undesirable tenant.
You went downhill fast. From quiet dinners with
your bosses who bedded you
in time to be home for *Shabbas*
to the merchant marine who doused himself with your
perfume while you knelt between his legs
and threatened to kill you every week if you didn't
turn over your paycheck

Oh mama the things I saw and the things you did.
No wonder you are a lesbian they will say.
No the wonder is my mother
who taught me when to go on my knees
and when not,
who kept alive her right to sexuality when sex was killing her.

Jean was a misfit, but she didn't know it. At the age of fourteen, dark-eyed, short, beautiful pair of breasts, a good behind, dimples, a Jewess, hot in the pants—that was the description. Almost perfect for a fine Jewish boy to have sport with. His kind, her kind. Only there was something wrong. Obviously a good lay, but inside thinking this was a way to reach life.

Where else to seek but from the men she had access to? She knew one individual man, her father. Jean saw him as a flat surface, no dimensions. He ate, he gambled, he never reached out except to touch her breasts once or twice, slyly to be sure. A loving fatherly gesture. Jean knew the man was on the make.

Rockaway 1924, a gaudy summer resort. Jean was there to take care of her older sister's child. The deserted beach was her retreat. The ocean was her savior. She could see a great span of space. She was not aware of the beach or the waves touching the shore, retreating flirtatiously, only the horizon, the escape, no buffeting, no challenge, just space. Jean knew the loneliness, always knew it but did not recognize it, so when this beautiful young man came to sit by her, in the evening twilight with the beach deserted, he unknowingly joined her in her quest.

He was about twenty-five, curly hair, blue eyes, stocky build, good-looking. "A pretty girl alone. How come?"

"Just watching." Jean's voice was muted. The challenge had come—a young man was seeing her. Jean watched herself as a warmth crept over her body. Her dimples were showing. She thrust

her body forward to accentuate the outline of her breasts. Jean was
going to make it.

My mother's legacy to me was the story of her desire. She has left sexual trails for me, private messages: how she saw her breasts, how her body swelled with want. She has also left the record of her anger, her fury at herself and others for forgetting the connection between generosity and lust. She never knew who to blame for her sexuality, for the rape, because the voices around her said her hunger deserved punishment. Forty-Second Street did not scare or repulse her. It reminded her of empty beds. My mother feared and hated the women who, from the comfort of their marriages, called her *whore*. But she also knew on her own body, carried in her soul, the scars of sexual abuse. My mother accepted the fact that desire had made her homeless.

One night about two months later he invited me to a party. I went with fear, not trusting the man I loved. Yes, I thought I was in love. You know the saying, when you have had one, you have had them all—well, that was what happened to me that night. He passes me on to his friends, three in all. I wonder to this day how many of these men, I am sure now successful, ever think of that night and the complete frustration they had? I did not move. I disconnected myself from my body, froze my mind. I was considered a lousy lay by the three. Were they cruel? They were young men who thought the world was theirs.

I went home. He took me to my door at six in the morning. Not a word did I say. My mother and father were waiting. My father started to call me all the vile words he knew in English. My mother quietly stated she controlled the children. She would mete out punishment if necessary and that would be the final word. When we were alone she asked me if I was alright, told me if I was pregnant I

would not be alone, kissed me, and told me to go to bed. Never again was the incident brought up.

God did I need help.

I would not accept the tangibles, the penis, the vagina, as a way of life. Necessary yes. I treated the physical as the entree to the man as he entered me. Doctor, this one experience now haunts me and I seek the answer. Was I the victim or the stimulus of the event? That evening of the rape I came away still young, still desiring the beauty of a sexual relationship, frightened of words not being able to express the experience, afraid to admit that there existed in men such cruelty. I buried the truth. I lived the lie that men do not and cannot perpetuate evil. Love is all-pervasive. Cruelty does and did exist, but the people were sick. But in my life despair took over.

Doctor, I still believe the lie that human compassion, humble awareness is the only common sense.

Our love affairs collided as we grew older. Once when I needed your solace because I was losing a woman I loved deeply, I walked the eighty blocks between our apartments to find you sitting in your slip with your boss and lover, Mr. Ulano. He sat across from you in his short sleeves and suspenders, in the formal intimate way I had come to know as your post-lovemaking demeanor. I could not speak to you then. Mother and daughter were pursuing illicit loves. I never thought you saw my need of you, but I was wrong.

June 27, 1970. I saw Joan today and it was a portent of all things to come. She was going to the coast for two months. Afraid to say good-bye, she called and said she didn't have time to see me. I wished her a good trip. She called five minutes later to tell me she would stop by for a very short time—a minute or so. So full of love and guilt, not knowing how I feel, speaking trivialities when my

*heart is screaming out to her, take care, take care. I love you my
dearest. God, may she always see her way and not despair. Shedding
her responsibilities, her work, headed like a child to her fun, knowing
she deserved it. She removes herself when she thinks she will hurt.
Can I show less courage and integrity than she? The daughter be-
comes the teacher, the mother the student.*

Sometimes all we have to give each other is words. We hoped
the cracks would not get deeper, but they did. The bosses never
left their wives; they never solved my mother's financial problems.
But at least the office where my mother lived most of her life
was emotional territory, an erotic home where praise for busi-
ness skill was given with a wink of appreciation for her sexual
abilities. She diffused their power by fucking them. When she
left, she made sure their books were in good order.

At some point in the early fifties, it all began to drift away. The
weekly subpoenas would be jammed into her bag, unopened. I
lived waiting for the legal explosions; they came but they never
blew her entirely away, just piece by piece.

In 1958, when she discovered me in bed with a woman lover,
she gave me an ultimatum—leave the house or see a doctor. She
knew seeing a doctor was not going to be my choice. She kicked
me out of the house and I became part of the torrent of the
sixties; it was the right time for me. I could use all she had taught
me, all I had witnessed: my anger at bosses, at the finger-waggers
who called her *whore*, at the secure who flourished in streets of
pain, at bigots who locked restaurants and school buildings. My
queerness rode with me on Freedom Rides, walked the miles
between Selma and Montgomery, helped swell the ranks of the
peace marches, protested shelter drills, sat with me in front of
the House Un-American Activities Committee as we applauded
an exhausted John Grant while one of the senators called us

scum of the earth. And while I marched and chanted, my mother worked day by day to keep herself alive.

> *December 29, 1969. I'm drunk. I'm listening to the hilarious news on television. More draftees, more killings, more injustice. I can't hold on much longer. Is it my own unhappiness? I am not as holy as I wish to think. I hate the man I love. I hate myself for loving him. I hate his values, his estimation of who you are, how good is your credit, how much money do you have. I have no money, no position. I live week by week, salary by salary, hate my work, hate what kept me alive. I could have gone on if I was able to give and receive love. So, you say, what the hell do you want? So I didn't get it. So I didn't deserve it. So I didn't play the game. So they didn't play my game. Only fucking, literally and figuratively, is the whole game. Do it well and you will be a success, do it with your heart and call it love, be sure you will get a good fucking. I am sick of my body demanding the touch of love, sick to my soul of all the ugliness.*
>
> *Come on Youth, fight with all your weapons. Save this world for yourselves. We have only garbage. I am part of it. Dump us, burn us, but don't become one of us. Be humble to your own. Give yourselves love; we won't recognize it.*

I had to wean myself away from expecting love administered in the custom of the families around me. My mother never taught me how to be a lady, how to brush my teeth or the right way to wipe myself. She never passed on recipes or fashion hints or her favorite brand of lipstick. She never told me to get married or go to college. She did pay a man to fuck me to see if I was a lesbian. She was drunk when she arranged it, but I think she was not ashamed of her attempt. She needed to know if I, too, could be a good lay. I was, Regina, with the women who made me feel beautiful. She taught me how to search out live nit

eggs that clung to the bottom of my hair and crack their bodies between my nails. She taught me laughter and endurance and the right to passion. She taught me the absurdity of power when it is used on the powerless.

> *December 29, 1969. I was born, given a name, parents—made the best of it. I was a wife who could not follow the beaten path, always hungering for an answer. I was a mother, a sick mother, but a mother. I gave birth. The physical event was not important, but I loved another human being. Not the right outlook for a mother, so I loused that up. But by God I love these adults, not because I am a mother, but I see them struggling to gain identity.*
>
> *Regina the woman: who the hell is she? In bed, terrific, so I am told. A good lay is still a good lay regardless of what causes the good fucking. How lonely is all the playacting. What do I need to make me whole?*

What do I do with this legacy—a mother who wills me her views on fucking, her despair, her outrage? Her rebellion outlasts those of Abbie Hoffman, Jerry Rubin, and Eldridge Cleaver. She just got tired. The days of work did not stop, and she was no longer the boss's best friend. Elliot and I started getting telephone calls. "Bail me out. I need money. Come get me." She would go for long periods without telling us where she was working. Then I would get a frantic call from Miriam, her twin sister, asking me if it was true our mother was a prostitute. When the calls from her finally came, they showed me worlds of humiliation in which she had learned to survive: the residential hotel that evicted her, where my lover and I had to rescue her clothes. I introduced myself as Regina's daughter and they told me to wait outside. They wheeled out a dirty laundry bin, trailing her stockings and underwear, on the street. We scooped up handfuls of her clothes

and stuffed them into suitcases. The tape recorder I had given her to help with her writing had disappeared.

Soon the trail left behind grew smaller and smaller. Each eviction pared down her possessions. The final time I picked up her pieces was in the green-walled basement of the hospital where they had put her suitcase and I found myself touching her shit. My last gift to her, a green bathrobe, covered with her final fear. They had carefully placed it in a plastic bag and laid it on top of her writings. For one moment, the whole world smelled of shit and then I realized it was only the bathrobe, and I threw it in a garbage can.

An Open Letter to My Children, 1969. You, my son, visit the neighborhood, the apartment house, peer through mailboxes looking for familiar names, looking for your innocence, your dreams. Do not let memories dim the present or the future.

You, my daughter, love yourself, you are worthy. Bear no guilt. Out of sorrow you have created love and compassion.

I, too, search the old home, saw two small children look at me with confidence and love. I see you both and now I see the present, the anger that shields your love, my life entwined with yours, part of the memories. Now that you are both grown and I am in the deep middle age of life, I know that we are richer for all our hurts. What you will be will encompass all memories, we three who love each other very much.

From the Lesbian Activist section of the *Gay Activist Alliance Newsletter*, April 1973:

"Blessed Be the Mothers of the Lesbian Nation"
Feb. 4, 1973, marked, perhaps, the beginning of a new stage in the Lesbian movement. The Lesbian Liberation

Committee sponsored a panel called "Mothers of Lesbians" which proved to be one of the most exciting and hopeful Lesbian discussions presented at the Firehouse, to date. Joan Nestle's mother made a very moving statement about Joan as a person: a beautiful person whose choices could only be good ones.

Twice my mother stole from her bosses, once out of desperation and the second time out of terror. When she stole for herself, she stole badly and was caught both times. By now, my mother's world was slipping away. She couldn't control the numbers or the men anymore, but she fought back with all the magic of her bookkeeper's language:

Oct. 15, 1976

Mr. Brenner:

I received the subtle threat addressed to my children, with regards to my misdeeds, which, incidentally, you were aware of as far back as two-and-a-half years ago. I did not at any time cover or manipulate your books to hide the deficit. I am not pleading my cause, as a matter of fact, part of my healing is admitting to "improper behavior"—but for you to assume a holier-than-thou moral judgement is laughable. The powerful have the right, your philosophy?

Now to the settlement of the debt. There are discrepancies and I shall enumerate: According to my records, $800.00 given back to you from my bonus seems not be credited to my account. I may be in error and the only way this can be proven is to send copies of my earning sheets of 1974 and 1975, showing deductions from my income to be credited to indebtedness and judgments against my salary. As to the $60.00 for dresses that you list, I paid this sum to your former colleague, Johnnie, you remember him, your disposer of checks. I am being sardonic and humorous, poor soul. He thought

he had it made. Don't we all, including you. I am sure I am not intimidating you, and it is not my style, as I am accountable for my actions as you are for yours and I do believe in justice. However, you better believe that all correspondence now or in the future directed to my children shall possibly be a heartache to you. My sins are mine, period.

I am enclosing, herewith, a money order for $75.00 which you will be receiving every month until the indebtedness is paid, but I must insist upon receiving the papers requested. In the event you do not accept these terms, I shall return to New York and you shall determine your method of justice and I shall pursue mine.

Now even the dresses must be accounted for. No longer does your body soften the edge between the boss and you. You use the language of business, its *herewiths* and *the aboves*, to fight desperate battles. I also fight back on your behalf, tired of the years I had to be a good girl in front of the bosses.

September 17, 1976

Dear Mr. Brenner:

I am sending you my mother's address but first I want to say some things. My mother helped in paying back the $3100. She is now living on Social Security with my brother in California. My mother has worked her whole life primarily for one thing—to raise her children with dignity. She did this alone, working in small rooms, taking care of the bosses' books. The years of loneliness and frustration did not produce an always sensible, "rational" woman. When she committed those "improper actions," she was ill—ill with a life of struggle and loneliness. The money went to a man who regularly threatened to kill her. I look at my mother now and I love her. Sometimes

she is "crazy," but she has worked a lifetime in a business world that never saw her as an important person, in a man's world where she serviced her bosses—lied for them, cheated for them, saved on taxes, off the books, on the books. I don't know if this letter makes sense to you, but I had to write it. Much more was taken from my mother than she ever took. Someday the world will be different. Profits and business will not be based on the lives of less powerful people—particularly women. My mother has my everlasting honor and respect.

"I am not a mother," she would say. "I am Regina, a woman." Always, always that would be her cry, and when she came to me for money I did not have, or because her lovers brutalized her, or when she lost a job, I wanted to cry, "But Mother, I am not a daughter, just a woman. Please leave me alone."

I don't know when my mother started gambling, but the racetrack and later OTB were as necessary to her as lovemaking. Driven by loneliness, my mother pushed herself into unwomanly territory. She rode the lonely people's bus, scrawled her figures on any available piece of paper in her purse, usually lost. She stood in small gatherings feeling the warmth of nightly comrades around her, people like herself who needed to win and should have won and yet who knew that just being there they were already losers. Sometimes she took me, but I hated it all. All I saw was Regina surrounded by shabby men. Regina being an expert, once again using magic numbers to win warmth, and always, it seemed to me, Regina losing. I watched with fury as rent money disappeared under the grill, transformed into small dull tickets like the thousand others scattered on the stained cement floor. I thought

my mother's money should be spent on food and shelter. I did not know her fury at the money she was forced to make, her refusal to accept the tedium of her life by doing the right things with it. In her last year, she would flee the apartment Deborah and I had furnished for her to the OTB across Broadway. She would stand there, cradling her pocketbook under her arm, in a light blue coat, a small woman once again surrounded by men.

The bus awaits, the program is bought, away we go to glory or to doom. It doesn't matter. We are where the action is, the comradeship, the sympathetic ear, the boast of winning the day before. We look at each other almost lovingly. We all protest we are not compulsive gamblers, but we do not confess the need for ties that have meaning. We are not missed anyplace, are on the bus because we have no other place to go. The prostitute is there to reap from men their rejuvenated masculinity. The woman no one needs is there hoping for a crumb of attention. Maybe she will be acknowledged as a good tipster. There is no sex.

We reach the bus, the evening over. Some think about the lonely trip, what the hell am I doing here, others hate themselves and hate the world, others boast of their winnings and hurt their comrades. All agree it is a crooked game.

Of all of it, it was your loneliness I could bear least: you who wanted touch so much became so diminished in your passions. I always saw you coming home from work so tired, so burdened. I wanted desperately to be able to call in from the other room your young husband full of strength and safety. Then, as I grew older, I wanted you to accept the love of women. Finally I wanted you to accept my love. But you did things your own way, like a tenacious farmer chopping earth away from stone.

I met him on a bus coming home from the track. I was terribly depressed, not because of losing, but from the sheer terror of spending an evening without any personal contact. He sat down beside me, even though there were many empty seats. Casually glancing at him, I got the impression of a man in his middle forties, a strong-featured man with a brooding face, hunched shoulders, a big man. He asked me how I made out. I told him indifferently that I had lost a little. The conversation became desultory until I heard him say he had just returned from Viet Nam. I reacted immediately, wanted to know more. I found out he was on a warship delivering war materials. On hearing his version of the war, I dubbed him a reactionary but what the hell, he was somebody to talk to. We got off the bus at Forty-Second Street. He indifferently asked me if I would care to have a drink. We went to a bar across from where I lived and I proceeded to get cockeyed drunk. Left myself wide open for whatever would happen. Do I sound unemotional about it all? Did I know this man was to offer me a challenge? Yes I knew from the beginning. I knew he was a loner. I knew he needed human contact, but so did I. Thinking that I could help myself by reaching out, I reached out, loaded, angry, crying. I brought him up to my apartment. We clung together. I fell asleep in his arms, not knowing his name, not caring.

I remember the night in Flushing when you came home drunk. We were all waiting for you: Uncle Jack, your most devoted boyfriend; Mabel, waiting to be paid after a long day of work; Susan, my first woman lover; and myself. You came in staggering and saw us all staring at you with worry. You started throwing money at us, shouting that was all Regina was good for, that was all we wanted you for. You collapsed on the couch and when I bent over you, you grabbed my arm and started kissing it, feverishly telling me I was the only one who understood. Susan ran out the door, frightened by the chaos. Mabel told me, "Go

after your woman, I'll take care of Regina." I did. I fled from the knowledge that you loved me for being the one closest to your torment.

I started work at thirteen and I never took money from you, but I wished it was not me that you had to come home to. When I walked in countries you had never seen, had years of peace with Deborah, my lover, that Jonas did not live long enough to give you, I measured my freedoms against your servitude. The day before you died, I told you you would not have to work anymore. You called Rose, your enduring friend, to tell her that your children had freed you.

May 7, 1977

Joan Dear,

Your birthday—my celebration of the beautiful gift I received on Mother's Day thirty-seven years ago—when I held you in my arms and you were not more than three hours old and you looked up at me with your glorious blue eyes. They did not wander to flitter as most babies do. The bond was made and if it seems, at times, the communication is weak, the compelling tie of love and devotion, recognition, strength was there.

My love is so great that see you face to face I would become "emotional." just today I want to say that for always your love has been my greatest gift—you made me a beautiful person in my eyes for which I say thank you for being my daughter.

December 22, 1978. Mother, today I brought you Colette and Willa Cather whom you wanted to read, but I knew you would not be able to. You are lying on your deathbed, plugged into small television screens that record in orange lines when your heart bleeds or screams or stops. Since Tuesday you have been a captured woman. When I was very small, lying in a hospital bed,

scared and wanting you there all the time, I remember you standing above me, dressed for business, a working woman who could not miss a day. You looked down at me and said, "Don't worry, I'll be here." Later, when you thought I was sleeping, you called your boss to apologize for being late and to say you would be in soon. We both knew you could not stay.

Now I cannot see you. You lie in the most critical bed—a place of honor. I see down the long blue corridor. Yellow lights shine at the end and white coats swing as they go in and out of your room. You waited for me to get home from work before you would accept the heart attack. You waited for your working daughter. I found you dying, and now I go to work every day before I come here. In every hour, I have ten minutes to give you my love. Your eyes beg me for help. You are tired and in pain. You write me a note: "Death would be a treasure." The machines are pumping at you, liquids are flowing in. The doctor turns down your stained sheet to show me the heart burns from electric shock, but all I can see is your pink nipple.

John Preston and Myself

July 9, 1964
Aurora, Colorado

Dear Bob,
I shouldn't have to tell you that your letter made me cry. You
are the only person I miss from Great Falls—I miss talking
with you and being with you. It is much easier for me to say
things by writing them, and there is something I have wanted to
tell you for a long time. As a person, you are rare. I don't know
if you realize it or not, but it is almost impossible for a girl to
be a friend to a boy.[1]

I first met John Preston sometime in the early eighties when
we were on a panel of pornographers as part of a conference
of gay and lesbian journalists; a group of writers who had been
censored for their subject matter were meeting in one of the
ground-floor rooms of the newly opened Lesbian and Gay Cen-
ter of New York City. I was the last panel member to arrive, and
I remember Pat Califia asking the whole panel to rise so I could
wedge myself in behind the long table. John Preston was one of

1 The excerpts from the Colorado letters are part of a special collection
documenting the friendship between a lesbian and a gay man in the 1960s.
Donated to the Lesbian Herstory Archives by Robert Cunningham, who
died in 1997.

my colleagues on that day. He sat straight and tall, unflinching in his gaze, as he chronicled his career in erotic writing. Intrigued by his honesty and dedication to his writing, I began to read his books and keep an eye out for his name as he toured the country.

Over the years, I would get warm, encouraging cards from John, words that I needed in the face of some of the more ugly responses to my erotic writing. We were comrades in our dedication to telling the tales of how touch and taste and yearning encouraged life. My other good gay friends, Jonathan Katz and his lover David, Allan Bérubé, Bert Hansen, and Eric Garber, were all supportive of my history work, but it was John who read my books as portraits of sex.

In the mid-eighties, I grew aware of another dimension in John's work; he became one of the first creators of and spokespeople for a new eroticism: safer sex. He put his authoritative stance behind the possibility of hot, heavy gay male desire. Here we shared another parallel in our work. My erotic writings existed in a world where women lost their lives every day because of male violence. Every time I wrote of touch and entry, I had to weigh the consequences of my words. I had to ask myself if I was serving life, the fuller life of women, by breaking erotic silences. Both John and I chose to keep alive the taste, the power, of homoerotic desire.

In 1991, John started writing me letters about his idea for a book about relationships between gay men and lesbians. John was in love with the publishing world, and he was always looking for new projects that would please his agent and calm his relationship with the Internal Revenue Service. "Fondest of my Fantasies," he greeted me in one of his increasingly imploring letters, "it is time for us to get to work on this project." His salutations became more and more baroque as our correspondence grew: Dearest Love Goddess, Dearest Erotic Icon of My

Soul, and finally, Dear Divine Being of My Groin. How could a girl resist? The letters themselves, after their courtly flourishes, showed the hard work of a professional writer. We both had other editing, speaking, and touring commitments that kept pushing at the time we had put aside for this book, but finally, in 1992, John demanded that we find the time for the project that was to become *Sister and Brother: Lesbians and Gay Men Write About Their Lives Together.*

In the two years we worked together, I discovered more about John's history of activism in the gay community than I had ever known. I suggested that we hold a public conversation about why we wanted to write about the connected lives of gay men and lesbians in a celebratory way. I would write one section, and then John would answer. I am sure John found this a bit touchy-feely, but in his ever-courtly way, he bent over backward to accommodate me. Every new paragraph from him deepened my understanding of his journey—from his childhood in a small town in Massachusetts to his involvement in the civil rights movement in Boston, Chicago, and Montgomery, Alabama. He told how in 1969 he threw himself into the gay activism that was making Minneapolis a hotbed of queer organizing, founding the first gay and lesbian community center in the country—Gay House. In that city, he shared a house with Cindy Hansen, the lesbian co-director of Gay House, and her lover, Sharon. This experience of living with two lesbians and the long discussions he had with them about fathering a child with Sharon laid the basis for his willingness in the early 1990s to shatter some prevailing myths about relationships between gay men and lesbians. Not only had the specter of fatherhood raised itself in that shared house, but complex sexual desires had also made themselves known.

John challenged me to write about my relationships with gay men in a way I could not have done in an earlier decade. Part

of the price we had both paid in trying to create a public erotic voice was some simplification of our own erotic histories. My own relationships with gay men began in 1959 when I was attending Queens College, part of the City University of New York. Here in this working-class Berkeley of the East, I met Carl, the son of a trade unionist who had been purged from the union he had helped to organize in the first wave of red-bashing in the forties. Tall, broad, with a permanent cowlick over his forehead, Carl was part of a whole family of red-diaper babies who were studying such subjects as anthropology and psychology in the hopes of finding another way to keep the causes of the left alive.

This group of committed activists gave my own class anger a historical setting; my first date with Carl was to see Lotte Lenya portray Jenny in Brecht's *Threepenny Opera*, in a small Village theater. Afterward we sat in a huge and sparsely populated automat, where he explained Brecht's vision of the theater to me, the coffee cups piling up and the ashtray spilling over.

That night we attempted to make love as my mother slept in the next room. I was naked and Carl was stroking me when my mother sleepwalked into the room. Carl threw his body over mine, and I said in a stern voice, "Mother, go back to sleep." Obediently, she turned herself around and marched back the way she had come. "What will I tell her in the morning?" I wondered out loud to Carl. "Tell her," he said quietly, "we were trying to find each other." All night we talked, not about Brecht or Joseph McCarthy but about Carl's first sexual experience with another man the night before and my own sexual explorations with women. We talked until the Queens sky turned orange with the new day; I still wanted Carl to make love to me, but I already knew that my womanness was not what he sought.

We kept our erotic searchings to ourselves while Carl and the others continued my cultural political education: hootenannies, early-morning gatherings in the deserted streets of Times Square to catch our bus to Washington, lessons in self-criticism, walks for peace, sit-downs for nuclear disarmament, training in how to survive tear-gas attacks, which we needed to know for our protests against the Vietnam War, which carried us to the steps of the Pentagon. It was with these young people that I faced the uplifted bayonets of the National Guard for the first time. And while Carl and I did these actions together, while he taught me about the long tradition of radical protest in this country and introduced me to people like Paul Robeson Jr. and Joanne Grant, we were also exploring how we could arouse each other's desire. I remember, before one political meeting, wearing a sailor's cap as I made love to Carl, his long body stretched out before me. I spoke as if I were a young man and stroked his cock to arousal. Even in those early days, when sexual politics were not part of the leftist agenda, some of us sensed another knowledge waiting for its time. In 1992, in our talks and writings, John called these memories out of me.

At first our collaboration was marked by John's certainty about how to proceed. We used his agent, used his description of the goals of the book, used his list of gay male friends—and then, slowly, he grew weaker. His HIV status changed; the AIDS virus grew virulent, and I stepped in to take over the book. The tone of our conversations changed. Late at night, John would call me, furious at his loss of powers. I remember one night in particular when John wept on the phone, saying that he had turned down a gay video maker's request that John allow himself to be filmed. "I am not going to be just another faggot dying on film," he said. "I want to be remembered as the young boys saw me, the author of those hot books." I had no easy words for my

dear companion other than to assure him that the book would get done. In 1993, John was making one final round of the New York publishers to sell his autobiography, and he stopped off to visit me and my lover. Sprawling on our couch, John extended his long legs far out into the living room. Our dog, sensing his love of the species, curled at John's feet. It was a sweltering summer day. This was the first time John met Lee, my partner, who is a devoted fan of his Mr. Benson series. From across the room, I noticed how they resembled each other—both lean and gray, both marked by the slate blue of their eyes. John was tired and upset at the lack of interest in his proposed autobiography. He repeated the words of an influential editor he had just spoken to: "You know, Preston, the story of a middle-aged gay man fighting AIDS is not news anymore."

John's retelling of this encounter brought back to me a conversation I'd had a few months earlier when I called a Jewish archives to see if they would be interested in receiving a copy of my neighbor's story of how he had survived the ghetto of Riga. I had worked with David, now a man in his seventies, as he translated his original Yiddish text into English. David sat by my side as I typed his journey of loss, of flight, of resistance into my computer, stopping only when his grief overcame his words. He had insisted that his story must be remembered, beyond the confines of his immediate family, and so I made the call to a likely place. "Miss Nestle," the weary voice of the archivist informed me, "I know you find this story very impressive, very dramatic, very unique, but I am saddened to have to tell you that we already have thousands of such stories."

The afternoon after John's visit was the opening of the new Brooklyn home of the Lesbian Herstory Archives. Again the heat blared down, but I was so excited by the crowds of women, by the beauty of our new space, that I just plunged ahead. Through

the streets of Park Slope we marched, our own small band drumming us along, over four hundred celebrants jamming into a building in Prospect Park to hear speeches, to eat, and, of course, to dance. I ran from table to table along with the other archives workers, making sure the chaos was pleasurable for our guests. Finally too tired, too hot to keep up the hectic scurrying, I stopped and just looked around at the moving, swirling mass of lesbians celebrating their own cultural institution. Then I saw John, his head towering above most of the crowd, standing with sweat dripping down him, his luggage pulling at his arms. I made my way toward him. "I just had to come," he said. "I knew how important this was to you. I can't stay; I have to make a train home." He bent his head so I could kiss him goodbye and I felt his fever, like another sweltering August day, burning inside of him.

One place John and I counted on seeing each other was at the annual OutWrite conference, a gathering of queer writers, editors, and readers. The conference of 1993 was our last chance to solicit manuscripts for our book, so we had several work-related meetings. One of these took place in the main lobby of the Boston hotel that opened its endless rooms to the almost two thousand OutWrite participants who poured out over its corridors and coffee shops. A favorite gathering spot was a small bar and lounge on a raised platform in the bustling lobby. Here I joined John, who was seated in the center of a small couch; on either side of him were men, some young, some not, some California suntanned, some New York weary. I joined this circle and, for a short time, shared in what was John's world. The talk was about the previous evening's party for John's new *Flesh and the Word* anthology and the erotic adventures that flowed from it. The men teased each other, encouraged each other, and made promises to stay in touch. Even though the men

were speaking to each other, they all sat half-turned to John, who from time to time told them a story about a man he had made love to there . . . here . . . His voice hoarse and weary, he spoke again about the traveling salesman who had inaugurated him into the power and joy of sex many years ago, close by to the very hotel in which we were now sitting. In my younger years, I would have been uncomfortable in this setting, lost in my difference, but now in my mid-fifties, secure in that very difference, I was content to listen to the stories, the erotic gossip that was laced with love. I soon understood that the men were paying their homage to John, that they were thanking him for years of writing about and work for the gay male body and its travels.

Later that same day at OutWrite, a small group of us squeezed in a trip to the park that bordered the hotel so that a photographer could take publicity photos of John and me. Huddled against the November wind, John and I positioned ourselves on a bench, trying to find poses with which we both felt comfortable. Finally I gave up trying to find the pose that would not call up stereotypical male-female images and just let my body find its own position. I knew I wanted to hold John, for my own self, and so I raised myself up and held his head against my breast. Immediately, I became aware of his fever, of the heat emanating from his body. Several months later when I saw the finished photos, I was struck by how our hands had found a way to hold on to each other's bodies.

Back in my hotel room that night, I wondered at how John Preston, New England gay man, and Joan Nestle, Bronx fem Jew, had ended up on that Boston bench together. Our need to write about sex, to have sex, our long histories of community struggle, our delight in the published word, even the growing frailty of our own bodies had drawn us into each other's worlds.

I do not fool myself into thinking that I knew John Preston well; I did not. I do not fool myself into thinking I was one of the public personas, like Anne Rice, on whose support and style he thrived. I was not. But we had traveled some roads together. He, like me, had insisted that flesh could find its words, and he insisted on giving his readers the sweetness of palpable desire.

Denver, Colorado
December 12, 1964

My darling, my darling Bob:
Your magnificent letter! I kissed it and tried to think how I could convey in words the love I feel for you. There is no way I can tell you how much I need you in my life—don't ever step out of it.

Who Were We to Do Such a Thing?

In Memory of Allan Bérubé, 1946–2007

In Memory of Georgia Brooks, 1943–2013

> *[The colonized] draws less and less from [her] past. The colonizer never even recognized that they had one; everyone knows that the commoner whose origins are unknown has no history. Let us ask the colonizer [herself]: who are [her] folk heroes, [her] great popular leaders, [her] sages? At most, [she] may be able to give us a few names, in complete disorder, and fewer and fewer as one goes down the generations. The colonized seems condemned to lose [her] memory.*
>
> —Albert Memmi, *The Colonizer and the Colonized*, 1957 (female pronouns mine)

> *We had rituals too, back in the old days, rituals born out of our lesbian time and place, the geography of the fifties. The Sea Colony [a working-class lesbian bar in New York City] was a world of ritual display—deep dances of lesbian want, lesbian adventuring, lesbian bonding. We who lived there knew the steps. . . . But the most searing reminder of our colonized world was the bathroom line. Now I know it stands for all the pain and glory of my time, and I carry that line and the women who endured it deep within me. Because we were labeled deviants, our bathroom habits had to be watched. Only one woman at a time was allowed into the toilet*

because we could not be trusted. Thus the toilet line was born, a twisting horizon of lesbian women waiting for permission to urinate, to shit.

The line flowed past the far wall, past the bar, the front room tables, and reached into the back room. Guarding the entrance to the toilet was a short, square, handsome butch woman, the same every night, whose job it was to twist around her hand our allotted amount of toilet paper. She was us, an obscenity, doing the man's tricks so we could breathe. The line awaited us every night, and we developed a line act. We joked, we cruised, we commented on the length of time one of us took, we made special appeals to allow hot-and-heavy lovers in together, knowing full well that our lady would not permit it. I stood, a fem, loving the women on either side of me, loving my comrades for their stance, the hair hitting the collar, the thrown-out hip, the hand encircling the beer can. Our eyes played the line, subtle touches, gentle shyness weaved under the blaring jokes, the jukebox tunes, the surveillance. We lived on that line: restricted and judged, we took deep breaths and played.

But buried deep in our endurance was our fury. That line was practice and theory seared into one. We wove our freedoms, our culture, around their obstacles of hatred, but we also paid our price. Every time I took the fistful of toilet paper, I swore eventual liberation. It would be, however, liberation with a memory.

—From "The Bathroom Line" in *A Restricted Country*, 1987

I have been lucky enough in my own life to have participated in the beginning moments of a people's movement from private history to public discourse. I remember the early meetings in Boston, Manhattan, Maine, San Francisco, and Toronto, where a handful of men and women gathered to share their discoveries and to agonize over how to find the money to continue their work, how best to share

*these discoveries with the communities they were documenting, and
how to balance the need for anonymity—a survival tactic of our
people for so long—against the delight of revelation. I remember the
flickering slide shows, capturing the lost faces and communal streets
of other gay times, and the stunned recognition of audiences who
were meeting for the first time with their own public story. In those
days, we were not always sure that this fledgling idea of lesbian and
gay history would find a home in the world . . .*

—From the Introduction to *A Fragile Union*, 1998

Wars pound at my heart as I write this, images of lifeless
Palestinian children being dug out of ruins, other bodies
held hostage in farmer's fields, extreme nationalistic movements
carving out who will survive and who will be driven into exile
and the smug weapons-dealing power brokers reaping billions
while pretending to be sad at the state of the world—always the
push of unsettled histories, unresolved inequities. This uneasy
terrain of invasion, diminution, and attempted erasure has been
my background for all the conscious years of my life, let us say
from 1950 until now, a time parallel with my queer fem coming
out into the working-class butch-fem bars of New York City
and, in 1974, the co-founding of the Lesbian Herstory Archives,
born at the juncture of gay liberation and the women's liberation
movement.

I know how to live in the shifting terrain of the mar-
gin, for there we knew more than the intruders, but I
move very cautiously into the new territory that is being
offered. Perhaps younger women will feel more at ease,
more trusting of this new place, but they will not have the
same memories, the same fears of betrayal, the same sense
of comrades left at the border who could not cross over.
How do I remain true to Maria, the bartender from Bar-

celona, who protected me from police entrapment in the early 1960s or to Rachel, the lesbian whore who lay in my arms dreaming of a kinder world, or the butch women I saw stripped by the police in front of their lovers? These actions happened in marginal places, the reserves on which we were allowed to touch or dance or strut until someone decided enough of these freaks and took our fragile freedoms away. But this old country, as James Baldwin called his historical ghetto—the Jim Crow–ridden American South—is a complex and paradoxical place. I never want my lesbian daughters to find each other in bars where police brutality is rampant, to dance in a public place where a bouncer measures the distance between the partners to make sure no parts of the body are touching. I never want their nipples and clitorises measured by doctors convinced that lesbians were hormonal abnormalities, as was done in the thirties and forties, and yet, while I know that living in the pre-liberation queer ghetto endangered my life, remembering it gives me life.

(From "The Will to Remember: My Journey with the Lesbian Herstory Archives," 1998)

In the last ten years or so, it has been fashionable to show the faults of the liberatory impulse, to see it as a false narrative of beginnings and endings, but as I look over my lesbian queer archiving life, I can see how deeply the sense of what Didier Eribon called the daily insult to the gay self—I would add, the working-class gay woman's self—propelled my involvement in the project called LHA. Throughout the late fifties and sixties we had taken to the streets to question the House Un-American Activities Committee and its punishing of deviant thinking, the brutalities of racial injustice, and the futility of

war. This belief in committed group protest, in the collective power to refuse designated hatreds, this touch between endangered bodies—holding each other against the push of Reagan's mounted police, the feel of Mr. White's hand holding mine as we marched through Selma on the road to Montgomery, the shared water-soaked bandannas held to eyes seared with tear gas as we sat in front of the Pentagon, the push of women's bodies as we packed the streets of New York marching for abortion rights—these grassroots moments of protest and creation were the roots of my archival dreaming. We asked no permissions to announce our desires for change; we had no training except the lessons of life based on racial, gender, and class hierarchies; but living on the borders of the acceptable had shown me the richness of difference, the comradeship of the obscene. It was always the primacy of the endangered body, and then the question, How do you imagine a grassroots site of appreciation for the shamed and the derided, for the defiant and the lustful?

Forty years later, the uniqueness of LHA still stands: its grassroots base, its refusal of governmental funds, its demystifying of the archives profession, its determination to keep *lesbian* as the all-inclusive noun, the collective ownership of its building which functions as a community cultural center, funded through small donations from many, its collective structure where consensus still rules—thus the building, the means of organization, its lesbian-centeredness makes LHA its own kind of artifact. None of us in the founding collective were professionally trained archivists or librarians. Judith Schwarz, who joined us in the late seventies, came the closest—she was a pioneer in the field of records management. None of us taught or attended queer/LGBT studies in traditional universities, but I did attend Jonathan Katz's class in gay history at the Alternative

University in NYC. We were a band of independent "scholars" sharing our work often under the gaze of more professional gatherings like the Berkshire Women's History Conferences or the National Women's Studies gatherings. Sometimes we acted like the working-class kids we were. I remember one particular beautiful summer night on the campus of Smith, or it could have been Bryn Mawr, Madeline Davis and I decided to strip and plunge into the lake that so beautifully framed the campus. We had waded far offshore when our landed buddies started telling us to get out, but their shouts were drowned out by the roar of campus-security vehicles screeching to a halt on the shore, and in no time at all, Madeline and I, large women both, were bathed in a merciless spotlight and called to attention by the loudspeakers announcing that we had broken college rules—they kept the light on us for that very long walk back to shore and proper decorum. There were many moons that night.

The 1970s
The Sheer Joy of Collectivity

The apartment turned into a silk-screening factory for our first and only T-shirt with the word *lesbian* in over forty languages, with photographer-artist Morgan Gwenwald directing us, dozens of women working in every nook and cranny, washing lines draped through every room, festooned with T-shirts hanging out to dry. All of us learning a different aspect of the task, the great bustling of bodies in motion, of wonder at what we were creating. Turning inexpensive white cotton T-shirts into an international singing of the word *lesbian* in all its variety.

The Sheer Sexuality of It

Welcoming visitors to a private home that was a people's public space, the seduction of formality into comfort, my fifties' fem self—opening to the stranger, the researcher, the new volunteer, taking them in as I placed bowls of fruit before them, as I piled up the subject files they would need, as I took them on the tour of the archives-apartment, intimate living space transformed for that time into offered sites of desired resources, my bedroom the audio-visual room of the collection, my bed heavy with bodies intent on studying the offered images, the erotics of it all, the fulfilment of want and longing for a touchable past.

The Sheer Grassroots Socialism of It All

Apartment 13A, the biggest living space I had ever had, giving home to my broken mother, my lover, and myself and still room for collective undertaking. Resources shared from purloined office materials; from the salaries of our daily jobs; from the boxes of materials left in front of the door; from the hands of travelers from across the seas who wanted to see this new thing, a Lesbian Archives. The "At-Homes" where lesbian cultural workers presented their creations to overflowing crowds, everything free; sometimes we had to have a second showing with women filling up the 1928 tiled hallway as they waited their turn. The kindness of neighbors in this rent-controlled building on Ninety-Second Street, New York City in the grips of a depression, the well-off not wanting to live above Seventy-Second Street, the city "dirty and filled with danger" as the seventies have been described, "unwanted" people photographed in dark doorways—whores and drug dealers deplored in the right-wing papers—three sex workers lived on the same floor of LHA when we found the

apartment, interracial couples abounded in the building, a safe place for the different, and no one questioned the steady stream of gender-questioning people through the doors of 215. A crack in the economics of a city allowed many grassroots collective undertakings to come to life. Womanbooks on the corner, a constant flow between this pioneering resource and LHA. How marginalities can speak to marginalities, again below the gaze of the Nationally Valued.

The Sheer Generosity of It All

Volunteers flooding the apartment on work nights, after long days of survival work, staying late, filing, talking, planning, welcoming, opening mail, preparing mailings, pasting up exhibits to be loaned, logging in journals, shelving books, Deb Edel always finding more room just when the apartment said no more, and then, after endless hours, out into the night for long subway rides back to Brooklyn, Queens. Keys left downstairs, materials left out on the archival table for researchers' use, the whole apartment theirs, nothing ever taken. I come home from teaching, never knowing who will be in the house, friends made for life. Artists like Joan Jubela bring original works growing out of their lesbian moorings: Jubela crafts a wooden box with two glass doors, a box filled with sports cards—the kind that used to come with sweet pink plastic gum—of her own making, documenting her all-lesbian softball team, a photograph of each player in action and on the back, meticulously hand-printed, are win-loss records and the player's yearly statistics. The cards are nestled into the pocket of a well-worn glove. The artists bring their work, share their skills, always adding to the knowledges we need. The collection grows because of a community's appreciation at being seen,

heard, housed. The interplay between generosities, moments of respite from struggling to survive in the city. From our newsletter, July 1980: "Georgia Brooks, a member of the collective, facilitated a weekly discussion group for Black Lesbians about Black Lesbian culture. Bibliographies and reading material were handed out on a wide range of topics including poetry, short stories, journal writings and individual authors such as Ann Allen Shockley, Audre Lorde, and Lorraine Hansberry. This study group will be repeated this fall and more will be added!"

The Sheer Comradeship of It All

Around the country, gay history projects begin reaching out to each other. Sitting in a circle on the wooden floor in the early days of the San Francisco Lesbian and Gay History Project—listening to Allan Bérubé telling us of his work on passing women in California's Gold Rush years, seeing his groundbreaking work, "She Also Smoked Cigars . . . ," the delight Allan emanated touching us all; Eric Garber's face flushed with excitement as he outlined his thinking about the gay Harlem Renaissance; Maida Tilchen talking about her work with the 1960s paperback covers, again bodies shaped by a kind of mutual lust for the historical knowledges that seemed to be waiting for us just beyond the diurnal; John D'Emilio, Amber Hollibaugh, Gayle Rubin, Estelle Freedman, Martha Vicinus; Judith Schwarz sharing her work on the women of the Heterodoxy Club of New York City in the early twentieth century, a work engaged in after grueling hours of paid labor in the records libraries of legal firms; Pat Gozemba and the men and women of the Boston Lesbian and Gay History Project; the women of the Atlanta Lesbian Feminist Archives, the Philadelphia Lesbian History Project, the New Alexandria Lesbian

Library Project—a community filling in the historical empti-
ness. Sparking off of each other, the wonderful larrikin feeling
that we had as we followed leads, shaped lines of inquiry, met
in other countries, visiting Jonathan Katz in his old West Vil-
lage apartment where his black-and-white, seemingly-always-a-
kitten cat strolled over the shoeboxes filled with thousands of
index cards, the tracking of desire and punishment that would
become *Gay American History*; attending our first workshop on
how to do oral histories, where Deb and I stood with Paula
Grant, Liz Kennedy, and Madeline Davis, our backs leaning
against the hard walls, Liz and Madeline already deep in their
study of the working-class butch-fem community of Buffalo,
New York. Bert Hansen calling us to say on his way home from
work, he had found boxes of file folders with some papers still
in them spilling out into the gutter in front of a Village apart-
ment house, and knowing we always needed folders, he wanted
to bring them over. This was how we found the 1920 love let-
ter written to the labor educator Eleanor Coit, by Alice, the
young woman who so loved her: "This is a 'very quiet' letter,
Eleanor dear, and you won't read it when you are dashing off
somewhere in a hurry, will you—please." Helping each other
without the possessive territoriality that so often marks aca-
demic endeavor. That was to come later, but now we laughed
and worked and wondered at it all. LHA has a photograph
of a group of us, queers all, the sun hitting our faces as we took
a break from the Sex and the State Conference in Toronto.
Before the world of academics and archival professions, there
was Allan Bérubé, his moustache thick and smiling, an inde-
pendent scholar who sang of class, history, and queer desire.
It is his body I see now, in his just-right-fitting blue jeans, his
flannel shirt, and his welcome, the twinkle in his devoted eye.
These people, these projects, were the golden riches of my time.

The sheer womanness of it all, the sheer lesbianism of it all, all the variations of woman and lesbian welcomed.

Again the photographs of this history, so carefully posted now by Saskia Scheffer on LHA's website, so far from the boxy DOS-running computer we started with: a series of heads and upper bodies of women to be found in the work nights, visitors' weekends—twenty, thirty LHA visitors, many previously unknown to each other, all bodies pressed into a momentary intimacy to fit in the camera's frame. I look now from my new geography, so far away from those 13A rooms, at one of these fading group images, looking back at the first decade of LHA, and call out their names as best as I can remember—Mabel Hampton, Pamela, Julia, Sahli, Georgia, Valerie, Judith Schwarz, Linda McKinney, Polly, Alexis, Clare, Nancy, Beth Haskell, Irare, Amy Beth, Sam, Jan Boney, Ruth Pardo, Terry, Sabrina, Deb Edel, Morgan Gwenwald, Saskia, Paula Grant, Arisa Reed, Leni, Teddy, Marcyne, Rikki, Tally, Maxine, Joyce, Lisa, and multitudes more . . . and now new generations taking LHA into another kind of archival imagining. Maxine, Desiree, Flavia, Shawnta, Rachel, Devin, Nicole, Kayleigh . . . and always Deborah Edel.

The Sheer Complexity of It All

LHA was born in my eyes as an anticolonization project, what we called in the 1970s *lesbian separatism*. A cultural, political undertaking to put us back into history, but always in our full complexity. Not in the service of lesbian purity but to provide one place where all who entered were, for that time, lesbians. *Lesbian* becoming the noun that stood for all possibilities of queerness, for all possibilities of deviations. Lesbian sex workers, my comrades from the bars, were in my hands of inclusion. Not

a role-model lesbian history, not an archive of safe stories, always my own undertaking of keeping in the archives the tensions of lesbian difference as we participated in the creation of lesbian-feminist New York culture. This was the one place in my life where I stood for a lesbian-specific world, and even though through the years, some of my queer archiving mates were uncomfortable with this specificity, Jonathan, Bert, Allan, Martin, Seymour, John, our early mates, helped in all the ways they could. In 1992 when LHA was holding a celebration in the Prospect Park pavilion to commemorate the opening of the new building, on a blistering hot day, amidst two hundred women, I looked up to see John Preston coming toward me, two suitcases hanging by his sides, his face bathed in sweat—John in the last months of his struggle with AIDS, and with whom I was doing a book on relationships between gay men and lesbians, had detoured from his train trip back to Boston to be part of the celebration—"I know how much the archives means to you," he said as he bent down and I strained upward for our lips to meet. Here we were, at this moment, the two pornographers as we laughingly said, embracing amidst hundreds of dancing lesbian feminists. I have never forgotten how much it cost John to make that pilgrimage that afternoon. The archives, through its own kind of generosity, brought into my life a multitude of inclusions.

The Sheer Politics of It All

Unfettered by institutional connections, we carried our LHA banner into the streets in support of a larger politic, first in anti-apartheid demonstrations, then in reproductive rights marches, in the Washington march against America's intrusions into Central America—wherever we felt seeing the words "Lesbian Herstory Archives: In Memory of the Voices We Have Lost" would

refuse an absence, would remind others of the hidden history of lesbian activism. No one ever asked us to step out of the line of march. The sheer politics of refusing to have a board of directors or a letterhead with "famous" names, our search to find a social justice bank that would take a risk with us when after twenty-five years we had outgrown 13A and needed a permanent home and the politic of honoring our commitments. The forty-year-long commitment to never allowing lack of money to deprive a woman of access to public LHA events. The politic of never wanting to be a National archives, that shifting thing of Nation, which in its generality hides its specific exiles. Believing in regional lesbian archives that were also community centers, safe spaces for unsafe discussions, always creating cultures of place, believing in the internationality of the lesbian self: "Send us something in the language you make love in." The books standing on the shelves in the alphabetical order of author's first names, to deny the power of patriarchy, we used to say. The archives as artifact.

The Sheer Struggles of It All

To accommodate all the needs of full-time work, then the work of LHA—another full-time job, to rise in the morning and go to bed at night in full view of all that needs to be done. To raise the money to ensure best archival practices, then and still now.

October 5, 1981

The morning when I went to walk Perry before going off to work and found a death threat outside our door on a pile of sex magazines. "To the two female faggots . . . I hate fags of both

sexes and my campaign of terror against you has just begun. You'll be hearing from me again and again and again. [Suggested sex acts for many lines.] Signed jack the ripper, the real one." We made the letter public in *Womannews*; many volunteered to be a protective brigade. We and the collection survived.

August 13, 2014

Trying to finish this written journey before we head off on our exhausting necessary trips, back to New York for LHA's for-tieth- anniversary celebration, to see dear friends separated from me now by continents, by twenty-three hours of flying, by an aging body.

There is no end to my thoughts about Lesbian queer ar-chiving, though. No end to the LHA, but new questions, new uncertainties about what we thought it all meant and what the future seems to be about. When Daniel Marshall, an Australian friend and queer archivist, visited the other day, I said to him that in the past we were worried about exclusion from history, and now I worry about inclusion—as more and more gay peo-ple turn to the right, as we are welcomed into the national fold, as we are no longer the unwanted deviant but are now courted for our votes, for our domesticities, for our support of national agendas of security—I am speaking in the American context, but in Europe, the coalitions between gay- and migrant-hating have grown stronger. I have read the phrase, the activist archives, used to describe our projects of reclamation, the archives as a partner in the liberation of a people. But some of the most im-portant collections in the LHA for me are the documents of our failures, of our own exclusions, of the complex face of gender and sexual differences. Queer archives of the future perhaps will give evidence that it is harder to live with a history than without

one by giving us the traceable arc of the public choices made, the markings of whom we left at the border, the futility of thinking such words as *Lesbian* or *man* or *woman* have fixed meanings.

The archiving that calls to me now, and perhaps always did, is the archiving of dissent. Times of war call for unified fronts, and this is an endless time of war, an endless time of the policing of the borders. The Lesbian queer archives must be a border crossing in all directions. I am saying good-bye now, this seventy-four-year- old Jewish working-class fem Lesbian-feminist who once helped bring a Lesbian archive into being and who is now the archived. What did my over forty years of work with LHA teach me—to question orthodoxies, the Nation's and within our own communities; to refuse allotted places; to move into unknown waters with comrades on either side; to take on huge statements of No; to collectively say Yes to previously unthought-of equities; to take pleasure in new decipherings of old conversations; to compose homes in exile; to find the songs of the exiled who perhaps need another kind of body; to keep alive the markings of the disappeared.

From My Haifa journal, May 2007

Hannah and Dalia, our friends in Haifa, made us see with their eyes, and so we saw through the landscapes to deeper histories. When we first travelled the roads between Tel Aviv and Haifa, our eyes fell off the scrub hills, but Hannah asked us to look again. "See those prickly pear cacti" and she slowed the car down so we could focus our gaze. "Every time you see a cluster of them, you are looking at the ruins of a Palestinian home. The farmers used the plants to form natural corrals for their grazing animals and also ate the fruit born at the tip of the rounded leaf." We started to look deeper, longer, and soon we

could see the tracings of another people, a recently displaced people. Stone foundations started to appear, buried in the living scrub. May you all have friends—and archives—that make you see again.

Written on the unceded land of the Wurundjeri people of the Kulin Nations, in Naarm/Melbourne, Australia.

Sex

Esther's Story

I had heard of Esther. She was tough, a passing woman whose lover was a prostitute. [1] Sea Colony talk. We all knew stories about each other, but like huge ice floes, we could occupy the same ocean without touching. This night we touched. She was sitting at the bar speaking a soft Spanish to Maria, the bartender from Barcelona. Amidst the noise and smoke, Esther sat straight and still, a small slim woman who dressed butch. Her profile was severe, gray hair rising from her forehead and waving back in the classic DA style. A small mole broke the tautness of her face. I do not remember how our contact began, but at some point I was standing between her legs as she sat with the lights of the bar at her back. Her knees jutted out around me, and I worried that I could not hold her attention. I was not sure I wanted to. We were wary of each other, but an erotic need had flashed between us, and neither of us would let it go.

Later that night she offered to take me home. We agreed to go for a drive first. The night was dark, and Esther drove with ease, one hand on the wheel, the other holding her endless cigarette. She told me how she had left Ponce, Puerto Rico,

1 The word *passing* is used here to represent a lesbian who looked like a man to the straight world. She wore men's clothes and worked at what was considered a man's job, such as driving a taxi or clerking in a stockroom. Language here is inadequate, however. Neither *passing* nor *transvestitism* explains the experience of the passing woman. Only she can.

her grown sons, and her merchant-sailor husband to come to America to live like she wanted. Her family had cursed her, and she had built a new family here in New York. Her life was hard. Her girlfriend gave her a lot of trouble; they both had struggled with drugs, but life was getting better now. She enjoyed driving the taxi, and because her customers thought she was a man, they never bothered her. I looked at her, at the woman in a neat white shirt and gray pants, and wondered how her passengers could be so deceived. It was our womanness that rode with us in the car, that filled the night with tense possibilities.

Our ride ended in a vast parking lot at Jones Beach. Spotted around the lot were other cars, far enough away from each other so that lovers could have privacy. We sat in silence for a while, with Esther's cigarette a sharp red circle moving in the car's darkness. She put out the light and turned towards me. I leaned into her, fearing her knowledge, her toughness—and then I realized her hands were trembling. Through my blouse, I could feel her hands like butterflies shaking with respect and need. Younger lovers had been harder, more toughened with the joy of touch, but my passing woman trembled with her gentleness. I opened to her, wanting to wrap my fuller body around her leanness. She was pared down for battle, but in the privacy of our passion she was soft and careful. We kissed for a long time. I pressed my breasts hard into her, wanting her to know that even though I was young, I knew the strength of our need, that I was swollen with it. Finally she pulled away, and we started the long drive home. She asked me if she could spend the night. I said no, because I had to get up to go to work in a couple of hours and because I could no longer balance my need for Esther and the fear that I was beginning something I could not control. She said she would call. She told me later that I was the first woman who had said no to her. She said it

with admiration, and I felt dishonest. It was not fem purity that kept me from her that night.

A few weeks passed, and I was sitting in the back room of the Sea Colony waiting for Vicki to return from cruising in the front room. A 7-and-7 appeared on the table. "Compliments of her," the waitress said, gesturing to the corner. I turned to see Esther smile, constrained but amused. Later in the night, when all things were foggier, I heard a whisper in my ear: "You will be mine." I just saw the shadow of her face before she disappeared.

She called not long after, and I invited her to dinner. I knew I was testing my boundaries, and I think she was, too. I was a young fem seeking the response of women I adored, needing their desire deep inside of me. I had brought several women home to my railroad apartment on East Ninth Street, but usually I was in control: I was sexually more expressive and on my own territory. From the first with Esther, I knew it would be different. I was twenty, and she was forty-five. I was out only two years, and she had already lived lifetimes as a freak. Her sexuality was a world of developed caring, and she had paid a dear price for daring to be as clearly defined as she was.

The day of our dinner dragged at work. I knew I would not have time to change from work clothes and cook dinner before she arrived. At least that was my excuse for staying in my heels, nylons, and dress. But the deeper reason was that I wanted her to see my competent fem self, self-supporting and sturdy, and then I wanted her to reach under my dress, to penetrate the disguise I wore in a world that saw me as having no sexuality because I had neither boyfriend nor husband.

I bought a steak and mushrooms on the way home, prepared a big salad, and set the oval table in the third room, the combined living and bedroom. This was a scene I had prepared many times

before, my foreplay of giving. Each time I had felt fear and pride that two women could dare each other so. At seven-thirty she knocked. I opened the door breathlessly, as if I had run a long way. She walked past me and stood in the center of the living room, looking around, while I explained that I had not had time to change. She was wearing a white-on-white shirt with ruffles down the front, sharply creased black pants, and loafers. Her slimness shone clean and sharp. All of a sudden I felt everything in the apartment was too big: I was too big, and the table was too full, my need was too big. Esther stood quietly, looking at the set table filled with my offerings.

"Can't I do something for you, please," she said. She examined the old apartment until she found a chair that needed repairing. "I'll fix that for you."

"No, no, please, you don't have to."

"I want to."

She left and returned in a few minutes with some tools. She turned the chair upside down and repaired it. Only then would she allow herself to sit at my table. "So much food." We both ate very little, weighed down by the erotic tension in the room.

After dinner I asked if she would mind if I took a bath. Ever since I had started working at age thirteen, I had felt a need to break the workday from my own time by taking a bath. The hot water marked the border between my world and theirs. Tonight there was another reason as well. I knew we were going to make love, and I wanted to be clean for her. Since my tub was in the kitchen and there were no doors between the rooms, it meant she could watch as I bathed. But she did not. When I finished, I put on a robe and went to sit next to her. Joan Baez played on the phonograph, and we spoke half in English, half in Spanish about our lives. She asked me about my job, school; I asked her about her girlfriend, driving the taxi.

The room was dark. We always met in darkness, it seemed. I knew that soon she would touch me, and I was already wet with wanting her. Here, now, on the bed all the offerings would be tested. We both had power in our hands. She could turn from me and leave me with my wetness, my need—a vulnerability and a burden. I could close up, turn away from her caring and her expertise. But neither happened. With extreme tenderness she laid me down. We kissed for a few minutes, and soon her hands knew I was not afraid. She smiled above me. "I know why you took that bath, to be clean for me." We began caring but demanding lovemaking. As I rose to her, she said, "*Dámelo, Juanita, dámelo.*" I strained to give to her, to pour my wetness in gratitude upon her hands and lips. But another part of me was not moving. I was trying so hard to be good for her, to respond equally to her fullness of giving, that I could not come. She reached for pillows and put them under my hips. My legs opened wider. I held Esther's head in my hands as her tongue and fingers took my wetness and my need. I had never felt so beautiful. She reached deep into me, past the place of coming, into the center of my womanness. But I could do no more. I put my hand over her lips and drew her up along my body.

"Please, no more. It feels wonderful, and you have given me deep, deep pleasure."

"Come home with me, I have things that will help."

I knew she meant a dildo, and I wanted her to know it was not a lack of skill or excitement that was stopping me. It was her forty years of wisdom, her seriousness, her commitment to herself, and now her promising to me, that scared me. She lay still beside me; only her slenderness made lying on that small bed possible. I turned to touch her, but she took my hand away from her breast. "Be a good girl," she said. I knew I would have to work many months before Esther would allow me to find her

wetness as she had found mine. The words, the language of my people, floated through my head—*untouchable, stone butch*. Yet it was Esther who lay beside me, a woman who trembled when she held me. Before she left, she told me if I ever needed to reach her, in the afternoons she was next door, sitting with an old woman, *una vieja*, a woman she had known for years who was now alone. She gave me the woman's number.

The next day was Saturday, and I spent the morning worrying about what I had done, my failure to perform. One-night stands are not simple events: sometimes in that risk-taking a world is born. I was washing my hair in the sink when I heard a knock at the door. Expecting a friend, I draped the towel around my naked shoulders and opened the door to an astonished delivery man. He thrust a long white box toward me as he turned his head. I took the box and closed the door. I had never had a messenger bring me a gift before. Twelve red roses lay elegantly wrapped in white tissue paper, a small square card snuggled between the stems:

Gracias, por todo anoche,
De quien te puede amor profundamente
Y con sinceridad

Esther

For one moment the Lower East Side was transformed for me: unheard-of elegance, a touch of silk had entered my life. Esther's final gift. We never shared another night together. Sometimes I would be walking to work and would hear the beeping of a horn. There would be Esther rounding the corner in her cab, with her passenger who thought she was a man.

On Rereading "Esther's Story"

I turned to touch her, but she took my hand away from her breast. "Be a good girl," she said. . . . The words, the language of my people, floated through my head—untouchable, stone butch. . . .

Whenever I am applauded for having given over so much of my personal living space to house the Lesbian Herstory Archives in the first twenty years of its life, I answer quite truthfully that the Archives has given me more than I ever gave it. In periods of illness, it provided endless small tasks that kept me stimulated and productive; the constant stream of materials kept me current in a complex cultural discussion; and I found long-lasting friends among the many women who came to my home on a search for information or for self. One of the results of this constant interplay between my private life and a river of news and personalities was that I became comfortable with shifting perspectives; in fact, it almost seemed a given that whenever I was sure I knew the only answer to something, someone or some text would force me to rethink or pull back from a sweeping generalization to arrive at a very specific particular. I thought I would lose all these gifts when the Archives, like a daughter come of age, moved from my home to its own. But I was wrong.

In its four-year life in the Park Slope section of Brooklyn, the Archives has made new friends, two of whom are Chelsea Elisa-

beth Goodwin and her lover, Rusty Mae Moore, both transgender women. I had spoken to Chelsea several times on the phone about transgender issues, and she had sent me copies of several position papers she had written on the transgender struggle for civil rights recognition. I knew that Chelsea had been volunteering at the Archives for some months, but I had not yet met her. Then one day, when I was giving a tour of the Archives, I led my small group up to the second floor, where all the mail is processed. There, bending over the long table filled with newly arrived newsletters, was a very tall, very thin butch woman who turned to greet us. "Hi, I'm Chelsea," she said with a quick turn of her head.

"Finally, we meet," I said, both curious and moved, as I often am when I see a new volunteer giving up her time to do the often-tedious work the Archives demands. As far as I knew, Chelsea was the first transgender woman to work with the Archives, and I knew she must have felt some trepidation about how she would be welcomed. The Archives collective is made up of approximately twenty women who see the world from very different perspectives. While I knew there had been an ongoing discussion about how to define the word *woman*, the collective had sorted itself out and Chelsea's help was greatly appreciated. Before continuing my tour, I thanked her for the material she had sent me and promised we would talk later. We did meet several times more after this first encounter—at speaking events and at Archives open houses. More and more, Chelsea revealed herself to be a courtly and caring lover of women. At one Archives event, she made a stirring speech about how older fem women such as her lover, Rusty, had brought great beauty into her life. At the close of that evening, she took leave of me by kissing the back of my hand. But still I did not know Chelsea, other than by the complexity of her

choices: to be a woman, to love another transgender woman, to identify herself as butch.

Our relationship deepened one hot summer day in the basement of the new Archives. I joined Chelsea at the processing table, and together we waded through the never-ending stacks of periodicals. While we worked, we spoke about sex, about butch-fem relationships, and about the difficulties of organizing a marginalized group. Chelsea spoke as a committed activist who was struggling to keep the transgender-transsexual movement dynamic and inclusive. She told me about her younger days as a street transsexual, when she was schooled in survival by Sylvia Rivera, the sweet, tough queen whose young face had been photographed in front of the Stonewall bar the night of our insurrection in 1969. Left behind by the mainstream respectable gay liberation movement, Sylvia now lived with Chelsea and Rusty in their collective trans home around the corner from the Archives.

The light from the naked bulb under which we worked flashed over Chelsea's face, a strong, chiseled face, with thin arching eyebrows and a prominent, bony nose. As she spoke of her days on the street, when she was always running from the police, and her constant search for a place to spend the night, all the years between those gritty times and the present seemed to melt away. I listened not only to her words but to the turn of her head, the softness of her demeanor, the passion of her vision. Here I was in my late fifties, witnessing once again the power of memory to inform conviction, the conviction of one's right to survive. Still haunted by the realities of street life, Chelsea had asked not to be left alone at the Archives in case the police showed up, as they sometimes did when some door or window left open triggered our building alarm. Chelsea's words poured into the steamy basement, demanding that room be made for another layer of lesbian history.

Before the heat drove us upstairs, I responded to Chelsea's concerns about how best to serve a growing movement for liberation with memories of some of my own struggles with the early spokeswomen of the lesbian-feminist movement, my anger at their disdain for the bar community that had given me my first lessons in queer defiance, my fears about the exclusions deemed necessary when a political passion calls for a united front. Feeling like a veteran of a half-won war, I urged Chelsea to learn from our mistakes as well as from our victories. "You have a chance to do things differently," I remember saying. Behind those words was my conviction that if we had done things differently as lesbian-feminist women, as a gay liberation movement in the thirty years since Stonewall, Chelsea and her comrades would not have to be fighting for their most basic rights in the 1990s. But we had been so sure then that we knew who was a "woman" and who a "man," what gender meant and what it did not, what embarrassed us and what made us feel, in our own peculiar way, at home. It is one of the complex ironies of liberation movements that often the passion of their certainties creates the need for future, more inclusive visions of emancipation.

My final words to Chelsea that afternoon were to urge her to call me if I could ever be of any help to her.

In August of that summer, 1997, Chelsea took me up on my vague offer. She reminded me of the group she and Rusty had organized, the Metropolitan Gender Network, and asked me to fill in for Leslie Feinberg, who was too ill to speak as scheduled on the following Sunday. My first response was to wonder what I could say to a transgender group. What qualified me to appear before this forum? Chelsea listened to my fears and then patiently told me that my writings about butch-fem relationships had helped to open up the discussion of gender representation for many communities. What posed as political and cultural

modesty on my part was really a lack of understanding of the transgender, transfolk community and my fear of moving into their world. I was condescending both to my own work and to the members of the Metropolitan Gender Network. But years of work with the Archives had taught me that when I was frightened of a new forum, that was exactly the time when history would speak to me, both to my head and to my heart.

I spent the next few days thinking about what my text could be. I decided to look over my work in my first book, *A Restricted Country*, to see if I could find a passage that would be a good starting point for discussion. Like a preacher preparing for her Sunday sermon, I searched for my chapter and verse. I found what I was looking for in "Esther's Story," a story I wrote in the 1980s to pay homage to a passing woman whom I had met in the Sea Colony, a 1960s working-class lesbian bar in Greenwich Village. Like other pieces in this 1987 book, "Esther's Story" was written (and the events in it re-visioned) from both the perspective of my lesbian feminism and my need to push against lesbian-feminist boundaries of acceptable history. I was determined to keep alive the world of my bar community with its one-night stands and sexually diverse clientele. Esther was a woman in her forties who passed for a man. The story tells of my amazement at her tenderness and describes how her hands shook when she first held me, and how my young woman's body reached out to her for more:

> Through my blouse, I could feel her hands like butterflies shaking with respect and need. Younger lovers had been harder, more toughened with the joy of touch, but my passing woman trembled with her gentleness. I opened to her, wanting to wrap my fuller body around her leanness. She was pared down for battle, but in the

privacy of our passion she was soft and careful. We kissed for a long time. I pressed my breasts hard into her, wanting her to know that even though I was young, I knew the strength of our need, that I was swollen with it.

But when I reread the story, keeping in mind what I had and had not allowed myself to say about Esther's sense of self and gender, I saw clearly (and indeed, I knew this at the time I wrote the story) that I was being simplistic in my description of Esther's desires. I was trying to serve two histories at once. I knew that if I had written "Esther wanted to be a man," the story would have been dismissed and so would Esther and all I wanted for her in the new world of the 1980s. This balancing act led me to cast Esther's "maleness" in a more womanly way. It was as if I were attempting to slide under a descending iron gate and carry all that was important with me to safety before it crashed to the ground.

She told me how she had left Ponce, Puerto Rico, her grown sons, and her merchant sailor husband to come to America to live like she wanted. Her family had cursed her, and she had built a new family here in New York. Her life was hard. Her girlfriend gave her a lot of trouble; they both had struggled with drugs, but life was getting better now. She enjoyed driving the taxi, and because her customers thought she was a man, they never bothered her. I looked at her, at the woman in a neat white shirt and gray pants, and wondered how her passengers could be so deceived. It was our womanness that rode with us in the car, that filled the night with tense possibilities.

Now I must ask myself who was the deceived one. This forced questioning of what we need to be real or true or right holds for me the deepest importance of liberation movements. If I know the dreams of only my own, then I will never understand where my impulse for freedom impinges on another history, where my interpretation of someone's life is weakened by my own limits of language, imagination, or desire. Chelsea's invitation to speak to her group had made me revisit my own text and realize that even when I thought I had been preserving a life, I was perhaps burying it. Esther's story is not finished, and my own understanding of butch and fem, of the drama of gender, of what the mind wants to do with the body and what the body wants to tell the mind, of what societies will do to keep gender certainties in place and of how women will survive all that is both created for them and taken from them, must be constantly challenged by new voices demanding action.

For one moment the lower East Side was transformed for me: unheard-of elegance, a touch of silk had entered my life. Esther's final gift. We never shared another night together. Sometimes I would be walking to work and would hear the beeping of a horn. There would be Esther rounding the corner in her cab, with her passenger who thought she was a man.

A Change of Life

Her hair fell across my face, long brown curls that kept the moonlight from my eyes. I pushed it back and watched the light reclaim her face. "Oh, Joan," she said, but I knew I would soon move from under her, and with my hand wrapped in her hair, I would pull her down under me. I would move on her, waiting for her to beg me enter, and when I did, when I knew what this woman wanted, and when I undertook to give it to her as best I could, I would be answering all the desires I had ever had when I was on my back under the women who moved me.

"After forty, fems turn butch," we would repeat laughingly, young women in the bars. But the transformation seemed so far away, and we stood so hot in our pants, that this prediction was emptied of its cultural wisdom.

Now I am in my mid-forties, and for the first time I hold in my arms a woman who delights in her femininity, whose perfume I seek out, whose lipstick-lined lips make me melt for her, whose full body I want to hold with hands that are strong enough to leave their mark without losing their tenderness. I know her fears; they have been mine. I know her hungers; they have been mine. I know her delights; they have been mine.

Yet she is not me, not what I was or what I am. She is audacious in her femininity, in her flounces and swirls, in her long, tapered fingers and the bows at her neck. She is younger than I by many years, just as the old stories said she would be. I have

become our own mythology. It has happened, a change of life, at least for the time I am with her.

My own body wants to be known only in giving. I want to come on top of her, moving my hips on her body, moving, moving, until I grow large and wet and then explode on her, my wetness pouring out on her thighs, her belly, her cunt hair. I keep my pants on, go bare-chested. I know I am trying to feel like something other than the woman I usually am. I kneel before her and slide my hand up her skirt, parting her legs, finding her hidden warmth. My fingers slip in under the wet panties and I find my home. She sits on the edge of the bed, totally dressed, held by my thumb buried deep in her cunt. I look up at her, watch her changing face as I rock her, push into her until she must fall backward on the bed. I want to be potent for her. At other times, I pleasure her with my dildo. I carefully rub the jelly on its tip while she lies watching me, her breasts spilling out of the negligee I have brought for her. I gently, kindly, spread the cream on the tool of her pleasure. I feel I am being kind to myself as I caress the false cock. No need to hide the word anymore. No need to hide my desires.

Let me be butch for you; I have been a fem for so long. I know what your body is calling for. I know when I turn to you before the sun has broken through the morning sky I will find you wet and open, as if you had been waiting for a lover in a dream. And so it is. When I turn you over in your sleep and spread your legs, I feel your wetness before I enter you. Then you begin to move in deep, deep circles, moving as in a dream where bodies can swim through the air. I will move you from your sleep up through the waves of want. I will be deep inside of you before the sun hits the building tops, and by the time it is glinting off the water towers, I will have brought you to your pleasure. Then I will give you back your sleep again.

I hear the old butches laughing. "I was waiting for when you would become Poppa," Mabel said. "It's about time," she chuckled. Then later in the day, for the first time in our thirty-five-year history, she called me Mr. Nestle.

I look through the years and see the faces of women who have disappeared, women who tried to teach me the ways of our people. I am changing life now, but I travel with the old movements still inside of me. She sometimes thrusts her long fingers into me as I lie on top of her and asks me to move on her, to rock on her fingers, but I fight the tempest in my own hips. I have bucked for many years. I have swirled my hips, I have thrust against woman mountains, and I have moved them, but now I do not want my own movement to change the world. I want hers—her hips to call forth the new order, her surging hips that threaten to throw me off as she takes and mounts her pleasure.

Reach, my love, for all my hands can give, and I will give you more. Reach for all of us who began in our desire to grip the world between our legs, and reach now for me who has changed her form. I hear my elders, scarred and knowing, laughing kindly, saying to me, Come on girl. We welcome you.

A Feeling Comes

I lay quietly, thinking of ways to bear the pain.[1][*] If I kept perfectly still, the terrible aching would become a dull throb, a constant warning of the power of a renewed attack. So much of being ill is a matter of bargains, of negotiations with the seen and unseen in an endless attempt to appease the spirit of the illness and gain the kindness of strangers.

For many years, I had lived in a world of whispered prayers, heard only by me, trying to ward off further humiliations of the body. I knew I could always take the painkillers waiting on the overloaded night table. Surrounded by books and glasses of water, the little bottle carried the promise of the dissolution of feeling and thought. It beckoned me to a climate where a soft fog dominated the landscape. I had already spent two days, flat on my back, traveling between the mist-shrouded peace of this land and the rocky murmurings of pain. I now chose to decline its passport.

Tonight I was lucky. I was not alone. I could hear Lee preparing something in the kitchen. A few minutes later, she appeared in the doorway, carrying a steaming cup of tea.

"Here, darling. I know you think tea is tinted hot water, but try this."

1 [*] The title is adapted from an Emily Dickinson poem, "After great pain, a formal feeling comes—."

She made room on the nightstand, pushing away the debris of illness, and sat on the edge of the bed.

"I have to go soon, but I hate leaving you this way."

Just the weight of her on my bed gave me hope. I reached out and took her hand. "I'm sorry we did not have more good time together. Our weekends are so precious. I'm so sorry."

I could feel the tears coming, the words of regret for being this burden in her life, but the sight of her, trying so hard to help, stopped my outburst. Instead, I pulled her closer, delighting in her gray eyes, direct and yet struggling to be hopeful, her smaller body, which the world would call boyish even if she was close to fifty. I touched her with my eyes and she smiled, relaxing a little. Encouraged, I began to unbutton her shirt; she held perfectly still while I uncovered the swell of her breasts. I let her sit there, just like that, in the still room for a long moment. Then she laughed and returned my challenge by throwing back the cover and teasing my nipples so even the flannel nightgown could not contain my excitement. I took her hand, which had given me so much delight in our time together, and brought it to my mouth, running the back of it over my lips, tracing its veins with my tongue. All the while, we were, with our eyes, giving permissions and wondering how far we could go. I let go of bargains and prayers. I no longer feared the pain.

"I want to make love before you go . . . Don't say no, I want to take back part of what we have lost."

"But can we?" Lee questioned, even as I pushed her off the bed. Very carefully, keeping my head and back straight as I could, I left the bed and walked toward the closet. Hanging on an outside hook was my black nightgown, the one that excited Lee the most because its lace panels exposed just enough to make her want more. I left her standing next to the bed and I marched out of the room.

Dressed for desire, I stood before my lover, who was once again sitting on the edge of the bed, her head bowed.

"Darling, here, I am here."

I lifted her head up and stroked back her hair. Lee moved her face into my breasts, then into my belly. She wrapped her arms around me and pushed me forward so her tongue could push through the lace. For a minute, the pain sprang up, lashing its tail, but my belly swelled with want, and I refused to turn back. Lee reached for my breasts, teasing my nipples until they made their own way through the labyrinth of lace. With closed eyes, she moved from nipple to nipple, sucking them into her mouth, her tongue rolling them over and over. I heard her sighs and felt her strength; I soon had to pull away.

"Honey, are you okay?" she breathed into my belly.

"I will show you how well I am doing," I said in that playfully serious way we had that signaled I was going to deliver an erotic order. "I am going to lie down and you are going to sit on my face so I can taste you."

For a minute Lee looked concerned, and then she realized that I had found a way to accommodate both pain and pleasure. She stood up and I lay back down on the bed, a bed made different by our touch. I spread myself out for her, fanning the gown around me. My hips recognized the change first and began to ride the bed, very slowly but very surely. My thighs, which had been so heavy in the flannel, woke to their power. I lifted one leg so Lee could see my want.

"Come closer," I commanded, and when she did, I reached out and began to unzip her dungarees, stopping from time to time to push my hand against her. Lee took this for as long as she could and then pushed my hand away and stepped out of her pants.

For one moment, she stood there, looking down at me, her belly bare, her sex lips clearly visible through her hair, and then she straddled me, but still careful, keeping her weight on her knees. She bent to kiss me, and I grabbed her tongue with my need, my hands caught on her arms. Finally, she lowered herself onto my belly and I could feel her sex on me, warming my body. I gently moved under her, rocking her against me, letting her ride each wave. Her breath came more quickly, and I curved my body upward, pushing against the pain, pushing for her, moving her up to my lips. She reached behind me, putting a small pillow under my head so I did not have to strain to taste her. Using the wall as her brace, she lowered herself onto my lips.

All was dark in the room now, but caught between her thighs, I found bright worlds of taste and smell. In gratitude, I reached up and grasped her breasts, which were hanging over me like small fruits. From far off I heard her moans, but closer I heard the roar of waters. I reached my tongue farther into her, finding such multitudes of taste and texture, sweetness and salt, curves and walls, hair sharp and flesh rounded and wet, that I could not stop my travels. All of her was poised on my mouth, a world of a woman held on my tongue, and I was rolling pleasure into her. Soon, too soon, she threw back her head and shouted.

Silence returned to us, and as I opened my eyes and she lifted off me, I could see my pain advancing toward us—its head bowed in tribute.

Taking Rita Hayworth in My Mouth

I sit on the edge of a couch in a dark room, the dark is the dark of night. This nearly empty apartment on the edge of the Village is lit only by the streetlights of Soho and the red-and-green rivers of late-night traffic. Muffled sounds of a summer city night float into the room. I am a person waiting for something, waiting in near darkness, sitting on the edge of my seat. I am a customer awaiting the appearance of a dream I had ordered. She is in the other room, getting ready to make her entrance. It is a rare thing in life to be able to call into being the haunting mysteries that have followed one since childhood. If I tell you I am almost sixty when this night dawns, this night of apparitions, will it make it harder to hear what follows? An aging woman waiting at the edge of her seat for the dream only another woman can give her.

I smell her perfume before I see her. She comes out of the darkness, and I turn my gaze from the direction of the windows to take her in, her steady even progress towards me. Her red hair falls down around her shoulders, her face is marked by the redness of her lips, the hard blue-gray brightness of her eyes; she has the worldly look of a woman who has seen it all. A slight smile plays around the edges of her large mouth. Her broad shoulders push the darkness open. I hear nothing now but the sound of her approach. She stands before me for a minute, a tall broad woman in a black blouse opened at the throat so her breasts swell above me, a short leopard-printed skirt rides

high on her thighs, all done to my order. "Is this what you wanted," she says, half amused, confident that this is exactly what I wanted. I cannot take my eyes off her face, off the world of work and experience she is radiating in the darkness. I see again, as I did as a child, my mother dressed for work and, at the same time, dressed for her lovers. My mother in that erotic blend of self-support and desire on the prowl, her costume, the black dress, the small hat with its veil of stars, the nylons with their seams down the center of her legs. I watched her dress, saw her raise her arms before the mirror; that mix of pain and pleasure comes to my mouth, her beauty, her leaving.

I cannot drop my eyes from my dream's face, I do not want to. She sits in the chair we have placed right in front of me, a few inches from the end of the couch. Still smiling, she raises one leg and tucks her toes under the sofa's pillow. Her skirt is now a band around her lap and she sits, waiting for me to drop my eyes. She grows larger in the darkness, in her solid angular position waiting for me to do what I must, what I have waited all these years to do. I am hardly breathing and I have lost all sense of what sex I am. The dark night has become illuminated by the power of myth, the power of legend. "Go ahead," she encourages. My breath escapes me and I lower my head, taking my eyes from her large strong face with its worldly cool welcome to what she is exposing to my view. It is only a small distance to travel but I am terrified of the journey.

Right in front of me now, I see a second face, with its red lips flaring in a nest of hair, drops of liquid caught in its strands, its own perfume opening up to me, right in front of me, the naked center of a woman. I raise my eyes once again to the public face, and I reel with the contrast. I cannot keep the two faces in the same place, on the same body. It is as if I am being allowed to see below the surface of all the days, of all the mothers. I almost

plead with her, *Don't let me go under again*, but she says nothing, just watches. I feel the pull of her other face and give in to its ancient world. I let go of all pretense and gaze totally at the sex right before my eyes, smell it, hunger for it. And then, I fall to my knees, onto the pillow we have arranged in just the right place to catch my weight, before this gleaming mask that is as real as hair and bone and flesh can be. I push my face into the one between her legs, my mouth as wide as a whale's, my tongue pulling all of this dream into me, I swallow, I hunger, I drink, I eat. She allows it all, giving herself to my relentless hunger, to this beggar on her knees. My tongue swirls, finding hidden passageways, pushing at the confines of her wet red walls. I am nothing but this exploration, kept from me by so many years, by so many laws. Above, I feel tremors and know that in some other place, the country has shifted. Somewhere on what remains of the surface, I know she is coming, I have sucked pleasure into her, but that is part of the more common world, the one I have known for all the past years. Where I am now is somewhere else, somewhere beyond gender, in the labyrinth of myth and legend, where mothers are falling stars and shame sprouts wings.

My Cancer Travels

1.

January 15, 1997

I haven't been able to write a word since I was told I have colon cancer: all of it—the bleeding, the tests, the operation, the chemo, the fissure that will not heal, and the doctors who did everything so fast and did not listen to me—all now embody everything I detest, including my own body. Embody. I embody disease and disavowal, blood and shit and a body bound in pain. Everything tastes like acid now, like car batteries in my mouth. If ever words could bring me life, and they have, please please do it now.

A memory: Bayside, Queens, 1952, in the housing development. My twelve-year-old body covered in welts, huge red platelets signifying the body's anger with penicillin. My mother had to go to work. I had pleaded with her to call a doctor, never a child's desire, but we didn't have the money and she didn't have the time. That morning when she saw the welts, she must have known that I needed help. She went to work, but the doctor did come. Did I call the doctor? Did my mother, from the confines of her bookkeeper's office? Have I softened the memory of her neglect? The young doctor came into our disheveled apartment. "Where is your mother? Does she often leave you like this?" he asked as he poured baking powder into the bathtub, helping me lower my tormented body into the cooling bath. "You could have died from this." After the bath, he took me back to my bed

and covered the sheets with the same cooling powder. Perhaps he gave me medication to counter my body's anger—I do not remember—but he gave me concern and relief, he gave me care. Another history we have: the history of those who have cared for our bodies.

January 23, 1997

Riverside Park on an early evening in January, the night growing colder by the moment, walking Perry on the adventure I had promised him and me—the curve of the bowl running deep down to the playground—just a shadowy empty town now—the old trees surrounding us. We walk up to the plaza in front of the Civil War Memorial—always a special place for me, the prow of a ship with a tattered flag whipping in the wind, the stone steps leading up to the marble mausoleum, the frozen-in-stone cannonballs passed along the way. I would sit on those steps on summer afternoons with Denver, her big body against me, her shaggy head turned straight ahead—she was the captain of my ship. Always I have adventured in little places, but the glow of freedom, Denver off her leash, Perry running free in the marbled night air, choosing to sit with me, to return to my side—these were wonders. Now, tonight, I give this walk as my gift; for a minute Perry and I are adventurers in the night, the plaza all ours, a lesbian and her dog, a woman with cancer and her dog, the flag of no country straining in the wind, clinking its tether against the masthead of a pole. Soon the cold seeps through my coat, and I turn us toward home. As we walk farther from the park, the night growing darker, I am walking further and further away from all I love.

I hate what is happening to me; I hate the pain, the numbness, the nausea, the cold, the chemo pills waiting for me like small bombs in the Duane Reade bag. I hate it all.

February 23, 1997

"Cancer cells are immortal," said the article in the *New York Times*. "They grow forever in the laboratory." I sit looking at these words. I and so many others are host to this indomitable life force, a cellular surge to move ahead, leaving us fragile in its wake. Every Tuesday night I go to a Cancer Care support group, my CR group of the '90s, made up of seven women, none of whom are immortal. We come with our bodies scarred by surgeries and treatments, by insertions and removals, we come to tell what the week has brought us; some speak of the small loves they do not want to lose, the warmth of sunlight on a face, the excitement of a trip, the taste of food. We talk of night terrors and the loss of lovers. While the cancer cells inside us glory in their dedication to life, we mark our survival by their death. Doctors call it a war; I do not yet know what to call it, this push and pull between a cell's minute and yet endless passion for life and my own organically larger but perhaps not as determined need to live.

When I lay on the table, a table so thin I thought my large woman's body would hang over the sides, fear shrank my body. I turned my head, taking it all in. The masked doctors, the swiftly moving nurses, the tanks of gases, the light as total as a sun hanging over me. I spoke to myself, about how final all this was and how brave I was to want to take it all in. Do this, Joan, I said. You who have so often thought you needed someone to take care of you, you who gave over so much of yourself to so many over the years, look hard at everything around you. Do not flinch from anything. I turned and saw a palette on which lay scores of scalpels, all nestling into each other, all sharp and shining with the clarity of their purpose. I did not flinch from their sight. If I can look upon the coldness of knives that will slit my skin and not ask anyone to intercede, I will never again

betray myself. This is the kind of fem you are, I said to myself, and don't ever forget it.

I have always taken delight in the richness of contradictions, but this one gives no pleasure, no surge of intellectual insight or emotional wisdom. I know I am supposed to be a fighter, a warrior against the intruders, but in these early words, I cannot be. I have always wanted to write hope, to inscribe yearnings—the moments when the face turns to the sun.

2.

"I am officially dying," Anita said to me over the phone. The small black box caught the message, but I was lost under the words. I had met Anita in the Cancer Care support group I attended after my own diagnosis and surgery. My last CR group, I thought to myself as I waited with the three other women for our counselor to catch up with us. We met for eight weeks, long enough to know who was dying sooner than the others of us. Anita won the prize. Her breast cancer had metastasized to her brain. She sat, her head wrapped in a dramatic turban, scornfully pointing out to us what novices we were in the cancer journey. A short, edgy woman whose temperament was not improved by her total lack of body hair, her brain-damaged stagger, or her unreturned telephone calls to her doctor, Anita did not court closeness.

Unrepentant optimism did not please Anita either. "Don't give me that 'just a day in the sunshine' bullshit," she would mutter as she carefully picked out the best McDonald's fries from the overflowing grease-stained bag. At the end of her life, Anita developed a passion for junk food. Hamburgers, fries, candy bars. At least I assume this was a newly acquired taste. I knew Anita only at the very end of her life. Because Anita found herself needing a lot of care very quickly, she had to suffer friends

made as quickly as the food she loved to eat. We had immediate intimacy, you could say. I gave a bath to a woman I had not known a month before. I cleaned her kitty box and washed her dishes. I brought my lover over to visit with her, and together we bought her a microwave so her hospice workers could have tea and warmed-up meals. We all had discovered that Anita's stove was as temperamental as she was, blowing up at the mere sight of a match.

Anita Finkel, who could barely walk when I met her, turned out to be a lover of the ballet and professional ice skating. Anita Finkel turned out to be a New York original. Her apartment was made up of one room and a kitchen. Her bed, the only piece of real furniture in her home, faced a large television screen on which she watched *Jeopardy* the way some people go to church. Every night she was on the phone with a gay male friend guessing the questions, holding on to answers. I too came to know the need for rituals that give the semblance of still being involved with daily life—my choice was *Law and Order*.

But it was on her kitchen table that I found the heart of Anita's life: a computer screen and keyboard and to the side, a neatly stacked series of self-printed dance journals. Everything in Anita's apartment had been subordinated to her love of choreography and movement. Cleanliness, space, possessions, family, perhaps lovers—all had been washed away by her devotion to art. Anita Finkel had made herself into a one-woman school of dance criticism, using all the money she eked out of freelance editorial jobs to publish her dance journal. At her funeral service I learned what a gadfly she had been on the backs of the more conventional dance aficionados, but I had discovered the secret myself when I was making her a cup of tea one afternoon and saw her name on the masthead of the small, square newsletter sitting on her gritty kitchen table.

I was learning about this prima donna on the job. Anita sitting perched up on her bed, growing smaller each day no matter how many calories she consumed; Anita telling me as I stayed arm's length away from her cat, Ariadne, whose talons slashed the air with the same ill temper as her owner's, that she had always been terribly vain about her hair, her small feet, the shoes she compulsively bought—the higher the heels, the better. She exemplified her pride in the past by lifting her leg, now thin and cat-scratched, into the air, clearly expecting me to admire the high arch of her instep. I did, tracing its glory with my finger, while I kept an eye out for the cat. Then the shock of her circumstance would hit her and she would collapse back onto her pillows, her voice growing small with disbelief. "How did this happen to me? I'm too young."

Anita was disdainful of her visitors, methodically turning the pages of the *New York Times*, which she could no longer read, and ignoring their presence until she needed a pill or a glass of water. No longer able to reach for these things without help, she would issue her demand keeping her head turned away from her provider as her outstretched hand shook in expectation.

The one visitor she looked at full in the face was a small, round woman with dyed red hair, her Portuguese neighbor Maria, who shared what little she had with Anita, who cajoled her into taking baths and changing her nightgown—by the end, Anita's vanity was rhetorical but still in place—who accompanied her to radiation treatments and to the futile CAT scans that only verified the loss of brain cells to cancer cells. One day I received a frantic call from Maria. "Joan, we are down at the hospital and Anita has no money and I don't either. We have no car fare to come home." I imagined the two of them, the princess and her gypsy companion, dancing in the streets of some forgotten ballet, trying to flee the cold country of the hospital. I met them

at Anita's door and paid the taxi driver. Maria, whom no one thanked at the funeral service, made sure that Anita had something to eat every day. I promised her the microwave "when it was all over," as I euphemistically put it, but one of Anita's fellow dance critics got to it first.

At her memorial service, where I met the public Anita for the first time, I learned that in her closing days she had selected the part of the Bible with which she could live—the Book of Psalms. In the late hours of the night she asked the visiting rabbi to chant their words of adoration and anger, a mixture of beauty and sternness that I can only imagine approached her own aesthetic.

Because of my own cancer, I became part of Anita's dying. And in her dying I learned about her life, a New York life lived in a rent-controlled apartment, filled with an acid-laced dream of swooping grace. She did not approve of her death. "This should not have happened. How did this happen? I am too young," she said to me over and over on the phone until the last time, when half her words were gibberish, and she did not know it.

> Behold you are beautiful, my love;
> Behold, you are beautiful.

3.

She stands, so fresh and open, in the doorway, a gray scarf hung loosely from her muscled neck. Her green winter jacket is already zipped, and in her right hand is a large blue carry-all, bulging with tools. I turn to say goodbye and all time stops. This woman with whom I have shared a decade as lovers. This woman who on her fiftieth birthday ran with dogs over a Maine lake turned to ice, who had slept on spruce boughs with the snow under her, this woman who loved the feel of wood and glass,

bending them into shapes to hold the earth, to catch the light, this woman who walked with poets, holding close to the words of May Swenson, saying them into my sleep so I could see how they spun with meaning.

This woman who sat by my bed in a darkened hospital room, hour after hour, keeping guard. One night in the hazy but impenetrable sleep of drugs, I felt someone tug at my fingers and thought it was the nurse taking my blood, but it was my love gently sliding back onto my finger the ring she had given me ten years ago, before the flood of cells.

This woman who would take me in her arms, lift my whole body up, and settle me back down on a nest of pillows, preparing me for love. This woman who would lower herself on top of me, her weight so good, so full of promise. I held her to me, my fingers gripping her back, so solid with her strength, so hard with her passionate determination to give pleasure, to force desire into sound. Once in the beginning, on a mattress on the floor of her Brooklyn apartment, we made love for eighteen hours. Every time I said there is no more, she proved me wrong. She bought me a rhinestone pin shaped as the number 18, so when I was speaking or reading in a public place, I would remember that private time.

This woman who worked with my words and images of lesbian history, filling a red notebook with the choreography of my presentation, so word and pictured face would carry meaning, who ran me through my lines night after night when I was to play a St. Louis madam in a lesbian play down on Fourth Street, who sat in the darkened theater, performance after performance, trying to will me into remembering.

This woman who worked tirelessly to serve the community she loved, coming home after longer and longer days and nights at endless meetings, fighting for a sick man's apartment or for

a public place we could call home or to educate the police into holding back their hatred or the teachers into talking about us as if we had a history, who hung on the walls of a city office building the first pictured history of our community, this woman who walked away when asked to leave, defeated by a political shift that did not care about her excellence, this woman who wrote a book between physical calamities and worries about a job, who never let go of the possibility of a task completed if she had anything to do with it, this woman who won Mabel's love with her Kansas ways and Friday-night dinners, the table all shiny with candlelight. "Where did you find this one?" Mabel would ask me, winking in the shadows. "You better hold on to her!"

This woman who wondered where my passion went, and waited while I wrote and talked of love, waited for my body to return, and cried with pain, with me, for what had seeped away in the hospital night, in the childhood years.

This woman who tirelessly moved earth and stone, shaping Catskill hardness into Catskill meadow, who sought adventure with a child's delight, who loves the beauty of a woman all in color, this woman who in all her wonders and her gifts laughs in the face of those who say we are less than life, this woman who stayed and stayed and tried and tried to hold on to me, to us, is at the door. I turn to say goodbye, and all time stops.

4.

In February of 1998—a year after my surgery—I was asked to participate in a reading from a new collection of lesbian erotica edited by Karen Tulchinsky, a good sturdy friend from Vancouver, Canada. She had selected my story "A Different Place," a story written in 1986 that celebrated the pleasure of anal fucking. This was my first public appearance as a writer since the cancer, and up to the last minute I did not know if I would be able to

read that story in public. Everyone before me read from their piece that appeared in the collection. When I stepped up to the microphone, I thought I would give it a try, but as I read the opening passages of the story, describing the preparation Jay was going through to be ready to perform anal penetration, I knew that I would stop before the scene of entry. I have colon-rectal cancer and it may kill me; that story overwhelmed the narrative of a night of pleasure in Connecticut over ten years ago. Torn between still wanting to preserve the space I had opened for my audience, the space that allowed women to enjoy all forms of sexual activity, and my own recent need for sexual silence, I chose as gracefully as I could to leave them with the sense of wonderful expectation, the promise that the story would bring them pleasure—but I could not go there with them, I explained, because of my cancer.

This writing about the queer body, this revealing of open thighs and scratched backs, this wet hard use of language is not always an easy thing to do. This mapping of where hands push in, of where mouths suck out, this capturing of sex sounds, of murmurs and moans, of shouts and cries, of yes and more and now and now and please don't stop is not always welcomed in this world. And because the heart follows the mouth and the hand, when I am on my knees before my lover, cupping her ass with my spread fingers, pushing her cock forward into my mouth, my breasts swelling with the weight of all her wonder, I am always surprised by the anger awaiting these words. But something pushes at me to keep finding words for the bend of the back, the thrust of the fist, the woman's cock in my woman's mouth, the taste of her cunt, my breast covered with the wetness of want, legs spread so far apart that countries could enter. And so I wrote of these things, as a fem woman, as a woman who has lain on her back and pushed at her lover's hand for more,

who has helped buckle the leather straps of her lover's harness so desire could shape the air.

My friend John Preston read my words. From long distances over years, he kept a lookout for the assaults; postcards would arrive after some public battle, just a sentence from one pornographer to another. Be strong, my friend, he said. Later, when we spent more time together, I learned as he spoke in his raspy, tired voice that he too was always saying thank you, thank you to the middle-aged salesman who had taken a young man to his hotel room one night and after the stroking and sucking, as their bodies cooled down, had told him never betray your own voice.

It is not easy to open the body to words, to make a life of sex writing. Comrades are needed, friends who understand both the bravado and the yearning, friends who know that even if all your skill is poured into the portrait of the ass raised for entry, you will never be called a writer. Preston, as he signed his letters, stood so tall; he was to me so gallant; he knew that a woman writing about sex was different from a man; but he always wanted more, more challenges to the silences imposed on the body.

My dear pornographer, we had planned so much together, collaborations of erotic wanderings fiercely anchored in clear, direct, seeable language. Now you have traveled ahead; your words of comfort are pieces of a treasure. When once again the body calls for its own language, for its own image of desire, I write sex for John.

This is now my battle: to win back from the specifics of medical treatment—from the outrage of an invaded body where hands I did not know touched parts of myself that I will never see—my own body, my own body so marked by the hands and lips of lovers, now so lonely in its fear. Touch my scar, knead my belly, don't be afraid of my cancer. Enter me the old way, not through the skin cut open, but because I am calling to you

through the movement of my hips, the breath that pleads for your hand to touch the want of me. Heal me because you do not fear me, touch me because you do not fear the future. Cancer and sex. One I have and one I must have.

5.

Like a little girl bringing out a favorite doll, I shouted from the bedroom, "I need to show you something." You, my new friend, were sitting at the dining-room table and turned expectantly toward me when I reappeared. "I need you to see this," I said, holding up my shirt and pulling down the band of my pants so you could see the still-red scar that started at my waist, skirted my belly button, and made its way down to the beginning of my pubic triangle.

I stood in front of you, not clear about why I was doing this, a fifty-seven-year-old woman exhibiting her cancer scar to a new friend. You reached out and traced the path of the incision with your fingers, and I started to cry. Not a little girl anymore, but a woman with colon cancer, a cancer that should have been found when I had the colonoscopy done a year before the tumor grew so large it invaded the surrounding tissue but that a rushed doctor had missed. "I pulled out too quickly," he told me later, after the tumor had broken through the wall of my colon and spilled red blood into the toilet bowl. "Have you cried yet?" he asked me in 1997. It took a year for the tears to come, and they came only when I stood in front of a woman who I wanted to touch me, to make love to me like it used to be.

It will never be like it used to be. Cancer has claimed me; "my cancer," I say now, like others talk about their cars or children. We suggest you have a year of chemo, the doctors said, and I did—or as much of it as I could stand. For that whole year, I did not allow anyone to touch me, except doctors, nurses, techni-

cians. My body was filled with chemicals that sickened me. I sat on the edges of tables in small cubicles, the IV needle precariously housed in my arm, in a small vein on the back of my hand, or anywhere else the oncologist could find a vein large enough and strong enough to absorb the needle and the acid. Sometimes the vein would collapse, and the chemo would start pouring out under my skin. "You are lucky," the doctor said. "This chemo is not as dangerous as some of the others."

And I knew he was right. I was one of the "lucky" ones. I would keep my hair; I avoided a shunt; I only had 500 mg of 5-FU every week with 50 mg of Leucovorin, a form of folic acid, a natural substance that some people want to ingest. I had not been able to take the initial treatment, 5-FU with Ergamisole, a drug used to kill worms in the stomachs of sheep. After two treatments with the little white pills, I did not care if I lived or died.

This is not the story of every cancer patient; it is my own, just like this cancer, this colon-rectal cancer, is my own. Just like this body, now a year and a half after the surgeon removed four feet of colon, my transverse colon, and reattached my intestines in a new configuration, is my own. I need you to know all the details, the scientific names, the side effects, just as I had to learn them. Illness, like sex, gives the body another dimension, makes it transparent. I could feel the chemotherapy liquid enter my veins, trace its burning journey through my arm, just as I used to feel a lover's tongue trail down my neck.

6.

Ten years have passed since I crossed the seas. Ten years of work and play and then so much loss. Now I hold the renewed passport in my hand. All because of you, because you insist on hope, a hope that sings in your upturned phrases, that

sits perched on your backpack sharing its bumpy ride down the streets of Havana, London, Melbourne, New York, Beijing. You make a home in whatever city your work takes you, your true home being the ideas that shape your vision of a world more equitable in its securities while still thriving with difference.

Wherever there is a desk, you live. I have watched you work, my black slippery coat with its gold dragon draped around your shoulders, books and papers piled around you as, hour after hour, you read through texts, always looking for the insight that will move your work along, that will push into place the next step of your argument. The huge shadows of your antagonists hover over you, the governments and the banks, the soldiers and the courts all pitted against the fall of your red hair, the squareness of your copied words. I turn to look again as I go back into my room to put my own words on paper, and see the frail places in the world, trying to chip away at the stolid face of unquestioned, unquestioning power.

I am afraid to leave what I know, to leave my home. I am afraid to take my body with its fumbles and mysteries into countries where I have never lived. And then you lay me down, and laugh gently in my ear. "You're a funny old thing," you say. I cling to you, to the difference of you, your sounds and smells from so far away, too far away. I weep into your shoulder. "I'll be back," you always say before leaving.

But now you are here, your hand moving down my belly, your hair trailing its red fingers over my face. I tense with waiting for the homecoming, and then you reach me and pause before my hunger. This is another kind of power, one that leaps from your hand into my heart. You pull your head back so you can watch how I will take you in, how I will arch with pleasure, my head thrown back with the wonder of the first thrust, and then all my will sinks to my hips and I call to you to never stop, to keep

entering me with your difference, with the worlds you carry on your fingertips, to paint my caves red with your travels.

I hadn't thought it possible or wanted it. The night before you were to leave for England, the day we heard the news that Marjorie had died her cancer death, we made love as if all the days and nights ahead of us were lost in darkness.

You were lying against the pillows, your red hair spreading across them, your lipstick making the blue of your eyes even sharper. I get caught on those eyes; I think I see in them the seas I will never see—the endless blue on the map surrounding the continent of Australia, a blue I fear because it is as vast and unknown as death itself. You turned toward me when I entered, your body urging me to hurry. "I want you," you said as I bent over you, taking you in my arms. I was deeply moved by your direct request and by my knowledge that I could meet your need.

I kissed hard and then light, kissed your neck and shoulders and throat. I wetted your nipples, my mouth pulling on them through the sheen of your nightgown. I buried my head in your hair, pushing your face to one side with my cheek. I just wanted to touch you, to taste you, to make up for years of fear, of deprivation. Your breasts swelled to my mouth and I pulled them free of the gown, rounding them in my hands, resting my head against their swell. Here was an ocean I could survive.

I slowly caressed the wetness out from between your drawn-up legs, opening you up, making love to every fold and crevice of your sex, knowing just what I was doing, and letting you know that I held your need in my hand. I was making love as much to your belief in me as to your body.

I leaned over you so my mouth could pleasure you, and I could see so clearly the movements of my fingers, the redness of your cunt, taking me in. I entered you, pushing against the swollen flesh until it gave way; then slowly, I moved in

and out while I sucked you into my mouth, all of you bursting in my mouth like all things hot and moist and deep. You were all around me, your thighs like high walls keeping me in, your breasts above me still hard with want, your sounds, small moans, sharp intakes of breath, and I was in all of you. You came in the way I had come to know, first small grippings of orgasms, and then as I kept on, not fooled by these first signs of pleasure, you pulled up into yourself, your moans becoming a hot wind above me, and roared your full giving into my mouth, on my fingers, through my soul.

Then your broad shoulders rose into the night, and your face looking down at me became my total vista. You smiled as you untied my black silk jacket. I asked you to turn the light off, and a sadness flickered across your face. "I will, darling, if you want me to." You leaned across me and the room fell into darkness. Now I could allow all to happen.

You kissed me deep and full, the kiss I had such a hard time accepting when we first started to explore our desire. Like the whore I sometimes was, kissing was the gift I did not give away. After such a drought, I was afraid of the intimacy of kissing, not of fucking, but of the hungry touch of mouths. One day in Riverside Park, with the sun falling into the river, you had held my head so I could not turn it away and forced me to take your kiss, your tongue. Now I raised my head in hungry pursuit of your lips, wanting more and more of you.

Your large, strong body, the assurance with which you maneuvered me under you—you surprised me. This woman, who was so languid an hour before, who half-draped her eyes with receptive want, now bent over me, holding me, teasing my nipples until I moaned for relief. I could feel your smile moving over my body as you spread my legs with your knee. "You keep open for me," you said, and I did not move. I felt you reach for the small

bottle of lubricant we kept near the pillow. You kneeled between my legs, bathing your hand in the slippery lotion, your shadow large against the moonlight. Suddenly, very quickly, before I could contract with resistance, I felt your hugeness enter me. Your hand, sleek in its liquid coating, pushed past the guarding muscles, and you had me, all of me, waiting on your smallest move, longing for your thrusts. Not even breathing was as important as your next motions. "This is what you will remember each day I am away," you whispered, forcing the turn of my head by your grip on my hair. And you thrust into me with such power that my whole body moved into the air; "and this," you said again and again. Five times you took me with your hand, five times, one for each day you would be away. Then you stopped and I trembled in your arms, and you lifted me, held me, against you. I was emptied, or so I thought.

We lay in the darkness, my head on your shoulder, waiting for calmer breaths, the air still heavy with our need. You asked me to enter you. I did. And then you entered me, not all of you, not like what had come before, but enough so my swollen clit could feel you, and then you said, "Now fuck me," and I started to move my fingers in you. With all my focus on you, I did not realize for the first few seconds that you, too, were moving inside me, on me, that our bodies were moving together, pushing toward the same pleasure. This was something I would never have allowed, this sameness of penetration, this blurring of bodies, and you had known that. Before I could take in what was happening, I was coming in bursting waves upon you, and you, pushed by my movements, came with me.

Too exhausted to move, too amazed at what had happened, I just lay alongside of you. "You see, Joan," you said, your Australian accent incongruously crisp in the sex-scented night air, "it is all possible for me, for us, all of it."

7.

Ten days had passed, ten nights of late-night telephone calls to her Havana hotel just to hear her voice. Sometimes she would take the telephone out to the balcony—so I could hear the ocean, she would say. I pictured her standing in her nightgown, the dark, warm night lifting the gown's edges, her breasts outlined by the wind. Ringlets of hair weighed down with the wetness of the night. The sounds of that ocean never did reach me, but I knew what I was supposed to hear, and I could see, in the darkness of my room, the white heads rolling onto the beach, the curving sea wall that enclosed the people suffering in their beautiful city, suffering from the vindictiveness of my own government.

She told me, as I yearned for her, that at dusk young lovers drape themselves over the sea wall, their bodies hard with want. In all the cities of the world torn by war or hatred, crumbling from bullets or embargoes, citizens search for the alley or rooftop that will harbor their love. I want the governments to know this, to know that this century is marked by people's struggle to survive the deadlines of officials, young men and women, the lovers, proclaiming their hope in the grips of flesh.

Havana, all torn by history and hope, was home to my lover, and I was jealous of its hold on her. My own history was crumbling and I, too, wanted my love to hold back the emptiness of disaster. But countries are larger than hearts, and so the days passed, and I did my days.

The night of her return was marked by hours of delay, connections missed, planes delayed, hours added to hours until late into the night. Finally I heard her push the door open, heard the roll of her suitcase and her voice calling out, "Darling, I'm home."

I carefully walked out of my bedroom into the hallway and saw her there. Brown and red from the sun, her throat bare, her eyes wide with excitement. I could barely see her for the brightness of the sun she carried with her that late night. We held each other for long, long moments, my head buried in her neck. I could smell her travels, taste the distance that had stretched out between us. She held me firmly in her arms, her blouse rolled up so her forearms were bare, and I thought how in so short a time I had come to know the path of her veins, the lie of the muscles beneath her soft skin. She held me and held me, my need of her part of the history she had seen.

8.

"My dear, my dear it is not so dreadful here"[1]

Late at night, when even the raw sounds of the city drift farther away, I sit alone, listening once again to the story of my body. No lover's hands will keep me from myself. Lee sleeps downtown, wrapped in the arms of her new lover; Dianne has flown back over the oceans to her vast continent of friends and work. I stare at the wall in front of me. Like so many others, I am caught in the limbo of cancer, the still place at the heart of the night. I cannot travel back to the physical safety I once thought I had, and I can't go forward with any assurances that I have a future. I am not unique in this stasis, but this is my bedroom, my history; these are my questions of endurance. How will I travel in my life? What belongings will I carry with me?

1 A line from a poem by Edna St. Vincent Millay, written to mourn the death of a young, willful woman lover. The poet asks Persephone to comfort her frightened friend who wanders weeping like a lost child in the wilds of Hades. I thank Naomi Replansky, my friend who is also a poet, for bringing me these words.

Let my desire remain, even if the cancer grows again into its gray mounds of life. Let my breasts and cunt grow hard with answering determination. And let me keep what I have learned from this illness—that terror is a human thing, that the body, even in its vomit and blood, wants to stand on its feet again, that kindness makes its way through the dead skin, that sickness too yearns for its human voice.

These are my travels. Late in the night, I will go deep into my body's story and hear its tale of life battling life. And as I welcomed home my other beloved travelers, I will bury my head in the gift of hope only I can bring to the surface.

Education

My History with Censorship

My despair at the new antipornography movement and the censorial atmosphere that is fed by it is the legacy of my history. I came of age in a time that has marked me for life, the McCarthy period, the America of the 1950s. I entered that decade a lonely ten-year-old living with an aunt and uncle because my mother could no longer afford to keep me. By the end of the fifties and early sixties, I was a practicing lesbian, a member of CORE and SANE Nuclear Policy, a veteran of ration drives and the march from Selma to Montgomery. I had refused to take cover in air-raid drills and was on file as a subversive on my college campus.

I was a member of a group of students who protested against the House Un-American Activities Committee. We sat in disbelief as lawyers for the Committee screamed at and badgered an exhausted Joanne Grant and Paul Robeson Jr. I remember to this day the chairman's words as we applauded every time one of them took the Fifth Amendment to protest the Committee's right to invade their privacy. He said, "You people"—gesturing at us—"are the scum of the earth." I remember, as we huddled in the corridor during the break, a member of the Committee steering his girlfriend away from us, even brushing her dress aside to make sure it did not touch me. I remember the fifties in tones and gestures, in cadences of accusation. I will never forget the words "Are you now, or have you ever been . . . ," nor the frightened or tired or courageous eyes of those who had to hear

247

them. I watched Joanne Grant sit stolidly while a lawyer for the HUAC waved a piece of paper over her head, shouting, "Did you ever attend a Pete Seeger concert?" She refused to answer. Any answer delivered her into the hands of those who had already condemned her.

I could go on and on about what it was like to get terrified students and teachers to sign petitions, what it was like to watch the hearings day after day on television, to watch Joseph McCarthy accuse, condemn, and try his victims all at the same time—but not by law. He always said, "We do not send anyone to prison. We are not a court of law," and yet, right before one's eyes and in one's neighborhoods and over the radio, imagination and discussion were struck down.

Any dissension became a heroic act. If you spoke the wrong words or supported the wrong people, you were labeled un-American. You were sent into national, and in many cases private, exile. I watched people in their forties and fifties shrink from their children, withdraw into long, slow deaths. I heard read over the radio the names of those who were to be called in front of the Committee, before the Committee even reached a city. Long enough in advance for employers to fire the accused, long enough to give neighbors time to ostracize the marked family, long enough to give the stigmatized individuals time to take their lives. None of this was done by legal power. It was done by the power of orthodoxy, of one prevailing view of how to make the country safe. It was not trial by jury in a court of law: it was conviction by innuendo, by association, by labeling.

This is my historical and emotional starting point on the issue of censorship. Those were the years I learned about censorship, the overt kind and the more subtle kind; the years I learned about a mentality that reserves for itself the words that mean everything good, and labels dissenters with any term

that will set off the alarm. Those were the years I learned about anonymous telephone calls warning people about the unde- sirables among them; the years I learned about visits to places of employment to make sure employers knew who they had work- ing for them. It was the time I learned about silence, enforced by the fear of losing whole communities, about words and pictures never born because difference was a curse.

But all along I had another world to sustain me, the deviant criminalized world of butch-fem lesbians in Village bars. Here, also, I was part of a judged community. We were moral dangers. Here I learned that vice squads existed to keep obscenities like myself from polluting the rest of society. Here I learned how to take brutal insults to personal dignity and keep wanting and loving. Here I first learned what a community of women could do even when we were called the scum of the earth.

I worked in the gay liberation movement and the lesbian liberation movement and then the women's movement for many years before I thought I could begin to explore the meaning of my own life, before in my own mind I was sure that we had won enough ground that I could raise some visions of resistance other than the prevailing ones of the seventies. In 1981, I wrote an article called "Butch-Fem Relationships: Sexual Courage in the 1950s" and published a short story called "Esther's Story." That year marked for me the second McCarthy period in my life. Only this time, many of the holders of truth were women.

Women called the organizers of conferences where I was speaking and told them I was a "sexual deviant," labeling me a dangerous person who betrays the feminist cause. A member of Women Against Pornography, who saw it as her duty to warn a group of students and professors about me, visited the place where I earn my living, Queens College. "Don't you know she is a lesbian?" "Don't you know she practices S/M?" "Don't you

know she engaged in unequal, patriarchal power sex?" (Butch and fem is what she meant here, I think.) I was called to the women's center on campus and asked by a group of women students gathered there whether the accusations were correct. Only those who remember the cadence of those McCarthy words— "Are you now, or have you ever been . . ."—can know the rage that grew in me at that moment. These young women, so earnest in their feminism, were so set up for this sad moment. "I cannot answer you," I said, "because to do so would bring back a world I have worked my whole life to see never come again."

In the same year, I had another painful encounter with censorship that made me feel again the wounds of the past. One of the most terrible things about the McCarthy period was that friends or supporters could be severely punished for association with a "known subversive." In 1981, Susan Cavin of *Big Apple Dyke News* accepted for publication my short story about a one-night stand with a passing woman. On a May afternoon she called to tell me that the story had been called pornographic by a woman typesetter. She had received the following letter from the Addison Press management:

> Dear Susan,
>
> I have just come from a meeting with the brass of this press regarding your paper. It seems that the typesetter that set the current issue of B.A.D. News made such a stink about "offensive" material, that it has caused Mr. Mills, the publisher, to reconsider our business relationship. Fearing legal problems by her potentially quitting over the issue, he would like me to communicate the following to your organization: "The Addison Press will decline to print any subsequent issues of B.A.D. News

which contain explicit sex. This is primarily in reference to "Esther's Story" and certain dream material. . . .

The choice Susan had was to drop my story and keep their printer or drop the printer and keep "Esther's Story." I heard her voice telling me her predicament, and it all came back. *B.A.D.* did not have and does not have many resources to rely on for cushioning. My vision had gotten them into trouble. The paper was being punished for association with my ideas. Susan held the line and found a printer in New York who did not care what the words in the story said.

After the Barnard Conference on Sexuality in 1982, when *off our backs* was doing its reporting, I received a late-night call asking me if I had ever spoken out in favor of S/M relationships. That voice over the phone, my tiredness, the power on the other end, all brought home again the litany of the fifties. I had been told by a member of Women Against Pornography that if I write about butch-fem relationships in the past, I am okay, but if I am writing about them now in any positive way, I am on the "enemy list." The labels chosen for me this time around are "reactionary," "heterosexually-identified lesbian," "believer in patriarchal sex."

I now had a sense of what I faced—the lesbian-feminist antipornography movement on one side, and the homophobia and antisex mentality of some straight people on the other.

Recently, sexually controversial writers lost another piece of ground. Amy Hoffman and I were asked to submit poetry to the *Women's Review of Books*, which is partially funded by Wellesley College. Both of us—she formally, me through a personal letter from a dissenting editor—were told that because our poetry was sexually explicit, the *Review* could not risk publishing it without endangering its funding from the college. Here is an example of

censorship coming from a different direction: women's institutions that have some power but are afraid of using it.[1]

Another way censorship works in our community, and it is very effective, is through the closing of bookstore doors to the works of stigmatized writers or publications judged offensive by "feminist" standards, even when they are the creations of other feminists. For instance, two journals I write for, *Bad Attitude* and *On Our Backs*, have not been allowed into many women's bookstores around this country and in Canada because the contents were found to be "pro-sadomasochistic, antifeminist, antiwoman, antisemitic, and racist." Now, as you all know, these are the words that call for exile from our community, for there is no argument possible when this code is used. (As a Jewish woman, I find it ironic that Gentiles are in such a hurry to protect me from myself.) The territory I am allowed has shrunk even more. Once you close the bookstores to a writer who has chosen to write for her community's publications, you make the creation of an audience almost impossible.

Sadly, as a community, we have been inventive in discovering ways to control ideas. The refusal to allow someone to speak on a panel because she represents a certain point of view, the spreading of rumors about a woman's sexual practices, the refusal of meeting places to those who embarrass us, or the little white cards that popped up for a while in feminist bookstores, warning the potential reader of what to expect from a book, to protect the customer's sensibilities.

The latest accusation of pornography came my way last month. Now it is not my words, but a photograph of a part of my body and a dildo and a former lover's hand that has been

1 One of the joys of doing an edition of this book years later is that I can point out where change has occurred. I now enjoy a very accepting writing relationship with this publication.

called unacceptable. Here it is—a forty-five-year-old lesbian's vagina being touched and opened by her lover's hand to insert a latex dildo. This photo is one of a series of my lover and me making love that appeared in *On Our Backs*. In a subsequent issue of *off our backs*, this photo and the magazine were called pornographic. If the ordinances that are being proposed were now in effect, other lesbians could get this journal banned from the stands, and this photograph would never be seen. But you see, this image is what my life has been about. This image is what the police tried to bash out of me. This image is what I was always told to keep secret. This image puts me and my body beyond the pale.

Think of what is happening. Think of the times and the traditional relationship between the state and sexual minorities. Think of the tools of repression some are helping to put in place.

The antipornography movement is helping to create a new McCarthy period in the lesbian community. Some lesbians are more acceptable than others. Leather and butch and fem lesbians, transsexuals, lesbian prostitutes, and sex workers, writers of explicit sexual stories—little by little we are being rounded up. First we are distanced and told we are not feminists, even though many of us have spent years building the movement. Then we are told that we are patriarchal, that we are heterosexual lesbians. The doors close to us. Then in a Reagan America, a Jerry Falwell America, in a family-God-nation America, there will be nothing between us and the government that the antiporn movement is helping to empower. Some lesbian feminists will turn us in and feel they have made the world safer for women by doing so.

All I have are my words and my body, and I will use them to say and picture the truths I know. I have been homeless before and I can be homeless again, but I almost think I have lived too long when I see lesbians become members of the new vice squad.

Lesbian Sex and Surveillance

Decisions of individuals relating to homosexual conduct has been subject to state intervention throughout the history of Western civilization.

—Chief Justice Burger in his concurring opinion
in *Bowers v. Hardwick*, 1986

Most female homos hangouts are on Third Street, and here a few feet away from the women's prison, in a small, smoky and raucous saloon every Friday night is held a lesbian soiree at which young girls, eager to become converts, meet the already initiated. These parties are presided over by an old and disgusting excuse for a woman, who is responsible for inducing thousands of innocent girls to lead unnatural lives. . . . Homos are not molested by police if they remain in the district and don't bother others on the theory that you can't do away with them, and as long as they're with us, it's better to segregate them in one section where an eye can be kept on them.

—From *New York Confidential*, 1948

If you didn't have on three pieces of women's clothing, honey, you rode. You had to have a bra, nylon drawers and girls' socks; otherwise you were arrested for impersonating a man. I sewed lace on my socks so the cops wouldn't have any problems seeing they were women's socks.

—Riki Stryker, speaking of the bar raids of the 1950s

After engaging in lesbian history work for over twenty-five years, I have discovered that certain motifs haunt me. They change with the times, as do the cast of characters and the forms the cultural confrontations take, but there are themes, even in this postmodern time, that remain. Or perhaps these are the tropes that have come to symbolize the wounds and victories of my own queer history. I am thinking now of my long experience with sexual surveillance.

I have the unique privilege of being one of the few people to have been a speaker at both the Barnard conference on feminism and sexuality in New York City in 1982 and the SUNY New Paltz conference on women's sexuality in 1997. At both these gatherings, sexual talk by women was under close scrutiny. At the earlier conference, the ones patrolling the discussion were other women; at the more recent gathering, representatives of Concerned Americans for a Moral Society were in attendance along with a member of the SUNY board of trustees and a representative from the New York governor's office. All of these good people mobilized themselves when they received word that a public university was sponsoring a conference, under the aegis of the women's studies program, that included references to lesbianism, sex toys, and S/M sexuality.

It has taken almost twenty years for a family discussion to become a national one, for sisters to be replaced by gray-suited men and properly attired straight women, but the atmosphere created by those watchdogs was much the same: anxious organizers, late-night telephone calls warning speakers that the conference might be disrupted, pressure on the convening institution to cancel the event, a physical presence meant to intimidate, and far-reaching communal consequences.

Even though my chemo treatments had left me exhausted and I had warned Amy Kesselman, one of the organizers of the

conference, that she should be prepared for my having to cancel, I knew on that rain-drenched morning I had to be in New Paltz. When Amy called me the week before, concern pouring into her voice, to warn me about the possibility of disruption and to tell me of the struggle she had waged to keep the college's administration open to the event, I felt my blood warm up. I knew these battles deep in my gut, and this surge of engagement was a good antidote to the poison in my veins.

From my first forays into the Greenwich Village bars of the 1950s, I had understood that to be queer meant to travel in policed territories. Confinement made us easy targets; bar raids and street violence were frequent companions, and often the police were the perpetrators, not the protectors. A set of rules was laid down for us, encouraging over the years a responding body of survival lore. Along with the cigarette smoke and beer fumes that clung to our clothes long after Saturday night went the warnings about what to wear and whom to touch. Even though I was a fem, I dressed carefully for my nights out. What kind of world am I entering, I would think, where the police are with us even in the privacy of our closets? My slacks, sometimes men's slacks, because they were cheaper and fitted more comfortably around my big-hipped body, could become a reason for a representative of the state to thrust his hand down my pants. The cut of one's clothes or the placement of buttons were cause for verbal harassment and worse. This threatened surveillance of our clothing did not stop us from "vining back," but it served as a reminder that even that which lay against our skin was subject to state control.

A great part of the excitement of the sixties, of the power of the liberation movements, was leaving this kind of surveillance behind. Of course, it was replaced by the cameras and notepads of the FBI agents who followed the peace parades and infil-

trated SANE meetings, but somehow that was different. Political activity was open dissension; sexual activity and its surveillance were secrets within secrets. Shame was companion to my fear in the earlier decade, making the surveillance an act of punishment in itself, but when I marched with thousands of others to end the Vietnam War, the whole nation was watching. One thing the sixties taught me was that powerless people could take over the streets, could challenge mammoth institutional vehicles like the Pentagon or segregation or the surveillance of a community. Every time the sixties is portrayed as a drug haze, this knowledge is betrayed.

We know now that starting in the late 1950s, the FBI was keeping the DOB (Daughters of Bilitis) and Mattachine Society under close watch, that as we left the closet and the bars, their eyes followed us. In 1965, when a group of gay men and lesbians held a gala costume ball to raise money for the Council on Religion and the Homosexual, the San Francisco police stood outside the doors, snapping photographs of everyone who entered and left. Oral histories tell of several lesbian teachers desperately trying to escape out of a back door so that they would not lose their jobs in the glare of a flash of light.

I remember one night in the early '70s when I had left the bars to attend the first dance held by the New York chapter of DOB in its new loft space. I took in the balloons hanging from the ceilings, the toned-down women in flannels and dungarees, and labeled it all innocuously tacky and boringly safe. They must be kidding, I thought, turning to leave, longing for the excitement of the sexually charged women of the Sea Colony—when all of a sudden, cops poured through the door, with the same look of disgust on their faces I had seen in the darkened streets outside the bars. However innocent I had found the DOB version of celebration, to the eyes of the state these women were

just as deviant, just as needful of watching as my butch-fem bar comrades. But in the large, open space of the DOB gathering, with its wholesome decorations, the police invasion seemed ludicrous. I laughed at them that night. Their blundering antics could destroy the tenderness of touch in a darkened bar, but there was nothing for them to put their hands on in the clearly political air of the DOB gathering.

One of the joys of my work with the Lesbian Herstory Archives is compiling its documentation of the paranoia and historical contradictions of surveillance. In our subject file on the FBI and its relationship with the American lesbian community, we have copies of its surveillance records, won for us by the Freedom of Information Act: white sheets with blacked-out lines, but with enough visible to read about the government's vigilance—the names of the founders of DOB, the description of the women visiting the San Francisco office—enough peers out of the still-hidden records to allow one to see the government's concern about this embryonic movement of organized deviants. Last year, we received a special collection that tells the story of a lesbian who became a minor celebrity in the late 1950s when she went public with her story of her FBI-sponsored surveillance work of left-wing groups. In the context of the Lesbian Herstory Archives, the picture of this small, dark, very butch woman sitting at her typewriter as she informs on subversives forces us to let go of easy understandings of marginality. All archives, not just lesbian and gay ones, are sites of retextualization, where acts and words resurface in the glare of another cultural time; they are places where those abused by national power or societal ignorance can outlast the small minds and bitter hearts of their persecutors. The revelation of the Dartmouth letters of the 1930s protesting the presence of too many "Jew boys" on Dartmouth's campus, which were

read at the opening ceremonies of the school's new Jewish Center, reflects how archival documents can exist in both an air of condemnation and one of hope. In the same manner, the Lesbian Herstory Archives is a place where records of public intimidation can be answered with stories of private resistance.

In the 1970s and '80s, while the FBI and the police were still observing and controlling the lives of sexually "deviant" women, another kind of surveillance surfaced. Swept up in the lesbian-feminist movement, I no longer feared the vice squad. Freed from this daily surveillance, some of us began to explore, in public words and deeds, the rich diversity of lesbian sexual desire. However, at the same time, the anti-violence-against-women struggle was undergoing a transformation, deepening its position that pornography was the basis of all acts of violence against women. Many of us had been active in the antiviolence campaigns of the early seventies, but it was clear that sexuality, and the perceived need to control it, was going to be a contested site in the 1980s. This was a discussion first and a "war" later, among feminist women, many of whom were the lesbian-feminist leaders of the cultural celebrations of the 1970s.

New texts of lesbian desire launched the conflict. In 1979, Pat Califia founded the lesbian-feminist S/M group Samois; in 1981, the *Heresies* collective published their sex issue, which included my essay on the courage of butch-fem sexual relationships in the 1950s, as well as "Feminism and Sadomasochism" by Pat Califia, "What We're Rollin Around in Bed With" by Cherríe Moraga and Amber Hollibaugh, and Paula Webster's "Pornography and Pleasure." To cap it all off, in the following year, Samois edited *Coming to Power*, an anthology of lesbian-feminist S/M writings. Now there were two streams of feminist discourse about women's sexuality, and they were to meet

in a torrent of passion on both sides when Carole Vance and others organized a conference at Barnard College on April 24, 1982, entitled "The Scholar and the Feminist IX—Toward a Politics of Sexuality."

The afternoon was to mark my first experience with the painful role of being deemed a traitor by one's own allies. I had received calls the night before alerting me to the probability of a picket line against the conference, organized by Women Against Pornography, and giving me the even more stunning news that the college had decided to confiscate the booklet that served as the program of the day's events. One of the original booklets sits now at the Archives, testifying to both the weakness of the sponsoring college and the silence of the feminist community about this most flagrant example of censorship.

Yes, there was a picket line that morning, and leaflets were handed out declaring some of us "sex perverts" because of what we had publicly said about sexual desire and history. Yes, there were warnings that such discussions would not be tolerated. But even more frighteningly, a decade of internal surveillance was launched that day. I would receive calls asking me, did I really say that on such and such a day; did I really stand behind the right of S/M women to practice their desire; was I writing about butch-fem in the past or present—for which there was really no correct answer, because neither was to be tolerated. It would be easy to dismiss all of this as small sectarian skirmishes, except that federal forces of sexual control, like the Meese Commission on Pornography, the Family Protection Act devotees, and the religious and political right, now employed the language of antipornography feminism in public statements and proposed legislation. In 1986, the Supreme Court gave its highest opinion about a homosexual's right to private touch. The *Bowers v. Hardwick* decision made the invasion of our bedrooms a legal right.

Whether this country is policing the act or the individual, our bodies and our memories are marked by state control.

I had come a long way from the vice squad–haunted bars of the 1950s where our sexual practice, not our talk, was the target of the state's surveillance. In those days, we did not even conceive of public debates about "deviant" desire. By the end of the 1980s, Andrea Dworkin, Catharine MacKinnon, Julia Penelope, Robin Morgan, Sheila Jeffreys lined up on one side of the issue; Gayle Rubin, Pat Califia, Carole Vance, Ann Snitow, Amber Hollibaugh, Dorothy Allison, and myself lined up on the other side. The sense of ideological surveillance moved from direct encounters to internalized voices to looking over one's shoulders to see who would be hunting down one's words. Some perfectionists felt it pushed back public work for many years. Others, like myself, found it gave us a reason to keep working, though never without doubt. Would my stories of asses and hands, cunts and dildos, history and need, hurt lesbian women? I still ask that question.

In the early 1990s, with the growing strength of queer studies and the postmodern notion to doubt everything, the feminist feuds seemed to be reduced to a dated rehashing of old grievances. Here were new questions, new couplings of gender and sex, a new way to read. Names like Judith Butler and Eve Sedgwick attracted a great deal of attention. Transgender writers and thinkers added a rich new source of experience and thinking about everything we had been struggling with for over twenty years. The wonderful richness of the dialectical method was at work again—synthesizing and, like a good composter, squeezing out the gold of fresh new ideas.

That is why it came as such a shock to be thrown back into the realization that women talking about their sexuality in a place deemed public was still an unacceptable event in 1997.

The event at SUNY New Paltz, with its outpouring once again of the forces of surveillance, was a slap in the face, a forceful reminder that feminists and queers need to see and honor their connections. The queer-theory celebrators who often hold prestigious jobs in private universities have to be concerned with the efforts that are going on in publicly funded colleges and universities to control the flow of ideas deemed subversive. Often it is the women, some in tenuous positions in their underfunded and under-respected women's studies departments, who bear the brunt of this surveillance. With the headiness of queer theory, I had come to think of women's studies as a rather old-fashioned pursuit, dusty with the niceties of the seventies. That morning in New Paltz showed me how wrong I was and how dangerously isolated both the students and the teachers in women's studies could become. I also saw that morning, as women carefully defended their right to talk about sex to the silent observers, that some of the chutzpah and theoretical independence of queer theory would be a powerful addition to the world of women's studies. That morning I saw how much we needed to honor our connected communities.

The moral indignation of Governor Pataki and the fury of Candace de Russy, a SUNY trustee; the call for the college president's resignation by the "moral" right; the outrage of some parents, who kept referring to their college-aged sons and daughters as "children" who needed to be protected from such filth; and the 1950s' language of hatred employed by Roger Kimball (a "so-called educated man," as my working-class mother would have said) in his article for the *Wall Street Journal* entitled "A Syllabus for Sickos"—all these are powerful reminders to us of what awaits autonomous women talking about sex at the end of the twentieth century.

When Larry Kramer, in his *New York Times* op-ed piece announcing his disgust with the Sex Panic activists, called on lesbians to speak out against the renewed possibility of gay men's public sexual pleasure, and the perils of sexual activity in general, he revealed his ignorance about this current battle and its long history. Lesbians are still fighting for the right to just talk about sex and culture without the surveillance of the state or of others who want to tell us what is "natural" for women. And those who would curtail our sexual discourse are growing larger and more powerful in many countries of the world. The increasing religious moral fervor in this country, the growing call for the blood of sexual offenders, the narrowing of allowable sexual tastes and discussions in the arts and in electronic communication are disturbing expressions of a national sexual panic, a phenomenon predicted by Gayle Rubin in her 1984 essay "Thinking Sex: Notes for a Radical Theory of the Politics of Sexuality." The protection of women, children, the family, and the white Christian God from the contamination of sexual or racial or religious "deviants" is on its way to becoming national policy.[1] Pataki's watchdogs could have had no idea all this was on my mind as I tried to give a brief history of lesbian sexuality that morning in New Paltz. My time of twenty minutes had shrunk to eight because of the long speeches the president and Amy had to make to explain why the conference had a right to exist. My fellow keynote speakers and I exchanged notes as we sat waiting for our time to speak. "This is like twenty years ago," Roz Petchesky scribbled to me. "We have to avoid their negative energy," whis-

1 The Clinton "sex scandal," which is unfolding as I revise this essay, raises interesting questions about the national stance on heterosexual private and public sexual mores. It is also clear that there are several cultural debates going on all at once that have as a subtext the role of women's sexual desire, both straight and lesbian, in national life.

pered Eugenia Acuña. I looked out over the audience, above the heads of those who had come to keep their eyes on us, their moving hands writing down our policed words, to the over two hundred young people who had gathered to launch the day of sexual exploration. They have always been the hope, the reason it is so important not to let the silence fall.

Things are not really the same. I am at the end of my life, not the beginning. I am not afraid of disclosure and only rarely ashamed. The end of the century is not the same as the middle of it. I know now that the eyes of the watchers are cold stones even when the sun of their convictions is riding high in the political sky. I know now that surveillance is the weapon of the insecure, the frightened, the pinched. I still fear, however, the human act of policing thought and speech, of hands holding pens to take down our words, never allowing themselves to enter into the messy world of debate. I still fear those who enter rooms cloaked in silent power and, while we speak, plan their retaliations. Surveillance is not seeing; it is the quiet planning of prisons.

From a letter sent to the Lesbian Herstory Archives, November 1980:

> I have been thinking a lot lately about my early days as a lesbian (I recently celebrated my 39th birthday and with it my 20th year as a dyke) and remembered something I thought you might find interesting. . . .
>
> I lived at home in 1960 (age 19). So did my lover. Sometimes we went to cheap hotels in the Times Square area, but often even this was hard to arrange. Somehow we heard of a woman on 14th Street who rented out rooms to lesbians (by the hour or night I no longer remember) and despite our terror (we were after all, 2 *very*

middle-class girls) of what we might find there, we went. The downstairs buzzer said Amazons Ltd. on it. We were greeted at the door by a smiling woman who took us into the kitchen, made us some tea and sat and talked with us for a while. Then she left us alone. The kitchen was at one end of a long hallway off of which there were several rooms. I guess these were the rooms she rented out for we could sometimes hear muffled sounds coming from them. I don't remember ever actually seeing anyone else there. We never rented a room (still too afraid to acknowledge to someone else our erotic feelings) but we did go there frequently in that cold winter to sit and talk with her in the kitchen or by ourselves in the parlor room at the other end of the hallway. The woman, whose name I wonder if I ever knew, never asked for money, or pressured us in any way. It was, for us, a safe space, and now I wonder about that woman, and would certainly love to hear of anyone else who ever went there.

Wars and Thinking

What is a lesbian? A lesbian is the rage of all women condensed to the point of explosion.
—Radicalesbians, "The Woman-Identified Woman," 1970

The realm of human sex, gender and procreation has been subjected to, and changed by, relentless social activity for millennia. Sex as we know it—gender, identity, sexual desire and fantasy, concepts of childhood—is itself a social product.
—Gayle Rubin, "The Traffic in Women: Notes on a Political Economy of Sex," 1975

Recognizing the power of the erotic within our lives can give us the energy to pursue genuine change within our world, rather than merely settling for a shift of characters in the same weary drama.
—Audre Lorde, "The Uses of the Erotic," 1978

Thus a lesbian has to be something else—a not-woman, a not-man, a product of society, not a product of nature, for there is no nature in society.
—Monique Wittig, "One Is Not Born a Woman," 1980

I mean the term lesbian continuum *to include a range— through each woman's life and throughout history—of woman-*

identified experience, not simply the fact that a woman has had or consciously explored genital sexual experience with another woman.
—Adrienne Rich, "Compulsory Heterosexuality and Lesbian Existence," 1980

What is the relationship between sexuality and gender? What is our stake in maintaining a still relatively rigid gender dichotomy in sexual temperament and behavior? What is the relationship between sexual fantasy and sexual acts? What is our rational control over fantasy and do we think there should be a sexual ethics that extends to fantasy? In other words, how set are our individual scripts for sexual arousal?
—Ann Snitow, Christine Stansell, and Sharon Thompson, Introduction to *Powers of Desire: The Politics of Sexuality*, 1983.

Heterosexuality, I now think, is invented in discourse as that which is outside of discourse. It's manufactured in a particular discourse as that which is universal. It's constructed in a historically specific discourse as that which is outside of time. It was constructed quite recently as that which is old: heterosexuality is an invented tradition.
—Jonathan Ned Katz, *The Invention of Heterosexuality*, 1995

From the beginning of wars in this region from '91 on I felt that I have to invent Ten Thousand ways to let my lesbian self breathe. At some moments during the last 8 years, it was not easy for me to put into words how do I feel when making love with a woman and in the back there is a radio with the news of war. Killed or expelled or other fascist acts. In my room, I would not be able to stand up and switch off the news, because I thought respect to the killed I will show

267

by not switching off the radio . . . reading Adrienne Rich, "Litany
for Survival," by Audre Lorde and essays of Joan Nestle kept the
light of my soul in wartime alive.

—Lepa Mladjenovic, in a private correspondence,

Belgrade, 1999

American bombs are falling on Baghdad; seven Iraqi women
and children are killed by young frightened American sol-
diers; Rumsfield grins his death-mask smile, "I wish I was the
author of this war plan, it is going so well." I sit in my new home
in Melbourne, Australia, driven here by breast cancer, landlord
greed, and my love for a Melbourne woman. Several months ago,
when the *Journal of Women's History* extended to me the invitation
to join this project of rereading, rethinking, I was hesitant to say
yes—I have never been a student in or taught a women's studies
class. I have been retired from formal teaching—I am now an
honorary fellow in the English department at the university here,
mentoring a small group of postgraduate students—for nine
years. Thus, I have no empirical data to anchor my judgments
about how important Rich's essay has been over the ensuing
years. This seems to be how I enter public discourse, with my
working-class shadow of self-doubt hovering over me, but now
at sixty-two, having endured two cancers and their treatments
and the loss of a lifelong home, I am impatient with this old
ghost, and so I send it packing.

My first undertaking was, I believed, to educate myself more,
to put this 1980 essay into a deeper context. This decision was
made before the coalition invasion. And this reading, this work,

Published in the *Journal of Women's History*, vol.15, no.3, Autumn 2003, A
Retrospective on Rich's "Compulsory Heterosexuality and Lesbian Exis-
tence"

has helped preserve my sanity; thinking in a time of war is an affirmation of the generosities of human life. For the past two weeks, I have been rereading—Katz, Rubin, Wittig, Snitow, Thompson, Stansell—with the BBC coverage of the war always on, muted but throwing its images into the room. I lift my eyes from *The Invention of Heterosexuality* and see a flash of light in a night sky. I turn a page of the introduction to *Powers of Desire* and see a tank spitting out green fire. I struggle to follow lines of thinking in Gayle Rubin's "The Traffic in Women: Notes on the 'Political Economy' of Sex" (1975), exalting in her elegant thinking, her fearless adaptations of Marx, Engel, Freud, and Lacan, to pursue roots of why women are the devalued sex/gender. I look up and see lines of gunfire, ending in flares of destruction. Thinking, the creation of meaning, the internal pact we make with words that they will be moments of human sincerity, the reconstitution of near-historical texts attesting to intellectual lineages—all of this stands in the face of the Orwellian speech of generals, press secretaries, and government leaders obsessed with ensuring their class positions. I have just read a sentence in Melbourne's most progressive newspaper, *The Age*, that I must add here, not as a parenthetical remark or as a distanced footnote: "The Marine uses a chilling term picked up from the US military in Afghanistan, to describe what might have happened to a dozen or more people thought to have died in this missile attack—they have become 'pink mist.' "[1]

I walk in demonstrations, hear that old 1960s shuffle of thousands of feet moving on asphalt, and think of the calls to action I have read in preparing this essay—Jonathan Ned Katz calling on us to dismantle the oppositional categories of "homosexual" and "heterosexual" by turning the historical eye on preconceived

1 *The Age*, April 8, 2003.

essentialisms, calling for a future pleasure system that will not be based on the denigration of the other—understand, they say, and then dismantle, build anew. Thinking in a time of war—dismantle brutal systems of power, amidst the gleeful reporting of the technological perfection of killing machines.

I have never struggled to write a formal piece on the eve of war— my tooth aches—I write this thinking this is true and then when I turn to my essay, "Some Understandings," written to celebrate the launching of Powers of Desire *in 1983, I find this sentence: "To even raise the issue of women's sexual freedom in the time of our government's invasion of Grenada may seem a bourgeois activity to some—our government is now mobilizing this country for further assaults on governments it deems deviant."*

I reapproach Adrienne Rich's essay "Compulsory Heterosexuality and Lesbian Existence" not as an objective reader, not even after twenty years. This document was a major force in the fierce debates about women's sexual pleasures and dangers that raged during the 1970s and 1980s. The Sex Wars, we call them. In print and in person, at conferences and book launches, in classrooms and women's centers, at sex parties and Take Back the Night marches, we argued our positions. I was on the side of the lesbian "pornographers," writing erotic stories for *Bad Attitude* and *On My Back*, claiming a place in lesbian and women's history for the butch-fem communities of my lesbian youth. I believed that sexual fantasy, sexual autonomy, sexual pleasure must be as deeply championed as our commitment to ending violence against women. Some of my colleagues in this dissent from the women-against-pornography arguments were Amber Hollibaugh, Pat Califia, Jewelle Gomez, Carole Vance, Liz Kennedy, John Preston, Madeline Davis, Ann Snitow, Pau-

la Webster, Dorothy Allison, Gayle Rubin. I list these names because they were/are my comrades—just as Rich turned to Catharine MacKinnon, Andrea Dworkin, Jan Raymond, and Kathleen Barry, among many others, for intellectual support in her essay.

In the face of a real war, it must seem worse than ludicrous for me to use the phrase *sex wars* with any conviction that their duration was an important time. But these were formative years for me, years of warring judgments, years that pushed my work, brought me into contact with writers and activists such as Adrienne and her partner Michelle Cliff, years that launched the Lesbian Herstory Archives (1973), years that taught me the complexity of women's history. When I first read "Compulsory Heterosexuality and Lesbian Existence," I hated it. I was infuriated by its intellectual alliances, by what I perceived as its antisex stance, by its transhistoricism, by its sweeping generalizations about women's and lesbians' lives. The sentence "Every woman is a potential lesbian" I read as rhetorical posturing that obfuscated the material realities of all women's lives. Deep in the passions of the times, I thought Rich was putting her tremendous influence in the service of the wrong camp. My heart broke as I read the uninflected litanies of the signs of male domination—made so familiar to me by the antipornography pamphlets and slideshows I had read and seen: paragraphs that equated rape and high heels and feminine dress codes in fashion as a means of confining women physically; warnings about false consciousness; assertions that heterosexual intercourse or sexual penetration was a form of legalized rape. I did not want to return to my mother's breast, and I knew her assumption that lesbians did not do the "bad" things gay men did, like anonymous sex, was simply wrong. I read the essay as a stern, severe voice from a land in which I did not want to live.

271

Having been part of a public butch-fem lesbian world since 1957, having been schooled in the ways the state policed desire in the Greenwich Village bars of this time, having brought myself up in the fierce way the children of sometimes desperate single mothers do—working at thirteen and leaving my mother's care so I could still attend school—I found the word *compulsory* a red flag in the face of my own determination. I distrusted Rich's positioning in society—I read her as a formerly heterosexual woman with some influence in the world, a renowned poet who was gracing my freak-rooted history with her presence. Ironically, her call for a lesbian continuum, her wish to expand the theoretical and political world of straight feminist discourse, was to me another exile for the specific lesbian life and communities I had known. I was very suspicious of respectability, and of feminist respectability even more so. My answer to the antipornography movement and Rich's essay was to write "My Mother Liked to Fuck." A once-married woman, the mother of three sons, writes the major document calling for lesbian inclusion, and a never-married, childless, old-time lesbian fem writes a call for the respect of heterosexual women's desire—both documents coming from our deepest feminist convictions.

In reading Rich's essay twenty years later and after reading Rubin's essay, where the phrases "obligatory" and "compulsive heterosexuality" are first used, I can separate out my own need for agency from (Rich's much needed) analysis of class oppression, of sex/gender systems of power.

Besides the fact that I was deeply involved in the discourses raging about sexuality and the best way to provide for women's safety, I also shared a New York lesbian-feminist community with Adrienne; she is not just the unknowable author of this (pivotal) essay. In the early seventies, I had a chance to meet Adrienne in different historical circumstances, and to this day I

wish I had not been so self-protective. I had been invited to join a Marxist-feminist study group by my mentor in feminist matters, Paula Webster, that met every two weeks in Marta's Upper West Side apartment. We would begin talking about our assigned chapters from *Capital*, but before long, in good consciousness-raising fashion, we left the text and fell into our lives. I was nervous about entering this world of accomplished feminist thinkers, but I soon realized I had a ready-made place in the group because I was the only lesbian. I often became the recipient of questions like, "Joan, is loneliness the same thing for lesbians?" (An interesting question, really.) In the beginning I did not mind this easily won ground of acceptance and respect, but as the months went by, I realized that it was a cheap way of holding my own in the group.

One night as we were breaking up, Marta asked me to stay for a cup of coffee and meet a friend of hers, Adrienne, who was a poet and also taught in the SEEK Program (in 1966, I had started teaching in this first of the open-enrollment programs of the City University of New York). Feeling like an exhausted imposter, I just wanted to get back to that safe space I called my world. I asked, "Is she a lesbian?" and Marta said she didn't think so. I can still hear my diminished voice saying, "Oh, I think I will skip it—I am tired of being the only lesbian." Perhaps if Adrienne and I had met back in those earlier days, before I became the pornographer and she the author of "Compulsive Heterosexuality," we might have become different kinds of friends, friends who argued their way through their historical times.

Rich and I were to meet many times over the lesbian-feminist 1980s—at parties, at readings, at Womanbooks (the large and wonderful women's bookstore that took up its home on the corner of Ninety-Second Street, the same street as the home of the

Lesbian Herstory Archives, which a group of us had founded in 1973 as a way to end the invisibility of lesbian lives past and present). I remember an earlier time when the bookstore was still in its smaller quarters across Broadway and Adrienne was the featured author. Hundreds of women looped around the block, unable to get in. On Broadway, people were stopping each other and asking what is happening—Adrienne Rich is giving a reading.

She was one of the first researchers to use the Archives, when it was still a small collection in the pantry behind the kitchen. There she did some work on *Of Woman Born*, eventually making a gift of her handwritten notes to the Archives. I just gave what must be my one thousandth sharing of the Archives slideshow, and there was the image of Adrienne that always travels with me: she is working at the small lesbian-made desk—we only wanted furniture made by lesbians in the archives then—her dark head lowered, her whole body concentrating on her work.

It was to Adrienne that I turned when, after twenty-eight years of being a lecturer in the SEEK Program, I dared to ask the formal English Department for a promotion. I needed letters of recommendation to accompany the copies of my books and other published materials—all with "lesbian" somewhere in the title. She graciously responded with a letter that made me glow with pride. When my second volume of memoirs was to be published in 1992, my editors at Cleis turned to Adrienne for a jacket blurb, and once again, her words were more than kind. On the walls of the Archives hangs a print of one of the original French woodcuts of Gertrude and Alice, presented to the collection by Adrienne and Michelle during one of their visits to our Manhattan home.

One morning later in the 1980s, I received a call from Adrienne. She had been asked to speak at a Times Square rally for a Take Back the Night march through the Forty-Second

Street sex district. A group of us opposed to the targeting of women sex workers had authored a flyer opposing this tactic. In an honest quandary, Adrienne asked me to explain my stance. Her search for a clearly thought-out position during this divided time deeply impressed me. The image of Adrienne that will always stay with me, however, is the summer afternoon the three of us met to talk about this growing schism in the movement. She invited Deborah Edel, my partner at the time and co-founder of the Archives, and me to her Montague, Massachusetts, home. Since we were coming from New Hampshire, we first stopped in Peterborough to lay a rose on the grave of Willa Cather—who lay in the shadow of the same mountain range that sheltered Adrienne's home. We sat in the backyard and tried to talk. Adrienne had recently been to Nicaragua, and she told us her arthritis had been so bad she had to be carried on and off the lurching buses that took the group around the country. In my memory, I felt awkward and inarticulate. My final view of Adrienne was of her standing in her shorts on the front porch, waving goodbye. I had never seen her body before, and bodies for me are the starting places of all our stories. A small woman, with scarred legs and twisted bones, a poet in the shadow of mountains, a tireless traveler for human rights. I need to chronicle these encounters that shifted between generosity and alienation because I am writing about the living time in which this text was produced. "Compulsory Heterosexuality" will never be just words on a page, but a breathing emanation from a rugged struggle. We were all living our ideas in passionate ways, creating homes for new histories whether in our poems, bookstores, or living rooms.

What we did in our bedrooms, however, and the significance of those acts, was where the break came. In the early 1980s, particularly after the Barnard Sex Conference, Rich and I were often

pitted against each other. We moved in different circles, both in terms of friendships and in our heads.

The social and political background of 1980 and now are eerily similar. In the beginning years of this twenty-first century, the American right wing, with a deadly disdain for dissidence and the disenfranchised, is firmly positioned to wipe away most of the progress accomplished in the last decade on issues of sexuality, reproductive rights, and gender nonconformity. Concerns about protecting the family, the demand on (Anglo-European) women to have more babies (a particular campaign here in Australia), the attempt to pull women out of the workforce make Bush's government a direct descendant of Reagan's America; now this son of the right with far too many fathers has pulled half the world into the abyss of war.

> *Computer images of helicopters rotating from side to side, missiles hanging from their bellies, inhuman-looking humans vaguely seen in simulated cockpits. Bush in blue suit, white shirt, blue tie, a small American flag pinned to his lapel, reads his lines; events in Iraq have reached their final destination—we have done nothing to deserve this—we will not drift—we have the sovereign authority—we will rise to our responsibility.*

At sixty-two, with my own body scarred by two cancer operations, with a new generation of students, some queer, some not, but all of them refusing unquestioned categories like "mother," or "man" or "woman," I return to "Compulsory Heterosexuality and Lesbian Existence." I still find it claustrophobic and relentless, a work too sure of all its assumptions, too eager in its marshaling of unquestioned supporting voices, too narrow in its understanding of women's sexual possibilities, and too essentializing of almost everything. (Of course, this description can be

applied to my own work as well.) In short, a work of its time. I do, however, have a better understanding now of the discourses required to start the dismantling of the sex/gender systems of power that rob us all of life. Rich, a post-1970s lesbian feminist, refused to accept her exclusion from feminist academic thinking lying down and, in her refusal, has given generations of women students a vision of nonheterosexual possibilities. My check of the internet showed that her essay is a staple of almost every women's studies program. A week before I was told about this project, a lesbian-feminist friend of mine who teaches sociology sent me an essay for publication that she had written about the representation of Italian women in three American films. Dawn, a once-married woman with a grown lesbian daughter, was going to use this article as a coming-out vehicle. In the first paragraph of her essay, she employs Rich's concept of the lesbian continuum as the conceptual framework that gives her permission to gaze upon these seemingly heterosexual cultural constructions with a lesbian eye. Thus, Rich's essay gave room both for an intellectual approach that did not exist before "Compulsory Heterosexuality" and a personal announcement of the author's own sexuality.

For myself, I am excited by the layering of thought, by discourses pushing against each other, by the cracks in certitude—even in a time of war. This time, as I read Rich, I carried Foucault and Butler with me, I understood that we were all trapped in a reversed discourse, but the questioning, the assertion of inclusion had to start somewhere. I realized how much of my own life's work has been, in Jonathan Ned Katz's words, "compensatory, affirmative action."[2] I see Rich's essay as a moment in

2 Jonathan Ned Katz, *The Invention of Heterosexuality* (New York: Dutton, 1995), 178.

a different continuum, one of public thinking about sex/gender constructions and resulting inequalities, with de Beauvoir, Radicalesbians, Wittig, Rubin, Katz, Foucault, and Butler all preparing the ground for the next generation of ideas that will challenge what we think we know and give us new tools to dismantle the systems of power that constrict our humanity. Thinking in a time of war is the preparation to end all war.

There are more ideas on earth than intellectuals imagine. And these ideas are more active, stronger, more resistant, more passionate than "politicians" think. We have to be there at the birth of ideas, the bursting outward of their force: not in books expressing them, but in events manifesting this force, in struggles carried on around ideas, for or against them. Ideas do not rule the world. But it is because the world has ideas (and because it constantly produces them) that it is not passively ruled by those who are its leaders or those who would like to teach it, once and for all, what it must think.
—Michel Foucault, "Les Reportages d'idees," 1978

Before I end, I want to say one more thing. Over the years, I have read savage reviews of Rich's poetry, reviews attacking her for being too polemical. Adrienne Rich has put her whole literary reputation in danger because she has ideas about injustices of all kinds, and these ideas inform her creative world. For the risks she has taken in this country of so-called free speech, where the disdain of the establishment can crush a writer's spirit, I will always honor her.

I want to thank the English and Creative Writing Departments of the University of Melbourne for giving me a home for the next eighteen months. I want to particularly acknowledge

Daniel Marshall, Renee Barnes, Cathy Gomes, Angela Keem, and Katie Hogan, postgraduate students all, for their gifts of ideas and their warm welcome.

In memory of Lynda Myoun Hart (1953–2000), who with brilliance and grace took the conversation even further.

The Politics of Thinking

Ideas have been both the prison and the hope of queer people, and I have lived in both. In the mid-fifties, my mother took me to a doctor because she thought something was not right with me. Perhaps it was the never-ending late-night telephone calls to Sheila, my fifteen-year-old coworker in the five-and-dime. "Yes," said the doctor, his bookcase full of popular psychology books, "your daughter suffers from excess facial hair, definitely a sign of a hormonal imbalance." I thought it was because I was Jewish. Later in the decade, after having found me in bed with a young woman, my mother ran to another doctor, this time a psychiatrist. "My daughter is a lesbian!" my mother cried. "Don't say that," hushed the well-educated doctor. "That is like saying she has cancer."

For so long, we existed in their ideas about us, and that translated into judgment, enforced treatments, and often terror, shame, and despair. Now, gloriously, we have given ourselves an understanding of ourselves. We can trace our movement through time and economic systems, through systems of power and desire, through shifting definitions and connected communities. We now have sex and discourse, and often one is as exciting as the other. Our thinkers have given us room to breathe, creating a new paradigm for questioning the "natural." With all their play and all our seriousness, the vision of our own humanity, and therefore of all, only grows wider and deeper.

I am stunned when I think of the road I have traveled in the last forty years: from a pervert, policed and contained, to a queer lesbian fem woman who writes of sex and history. Decade by decade we suffered and fought our way to sense. This journey was made possible by lovers—lovers of the body and the mind. I have often thanked those who touched my breasts and spread my thighs, but now at the end of this century, I am honored by the touch of another kind of lover—the thinkers who tell me that perhaps it didn't have to be that way at all, perhaps we can understand things differently. These words are as exciting and as necessary as kisses.

One of the greatest joys of going to college in the 1950s was the discovery that ideas did not have to wear the same gray hopelessness as so much else of my working-class childhood. In college I sat in worn classrooms and ate at a rich man's table.

I was introduced to ideas that seemed in their own time large enough and complex enough to carry truth forever, and I learned that every generation had to let go of certainty as economics changed people and people changed their society and technology changed people's lives and poets changed their dreams. Here in the cauldron of youth, politics, and ideas, I left behind my Bronx and Bayside territories of loss and peered into the minds of other centuries to see where I could live.

I was most drawn to the intellectual drama of the Victorians; under the guidance of Dr. Viljoen, an elderly, frazzled woman whose lips were blurred with shaky red and whose cigarette never stopped glowing, I read the essays of Darwin and Huxley, of Arnold and Ruskin. Here I heard for the first time the cries of anguish that signal the most dire challenge to intellectual certainty. The Bible or Darwin, the past or the future, total commitment to what we know to be truth or the despair of waiting on a moonlit beach listening to the ceaseless pull of the tides that

promise nothing we can be sure of—these were dramas of the mind that moved my heart. I know a little better now why I, as a Jew from the Bronx, a young fem woman opening up to lesbian love for the first time in her life, was drawn into these mid-nineteenth-century conflicts of faith and science, of the tension between grueling work and the need for daily beauty. Here was a time when power, and all the ideas that carried it, could be seen to be fallible, and in the cracks of certainty, I saw a place for myself. I also saw integrity and despair, not about money or love, but issuing from a concern about our fragility in the face of knowledge so huge we were afraid we would disappear.

Through my education, I began to understand that even though I was not of the ruling class, I could carry away ideas and make them mine. And so I did. Existentialism, with its resounding right to say no, with its brave loneliness, found a home in me. Marxism, with its call to pay attention to who eats and who does not, found a home in me. The ideas of Frantz Fanon and Albert Memmi, their understanding of colonized selves, of how much is lost in the psychological turmoil of cultural displacement, became like flesh to me. I still remember that late-fifties' afternoon when my Shakespeare professor drew the interlocking circles of the Great Chain of Being on the sun-drenched blackboard. I was charmed by this Elizabethan diagram of thought that suggested that people, at their best, could partake of the godhead and animals, in the full complexity of their development, could reach for the human sphere. Forty years later, these ideas still live in me, a gift given to me by teachers who could have no clue about what I would do with them in my life, a gift of ideas that allowed me to be an autonomous being no matter what social role others may have planned for a young woman like me.

Having ideas that differed from what the country was supposed to be thinking was not a popular stance in the late 1950s. I learned soon enough that the word *subversive* stood for the policing of thinking, whether that thinking led to action or not. In this decade I saw the power of ideas to both ruin lives and inspire courage of the highest kind. I listened carefully to the statements read against the banging of McCarthy's gavel as the House Un-American Activities Committee made victims out of defiant thinkers. "You will be held in contempt, sir," a Committee man would say as people like Paul Robeson struggled to explain their beliefs.

I was no longer a student by the time the Black and women's movements poured their passions into the intellectual insurrections of the 1960s. But I was a teacher of students who needed these ideas, and I too was changed by them. Soon it became clear to me that rethinking American history the way Frederick Douglass had suggested in 1845, from the bottom up, was essential not just for those who lived the history of marginality but for all world thinkers. How could we have ever turned away from the ideas that led us to listen to those who create the wealth of nations? How could we ever have pretended that entrenched gender and racial power does not shape nations? We did for hundreds of years, until people rose up with their thinking and, unfazed by scorn and trivialization, changed once again the mix of ideas, changed once again the nature of hope.

Now I am fifty-eight years old, and I have retired from teaching, but because of my wonderful, international world of smart women friends and my work with the Lesbian Herstory Archives, I stand once again engaged with ideas, and my blood runs as hot. Now I sit with comrades and read Michel Foucault and Judith Butler, just as I read T.S. Eliot and James Joyce so many years ago. Now, as I did then—when I struggled to learn

Eliot's world of high Protestant symbolism, translating some of his images into the walking dead of my mother's garment-industry world, and just as I traveled with Stephen through a Catholic boyhood until I found the moans of Molly in the closing pages of *Ulysses*—I experience the generosity of ideas, how they make me a citizen of the world.

And now I add the hope of postmodern thinking to my intellectual geology. What follows is my eclectic understanding of what is important in this current offering of ideas. I have not sat in a classroom speaking postmodernism; I have not read the French poststructuralist thinkers, male or female, and I do not have a job dependent on how well I manipulate the markers of its language in my latest book or article. But I have read *Queer Theory: An Introduction* by Annamarie Jagose, and to her I owe the outline of my thinking.

First there is the question of subjectivity—the process of becoming a self that is always re-forming in response to the forces of the world around it. Yes, I know this. To be working class is to experience the need to recreate one's self almost continuously if one wants to move about in the world of places and ideas, so the concept of "contested sites" or the idea of a mythical self that we use as if it were real is old hat in some ways. But I also know when to give respect to speakers who need to be all themselves in one self, those whose struggle to live is too severe to be undercut by theories of the nonexistent subject.

Then there is the deconstruction of what have passed for centuries as theories of knowledge, of philosophical regimes, of forced totalities, the myths of cohesion, the faith in foundationalism. I find nothing hopeless in this worldview of continuous disunities, in this belief that identities are created over and over again under the pressure of shifting social, historical, and linguistic terrain, in this questioning of the efficacy of

one story for all. The commitment to engagement now exists not under a banner of absolutes—perhaps it exists under no banner at all (except when conservative forces say we cannot carry one)—but in the name of the complexity of the human experience.

I find no nihilism here, nor a cynical disavowal of the preciousness of human life. In my postmodern soul, I see a chance for a multiplicity of heard histories. I see the hope of power revealed and beauties created every day. My Marxism, my understanding that people must have enough to eat and a place to live and cures for their physical suffering and roses for the soaring of their dreams, becomes a more inclusive demand when it is coupled with the understandings of postmodern humility.

I do find some problems, however, with the present debates over this new presentation of very old certainties.

Postmodern thinking, with its richness of shifting perspectives, must never be just the plaything of academics; political struggle, in the face of economic injustice and social exclusion, must never be dismissed as meaningless behavior. All economic classes of students must have access to both the play and the power of these ideas. Two public events that I recently attended made me realize that there is a growing politics of thinking in this country, a politics and an economics of who will have the ability to explore unsettling ideas and new world images, the way I did as that unsophisticated student so many years ago.

The first site of disturbance was at a publicly funded college in New Paltz, New York, in November 1997. When women gathered to discuss sex in a conference sponsored by the Women's Studies Department, conservative forces called for the dismissal of the college's president and for the protection of "children" from such disturbing ideas. "It is an outrage that public money is used to fund such gatherings," said

the governor of New York. SUNY New Paltz is home to a predominantly working- and lower-middle-class community of students. Representatives of the governor's office and members of the board of trustees met for long hours behind closed doors to determine what these students had a right to hear.

Two months later, I attended a discussion at Columbia University entitled "Intolerance and Sexuality." I expected a lively debate. Set in one of Columbia's on-campus theaters, the discussion was quiet and unfocused. The audience of mostly older people filed in quietly; the novelist Mary Gordon introduced the speakers as they entered, one after the other, and sat themselves down in a theatrically relaxed way. "I don't know why I am here," said one author, a gay man. "I haven't found anything to complain about." Except for the older straight literary figure who wanted to bring back a concept of sin that would include abortion, promiscuity, and sodomy, no one in the semicircle felt they had anything pressing to say about the topic. And then the gay author remembered that Maine had that very day voted to repeal its gay rights protection bill, but even this did not rouse him or the others from their lethargy. Boredom predominated, and each speaker was greeted with polite applause from the audience.

All this decorum broke apart when it was time for questions from the audience. One woman, a visitor to the campus who had been to the SUNY conference, spoke in anger: "How can you all sit there in the comfort of this well-appointed space and act as if speaking about sexuality on a college campus is the norm?" She informed them about what had happened at New Paltz, an event that had made all the city's newspapers, and students' voices rang out through the theater. "They tried to fire the president!" one shouted. "The students organized and petitioned for their right to hear discussions about all kinds of sexual communities—why

don't you address this?" another demanded. The few students in the audience began to walk out.

Then Mary Gordon came to life. "Yes, my husband teaches at New Paltz, and he says the campus is still traumatized by what happened." She spoke, half-turned in her chair, finally looking at the audience, like a person slowly waking up. But the evening was over. I left, bewildered like the others at the contrast between these two events.

Now I know what I was seeing: the politics of thinking. Privately funded schools can put on all the "literary" events they want; the accusation of the misuse of taxpayers' money is not going to be used like a club to stamp out discussions there. It is working-class schools that are going to be "protected" from the new ideas, the very ideas that these students need the most, the ideas for which I hope they will create a language not bogged down in impenetrable self-conscious prose. Postmodern discussion can be all the rage at Harvard and Yale, at Brown and Duke, but at public colleges, conservative forces are using the same techniques that have won them control of community school boards to police the campuses of higher learning.

When we add to this agenda the assault on affirmative action, the campaign to keep remedial help from working-class students in four-year public colleges, and the general downsizing of quality public college education, the picture becomes even clearer. Give postmodernism back to the young people; they have already found a suitable language to discuss it in—body piercing, music, performance, genderbending, their visions of the future.

But we who have been part of history longer have work to do to honor their explorations. In the newspaper on the day I was drafting this essay, an article appeared about a leader of a Christian family-values organization who is leaving his not-

for-profit organization to put his efforts into "jump-starting" a religious-right third party whose agenda will be the elimination of abortion, homosexuality, and promiscuity. Fundamentalism has made queer people the enemy once again; while we delight in discussions of the performance of sex and gender, philosophers like John M. Finnis use the ancient decree of natural law and gay people's exclusion from it to carry us back into a time when we were Satan's spawn.

Here is a fragile union of crucial importance, whose challenge is to keep alive the generous textual insights of Eve Sedgwick, the dialectical and humane understandings of John D'Emilio, Liz Kennedy, and Jonathan Katz; to take pleasure in the clarity and power of Gayle Rubin as she dissects this society's (including our own) fear of sexual minorities; to keep dancing on the edge of definitions and questioned reality with Judith Butler; to learn from the hot and wise narratives of Pat Califia while we struggle to stop the advance of an iron-bound war machine with a fixed morality and a growing political army that has made us the people chosen for annihilation. Playing my part in this struggle to keep the intellectual roads open is the best way I know to honor that young woman who worked as a salesclerk by night and traveled through the world's thoughts by day.

Archives

Lesbians and Prostitutes:
An Historical Sisterhood

The prevalence of lesbianism in brothels throughout the world has convinced me that prostitution, as a behavior deviation, attracts to a large extent women who have a very strong latent homosexual component. Through prostitution, these women eventually overcome their homosexual repressions.

—Frank Caprio, *Female Homosexuality: A Psychodynamic Study of Lesbianism*, 1954

We're having a meeting during Lesbian/Gay Freedom Week because many prostitute women are lesbians—yet we have to fight to be visible in the women's and gay movements. This is partly due to our illegality but also because being out about our profession, we face attitudes that suggest we're either a "traitor to the women's cause" or not "a real lesbian."

—Speaker at "Prostitutes: Our Life—Lesbian and Straight," San Francisco, June 1982

These indoor prostitutes are on the rise. Captain Jerome Piazzo of the Manhattan South Public Morals Division estimates that there are at least 10,000 inside "pros" in the city. Women Against Pornography contends that there are 25,000 prostitutes working inside and outside the city, over 9,500 of them on the West Side alone.

—*West Side Spirit*, June 17, 1985

To prepare for the United Nations' Conference on Women, the Kenyan government put new benches in the parks, filled in the potholes and swept the prostitutes off the streets.
—*New York Times*, July 15, 1985

The original impulse behind this essay was to show how lesbians and prostitutes have always been connected, not just in the male imagination but in their actual histories. I hoped that by putting out the bits and pieces of this shared territory I would have some impact on the contemporary antipornography movement. But in doing my reading and listening, a larger vision formed in me: the desire to give back to working women their own history, much as we have done in the grassroots lesbian and gay history projects around the country. Whores, like queers, are a society's dirty joke. To even suggest that they have a history, not as a map of pathology but as a record of a people, is to challenge sacrosanct boundaries. As I read of the complicated history of whores, I realized once again I was also reading women's history, with all its contradictions of oppression and resistance, of sisterhood and betrayal. In this work I will try to honor both histories—that of the woman whore and the woman queer.

First, my own starting point. In the bars of the late fifties and early sixties where I learned my lesbian ways, whores were part of our world. We sat on barstools next to each other, we partied together, and we made love together. The vice squad, the forerunner of the Morals Division with whom Women Against Pornography have no qualm collaborating, controlled our world, and we knew clearly that who was a whore and who was queer made little difference when a raid was on.

This shared territory broke apart, at least for me, when I entered the world of lesbian feminism. Whores and women who looked like whores became the enemy—or at best, misguided,

oppressed women who needed our help. Some early conferences on radical feminism and prostitution were marked by the total absence of working women in any part of the proceedings. The prostitute was once again the other, much as she was earlier in the feminist purity movements of the late nineteenth century.

A much closer connection came home to me when I was reading through my mother's legacy, her scribbled writings, and discovered that at different times in her life my mother had turned tricks to pay her rent. I had known this all alone in some other part of me, particularly when I shared her bed in the Hotel Dixie in the heart of Forty-Second Street during one of her out-of-work periods, but I had never let the truth of my mother's life sink in in many ways, and this was one of them.

And finally, in my own recent life I have entered the domain of public sex. I write sex stories for lesbian magazines, I pose for explicit photographs for lesbian photographers, I do readings of sexually graphic materials dressed in sexually revealing clothes, and I have taken money from women for sexual acts. I am, depending on who is the accuser, a pornographer, a queer, a whore. Thus, for both political and personal reasons, it became clear to me that this writing had to be done.

One of the oldest specific references I found to the connection between lesbians and prostitutes was in the early pages of William W. Sanger's *History of Prostitution* (1859). Similar to the process of reading early historical references to lesbians, one must pry the women loose from the judgmental language in which they are embedded. Prostitution, he tells us, "stains the earliest mythological records."[1] He works his way through the Old Testament, revealing that Tamar, daughter of Judah, covered

1 William Sanger, *History of Prostitution: Its Extent, Causes and Effect Throughout the World* (New York, 1876), 2.

her face with her veil, the sign of a harlot. Many of the women "driven to the highways for refuge lived in booths and tents, where they combined the trade of a peddler with the calling of a harlot."[2] Two important themes are set out here: the wearing of clothes as both an announcement and an expression of stigma, and the issue of women's work.

It is in Sanger's chapter on ancient Greece that we find the first concrete reference to lesbian history. Attached to the Athenian houses of prostitution, called *dicteria*, were schools "where young women were initiated into the most disgusting practices by females who had themselves acquired them in the same manner."[3] Here is evidence of intergenerational same-sex activity that was also used for the transmission of subcultural survival skills. A more developed connection is revealed in his discussion of one of the four classes of Greek prostitutes—the flute players known as *auletrides*. These gifted musicians were hired to play and dance at banquets, after which their sexual services could be bought. Once a year, these women gathered to honor Venus and to celebrate their calling. No men were allowed to attend these early rites, except through special dispensation.

> The banquet lasted from dark to dawn with wines, perfumes, delicate viands, songs, and music. An after-scene was a dispute between two of the guests as to their respective beauty. A trial was demanded by the company, and a long and graphic account is given of the exhibition [by the recording poet], but modern tastes will not allow us to

2 Sanger, *History of Prostitution*, 3–7.

3 Sanger, *History of Prostitution*, 48.

transcribe the details. . . . It has been suggested that these festivals were originated by, or gave rise to, those enormous aberrations of the Greek female mind known to the ancients as Lesbian love. There is, no doubt, grave reason to believe something of the kind. Indeed, Lucian affirms that, while avarice prompted common pleasures, taste and feeling inclined the flute-payers [sic] toward their own sex. On so repulsive a theme it is unnecessary to enlarge.[4]

Oh, how wrong the gentleman scholar is. This passage, far removed from the original, may be a mixture of some Greek history and much Victorian attitude, but it is provocative both in its tidbit of information and the language it uses to express it. In 1985, I attended my first Michigan Womyn's Music Festival. All during the festivities I kept thinking of those early flute players pleasuring each other, and I wondered if it would change some of the themes of cultural feminism if this historical legacy were recognized.

The primacy of dress codes runs throughout the history of prostitution. This drama of how prostitutes had to be socially marked to set them aside from the domesticated woman, and how the prostitute populations responded to these demands of the state, led me to think many times of the ways in which lesbians have used clothes to announce themselves as a different kind of woman. Prostitutes, even up to the turn of the twentieth century, were described as unnatural women, creatures who had no connection to wives and mothers, much as lesbians were called, years later, a third sex. Ruth Rosen writes in *The Lost Sisterhood*, "[The prostitute could] servic[e] men's sexual needs as other women could not, because a great gulf separated her na-

4 Sanger, *History of Prostitution*, 52.

ture from that of other women"; she cites an 1837 male speaker who claims, "In the female character, there is no midregion; it must exist in spotless innocence or else in hopeless vice."[5] This view of the prostitute as another species of woman is to continue through the years. In 1954, Jess Stearn, a popularizer of erotic subcultures, writes: "The only thing I was sure about then was that the prostitute is no more like other women than a zebra is like a horse. She is a distinct breed, more different from her sisters under the skin than she—or the rest of society—could possibly realize. . . . They have one common denominator, an essential quality that distinguishes them from other women— a profound contempt of the opposite sex."[6] Both dykes and whores, it appears, have a historical heritage of redefining the concept of woman.

To make sure the prostitute did not pass into the population of "true women," through the centuries different states set up regulations controlling her self-presentation and physical movements. In Classical Greek times, all whores had to wear flowered or striped robes. At some time, even though no law decreed it, the prostitutes dyed their hair blond in a common gesture of solidarity. In the Roman period, "the law prescribed with care the dress of Roman prostitutes, on the principle that they were to be distinguished in all things from honest women. Thus they were not allowed to wear the chaste *stola* which concealed the form, or the *vitta* or *fillet* with which Roman ladies bound their hair, or to wear shoes (*soccus*), or jewels, or purple robes. These were the insignia of virtue. Prostitutes wore the *toga* like men. . . . [Some], seeking rather to avoid than to court misapprehen-

5 Ruth Rosen, *The Lost Sisterhood: Prostitution in America 1900–1918* (Baltimore: Johns Hopkins Univ. Press, 1982), 6.

6 Jess Stearn, *Sisters of the Night* (New York: Gramercy Publishers, 1956), 13–15.

sion as to their calling, wore the green toga proudly, and over it the sort of jacket called *amiculum*, which . . . was the badge of adultery."[7]

A provocative point made throughout the history of state regulations concerning prostitute dress is the inclusion of men's apparel as part of the stigmatizing process. For instance, in the late fourteenth century, we are told by Lydia Otis, "In Beaucaire (1373) prostitutes were required to carry a mark on their left arm . . . whereas in Castres (in 1375) the statutory sign was a man's hat . . . and a scarlet belt."[8] Here, as in lesbian history, cross-dressing signals the breaking of women's traditional erotic, and therefore social, territory.

For the next three hundred years, prostitutes were marked by the state, both by being forced to wear a certain kind of clothes or an identifying symbol—like a red shoulder knot, a white scarf, or, in a chilling prefiguring of mid-twentieth-century history, a yellow cord on their sleeves—and by physical restrictions. As I read of the demanded dress codes, I was reminded of the warning older lesbians gave me in the fifties as I prepared for a night out: always wear three pieces of women's clothing so the vice squad can't bust you for transvestitism.

States also drew up litanies of control defining the multitude of ways prostitutes could lose their social freedoms. In fifteenth-century France, a prostitute faced up to three months' imprisonment if she were:

1. To appear in forbidden places.
2. To appear at forbidden hours. . . .

7 Sanger, *History of Prostitution*, 75.

8 Leah Lydia Otis, *Prostitution in Medieval Society* (Chicago: University of Chicago Press, 1985), 80.

3. To walk through the streets in daylight in such a way as to attract the notice of people passing.[9]

Five centuries later, on another continent, the language of control has the same purpose but is more elaborate in its requirements, according to H.B. Woolston:

Rules for Reservation, El Paso, Texas, 1921
- Women must keep screen doors fastened on inside and keep a curtain on lower half of screen door.
- Must sit back from doors and windows and not sit with legs crossed in a vulgar manner and must keep skirts down.
- Must remain in rooms until after twelve o'clock, and when they come out on the street . . . they must not be loud or boisterous or be playing with each other or with men. They must not be hugging men or women around the street or be trying to pull men into their cribs.
- Must not sit in windows with screens down, or stand in doors at any time.
- Must not cross the street in the middle of the block, but must go to Second or Third Street and cross over when crossing street.
- Must not yell or scream from one room to another, or use loud, vulgar language. . . .
- Must not wear gaudy clothes or commit any act of flirtation or other act that will attract unusual attention on the streets. . . .
- Must not work with light out.[10]

9 Sanger, *History of Prostition*, 150.

10 H.B. Woolston, *Prostitution in the United States Prior to the Entrance of the United States into the World War* (1921; Montclair, New Jersey: Patterson-Smith, 1969), 336–337.

I reproduce these decrees of control here because they are the prostitutes' historical documents of oppression. Few, I think, realize how completely the police could infringe on a working woman's life. They also foreshadow the control the vice squad was to have in lesbian bars in the fifties, when even our bathroom habits were under surveillance.

Yet within these constraints, some women were able to turn their social prisons into social freedoms, becoming the intellectually free women of their day. The history of prostitution has its luminaries, women who used the power of their stigmatized place to become unusual women, women who lived outside the domestic restrictions that entrapped the vast majority of their sisters. Thus, we have the biographies of famous courtesans, extolling their wit and depicting their involvement in literature and politics. Successful prostitution accomplished for some whores what passing for men did for some lesbians: it gave them freedom from the rigidly controlled women's sphere.

A rich, untapped source of lesbian history are the diaries and biographies of courtesans, madams, strippers, and other sex workers. Of course, taking these documents seriously, as seriously as the letters of female friends in the nineteenth century, will test the class and attitude boundaries of many feminist scholars. Another challenge is that fact and fiction are often intertwined in these works, but both the fact and the more imaginative creations can be valuable sources in piecing together a fuller lesbian history.

Cora Pearl's *Grand Horizontal: The Erotic Memoirs of a Passionate Lady*, written in 1873, makes several mentions of female same-sex activity. The first reference takes place in a French convent school for poor girls in 1849. The narrator soon discovers that her schoolmates had learned to please each other: "The degree of interest which my new companions exhibited not only in

their own but in each other's bodies was something strange to me."[11] The author then goes on to describe at length a sexual initiation scene in a bathtub under the careful tutelage of Liane, an older student who brings two of the younger girls to orgasm as the rest of the girls watch. At night, the courtesan-to-be says, "I was taught the pleasures of the body, which within a year or two became so keen that I was convinced that anyone who neglected them was a dunce indeed. These pleasures were of course exclusively female." She carefully assures her reader that these pleasures were never forced on any girl too young or inexperienced to receive them, and then goes on to tell how she discovered that the older women, the school mistresses, also enjoyed lesbian sex: "Going suddenly into one of the classrooms to fetch a set of needles I had forgotten, I discovered Bette on her knees before Soeur Rose, one of the younger and prettier of our mistresses, her head thrust beneath her skirt . . . I had still glimpsed an expression on her face which was familiar to me as counterfeit of that on the faces of my friends at certain times of mutual pleasure."[12] The narrator develops a philosophy of pleasure based on these early sexual encounters, but female bonding is also a part of the experience:

> Our nightly experiments in the dormitory can be imagined. Eugénie, my particular friend, hearing from Bette of the incident with Souer Rose, determined to introduce me to the pleasure the lips and tongue can give, and I did not find that pleasure at all mitigated by distaste; then as since, I was keenly conscious that one of the greatest joys in life

11 Cora Pearl, *Grand Horizontal: The Erotic Memoirs of a Passionate Lady* (1890; New York: Stein and Day, 1983), 19.

12 Pearl, *Grand Horizontal*, 22.

is experiencing the pleasure that one can give to one's lovers. And now I was fully grown, and keen to experience myself the full extent of the pleasure I could give to others. For the most part, we fell into pairs, and there grew up between many of us true and real devotion, unmatched since. . . . Our experiments were by no means without their effect on my later career, for I learned at that time to be wary of no activity which pleasure was the result of.[13]

Later on in these memoirs, Cora goes to bed with the lesbian wife of a male client, a woman described in what we would call butch terms. "She then invited me to 'warm her,' which being her guest, I did; she was of a sturdy and muscular build, with breasts which were firm rather than full, indeed no more presenting the chest of a woman than of some men I have known." The wife asks Cora to share her bed, explaining, "Not long after marriage she discovered that men and their figures were if not entirely repugnant at least unexciting to her, whereas an admiration for the female figure was what she could not but give vent to."[14] Cora muses as they make love, "Another woman must more securely know, through pleasuring herself, how to pleasure a fellow of her sex." In the world of women's history research, we often hear the statement "But proper women did not talk about sex in those days." If we turn, however, to different sources, like the writings and records of sexually defined women, we may discover that women of different social positions talked in all kinds of ways. The challenge is whether we really want to hear their voices and how we will fit them into what Adrienne Rich calls the lesbian continuum.

13 Pearl, *Grand Horizontal*, 23.
14 Pearl, *Grand Horizontal*, 166.

In 1912, a lesbian prostitute and anarchist named Almeda Sperry enters both histories by writing a love letter to Emma Goldman that uses a frankness of language we hunger for in our research:

> Dearest: It is a good thing that I came away when I did—in fact I would have had to come away anyway. If I had only courage enuf to kill myself when you reached the climax then—then I would have known happiness, for then at that moment I had complete possession of you. . . . Satisfied? Ah God. No! At this moment I am listening to the rhythm of the pulse coming thru your throat. I am surg[ing] along with your life blood, coursing thru the secret places of your body. . . . I cannot escape from the rhythmic spurt of your love juice.[15]

Emma Goldman, we learn from Candace Falk's work *Love, Anarchy, and Emma Goldman*, was no stranger to frank depictions of desire, so it comes as no surprise that she inspired such a passionate response. Almeda Sperry, lesbian and prostitute, should be as much a part of our history as Natalie Barney of the Ladies of Llangollen. But neither her language nor her profession is genteel. Although she may not fit easily into academic reading lists, the understanding of our history, of women's history, will be poorer for the exclusion of such voices.

The memories of Nell Kimball, a heterosexual madam, make many references to lesbians. One of the more famous madams of her time was Emma Flegel, born in 1867, a Jewish immigrant from Lübeck, Germany, who came to America and worked as a

15 Candace Falk, *Love, Anarchy, and Emma Goldman* (New York: Holt, Rinehart, and Winston, 1984), 174–75.

cook's helper until circumstances forced her to marry and settle in St. Louis. There she opened a highly successful brothel and was known throughout the subculture for her love affairs with her girls. "Emma apparently always had a favorite among her girls, with whom she'd carry on a crush for a year or so before seeking a new favorite."[16] Here we see how ethnic lesbian history can interconnect with the general story of both lesbians and prostitutes, as long as shame does not get in the way. This does not mean a history without concepts of conflicts, but it does mean a commitment to opening up new territory, to the inclusion of women who may challenge prevailing lesbian-feminist categories.

Besides recognizing the history of prostitutes as a valuable source for lesbian history, another connection that emerges is the lesbian customer and protector of prostitutes. In the wonderful and moving story of Jeanne Bonnet, a passing woman of San Francisco in the 1870s (given life by the work of the San Francisco Lesbian and Gay History Project and Allan Bérubé in particular), we meet a woman who first came to the Barbary Coast brothels as a customer but in 1876 decided to enlist some of the women she visited in her all-women's gang. They ended their lives as prostitutes and survived by petty stealing. One of the women Bonnet won away from her pimp, Blanche Buneau, became her special friend. But the anger of the scorned man followed the two women into the privacy of their life. In the words of Allan Bérubé:

> After dark, according to Blanche, Jeanne sat in a chair smoking her pipe and drinking a glass of cognac. She

16 From information sent to the Lesbian Herstory Archives.

took off her male attire, got into their bed, and with her head propped up on her elbow, waited for Blanche to join her. Blanche sat down on the edge of the bed and bent over to unlace her shoes when a shot was fired through the window hitting Jeanne, who cried, "I join my sister," and died.

We are told that her funeral in the year of 1876 in San Francisco was attended by "many women of the wrong class . . . the tears washing little furrows through the paint on their cheeks."[17]

In Jonathan Katz's *Gay/Lesbian Almanac: A New Documentary*, we find a mention of a "female case, R., age thirty-eight" who "proclaims her characteristics in the most flagrant way through her manner of dress which is always the most masculine, straight tailored hats and heavy shoes. She makes a living by prostituting herself homosexually to various women."[18] Here, embedded in the language of Dr. Douglas C. McMurtrie, author of "Some Observations on the Psychology of Sexual Inversion in Women," we have another clue to lesbian history. Perhaps R. will seem more worthy of our attention when we are told by the doctor, "R. feels absolutely no shame or delicacy regarding her position. In the city . . . she frequents public places dressed in a manner to attract general notice. She is heaped with contempt and scorn by the normal and feminine women who see her. She seems, however, to rather glory in this attention and adverse criticism."[19]

17 Allan Bérubé, from a manuscript sent to the Lesbian Herstory Archives.

18 Jonathan Ned Katz, *Gay/Lesbian Almanac: A New Documentary* (New York: Harper and Row, 1983), 339.

19 Jonathan Ned Katz, *Gay/Lesbian Almanac*, 339.

Homosexual women visiting lesbian prostitutes is also documented by Frank Caprio, a pop psychologist from the fifties, who captures that decade's combination of prejudice and sensationalism perfectly:

> In these brothels, which are referred to as Temples of Sappho, lesbian practices consist of intercourse via the use of a penis substitute, mutual masturbation, tribadism and cunnilingus. While many of the clients are passively homosexual, they often assume an active role and in this way they find an outlet for their repressed homosexual cravings. One of these Temples of Sappho in Paris, catering to women clients, is lavishly furnished. A bar occupies a portion of the lower floor where alcoholic beverages may be obtained. The lesbian inmates are attired in transparent, sex-appealing undergarments, and stimulate their women clients with inviting gestures. Private rooms in an upper floor are devoted to sexual liaisons which follow the preliminary acquaintanceship.[20]

It is the challenge of lesbian historians to sort out what is bona fide lesbian culture here and what is Caprio's imagination, but we do know from oral histories that such places existed—and not only in exotic Paris. Mabel Hampton, for example, a Black eighty-four-year-old New York lesbian, tells about a brothel in Harlem during the thirties that catered only to women customers, and whose lesbian madam kept a shotgun by the door to scare away curious men.

20 Frank Caprio, *Female Homosexuality: A Psychodynamic Study of Lesbianism* (New York: Grove Press, 1954), 93.

One important point I would like to make is the need to include questions about prostitution and prostitutes in any oral history done with older lesbian women. If the message is given that this is shameful territory, that the "feminist" interviewer would be appalled by fem whores or butch pimps, or by a myriad of cultural and personal overlappings of these two worlds, this whole part of our women's history will again go underground. We will lose insight and understanding about how lesbians in particular and women in general who live outside the pale of domestic arrangements organize their lives.

Lesbians have and still do turn to prostitutes for sexual comfort, as well as work as prostitutes themselves. In 1984 in a small town in Tennessee, the police set up an entrapment net using a policewoman posing as a prostitute. After the arrests for soliciting were made, the names of the arrested were published in the town's newspaper. In an article entitled "Police Sex Sting Nets 127," we hear a woman's voice:

> And many of them admitted they had made a mistake.
>
> "Some mistakes you can only make one time," said the only woman charged during the three-day undercover operation. "My mother and a grandmother are ministers in Missouri. I'm not a low-life."
>
> The woman, who turned 24 today, sat in her car and wept after being given her citation. She was convinced she would be fired from her job, which she only recently gained.
>
> "I do have some girlfriends, but things aren't great right now," she told the police decoy.
>
> She later told a reporter that she thought the undercover operation was unfair.

"I think the cops should have said, 'Hey, don't do it again,' and let me live my life. You're talking about a story. I'm talking about my career."[21]

In the early decades of the twentieth century, lesbians and prostitutes were often confused in the popular and legal imagination. Mabel Hampton, who had lived as a lesbian from her early teens on, tells how she was arrested in 1920 at a white woman's house while waiting for a friend. Because of an anonymous tip that a wild party was going on, three "bulls" came crashing through the door; even though Ms. Hampton clearly was a "woman's woman," she was arrested for prostitution and sent to Bedford Hills Reformatory for two years at the age of nineteen. According to Ms. Hampton, many of the girls arrested for prostitution were, in fact, lesbians. Taking adversity as a challenge, Mabel Hampton sums up her Bedford Hills experience by commenting, "I sure had a good time with all those girls." Ms. Hampton's good time was not hers alone. Estelle Freedman has chronicled the scandal over lesbianism that hit Bedford Hills a few years later. Here we have another clue to a fuller lesbian history: we need to go back to prison records and start exploring the lives we will find summarized in the terse sentences of the state.

We know from Rosen's *The Lost Sisterhood* that prostitutes had become the victims of antivice campaigns in the twenties, campaigns that established practices of harassment, surveillance, and arrest later to be used against clearly defined lesbians and their gathering places. "The growth of special courts, vice squads, social workers, and prisons to deal with prostitution" became the lesbian legacy of the forties and fifties.[22]

21 *Tennesseean*, November 22, 1984.
22 Rosen, *The Lost Sisterhood*, 19.

H.B. Woolston details the methodology. A police form used in interrogating prostitutes in the 1920s shows the following categories under the heading of general health: "Use Liquor, Drugs, Perversion, Homosex."[23] It is in this decade that police boast of the new methods they developed to humiliate working women: "A spectacular method of striking terror to the heart of wrong doers is the sudden and sometimes violent raid. A patrol wagon dashes up to the suspected house. Police scramble out and attack the various entrances and exits, and round up the inmates."[24]

Fifty years later, Barbara Turrill, a prostitute, describes a bar raid with these words: "You can feel them in the air, when you're in the bar, and sometimes they take the whole bar out, all of the girls sitting at the bar, and put them in the wagon and take them downtown and put them through a lot of hassles. They can just walk in and take you for I and D [idle and disorderly persons) if nothing else."[25] Any lesbian who has been in a bar raid would recognize this description.

Another striking example of how the two worlds come together is shown in an excerpt from an oral history by Rikki Streicher, owner of a lesbian bar in San Francisco. The time is the forties, but the incident has its roots in the 1900s:

> I was working as a waitress at the Paper Doll. Somebody called up and said the cops were on the way. I sent everybody home and stayed. So I was the only one there, so they took me in. If you were a woman, their charges were usually 72 VD which meant they took you in for a

23 Woolston, *Prostitution in the United States*, 331.

24 Woolston, *Prostitution in the United States*, 214.

25 Barbara Turrill, "Thirty Minutes in the Life," WGBH Radio, May 13, 1976; 8. Transcript available at LHA.

VD test and 72 hours is how long it took for the test. They took me in but decided not to book me. So a friend came down and got me out.[26]

Here the lesbian is being policed with a procedure growing out of the social attitude of viewing the prostitute as a carrier of a social disease. In the medical records of the state, lesbian and prostitute history often become one. According to Dr. Virginia Livingston, a staff physician of the Brooklyn Hospital for Infectious Disease during World War II, "the hospital had a clinic for prostitutes and many of the prostitutes were lesbians."[27] The connection between sex and disease that was to haunt prostitutes during the war years, causing many enforced incarcerations, is once again in the social air. And once again, whores and queers must be on the alert for the loss of civil liberties in the face of social panic.

Because prostitutes were the first policed community of outlaw women, they were forced to develop a subculture of survival and resistance. We have seen some details of this culture in the earlier discussion of clothes and women's gatherings. But to enter modern times, I suggest much unexplored lesbian history lies in the so-called dens of legalized vice that sprang up in the first decade of the twentieth century. In the famous red-light districts of that time, in New Orleans's Storyville, in San Francisco's Barbary Coast, in New York's Five Points and Tenderloin districts, lesbian stories are waiting to be told.

26 Rikki Streicher, excerpt from an interview in *In the Life*, no. 1 (Fall 1982), 5. Publication of the West Coast Lesbian Collection, available at LHA.

27 WBAI interview, March 7, 1980

An ad from one of the famous blue books of that period included in its listings of available sexual services a reference to female homosexual entertainment.[28] From the prostitute subculture comes the phrase "in the life," the way many Black lesbians will define their identities in the thirties and forties. From this world comes the use of a buzzer or light to signal the arrival of the police in the back room of a lesbian bar, a tradition still strong in the lesbian fifties. Rosen tells us that "red-light districts, although in a state of transition, still offered women a certain amount of protection, support, and human validation. . . . The process of adapting to the district . . . involved a series of introductions to the new argot . . . the humor, and the folklore of the subculture."[29] A prostitute in Kate Millett's *The Prostitution Papers* will comment years later, "It's funny that the expression *go straight* is the same expression for gay people. It's funny that both of these worlds use that expression."[30]

The final and perhaps most ironic connection between these two worlds that I want to discuss is how lesbians and prostitutes are tied together in the psychology literature. One of the prevailing models for explaining the "sickness" of prostitutes in the fifties was that prostitutes were really lesbians in disguise who suffered from an Oedipus complex and therefore were hostile to men. As Caprio put it in his 1954 work, "While it seems paradoxical to think of . . . prostitutes having strong homosexual tendencies, psychoanalysts have demonstrated that prostitution represents a form of pseudo-homosexuality, a flight from

28 Rosen, *The Lost Sisterhood*, 82.

29 Rosen, *The Lost Sisterhood*, 102.

30 Kate Millett, *The Prostitution Papers* (St. Albans, NY: Paladin Books, 1975), 41.

homosexual repressions."[31] Helen Deutsch saw the problem in another light. Identification for the prostitute was with the masculine mother, and she "has the need to deride social institutions, law and morality as well as the men who impose such authority"; another type of prostitute, Deutsch continues, is the "woman who renounces tenderness and feminine gratification in favor of the aggressive masculinity she imitated," thus making her a latent lesbian.[32]

Mixed in with the attempts to explain the sickness of the prostitute are the stories of women's lives. Caprio, for example, says he had done hundreds of interviews with lesbian prostitutes all over the world. I cannot bear to spend too many words on this connection because I have felt the weight of these theories in my own life. My mother took me to doctors in the early fifties to see who could cure her freak daughter. It is enough to say that prostitutes and lesbians have a shared history of struggle with the law, religion, and medicine, all attempting to explain and control the "pathology" of these unusual women. Lesbian prostitutes have suffered the totality of their two histories as deviant women—they have been called sinful, sick, unnatural, and a social pollution. In the decade of lesbian feminism, they have not been called anything because they are invisible. Even so astute and caring a gay historian as Jeffrey Weeks feels the need to deny their existence in the service of a patriarchally free lesbian history. The existence of lesbian prostitutes is not a blemish on the story of our people; their stories give us clues

31 Caprio, *Female Homosexuality*, 93.

32 Vernon Bullough, "Prostitution, Psychiatry and History," in *The Frontiers of Sex Research,* Vern Bullough, ed. (Buffalo, NY: Prometheus Books, 1979), 89.

about the complexity of lesbian history specifically, and about women's history in general.

While I was doing this research, I was struck by the connections among three separately disparate worlds: the lesbian, the prostitute, and the nun—all examples of undomesticated women who form communities marked by women-bonding. In 1985, the lesbian-feminist community enthusiastically welcomed the world of lesbian nuns into the lesbian continuum. And recent research by Leah Lydia Otis on prostitution in medieval society bears out a profound connection between at least two of these groups. In the fifteenth century, it was not unusual for whole houses of prostitutes, run by women, to turn themselves into convents when they reached the age of retirement. Thus the sisterhood was preserved and the women could continue to live in their version of medieval separatism. As always, the same-sex documentation is harder to find, but we do have a glimmer: "In Grasse in 1487 a prostitute was sentenced to pay a 50 s. fine for having disobeyed the vicar's regulation forbidding prostitutes to dance with honest women."[33]

Four centuries later, prostitutes and nuns are joined once again by a historical tragedy that called forth the highest acts of human courage. Vera Laska, in her passionate work *Women in the Resistance and in the Holocaust: The Voices of Eyewitnesses*, tells us that "some of the best safe houses for resistance fighters were brothels and convents."[34] She also asserts that some of the most daring women in the service of the resistance were prostitutes.[35] The full story of the fate of prostitutes both in the resistance

33 Otis, *Prostitution in Medieval Society*, 81.

34 Vera Laska, *Women in the Resistance and in the Holocaust: The Voices of Eyewitnesses* (Westport: Greenwood Press, 1983), 6.

35 Laska, *Women in Resistance*, 7.

movement and in the concentration camps still has to be told, and I hope the one who does it is a whore. I am sure that in the telling of this history we will also find lesbian women who wore the black triangle of the asocials. "Among the first women in Auschwitz were German prostitutes and Jewish girls from Slovakia. These women were issued evening gowns in which they were forced to help build Auschwitz in rain or snow. Of the hundreds, only a handful survived by 1944."[36] Nun, queer, whore: think of the challenge posed to the unrestricted feminist historian, and to all of our imaginations.

Both lesbians and prostitutes were and are concerned with creating power and autonomy for themselves in seemingly powerless social interactions. As Bernard Cohen, one interviewer of working women, has said, "From the point of view of the prostitute, power and control must always be in her hands in order to survive."[37] A lesbian prostitute wrote in 1982, "I'll make sure I'm out of there in 10 or 15 minutes. I'm always keeping my eye on the time and I decide how long I'll stay depending on the amount of money and what the guy is like. . . . They want more, but in the end we set the terms of the relationship and the Johns have to accept it."[38]

The class structure that exists for prostitutes also exists for lesbians. The closer you are to the street, the more deviant you are seen. Call girls and professional lesbian women have things in common. They both have more protection than the streetwalker or the bar dyke, but coming on to the wrong people can deliver both of them into the hands of the state. Both are of-

36 Laska, *Women in Resistance*, 15.

37 Bernard Cohen, *Deviant Street Networks* (Lexington, KY: Lexington Books, 1980), 97.

38 Terri Richards, from a statement read by the author at "Prostitutes: Our Life—Lesbian and Straight," San Francisco, June 22, 1982.

ten in a hurry to disconnect themselves from their sisters in the street in an effort to lighten their own feeling of difference.

At this point, lesbians have more legal protection than prostitutes because of the power of the gay rights movement. We have lesbian and gay elected public officials but no politicians who clearly claim their public sex past. Ruth Stout, a spokesperson for PONY—Prostitutes of New York—said in 1980 that if the hookers and the housewives and the homosexuals got together, we could rule the world.[39] In order to do this, however, we must face the challenge of our own history, the challenge to understand how the lesbian world stretches from the flute players of Greece to the Michigan festival of lesbian separatism. Why has this seemingly obvious connection between lesbians and prostitutes remained so unspoken in our current lesbian communities? What impact have cultural feminism and classism had on this silence? And will a reunion of these two histories give us a stronger political grasp of how to protect both prostitutes and lesbians in this fearful time? If we can make any part of our society safer for these two groups of women, we will make the world safer for all women, because "whore" and "queer" are the two accusations that symbolize lost womanhood, and a lost woman is open to direct control of the state.

The reclamation of one's history is a direct political act that forces the birth of a new consciousness; it is work that changes both the hearer and the speaker. I saw this very clearly when I attended the groundbreaking conference The Politics of Pornography, the Politics of Prostitution in Toronto and heard one of the keynote speakers, a stripper in Toronto's sex district, document the history of her art form in that city. Her telling created

39 Ruth Stout, "The Happier Hooker," *New York Daily News*, September 16, 1980.

history as it communicated it. In her soft voice she outlined the development of her profession and the oppression she and others had to fight. It was a straightforward history filled with both pride and problems. I was sitting with two other strippers, and as Debbie documented the changes and challenges in their work, they sat on the edges of their seats. They told me later they had never heard it put that way. Out of dirty jokes and scorn, a history was born. I hope that more and more women who perform our work in the world of public sex will choose to tell their people's story.

The collage method used in this essay has certain dangers that I want my readers to be aware of. The first is that I have diluted the historical specificity of each instance of connection because both the terms lesbian *and* prostitute *have their own socially constructed legacies. Second, because I have culled the references from a wide variety of sources and I am not an expert in any of the historical periods, I may have oversimplified the resulting discoveries. However, I mean this work to be both factual and provocative, to break silences and to challenge assumptions, and most of all, to provide the materials for us all—the lesbian, the prostitute, and the feminist (who may be all three)—to gain a more caring and complex understanding of each other so we can forge deeper and stronger bonds in the battles to come.*

I want to thank Margo St. James, Priscilla Alexander, and Gail Pheterson for their encouragement of my work and for their pioneer efforts in the prostitutes' rights movement.

Bibliography

Bérubé, Allan. From a manuscript sent to the Lesbian Herstory Archives (LHA).

Bullough, Vernon. "Prostitution, Psychiatry and History," in *The Frontiers of Sex Research,* Vern Bullough, ed. Buffalo, NY: Prometheus Books, 1979.

Caprio, Frank. *Female Homosexuality: A Psychodynamic Study of Lesbianism.* New York: Grove Press, 1954.

Cohen, Bernard. *Deviant Street Networks.* Lexington, KY: Lexington Books, 1980.

Falk, Candace. *Love, Anarchy, and Emma Goldman.* New York: Holt, Rinehart, and Winston, 1984.

Freedman, Esther. *Their Sisters' Keepers: Women's Prison Reform in America 1830–1930.* Ann Arbor: Univ. of Michigan Press, 1981.

Hampton, Mabel. From tapes in possession of LHA.

Katz, Jonathan. *Gay/Lesbian Almanac: A New Documentary.* New York: Harper and Row, 1983.

Laska, Vera. *Women in the Resistance and in the Holocaust: The Voices of Eyewitnesses.* Westport: Greenwood Press, 1983.

Maria. "Maria: A Prostitute Who Loves Women," *Proud Woman* 11 (March–April 1972), 4.

Millett, Kate. *The Prostitution Papers.* St. Albans, NY: Paladin Books, 1975.

Otis, Leah Lydia. *Prostitution in Medieval Society.* Chicago: University of Chicago Press, 1985.

Pearl, Cora. *Grand Horizontal: The Erotic Memoirs of a Passionate Lady.* New York: Stein and Day, 1983. First published in English, 1890.

Pheterson, Gail. *The Whore Stigma: Female Dishonor and Male Unworthiness.* Amsterdam: Ministeries van Sociale Zaken en Werkgelegenheid, 1986.

Richards, Terri. From a statement read by the author, a lesbian prostitute, at "Prostitutes: Our Life—Lesbian and Straight," a meeting in San Francisco, June 22, 1982. Organized by the U.S. Prostitution Collective.

Rosen, Ruth. *The Lost Sisterhood: Prostitution in America 1900–1918*. Baltimore: Johns Hopkins University Press, 1982.

Sanger, William. *History of Prostitution: Its Extent, Causes and Effect Throughout the World,* New York, 1876.

Stearn, Jess. *Sisters of the Night.* New York: Gramercy Publishers, 1956.

Streicher, Rikki. Excerpt from an interview in *In the Life*, No. 1, Fall 1982. Publication of the West Coast Lesbian Collection, available at LHA.

Stout, Ruth. "The Happier Hooker," *New York Daily News*, September 16, 1980.

Taylor, Katie. Interview. Spring, 1986.

Turrill, Barbara. "Thirty Minutes in the Life." Transcript of a talk for WGBH radio. May 13, 1976, available at LHA.

Weeks, Jeffrey. *Coming Out.* London: The Anchor Press, 1977.

Woolston, H.B. *Prostitution in the United States Prior to the Entrance of the United States into the World War.* 1921. Reprinted, Montclair, New Jersey: Patterson-Smith, 1969.

When the Lions Write History

*Things don't fall apart. Things hold. Lines connect in thin ways
that last and last. Lines become generations made out of pictures
and words just kept.*

— Lucille Clifton, *Generations*, 1976

"I am glad the time has come when the 'lions write history,'"
Wendell Phillips wrote to Frederick Douglass in 1845.
"We have been left long enough to gather the character of slav-
ery from the involuntary evidence of the masters." The Lesbian
Herstory Archives is all about lions writing history. It is about a
people's refusal to live within the dirty jokes and folklore pathol-
ogy of the controlling society. To deprive a people of their his-
tory, or to construct one for them that immortalizes humiliation,
is a conscious cultural act of the powerful.

In 1973, after being a lesbian for fifteen years, I read a
book that brought all the pieces of my life together: my life
with my mother, a Jewish working-class woman who embezzled
money and turned tricks to keep us together; my years on
the barstools and in the bathroom line of the old Sea Colony
bar; my years of teaching in the SEEK Program at Queens
College, where I learned about exile from generations of
students. The book, *The Colonizer and the Colonized* by Albert
Memmi, contained the following passage:

Text of a speech given on July 5, 1986, at the Men of All Colors Together
convention in New York City.

[The colonized] draws less and less from [her] past. The colonizer never even recognized that [she] had one; everyone knows that the commoner whose origins are unknown has no history. Let us ask the colonized [herself], Who are her folk heroes? [Her] great popular leaders? [Her] sages? At most [she] may be able to give us a few names, in complete disorder, and fewer and fewer as one goes down the generations. The colonized seems condemned to lose [her] memory. (female pronouns mine)

How could gay people have a memory of themselves as a people with a history when, for many years, our only social existence was on the pages of medical, psychological, legal, and religious texts—all dedicated to proving our pathology? It is not that our people did not speak, but that their words and their lives lived in the context of the colonizer. Now, after years of doing gay history work, we can go back to those early documents and liberate the men and women who are buried under the language of racism and homophobia. From *Sex Variants*, published in 1948 by Dr. George Henry, a medical work containing case studies of eighty gay men and women:

Walter R:
Father killed accidentally when Walter was eleven. Walter adopted by wealthy English gentleman. Walter only colored boy in community. Timid. Protected by older boy who initiated him in homosexual relations. Foster father made advances. Walter shocked and disillusioned. Left home. Promiscuous homosexual relations. Maternal interest in boy. Alcoholism.
(Passive, effeminate homosexual.)

General impression: Walter is a large Negro, tall and fairly heavy. His features are typical of his race. His forehead is receding, his nose flattened and prominent, his mouth large and his lips thick. . . . He has many of the characteristics of a benign colored person, a fussy spinster and a Southern mammy.

Marian J:

Marian is a large, middle-aged mulatto woman of medium height. Her well-developed breasts and hips suggest the gentle mammy but her square shoulders, erect posture, decisive gait and fearless attribute give the impression of being distinctly masculine attributes. . . . For forty years Marian has been a professional entertainer and for twenty years she was a favorite in European society.

Hidden in these fragmented and racist descriptions are real people, the forefathers and mothers for whom we search. It is part of our responsibility as people chronicling their own history to reclaim these colonized lives. Listen to the richness of Black lesbian history contained in these excerpts from two articles in *Jet* written in 1954:

"Women Who Pass for Men"

For thirty years, a hefty Mississippi woman lived as a man, sternly bossing a 10-acre farm and caring for an attractive, cream-colored "wife" and her daughter by a previous marriage. When the man died two years ago, an amazed undertaker discovered that Pete Bell was really a woman.

At the wife's request, the masquerade was hushed and the burial certificate listed no sex. . . . Incredulous citizens in the small town pooh-poohed the report, claiming "Old Pete just couldn't have fooled me."

Very often the masquerade is only uncovered by an accident or on a necessary visit to a doctor. After an automobile accident, Cincinnati doctors realized that "Charles Harris"—who had posed as a man for forty-five years—was a woman. Harris' true sex was revealed to a woman who knew her as her step-father. Mrs. Ida Belle said Harris (who died recently in Cincinnati at the age of 107) married her mother in 1902.

"Women Who Fall for Lesbians"

Just why some women fall for lesbians is perhaps best summed up in an observation made by writer-researcher Arthur Guy Matthews, who stated recently in a health magazine: "The lesbian makes a point of seeking out widows, lonesome women, the victims of broken love affairs, and those who have suffered from nervous breakdowns and other mental ills."

One Missouri school teacher, for example, who found herself getting on in years without the comfort and companionship of a man, succumbed to the wily advances of a lesbian of similar age, and opened her home to her. They lived together in presumed "spinsterhood" the remaining days of their lives. When the lesbian finally died of a heart attack, the then retired teacher, grief-stricken, soon followed her in death.

Similarly, a romance between a New York woman doctor and her nurse has been winked at and accepted by Harlem society for years.

It is tempting to focus our spotlight on the famous and accomplished, the men and women of letters, of theater, of politics. It is important to do this: think of the impact of public

acknowledgment of Langston Hughes's gayness. But other voices also await us, small voices, announcing themselves in just a few lines in an early gay publication, like the letter written to the *Mattachine Review* in 1959 by Mrs. M.A. from New Jersey:

> Review Editor:
>
> It's taken me a great deal of courage to write this. What does one do in going about or how does one go about obtaining a homosexual partner? I am 38, stout, 190 lbs., coloring brown-skinned. I've written coloring because we colored usually do. Separated from my husband. How do you help normal people in their sex problems? Please keep this confidential. I work as a domestic here. . . . New York is a very large city. There must be someone for me.

Or in a longer letter written to New York Daughters of Bilitis (DOB) in 1969:

> Dear D.O.B. Sisters,
>
> For some time now I have been receiving mail from you. I feel quite close to you through your newsletter. It is much like a letter from home each month. I would love to come to the meetings but my late working hours and our two small children at home make that quite impossible. My wife Delores and I feel we know all of you through your names and articles in the newsletter. Our neighborhood is not at all oriented to gay life, nor is there any gay socializing nearby. . . .
>
> In the beginning of 1969 we found ourselves pretty much in hot water. I had left a job in New York to live in Jersey with Delores. She wanted to move to New Jersey and so we did. Finding an apartment was pretty rough

because I had not gotten settled in a job yet, but we did manage eventually to get into a housing project that was very nice for the kids and Delores. . . . After all was settled, furniture and all, we set ourselves down to living normally again. . . .

We sent Jean, our oldest, out to play and soon after she came home crying. A little girl she had been trying to play with told her her mother said not to play with her. After much comforting, we all settled down and shrugged it off. Time went on and soon we found out there had never been any lesbians in this project before, nor were there any "known" lesbians in the area. Delores did have one or two who would say hello to her, but me they wouldn't speak to. I am very pronounced in my appearance, there is no mistaking me for what I am. I am a butch and Delores loves me that way. . . . The men and women in the building seemed to feel that my appearance was a threat to them. Getting on the elevator with me was out of the question. With Delores, they would hesitate and get on anyway.

I believe to this day the only thing that helped was Delores's way with the house and children. . . . Slowly she would run into a woman in the Laundromat who might comment on how well-behaved the children were. Each time Delores would run home simply elated. Nothing could have been better than someone really talking to her. It was such a small thing but it meant so much. I thought I would ask her to move, but she said she is here and she will stay whether they liked it or not.

Then I decided I would take her out for a night, go to New York, be with other gay people for a while. She might feel better. Delores asked one of the teenage girls in the building if she would sit for the children that night.

The girl said no first and then said that her mother had "finally" consented. All was fine until the day after we went out. I came home and found Delores totally wrecked. It seems the girl went home after sitting for us and was asked by her mother if she was propositioned, molested, or asked to return when we were both home. Well, I think Delores's heart was broken. . . .

Delores asked a woman one day if she wanted a ride to the store with her. The woman said alright as long as her husband did not know. Soon after we were known as pretty nice people but don't be alone with them. Each month passed until Summer finally came and it is the habit of the women in this building to sit outside and talk. We passed this group of sun bathers quite often and usually the air was pretty tense or the conversations would cease. It was very heartbreaking for Delores. She had not wanted to be part of any gossip or coffee clotch [klatsch], but the complete withdrawal from her was I think a bit too much. My heart went out to her then as it does now when she does something really great, which is pretty often.

Slowly people started giving credit where it belonged. Delores and the kids won them over whether they liked it or not. One day the electricity went out. Our Jean walked a man all the way up to the twelfth floor holding his hand because he had a heart condition. Then the day came when Delores and I were giving a birthday party for Jean. The children were to come at 1:00 and leave at 3:00. The party lasted until eight o'clock. The kids just wouldn't go home.

The next day our phone rang constantly, mothers calling, asking what we did. The children never stopped talking about how wonderful Delores and Lou Ellen were,

how they loved us. From the mouths of babes came the answer.

Now when Delores and I go out the door, ten kids rush to kiss her hello and couldn't they please come with us? Today they know in this community that lesbians are not stag film replicas. Today when they need a good meat loaf recipe or their hair done, even an interior decorator or a baby sitter, they simply call on the two lesbians who moved up on the twelfth floor two years ago.

We all have our struggles. Isn't it just great when we make enough headway to walk into a restaurant and not have the waitresses huddle in a corner whispering, or walk down the theater aisle and everyone keeps watching the picture, or walk down a street unnoticed.

Love to all of you,
Delores, Lou Ellen, Jean, Peter

A quiet courage of desire and a rock-strong resistance lie at the heart of these documents, and in our history, a people's history, they serve as monuments to the thousands of other lives waiting for us to find them. Our history work must go on in the face of all the insanities around us. Racism and homophobia feed on the destruction of a people's selfhood; while they rant, we must continue piecing together the fullness of our story.

Angelina Grimké, a Black lesbian writer of the Harlem Renaissance, calls to us, and her voice stands for a multitude:

> The days fall upon me;
> One by one, they fall,
> Like leaves. . . .
> They are black,
> They are grey.

They are white;
They are shot through with gold and fire.
They fall,
They fall
Ceaselessly.
They cover me,
They crush,
They smother.
Who will ever find me
Under the days?

In this finding, we will also find ourselves and lay a hold on our own future. Memory is a people's gift to themselves, and for an oppressed, a hated people, it is the place where the collective soul takes refuge.

Besides the voices of individual lives, we also have documents of the social and political groups that fought the history forced on them. We learn in Jonathan Katz's *Gay American History* of the Los Angeles group Knights of the Clock, an interracial group of heterosexual and homosexual men and women who joined together in 1950 "with the aim of promoting understanding among homosexuals, between blacks and whites, and offering social, employment, and housing services especially to interracial couples." We can also remember in our collective gay minds the click of the police photographers' cameras as they photographed the six hundred gay people who had the courage to attend a dance given by an early homophile rights organization in San Francisco: six hundred faces frozen in time, but six hundred women and men who continued walking through that door in our history.

Our organizations come into being because brave women and men understand that we must take responsibility for the

vitality and protection of all our community. In September 1976, a group of Black lesbian women wrote the following words:

> The official name of this group is the Third World Gay Women's Organization. We call ourselves the Salsa-Soul Sisters.
>
> We came into being because there was no other organization that we knew of in the New York area, existing for or dealing with the serious needs of third world gay women. We started by searching out each other, because of the strong needs we have in common, and to grow to understand the ways in which we differ.
>
> Our immediate aim is to provide a place where third world gay sisters can meet other gay sisters, other than in bars.
>
> We hope to become an organization of third world gay women who feel joy as well as pride in being able to say, "we did it ourselves." Meaning, we started, formed, maintained, and governed an organization that is helpful and inspiring to third world gay women. We share in the strengthening and productivity of the whole gay community.

Salsa-Soul fulfilled its promise, and these early words are now a document of a people's vision and the courage to carry it out.

Our history is made up of many histories—all the layers of identity that form our personhood, that connect us to legacies of love and pride and pain. This is the deeper challenge to a community that says yes, we come from different places, but we are queer and that is our bond. Respect for difference is more than rhetoric; it is education about where one's soul lives. For some of us there are historical symbols that make us wince in collective pain, symbols that we cannot play with because blood

and servitude are wrapped in their folds. History will betray us if we betray it. If we do not learn the language of each other's historical truths, if we do not grow aware of the places where life has been stolen, our histories and our lives will be selfish things. This is one reason why your organization, Men of All Colors Together, is so important.

Coalition politics is a desperately needed, desperately practical strategy in these Reagan times. One of its goals is to extend the boundaries of understood experiences so these boundaries become less lonely, less the burden of one group, and more the recognized need of communities in partnership. You take this strategy and turn it into lived lives. Politics becomes passion, or perhaps passion becomes politics. One of the strongest gifts you give this hate-filled society is proof that neither racism nor classism nor homophobia can silence a loving voice, nor stop a loving touch. I know this gift is not easily come by. I have read your newsletters and seen documented the hours of work and risk-taking. But you are changing history.

I write what some call erotica and others call pornography. I write it to celebrate the fineness and richness of sexuality, the complexity of women's desire, because it is at the center of our history as it is at the center of our oppression as gay people. That the state has decreed our lovemaking a crime, that each of us who touches his or her loved one, or enters him or her in that forbidden way, is open to legal punishment, depending on geography, should not surprise us after the initial shock of the Supreme Court decision has worn off. Is this not the same government that still refuses to stop the fascist nightmare in South Africa? Is this state that forbids our private love not the same one publicly declaring we will make possible the murder of men, women, and children because we disagree with their choices? Is this not the same state that brags about our pros-

perity while hundreds of thousands are homeless and foodless and hopeless? I know that all their decrees, all their appeals to their version of history, the ancient history of the hatred of sodomites, will not bring our movement to a halt, but a toll will be taken. Our young people face the medical warnings and social stigma of AIDS on one side, and the legal warnings of the state on the other. Now, once again, our history and the history of all those who resisted must be made a living thing. It must give nourishment and dignity and strength. It must show all the nuances of resistance, and it must not leave anyone out.

From Stonewall to Soweto the people are resisting, and that chant and this struggle have brought us into new lands. History is not a dead thing or a sure thing. It lives with our choices and our dreams. It is the story of our glories and our sadnesses. It is at different times a lover, an enemy, a teacher, a prophet. It is always a collective memory as complicated and as contradictory as the people who lived it, but it is always a people's story. Let our tale be marked by our knowledge of what had to be done, and let it shine with the passion of our attempt.

"I Lift My Eyes to the Hill": The Life of Mabel Hampton as Told by a White Woman

On Thursday nights, Mabel Hampton held court at the Lesbian Herstory Archives, opening the mail and gossiping with other archive workers. A devout collector of books on African American history and lesbian culture, in 1976 Ms. Hampton had donated her lesbian paperback collection to the archives. Surrounded by these books and many others, she shared in welcoming the visitors, some of whom had come just to meet her.

Another more public place we could count on finding Ms. Hampton in her later years was New York's gay pride march. From the early 1980s on, Ms. Hampton could be seen strutting down Fifth Avenue, *our* avenue for the day, marching under the Lesbian Herstory Archives banner, wearing her jauntily tilted black beret, her dark glasses, and a bright red T-shirt proclaiming her membership in SAGE (Senior Action in a Gay Environment). Later in the decade, when she could no longer walk the whole way, a crowd of younger lesbian women fought for the privilege to push her wheelchair down the avenue. Mabel Hampton, domestic worker, hospital matron, entertainer, had walked down many roads in her life—not always to cheering fans. Her persistent journey to full selfhood in a racist and a capitalistic America is a story we are still learning to tell.

In recent years, I have been dazzled at our heady discussions of deconstruction, at our increasingly sophisticated academic conferences on gender representation, at the publication of sweeping communal and historical studies, and at our brave biographies of revered figures in American history in which the authors speak clearly about their subject's sexual identity. Mabel Hampton's is the story we are in danger of forgetting in our rush of language and queer theory.

Telling Mabel Hampton's history forces me to confront racism in my own relationship to her. Our two lives, Ms. Hampton's and mine, first intersected at a sadly traditional and suspect crossroads in the history of the relationship between Black and white women in this country. These relationships are set in the mentality of a country that, in the words of Professor Linda Myers, "could continue for over three hundred years to kidnap an estimated 50 million youths and young adults from Africa, transport them across the Atlantic (about half dying, unable to withstand the inhumanity of the passage)."[1]

In 1952, my small white Jewish mother took her breakfasts in a Bayside, Queens, luncheonette. Sitting next to her was a small Black Christian woman. For several weeks they breakfasted together before they each went off to work, my mother to the office where she worked as a bookkeeper, Ms. Hampton to the homes she cleaned and the children she cared for.

One morning, Ms. Hampton told me, she followed my mother out to her bus to say goodbye and my mother, Regina, threw the keys to our apartment out the bus window, asking whether Ms. Hampton would consider working for her. "I told her I would give her a week's trial," Ms. Hampton said.

1 Linda J. Myers, *Understanding an Afrocentric Worldview: Introduction to an Optimal Psychology* (Dubuque, Iowa: Kendall/Hunt Publishing Company, 1988), 8.

This working relationship was not to last long because of my mother's own financial instability, but the friendship between my mother and Ms. Hampton did. I remember Ms. Hampton caring for me when I was ill. I remember her tan raincoat with a lesbian paperback in its pocket, its jacket bent down so no one could see the two women in the shadows on its cover. I remember, when I was twelve years old, asking my mother as we did laundry together one weekend whose men's underwear we were washing since no man lived in our apartment. "They are Mabel's," she said.

In future years, Regina, Mabel, and Mabel's wife, Lillian, became closer friends, bound together by a struggle to survive and by my mother's lesbian daughter. Ms. Hampton told me during one of our afternoons together that when Regina suspected I was a lesbian she called her late one night and threatened to kill herself if I turned out that way. "I told her, she might as well go ahead and do it because it wasn't her business what her daughter did, and besides, I'm one and it suits me fine."

Because Ms. Hampton and I later formed an adult relationship, based on our commitment to a lesbian community, I had a chance much later in life, when Ms. Hampton herself needed care, to reverse the image this society thrives on—that of Black women caring for white people. The incredulous responses we both received in my Upper West Side apartment building when I was Ms. Hampton's caretaker showed how deeply the traditional racial script still resonated. To honor her, to touch her again, to be honest in the face of race, to refuse the blankness of physical death, to share the story of her own narrative of liberation—for all these reasons—it is she I must write about.

Ms. Hampton pointed the way to how her story should be told. Her legacy of documents so carefully assembled for Deborah Edel, who had met Ms. Hampton in the early seventies

and who had all of Ms. Hampton's trust, tells in no uncertain terms that her life revolved around two major themes: her material struggle to survive and her cultural struggle for beauty. Bread and roses, the worker's old anthem—this is what I want to remember, the texture of the individual life of a working woman.

After her death on October 26, 1989, when Deborah and I were gathering her papers, we found a box carefully marked, "In case I pass away see that Joan and Deb get this at once, Mabel." On top of the pile of birth certificates and cemetery-plot contracts was a piece of lined paper with the following typed entries:

1915–1919: 8B, Public School 32, Jersey City
1919–1923: Housework, Dr. Kraus, Jersey City
1923–1927: Housework, Mrs. Parker, Jersey City
1927–1931: Housework, Mrs. Katim, Brooklyn
1932–1933: Housework, Dr. Garland, New York City
1934–1940: Daily housework, different homes
1941–1944: Matron, Hammalund Manufacturing Co., NYC
1945–1953: Housework, Mrs. Jean Nate
1948–1955: Attendant, New York Hospital
1954–1955: General, daily work
Lived 1935: 271 West 122nd Street, NYC
Lived 1939–1945: West 111th Street, NYC
Lived 1945–current (1955): 663 East 169th Street, Bronx, NYC

Compiled in the mid-fifties when Ms. Hampton was applying for a position at Jacobi Hospital, the list demanded attention—a list so bare and yet so eloquent of a life of work and home.

Since 1973, the start of the Lesbian Herstory Archives, I have felt Ms. Hampton's story must be told, but I am not a trained

historian or sociologist. However, in the seventies, training workshops in doing oral histories with gay people were popping up around the city, and I attended every session I could. There, Jonathan Katz, Liz Kennedy, Madeline Davis, and I would talk for hours, trying to come up with the questions that we thought would elicit the kind of history we wanted: What did you call yourself in the twenties? How did you and your friends dress in the forties? What bars did you go to? In the late seventies, when I started doing oral history tapes with Ms. Hampton, I quickly learned how limited our methods were.

J.: Do you remember anything about sports? Did you know women who liked to play softball? Were there any teams?

M.: No, all the women, they didn't care too much about them—softballs—they liked the soft women. Didn't care about any old softball. Cut it out!

I soon realized that Ms. Hampton had her own narrative style, which was tightly connected to how she had made sense of her life, but it wasn't until I had gone through every piece of paper she had bequeathed us that I had a deeper understanding of what her lesbian life had meant.

Lesbian and gay scholars argue over whether we can call a woman a lesbian who lived in a time when that word was not used. We have been very careful about analyzing how our social sexual representation was created by medical terminology and cultural terrors. But here was a different story. Ms. Hampton's lesbian history is embedded in the history of race and class in this country; she makes us extend our historical perspective until she is at its center. The focus then is not lesbian history but lesbians *in* history.

When asked, "Ms. Hampton, when did you come out?," she loved to flaunt, "What do you mean? I was never *in*!" Her audiences always cheered this assertion of lesbian identity, but now I think Ms. Hampton was speaking of something more inclusive.

Driven to fend for herself as an orphan, as a Black working woman, as a lesbian, Ms. Hampton always struggled to fully occupy her life, refusing to be cut off from the communal, national, and worldly events around her. She was never *in*, in any aspect of her life, if being "in" means withholding the fullest response possible from what life is demanding of you at the moment.

Along her way, Ms. Hampton found and created communities for comfort and support, communities that engendered her fierce loyalty. Her street in the Bronx, 169th Street, was *her* street, and she walked it as "Miss Mabel," known to all and knowing all, whether it was the woman representing her congressional district or the numbers runner down the block. How she occupied this street, this moment in urban twentieth-century American history, is very similar to how she occupied her life—self-contained but always visible, carrying her own sense of how life should be lived but generous to those who were struggling to make a decent life out of indecent conditions.

I cannot recreate the whole of Ms. Hampton's life, but I can follow her journey up to the 1950s by blending the documents she left, such as letters, newspaper clippings, and programs, with excerpts from her oral history and my interpretations and readings of other sources.

These personal daily documents represent the heart of the Lesbian Herstory Archives; they are the fragile records of a tough woman who never took her eyes off the hilltop, who never let racism destroy her love for her own culture, who never let the

tyranny of class keep her from finding the beauty she needed to live, who never accepted her traditional woman's destiny, and who never let hatred and fear of lesbians keep her from her gay community.

None of it was easy. From the beginning, Ms. Hampton had to run for her life.

Desperate to be considered for employment by the City of New York, Ms. Hampton began to document her own beginnings in April 1963.

To the county clerk in the Hall of Records, Winston-Salem, North Carolina:

> Gentlemen: I would appreciate very much you helping me to secure my birth papers or any record you may have on file, as to my birth and proof of age as this information is vital for the purpose of my securing a civil service position in New York. Listed below are the information I have to help you locate any records you may have.
>
> I was born approximately May 2, 1902, in Winston-Salem. My mother's name was Lulu Hampton or Simmons. I attended Teacher's College which is its name now at the age of six. My grandmother's name was Simmons. I lived there with her after the death of my mother when I was two months old. It is very important to me as it means a livelihood for me to secure any information.

On an affidavit of birth dated May 26, 1943, we find this additional information: Ms. Hampton was of the Negro race, her father's full name was Joseph Hampton (a fact she did not discover until she was almost twenty years old), and he had been born in Reidsville, North Carolina. Her mother's birthplace was listed as Lynchburg, Virginia.

This appeal for a record of her beginnings points us to where Ms. Hampton's history began: not in the streets of Greenwich Village, where she will sing for pennies thrown from windows in 1910 at the age of eight, not even in Winston-Salem, where she will live on her grandmother's small farm from her birth until 1909, but further back into a past of a people, further back into the shame of a country.

Ms. Hampton's deepest history lies in the Middle Passage of the Triangular Slave Trade, and before that in the complex and full world of sixteenth-century Africa. When Europe turned its ambitious face to the curving coastline of the ancient continent and created an economic system based on the servitude of Africans, Ms. Hampton's story began. The Middle Passage, the horrendous crossing of the waters from Africa to this side of the world, literally and figuratively became the time of generational loss. Millions died in those waters, carrying their histories with them. This tragic "riddle in the waters," as the Afro-Cuban poet Nicolás Guillén calls it, was continued on the land of the Southern plantation system. Frederick Douglass writes, "I have no accurate knowledge record of my age, never having seen any authentic record containing it." These words were written in 1845 and Ms. Hampton was born in 1902, but now as I reflect on Ms. Hampton's dedication to preserving her own documents, I read them as a moment in the history of an African American lesbian.

The two themes of work and communal survival that run so strongly throughout Ms. Hampton's life are prefigured by the history of Black working women in the sharecropping system, a history told in great moving detail by Jacqueline Jones in her study *Labor of Love, Labor of Sorrow: Black Women, Work, and the Family, from Slavery to the Present.* Though Ms. Jones never mentions lesbian women, Ms. Hampton and her wife of forty-five

years, Lillian Foster, who was born in Norfolk, Virginia, carried on in their lesbian lives traditions that had their roots in the post-slavery support systems created by Southern Black women at the turn of the century. The comradeship of these all-women benevolent and mutual aid societies was rediscovered by Ms. Hampton and Ms. Foster in their New York chapters of the Eastern Star.

Even the work both the women did, domestic service for Ms. Hampton and pressing for Ms. Foster, had its roots in this earlier period. Jones tells us that "in the largest southern cities from 50 to 70 percent of all black women were gainfully employed at least part of the year around the turn of the century." In Durham, North Carolina, close to Ms. Hampton's birthplace, during the period of 1880–1910, "one hundred percent of all black female household heads, aged 20 to 24, were wage earners." Very likely, both Ms. Hampton's grandmother and her mother were part of this workforce.

I'm Mabel Hampton. I was born on May the second 1902, in Winston-Salem, North Carolina, and I left there when I was eight years old. Grandma said I was so small that [my] head was as big as a silver dollar. She said that she did all she could to make me grow. One day she was making the bed and gettin' things together after she fed the chickens. She never let me lay in the bed; I lay in the rocking chair, and this day she put the clothes in the chair; when she carried 'em outside, she forgot I was in 'em and shook the clothes out and shook me out in the garden out on the ground. And Grandma was so upset that she hurt me.

My grandmother took care of me. My mother died two months after I was born. She was poisoned, which left me with just my grandma, mother's younger sister,

and myself. We had a house and lived on a street—we had chickens, had hogs, garden vegetables, grapes and things. We had a backyard, I can see it right now, that backyard. It had red roses, white roses, roses that went upside the house. We never had to go to the store for anything. On Saturdays we go out hunting blackberries, strawberries, and peaches. My girlfriends lived on each side of the street: Anna Lou Thomas, Hattie Harris, Lucille Crump. Oh-Ooh-O Anna Lou Thomas, she was good lookin', she was a good-lookin' girl.

One day Grandma says, "Mabel I'm goin' to take you away." She left Sister there and we went to Lynchburg, Virginia, because Grandma's mother had died. I remember when I got there, the man picked me up off the floor and I looked down on this woman who had drifts of gray hair. She was kind of a brown-skinned woman and she was good lookin'. Beautiful gray hair she had. I looked at her and then he put me down on a stool and I set there. They sang and prayed and carried on. I went to sleep.

However pleasant Ms. Hampton's memories were of North Carolina, she had no intention of returning there later in her life. "Lillian tried her best to get me to go to Winston-Salem. I says, 'No, I don't want to.' She says, 'You wouldn't even go to my home?' I says, 'No, because with my nasty temper they'd lynch me in five minutes. Because they would see me walkin' down the street holdin' hand with some woman, they want to put me in jail. Now I can hold hands with some woman all over New York, all over the Bronx and everywhere else and no one says nothing to me.'"

When she was seven years old, in 1909, Ms. Hampton was forced to migrate to New York. In her own telling there is a

momentous sense that she lost whatever safety she had in that garden of roses.

One morning I was in the bedroom getting ready for school [a deep sigh]. I heard Grandma go out in the yard and come back and then I heard a big bump on the floor. So I ran to the door and I looked and Grandma was laying stretched out on the floor. I hollered and hollered and they all came running and picked her up and put her on the bed. She had had a stroke. Grandma lived one week after she had that stroke. My mama's younger aunt, I'll never forget it, was combing my hair and I looked over at Grandma layin' in bed. It was in the morning. The sun was up and everything. She looked at me and I looked at her. And when my aunt got finished combing my hair, Grandma had gone away.

They called my mother's sister in New York and she came so fast I think she was there the next day. I remember the day we left Winston-Salem. It was in the summertime. We went by train and I had a sandwich of liver between two pieces of bread. And I knew and felt then that things was going to be different. After eating that sandwich I cried all the way to New York. My aunt tried to pacify me but it didn't do no good, seems as if my heart was broken.

Taken to a small apartment at 52 West Eighth Street, Ms. Hampton meets her uncle, a minister who, within the year, will rape her.

In telling her story Ms. Hampton has given two reasons for her running away at age eight from this home: one involves a fight with a white girl at school and the other, a terrible beating

by her uncle after she had misspelled a word. Whatever the exact reason, it was clear that Ms. Hampton had already decided she needed another air to breathe.

My aunt went out one day and he raped me. I said to myself, "I've got to leave here." He wouldn't let me sleep in the bed. They had a place where they put coal at, and he put a blanket down and made me lay there. So this day, I got tired of that. I went out with nothing on but a dress, a jumper dress, and I walked and walked.

Here begins an amazing tale of an eight-year-old girl's odyssey to find a place and a way to live. After walking the streets for hours, the young Ms. Hampton "comes to a thing in the ground, in the sidewalk, people was going down there." A woman comes by and thinks she recognizes the lost child. "Aren't you Miss Brown's little girl?" Before Ms. Hampton can answer, she places a nickel in her hand and tells her to go back home to Harlem. As Ms. Hampton says, "That nickel was a turning point in my life."

Instead of going uptown, Ms. Hampton boarded a Jersey-bound train and rode to the last stop. She came aboveground and walked until she found a playground. "I seen all these children playin', white and black, all of them havin' a good time." She joins the children and plays until it begins to get dark. Two of the children take an interest in her and she makes up a story: "My aunt told me to stay here until she comes." The girl calls to her brother, "You go get the cops, I'll try to find her aunt." She brings a woman back with her—a Miss Bessie White—who begins to ask her questions. Ms. Hampton: "I looked down the street and from the distance I see the boy comin' with the cop so I decided to go with the woman. Bessie said, 'Come, I'll take you home.'"

Ms. Hampton will remain with the White family until she is seventeen years old. One member of the family, Ellen, particularly stays in her memory:

> I seen a young woman sitting left of where I come in at. I say to myself, this is a good-looking woman; I was always admiring some woman. Oh, and she was. She had beautiful hair and she looked just like an angel. She got up out of the chair, she was kind of tall, and she says "you come with me." So she took me upstairs, bathed me, and said "we'll find you some clothes." She always talked very softly. And she says, "you'll sleep with me." I was glad of that.
>
> So I went and stayed with them. The other sister went on about lookin' for my aunt. I knew she never found her. See, I knew everything about me, but I kept quiet. I kept quiet for twenty years.

Mabel Hampton, from the very beginning of her narrative, speaks with the determination of a woman who must take care of herself. She will decide what silences to keep and what stories to tell, creating for herself power over life's circumstances that her material resources seldom gave her.

For Mabel Hampton, the 1920s were both a decade of freedom and one of literal imprisonment. In 1919, when she is seventeen years old, she is doing housework for a Dr. Kraus of Jersey City. Her beloved Ellen, the first woman friend to hold Ms. Hampton in her arms, has died during childbirth. With Ellen gone, Ms. Hampton's ties to the White family are loosening; she will find work dancing in an all-women's company that performs in Coney Island and have her first requited lesbian love affair. She will discover the club life of New York. This is the

decade in which Ms. Hampton will pay a visit to the salon of A'Lelia Walker, the flapper daughter of Madam Walker, and be amazed at the multiple sexual couplings she observes. She will perform in the Lafayette Theater and dance at the Garden of Joy, both in Harlem. In this decade, she will make the acquaintance of Ethel Waters, Gladys Bentley, and Alberta Hunter. She will be one of the 150,000 mourners who sing "My Buddy" as the casket bearing Florence Mills, beloved singer, slowly moves through the Harlem streets in 1927. This is Ms. Hampton's experience of the period that lives in history books as the Harlem Renaissance.

But before all this exploration takes place, Ms. Hampton will be arrested for prostitution by two white policemen and sentenced to three years in Bedford Hills Reformatory for Women by a Judge Norris. Ms. Hampton: "While we were standing there talking, the door open. Now I know I had to shut it. And two white men walk in—great big white men. 'We're raiding this house,' one of them says. 'For what?' 'Prostitution,' he says. I hadn't been with a man no time. I couldn't figure it out. I didn't have time to get clothes or nothing. The judge she sat up there and says, 'Well, only thing I can say is Bedford.' No lawyer, no nothing. She railroaded me."

When Ms. Hampton talks about her prison experience, she dwells on the kindnesses she found there: "It was summertime and we went back out there and sat down. She [another prisoner] says 'I like you.' 'I like you too.' She said no more until time to go to bed. We went to bed and she took me in her bed and held me in her arms and I went to sleep. She put her arms around me like Ellen used to do, you know, and I went to sleep."

But where Ms. Hampton found friendship, the board of managers of the prison found scandal and disgrace. Opened in 1902 in a progressive era of prison reform, Bedford Hills,

under its first woman administrator, Katherine Davis, accepted the special friendships of its women inmates. But in 1920, word that interracial lesbian sex was occurring throughout the prison caused Ms. Davis to lose her job. The new administrators of the prison demanded segregated facilities, the only way, according to one of the men, to prevent interracial sex.

By the time I was doing the oral history with Ms. Hampton, she had left this experience far behind. She told me that she seldom told anyone about it; she would just say she had gone away for a while. But toward the end of her life, Ms. Hampton wanted her whole story to be told. She realized that her desire to be open about her life was not popular with her peers. "So many of my friends got religion now," she would say, "you can't get anything out of them."

While Mabel Hampton so generously shared her prison experience with me, I read about Bedford Hills in Estelle Freedman's book *Their Sisters' Keepers: Women's Prison Reform in America, 1830–1930*. When I read the following sentence in Freedman's book, "By 1919, we are told, about 75% of the prisoners were prostitutes, 70% had venereal disease, a majority of low mental ability and ten percent were psychopaths," I was forced to see lesbians encoded in this list. Mabel Hampton was among these counted women. As gays and lesbians, we have a special insight, a special charge in doing history work. We, too, have had our humanity hidden in such lists of undesirables. I started this work on Mabel Hampton because her life brought to the study of history the dignity of the human face behind the sweeping summaries. And because I loved her.

After thirteen months, Ms. Hampton is released from prison with the condition that she stay away from New York City and its bad influences. A white woman with a green car whom she met in Bedford comes to Jersey City to take her to parties in

New York. When a neighbor informs on her, she is forced to return and complete her sentence at Bedford. Ms. Hampton later described some of the life that the state had declared criminal.

In 1923, I am about twenty years old. I had rooms at 120 West 122nd street. A girlfriend of mine was living next door and they got me three rooms there on the ground floor—a bedroom, living room, and big kitchen. I stayed there until I met Lillian in 1932. I went away with the people I worked for, but I always kept my rooms to come back to. Then I went to the show.

Next door these girls were all lesbians, they had four rooms in the basement and they gave parties all the time. Sometimes we would have "pay parties." We'd buy all the food—chicken and potato salads. I'd chip in with them because I would bring my girlfriends. We also went to "rent parties" where you go in and pay a couple of dollars. You buy your drinks and meet other women and dance and have fun. But with our house we just had close friends. Sometimes there would be twelve or fourteen women there. We'd have pig feet, chittlins. In the wintertime, it was black-eyed peas and all that stuff. Most of the women wore suits. Very seldom did any of them have slacks or anything like that, because they had to come through the streets. Of course, if they were in a car, they wore the slacks. Most of them had short hair. And most of them was good-lookin' women too. The bulldykes would come and bring their women with them. And you wasn't supposed to jive with them, you know. They danced up a breeze. They did the Charleston, they did a little bit of everything. They were all colored

women. Sometimes we ran into someone who had a white woman with them. But me, I'd venture out with any of them. I just had a ball.

I had a couple of white girlfriends down in the village. We got along fine. At that time I was active in the Cherry Lane Theater. I didn't have to go to the bars because I would go to women's houses. Like Jackie (Moms) Mabley would have a big party and all the girls from the show would go. She had all the women there.

In addition to private parties, Ms. Hampton and her friends were up on the latest public lesbian events. Sometime in February of 1927, Ms. Hampton attended the new play that was scandalizing Broadway, *The Captive*. Whatever her material struggle was in any given decade, Ms. Hampton sought out the cultural images she needed. Here, in a brief excerpt, is how she remembered that night at the theater:

Well, I heard about it and a girlfriend of mine had taken me to see this play, *The Captive*, and I fell in love— not only with *The Captive*, but the lady who was the head actress in it. Her name was Helen Mencken. So I decided I would go back—I had heard so much talk about it. I went back to see it by myself. I sat on the edge of my seat! I looked at the first part and I will always think that woman was a lesbian. She played it too perfect! She had the thing down! She kissed too perfect, she had everything down pat. So that's why I kept going back to see it, because it looked like to me it was part of my life. I was a young woman, but I said now this is what I would like to be, but of course, I would have to marry and I didn't want to marry [the play focuses on the seduction of a married

woman by the offstage lesbian], so I would just go on and do whatever I thought was right to do. I talked to a couple of my friends in Jersey City about the play. I carried them back, paid their way to see it, and they fell in love with it. There was plenty of women in that audience and plenty of men too! They applauded and applauded. This same girl with the green car, she knew her—Helen Mencken— and she carried me backstage and introduced me. Boy, I felt so proud! And she says, "Why do you like the show?" I said, "Because it seems a part of my life and what I am and what I hope to be." She says, "That's nice. Stick to it! You'll be alright."

The 1920s end with Mabel Hampton living fully "in the life," trying to piece together another kind of living from her day work and from her chorus line jobs. Later, when asked why she left show business, she will say, "Because I like to eat."

The Depression does not play a large role in Ms. Hampton's memories, perhaps because she was already earning such a marginal income. We know that from 1925 until 1937, she did day work for the family of Charles Baubrick. Ms. Hampton carefully saved all the letters from her employees testifying to her character:

Dec. 12, 1937: To Whom It May Concern: This is to certify that the bearer Mabel Hampton has worked for me for the last 12 years doing housework off and on and she does the same as yet. We have always found her honest and industrious.

Reading these letters, embedded as they were in all the other documents of Ms. Hampton's life, is always sobering. So much

of her preserved papers testify to an autonomous home and social life, but these formal letters sprinkled through each decade remind us that in some sense Ms. Hampton's life was under surveillance by the white families who controlled her economic survival.

In 1935, Ms. Hampton is baptized into the Roman Catholic Church at St. Thomas the Apostle on West 118th Street, another step in her quest for spiritual comfort. This journey would include a lifelong devotion to the mysteries of the Rosicrucians and a full collection of Marie Corelli, a Victorian novelist with a spiritualist bent. She will end the decade registering with the United States Department of Labor trying to find a job. She is told, "We will get in touch with you as soon as there is a suitable opening."

The event that changes Ms. Hampton's life forever happens early on in the decade, in 1932. While waiting for a bus, she meets a woman even smaller than herself, "dressed like a duchess," as Ms. Hampton would later say: Lillian Foster.

Ms. Foster remembers in 1976, two years before her death: "Forty-four years ago I met Mabel. We was a wonderful pair. I'll never regret it. But she's a little tough. I met her in 1932, September twenty-second. And we haven't been separated since in our whole life. Death will separate us. Other than that I don't want it to end."

Ms. Hampton, to the consternation of her more discreet friends, dressed in an obvious way much of her life. Her appearance, however, did not seem to bother her wife. Ms. Foster goes on to say: "A lady walked in once, Joe's wife, and she say, 'You is a pretty neat girl. You have a beautiful little home but where is your husband?' And just at that time, Mabel comes in the door with her key and I said, 'There is my husband.' " The visitor added, "Now you know if that was your husband, you

wouldn't have said it!" to which Ms. Foster firmly replied, "But I said it!"

Lillian Foster, born in 1906 in Norfolk, Virginia, shared much of the same Southern background of Ms. Hampton, except that she came from a large family. She was keenly aware that Ms. Hampton was "all alone," as she often put it. Ms. Foster worked her whole life as a presser in white-owned dry-cleaning establishments, a job, like domestic service, that had its roots in the neo-slavery working conditions of the urban South at the turn of the century. These many years of labor in under-ventilated back rooms accelerated Ms. Foster's rapid decline in her later years. But together with a group of friends, these two women would create a household lasting for forty-six years.

This household with friends took many shapes. When crisis struck and a fire destroyed their apartment in 1976, as part of the real-estate wars that were gutting and leveling the Bronx, Ms. Foster and Ms. Hampton came to live with me and Deborah Edel until they could move back to their home. Later, Ms. Hampton would describe our shared time as an adventure in lesbian families: "Down here it was just like two couples, Joan and Deborah and Mabel and Lillian; we got along lovely, and we played, we sang, we ate; it was marvelous! I will never forget it. And Lillian, of course, Lillian was my wife. I heard Joan laughing because I called Lillian 'Little Bear,' but when I first met her in 1932, she was to me, she was a duchess—the grand duchess. Later in life I got angry with her one day and I called her the 'little bear' and she called me 'the big bear' and of course that hung on to me all through life. And now we are known to all our friends as the 'big bear' and the 'little bear.'"

Ms. Hampton saved hundreds of cards signed "Little Bear." But when she appealed to government officials or agencies for

help, as she often did as their housing conditions deteriorated, she said Ms. Foster was her sister.

Letter to Mayor Lindsay, 1969:

> Dear Mr. Mayor, I don't know if I am on the right road or not, but I am taking a chance; now what I want to know is can you tell me how I can get an apartment, I have been everywhere and no success. I am living at the above address [639 E. 169th Street, Bronx] for 26 years but for about the past 10 years the building has gone down terribly. For two years we have no heat all winter, also no hot water. We called that housing authority but it seems it don't help; everywhere I go the rent is so high that poor people can't pay it and I would like to find a place before the winter comes in with rent that I can afford to pay. It is two of us (women) past 65. I still work but my older sister is on retirement so we do need two bedrooms. If you can do something to help us it will be greatly appreciated.
>
> Thanking you in advance,
> I remain, Miss Mabel Hampton

Finding this letter marked a turning point in my work. Ms. Hampton's request for a safe and warm home for herself and Ms. Foster now stands as the starting point of all my historical inquiry: How did you survive?

In a document of a different sort, the program for a social event sponsored by Jacobi Hospital, where she was employed for the last twenty years of her working life, we discover that a Ms. Mabel Hampton and Ms. Lillian Hampton are sitting at Table 25. These two women negotiated the public world as "sisters," which allowed expressions of affection and demanded a recognition of their intimacy.

There is a seamless quality to Ms. Hampton's life that does not fit our usual paradigm for doing lesbian history work. Her life does not seem to be organized around what we have come to see as the usual rites of gay passage, like coming out or going to the bars. Instead, she gives us the vision of an integrated life in which the major shaping events are the daily acts of work, friends, and social organizations, and the major definers of these territories are class and race; in addition, she expects all aspects of her life to be respected.

Every letter preserved by Ms. Hampton written by a friend, coworker, or employer contains a greeting or a blessing for Ms. Foster. "I do hope to be able to visit you and Lillian some evening for a real chat and a supper by a superb cook! Do take care of yourself and my best to Lillian," Dolores, 1944; "God bless and keep you and Lillian well always, I wish I could see you both some times," Jennie, 1977.

The 1940s were turbulent years, marked by World War II and unrest at home. While African American soldiers were fighting the armies of racial supremacists in Europe, their families were fighting the racist dictates of a Jim Crow society at home. Harlem, Detroit, and other American cities would see streets become battlefields.

For African American working women like Ms. Hampton, the 1940s was the decade of the slave markets, the daily gathering of Black women on the street corners of Brooklyn and the Bronx to sell their domestic services to white women who drove by looking for cheap labor. In 1940, Ms. Hampton was part of this labor force as she had been for over twenty years, working year after year without worker's compensation, health benefits, or pension payments.

In September of 1940, she receives a postcard canceling her employment with one family: "Dear Mabel, please do not come

on Thursday. I will see you again on Friday at Mrs. Garfinkels. I have engaged a part time worker as I need more frequent help as you know. Come over to see us."

Ms. Hampton did not let her working difficulties dampen her enthusiasm for her cultural heroes, however. On October 6, 1940, she and Ms. Foster are in the audience at Carnegie Hall when at 8:30 p.m., Paul Robeson commands the stage. The announcement for this concert is the first document we have reflecting Ms. Hampton's lifelong love of the opera and her dedication to African American cultural figures and institutions.

In 1941, perhaps in recognition of her perilous situation as a day worker, Ms. Hampton secures the job of matron with the Hammarlund Manufacturing Company on West Thirty-Fourth Street, assuring her entrance into the new social-security system begun just six years earlier by Franklin Roosevelt.

She still takes irregular night-and-day domestic employment so she and Ms. Foster can, among other things, on May 28, 1946, purchase from the American Mending Machine Company one Singer Electric Sewing Machine with console table for the price of $100. She leaves a $44 deposit and carefully preserves all records of the transaction.

On February 20, 1942, we have the first evidence of Ms. Hampton's involvement in the country's war efforts: a ditto sheet of instruction from the American Women's Voluntary Services addressed to all air raid wardens. "During the German attack on the countries of Europe, the telephone was often used for sabotage thereby causing panic and loss of life by erroneous orders. We in New York are particularly vulnerable in this respect since our great apartment houses have often hundreds even thousands under one roof. . . . The apartment house telephone warden must keep lines clear in time of emergency. Type of person required: this sort of work should be particularly suited for

women whose common sense and reliability could be depended upon."

In August, Ms. Hampton is working hard for the Harlem branch of the New York Defense Recreation Committee, trying to collect cigarettes and other refreshments for the soldiers and sailors who frequent Harlem's USO. In December of 1942, she is appointed deputy sector commander in the air warden service by Mayor LaGuardia. This same year she will also receive her American Theater Wing War Service membership card. Throughout 1943, she serves as her community's air raid warden and attends monthly meetings of the Twelfth Division of the American Women's Voluntary Services Organizations on West 116th Street. During all this time, her country will maintain a segregated army abroad and a segregated society at home.

In January and February of 1944, she receives her fourth and fifth war loan citation. This support for causes she believed in, no matter how small her income, continues throughout Ms. Hampton's life. In addition to her religious causes, for example, she will send monthly donations to SCLC and the Martin Luther King Memorial Fund; by the end of the seventies, she is adding gay organizations to her list.

On March 29, 1944, Ms. Hampton attends the National Negro Opera Company's performance of *La Traviata*. This group believed in opera for the masses and included in its program a congratulatory message from the Upper West Side Communist Party. On its board sat Eleanor Roosevelt and Mary McLeod Bethune, both part of another moment in lesbian history. In 1952, this same company will present *Ouanga*, an opera based on the life of the first king of Haiti, Dessalines, who the program says "successfully conquered Napoleon's armies in 1802 and won the Black Republic's fight for freedom." Ms. Hampton will be in the audience.

Continuing her dedication to finding the roses amid the struggle, on November 12, 1944, Ms. Hampton will hear Marian Anderson sing at Carnegie Hall and add the program of this event to her collection of newspaper articles about the career of this valiant woman.

Ms. Hampton's never-ending pursuit of work often caused long absences from home, and Ms. Foster was often left waiting for her partner to return to their Bronx apartment on 169th Street, the apartment they had moved into in 1945, at the war's end, and which would remain their shared home until Ms. Foster's death in 1978.

Dear Mabel:

Received your letter and was very glad to hear from you and to know that you are well and happy. This leaves me feeling better than I have since you left. Everything is OK at home. Only I miss you so much I will be glad when the time is up. There is nobody like you to me. I am writing this on my lunch hour. It is 11 P.M. I am quitting tomorrow. I don't see anyone as I haven't been feeling too well. Well the ½ hour is up. Nite nite be good and will see you soon.

Little Bear

In 1948, Ms. Hampton falls ill and cannot work. She applies for home relief and is awarded a grant of $54.95 a month, which the agency stipulates should be spent the following way: $27 for food; $21 for rent; $55 for cooking fuel; $80 for electricity; $6 for clothing; and for personal incidentals, she is allowed $1. But from these meager funds she manages to give comfort to friends.

Postcard, August 9, 1948:

Dear Miss Lillian and Mabel:

The flowers you sent were beautiful and I liked them very much. I wear the heart you sent all the time. It was very nice to hear from you both. I am feeling fine now. I hope you are both in the best of health.

Love

Doris

In 1949, Ms. Hampton writes to the home-relief agency telling the caseworker to stop all payments because she has the promise of a job.

The decade that began in war between nations and peoples ends in Ms. Hampton's version of history with a carefully preserved article about the international figure Josephine Baker. Cut out of the March 12, 1949, issue of *The Pittsburgh Courier* are the following words:

Well friends, fellow Negroes and countrymen, you can stop all that guesswork and surmising about Josephine Baker. This writer knew Edith Spencer, Lottie Gee, Florence Mills, knew them well. He has also known most of the other colored women artists of the last thirty years. His word to you is that this Josephine Baker eminently belongs. She is not a common music hall entertainer. She has been over here for a long time, maybe 25 years. The little old colored gal from back home is a French lady now. That means something. It means for a colored person that you have been accepted into a new and glamorous and free world where color does not count. It means that in the joy of the new living you just might forget that "old oaken bucket" so full of bitter quaffs for you. It means that once you found solid footing in the new land of freedom, you

might tax your mind to blot out all the sorry past, all the old associations, to become alien in spirit as well as in fact. It pleases me folks to be able to report to you that none of this has possessed Josephine. I tested her and she rang true. What she does is for you and me. She said so out of her own mouth. Her eyes glistened as she expostulated and described in vivid charged phrases the aim and purpose of her work. She proud when I told her of Lena and of Hilda [Simms]. "You girls are blazing trails for the race," I commentated. "Indeed so," she quickly retorted. After she had talked at length of what it means to be a Negro and of her hope that whatever she did might reflect credit on Negroes, particularly the Negroes of her land of birth, I chanced a leading question. "So you're a race woman," I queried. I was not sure she would understand. But she did. "Of course I am," she replied. Yes, all the world's a stage and Josephine comes out upon it for you and for me.

In my own work, I have tried to focus on the complex interaction between oppression and resistance, aware of the dangers of romanticizing losses while at the same time aggrandizing little victories, but I am still awed by how a single human spirit refuses the messages of self-hatred and out of bits and pieces weaves a garment grand enough for the soul's and body's passion. Ms. Hampton prized her memories of Josephine Baker, Marian Anderson, and Paul Robeson, creating for herself a nurturing family of defiant African American woman and men. Her lesbian self was part of what was fed by their soaring voices. When the *New York Times* closed its obituary on Ms. Hampton with the words "There are no known survivors," it showed its ignorance of how an oppressed people make legacies out of memory.

In our history of Ms. Hampton, we are now entering the so-called conforming 1950s, when white, middle-class heterosexual women, we have had been told, are running in droves to be married and keep the perfect home. Reflecting another vision, Ms. Hampton carefully cuts out and saves newspaper articles on the pioneer transsexual Christine Jorgensen. From 1948 until her retirement in 1972, Ms. Hampton will work in the housekeeping division of Jacobi Hospital, where she earns for herself the nickname "Captain" from some of the women she works with, who keep in touch with Ms. Hampton until their deaths many years later. Here she meets Ms. Jorgensen and pays her nightly visits in her hospital room.

From Ms. Hampton's documents: a *Daily News* article, December 1, 1952, "Ex-GI Becomes Blond Beauty," contains a letter written by Jorgensen explaining to her parents why there is so much consternation about her case. She concludes, "It is more a problem of social taboos and the desire not to speak of the subject because it deals with the great hush hush, namely sex."

Ms. Hampton begins the decade earning $1,006 for a year's work and ends it earning $1,232. Because of lack of money, Ms. Hampton was never able to travel to all the places in the world that fascinated her; but in this decade she adds hundreds of pages of stamps to her overflowing albums, little squares of color from Morocco and Zanzibar, from the Philippines and Mexico.

Throughout her remaining years, Ms. Hampton will continue with her eyes on the hilltop and her feet on a very earthly pavement. She will always have very little money and will always be generous. In the 1970s, Ms. Hampton discovers senior-citizen centers and "has a ball," as she liked to say, on their subsidized trips to Atlantic City. She will lose her partner of forty-five years, Lillian Foster, in 1978.

After almost drifting away in mourning, she will find new energy and a loving family in New York's lesbian and gay community. She will have friendly visitors from SAGE and devoted friends like Ann Allen Shockley, who never fails to visit when she is in town. She will march in Washington in the first national lesbian and gay civil rights march. She will appear in films like *Silent Pioneers* and *Before Stonewall*. In 1987, she accompanies Deborah and her lover Teddy to California so she can be honored at the West Coast Old Lesbians Conference.

She will eventually have to give up her fourth-floor walk-up Bronx apartment and move in with Lee Hudson and myself, who along with many others will care for her as she loses physical strength. On October 26, 1989, after a second stroke, Ms. Hampton will finally let go of a life she loved so dearly.

Ms. Hampton never relented in her struggle to live a fully integrated life, a life marked by the integrity of her self-authorship. "If I give you my word," she always said, "I'll be there"—and she was.

On her death, her sisters in Electa Chapter 10 of the Eastern Star Organization honored her with the following words: "We wish to express our gratitude for having known Sister Hampton all these years. She became a member many years ago and went from the bottom of the top of the ladder. She has served us in many capacities. We loved her dearly. May she rest in peace with the angels."

Class and race are not synonymous with problems, with deprivation. They can be sources of great joy and communal strength. Class and race in this society, however, are manipulated markers of privilege and power. Ms. Hampton had a vision of what life should be; it was a grand, simple vision, filled with good friends and good food, a warm home and her lover by her side. She gave all she could to doing the best she could. The sor-

row is in the fact that she and so many others have had to work so hard for such basic human territory.

"I wish you knew what it's like to be me" is the challenge posed by a society divided by race and class. We have so much to learn about one another's victories, the sweetnesses as well as the losses. By expanding our models for what makes a life lesbian or what is a lesbian moment in history, we will become clearer about contemporary political and social coalitions that must be forged to ensure all our liberations.

We are just beginning to understand how social constructs shape lesbian and gay lives. We will have to change our questions and our language of inquiry to take our knowledge deeper. Class and race, always said together as if they meant the same thing, may each call forth their own story. The insights we gain will anchor our other discussions in the realities of individual lives, reminding us that bread and roses, material survival and cultural identity, are the starting point of so many of our histories.

In that spirit, I will always remember our Friday-night dinners at the Archives, with a life-size photograph of Gertrude Stein propped up at one end of the table; Ms. Hampton sitting across from Lee Hudson; Denver, the family dog, right at Ms. Hampton's elbow; and myself, looking past the candlelight to my two dear friends, Lee and Mabel—each of us carrying different histories, joined by our love and need for one another.

Ms. Hampton's address at the 1984 New York City Gay Pride rally:

> I, Mabel Hampton, have been a lesbian all my life, for eighty-two years, and I am proud of myself and my people. I would like all my people to be free in this country and all over the world, my gay people and my black people.

The Will to Remember: My Journey with the Lesbian Herstory Archives

The most searing reminder of our colonized world was the bathroom line. Now I know it stands for all the pain and glory of my time, and I carry that line and the women who endured it deep within me. Because we were labeled deviants, our bathroom habits had to be watched. Only one woman at a time was allowed into the toilet because we could not be trusted. Thus, the toilet line was born, a twisting horizon of lesbian women waiting for permission to urinate, to shit.

The line flowed past the far wall, past the bar, the front room tables, and reached into the back room. Guarding the entrance to the toilet was a short, square, handsome butch woman, the same one every night, whose job it was to twist around her hand our allotted amount of toilet paper. She was us, an obscenity, doing the man's tricks so we could breathe. The line awaited all of us every night, and we developed a line act. We joked, we cruised, we commented on the length of time one of us took, we made special pleas to allow hot-and-heavy lovers in together, knowing full well that our lady would not permit it. I stood, a fem, loving the women on either side of me, loving my comrades for their style, the power of their stance, the hair hitting the collar, the thrown-out hip, the hand encircling the beer can. Our eyes played the line, subtle touches, gentle shyness weaved under the blaring jokes, the music, the surveillance. We lived on that line; restricted and judged, we took deep breaths and played.

But buried deep in our endurance was our fury. That line was
practice and theory seared into one. We wove our freedoms, our cul-
ture, around their obstacles of hatred, but we also paid our price.
Every time I took the fistful of toilet paper, I swore eventual libera-
tion. It would be, however, liberation with a memory.

 —From "The Bathroom Line," *A Restricted Country*

For the marginalized, remembering is an act of will, a con-
scious battle against ordained emptiness. For gay people,
remembering is an act of alchemy—the transformation of
dirty jokes, limp wrists, a wetted pinky drawn over the eyebrow
into bodies loved, communities liberated. When Albert Memmi
wrote the following passage in 1957, he was speaking as a Tu-
nisian Jew who had an intimate understanding of both cultural
exile and cultural power:

> [The colonized] draws less and less from [her] past.
> The colonizer never even recognized that [she] had one;
> everyone knows that the commoner whose origins are un-
> known has no history. Let us ask the colonized [herself]:
> who are [her] folk heroes, [her] great popular leaders, [her]
> sages? At most [she] may be able to give us a few names, in
> complete disorder, and fewer and fewer as one goes down
> the generations. The colonized seems condemned to lose
> [her] memory.
>
> —*The Colonizer and the Colonized*, 1957 (female pro-
> nouns mine)

When I read those words in 1971, I knew he was speaking
for me as well.

The politics of culture is a very complex thing, filled with
opportunities for acceptance that can turn in an instant to mo-

ments of betrayal of self and community. Deprivation of cultural recognition makes one hungry, makes one yearn for the center. But for those who have lived in a ghetto of any kind, the matter is not one of a simple exchange of marginality for normalization.

In 1992, I was asked to speak at an older women's educational forum at Bryn Mawr College. Three of us from differing backgrounds had been asked to address the themes of diversity, silence, marginality, and danger. I knew I had been asked to be a part of this event because of my work with the Lesbian Herstory Archives, and in preparation, I had been scribbling down random thoughts and disturbing excerpts from the daily newspapers, as I usually do when some idea, not yet clearly expressed, is nibbling at my mind. For some time, I had been wondering about what the national concern for diversity actually meant when it applied to gay people. I thought I had found some clues.

From the *New York Times*, March 2, 1992: "Jews Debate the Issue of Gay Clergy Members."

From the *New York Times*, April 9, 1992: "The bishops issued the 3rd draft of a Letter on Women calling for lesbians to practice chastity."

From the same newspaper, April 12, 1992: "Examples abound of subjects that were very much discussed by insiders [on the pro-tennis circuit] but publicly taboo, ranging from the gay subculture on the women's tour to drug abuse on the men's. No one wanted to spread scandal."

While I applauded the concern with diversity, these ongoing cultural skirmishes made me suspicious. How does a woman who has lived her life as what most societies, including this one, call a "sexual deviant" leave the cultural place that has been her home for over forty years? How does she decide what to take with her and what to leave behind? What to remember and what

to forget? For this is the challenge we face when we are asked to believe that the society around us is really changing, that marginal voices are being asked to join a chorus of equitable inclusion.

As a queer woman—and I use that term because I came to my sexual and cultural self in the working-class bars of Greenwich Village in the 1950s and sixties, and there I was schooled in queer survival—I am not convinced that the calls for inclusion really include me or my community, in our full cultural expression. I could pass as a woman, even as a feminist—though respect for this profound way of seeing the world is getting more difficult to come by—but as a lesbian who insists on the importance of her sexual choices, I do not feel on safe ground. I know how to live on the shifting terrain of the margin, for there we knew more than the intruders, but I move very cautiously into the new territory that is being offered.

Perhaps younger women will feel more at ease, more trusting of this new place, but they will not have the same memories, the same fears of betrayal, the same sense of comrades left at the border who could not cross over. How do I remain true to Maria, the bartender from Barcelona, who protected me from police entrapment in the early 1960s, or to Rachel, the lesbian who lay in my arms dreaming of a kinder world, or the butch women I saw stripped by the police in front of their lovers? These actions happened in marginal places, the reserves on which we were allowed to touch or dance or strut until someone decided, Enough of these freaks, and took our fragile freedom away.

But this old country, as James Baldwin called his historical ghetto—the Jim Crow–ridden American South—is a complex and paradoxical place. I never want my lesbian daughters to have to find each other in bars where police brutality is rampant, to dance in a public place where a bouncer measures the distance between the partners to make sure no parts of the body are

touching. I never want their clitoris and nipples measured by doctors convinced that lesbians are hormonal abnormalities, as was done in the 1930s and forties, and yet, while I know that living in the preliberation gay ghetto endangered my life, remembering it *gives* me life.

My journey with the Lesbian Herstory Archives can be told in two ways—the factual development of a vision into a building filled with the artifacts of lesbian life, or the interior movement from my sense as a person deprived of historical memory to one glorying in the possibility of it. The journey from deprivation into plentitude is how I have put it on endless Archives tours. It is also a journey from silence into speech, from shame into revelation.

From the Archives' visitors' book, 1979:

> For two days I have been thinking up wise and pithy things that I should include—no dice. So perhaps, the honest will work better. Only once before have I felt like I've come home. This is the second time. I never thought I would be that lucky again—and I realize it is my right to come home to the world. Thanks to you and all the lives in this room for showing me that right!
> —Judy

One of the first cultural goals of the Archives project was to salvage secrets, to stop the destruction of letters and photographs, to rescue the documents of our desire from family and cultural devaluation. At almost every presentation of the Archives slideshow, a woman would tell us a tale of loss, of a family member destroying diaries or burning letters. Time and time again a woman would confide in us how she had destroyed records of her early homoerotic life, whether it was

her stash of 1950s lesbian paperbacks, the first cultural products she had ever found that testified to a public lesbian world, or the passionate outpourings of young love. I will never forget the moments of understanding that occurred, of relief and sometimes of mourning, when an older woman accepted the possibility that acts she had considered shameful for so long could be seen in another way, could be seen as cherished cultural moments in a community's history. In the early 1970s, this acceptance of another context for the remembered touch was a pure act of will.

In the early years of the archives, Deborah Edel and I scoured small-town library and church book-sale tables, often finding a rare lesbian novel that had been selected for throwaway; in the mail, we would often get posters and other memorabilia that had been saved from trash heaps. So many times did this reversal of cultural fortune happen that we publicly spoke about transforming what this society considered garbage into a people's history. The retrieved documents, in their often coded and yet staunch way, challenge the prevailing historical view of the pathology of same-sex love. Now I understand that these acts of retrieval were also personal moments of reconstitution for me.

An excerpt from a love letter (c. 1920) found in a Greenwich Village gutter after the family had cleared out the apartment of Eleanor C., a labor educator of the thirties and forties:

> This is a "very quiet" letter, Eleanor dear, and you won't read it when you are dashing off somewhere in a hurry, will you—please.
>
> Thursday night
> Best Beloved

I'm writing by the light of two tall candles on my desk, with the flamey chrysanthemums you arranged before me. It's such a lovely soft glow and I'm glad because this is a "candle light" letter. I wish you could know what a wonderful person you are, Eleanor darling, and what joy your letter written last night gave me. Not the part about me—that is pitifully wrong and only a standard for me to measure up to—but you make it all so wonderful and are clear about it all, but I could never say so, even in incoherent fashion, and so many times back of my nobler resolves I am just plain selfish about wanting you to look at and talk to—and I'm not afraid dear, I know our love will help—oh so much and not hinder, it never does that, not even in my weakest moments. . . .

The candles are burning low, dear heart and the world is very still and beautiful outside. And I am so, oh so happy that I know you and love you. May God bless you through all time.

—Alice

My history with the growth of the Archives directly parallels my involvement with gay liberation and lesbian feminism. Just as my queer past was constructed by social judgments and culturally restrictive politics, my time of hope was hewn out of the glory of public possibilities. The early 1970s, so deeply influenced by the progressive movements of the sixties, was a time when some constructed a new social self.

In 1972, a few of us who worked in or were being educated by the City University system of New York, people like Martin Duberman and Seymour Kleinberg, founded an organization called the Gay Academic Union (GAU). This was how we did things back then: if there was a problem of lesbian

or gay exclusion or misrepresentation, we sat down in a circle and came up with an organization to address it. Concerned with the plight of gay students and teachers in high schools and colleges, the GAU became a rallying place for early gay scholarship and battles against isolation and homophobia in the educational system.

The Lesbian Herstory Archives was conceived in discussions with members of my GAU consciousness-raising group: women like Deborah Edel, who was to become my first lesbian-feminist lover as well as co-founder of the Archives; Julia Penelope Stanley, whom I had known in the "old" days and whose version of radical feminism I would come to vehemently oppose; her lover Sahli; and Pamela, a political lesbian. Here in an embryonic form were the streams of consciousness of the seventies, ranging from old-time fem to gay liberation politics to lesbian separatism to "lesbian" as a political identification without erotic significance. And here also was the beginning of the discourse about memory, history, and sexuality that would keep me in its throes for the next thirty years. In the Archives' statement of purpose, our need for cultural autonomy rings out loud and clear.

From the Archives' newsletter, no. 1, 1975:

> The Lesbian Herstory Archives exists to gather and preserve records of lesbian lives and activities so that future generations will have ready access to materials relevant to their lives. The process of gathering this material will also serve to uncover and collect our herstory denied to us previously by patriarchal historians in the interests of the culture which they serve. The existence of these archives will enable us to analyze and reevaluate the lesbian experience; we also anticipate that the existence of these ar-

chives will encourage lesbians to record their experiences in order to formulate our living herstory.

The Archives, with its collection of lesbians speaking for themselves in a myriad of ways, were to be our answer to the medical, legal, and religious colonization of our lives. In 1974, the Lesbian Herstory Archives took up its home in the large apartment I shared with Deborah Edel. My relationship with Deborah was a living symbol of the Archives' cultural compassion; she, shaped by the 1970s, never flinched at my tales of the bars, at my need to find the voices and images of the community that had given me life and to make sure that the artifacts of this earlier lesbian time had a home.

The generosity of Deborah's historical and psychological imagination allowed me to work out ways to give a place of honor to life I had lived on the margins of American society, while we worked to change the norms of that same society by creating the very notion of lesbian and gay history. I used the Archives' newsletter to express my concern about the kind of history we were about to create and to do battle with the more severe lesbian feminists who were so judgmental of my pre-liberation butch-fem community. Using all the tools of liberatory politics, I was attempting to hold on to a place I knew of as home and to let it go all at the same time.

From the Archives' newsletter, no. 7, 1981:

If we ask decorous questions of history, we will get a genteel history. If we assume that because sex was a secret, it did not exist, we will get a sexless history. If we assume that in periods of oppression, lesbians lost their autonomy and acted as victims only, we destroy not only history but lives. For many years, the psychologists told us

we were both emotionally and physically deviant; they measured our nipples and clitorises to chart our queerness, they talked about how we wanted to be men and how our sexual styles were pathetic imitations of the real thing and all along under this barrage of hatred and fear, we loved. They told us that we should hate ourselves and sometimes we did, but we were also angry, resilient, and creative. And most of all, were lesbian women, revolutionizing each of these terms.

We create history as much as we discover it. What we call history becomes history and since this is a naming time, we must be on guard against our own class prejudices and discomforts. If close friends and devoted companions are to be part of lesbian history, so must be also the lesbians of the fifties who left no doubt about their sexuality or their courage.

Because of my own experience with the criminalizing 1950s, I felt it was essential that the Archives not become a handpicked collection of respectable lesbian role models. The emphasis on inclusiveness made the Archives a focus of controversy. Yes, we wanted the papers of Samois, the first national public lesbian S/M group. Yes, we wanted the diary of a lesbian prostitute. Yes, we would cherish the pasties of a lesbian stripper. Yes, we wanted collections of women-with-women pornography. I knew that a memory fashioned to the prevailing precepts of one time, no matter how profound that time might be, would never be complex enough, never filled with wonders enough, to be the living, needed gift to the unknown future that we all wanted this collection to be.

Now hard hats and hobnail boots sit next to pasties and glossy prints of a famous lesbian stripper of the 1940s. They, in

turn, are joined by the Lavender Menace T-shirt of the NOW rebellion in the 1970s; photographs of bar patrons of the 1930s are in the same room as images from the Michigan Womyn's Music Festival. A DOB (Daughters of Bilitis) certificate of organization, an artifact from the late 1950s, shares a shelf with a Lesbian Avengers poster, an artifact from the urban 1990s. A copy of "Women-Loving Women," the manifesto of the early days of lesbian feminism, lies next to an album cover featuring the smiling, boyish face of Billy Tipton, the jazz musician who was born a woman but passed as a man for most of his life. This is the history I wanted: a conversation of possibilities, of lineages, of contradictions.

Throughout my intimate life with the Archives, for the twenty years or so that it filled my apartment with its file cabinets and bookshelves, its endless stream of visitors, I was always looking for icons of resistance. I found them in the out-of-print books, the oral history tapes, old copies of homophile publications like *Vice-Versa* and *The Ladder*, snapshots, and snatches of conversation between visitors. Stories came to me—the story of the young butch woman in the 1950s who always sewed a piece of lace on her socks before she went to the bars so the police would not arrest her for transvestitism; the story of the sophisticated fem who carried her dildo in a satin purse so when she left the bar with her chosen woman of the night, she knew the woman would be well pleased; the story of a young Jewish woman who had read *The Well of Loneliness* in Polish before she was taken into the concentration camps. "That book helped me to survive; I wanted to live long enough to kiss a woman," she told me one night while we sat at my dining-room table having a cup of tea. These stories filled my heart; they healed me and educated me and changed for me forever that which I would call history. They have become the tropes of my writing, the proclamations of

the lesbian spirit that I repeat over and over. They are my jewels of discovery, the riches that lay beneath that marginalized land.

From the Archives' newsletter, no. 3, 1976:

> Summer was an interesting time for the archives with a record number of visitors including women from California, England and Italy. I found that whether I was talking with lesbians from Manhattan or Europe, the concern expressed for the preservation of our herstory creates an energy that whisks the archives from the past into our daily lives. There is motivation and activity everywhere. In London, women are producing street theater in the Punch and Judy tradition to support the Wages for Housework Campaign. In Italy, lesbian groups are beginning to meet in high schools. Some of our visitors organized lesbian centers or were responsible for coordinating such notable events as the Lesbian Herstory Exploration near Los Angeles. Of course in many cases the enthusiasm was closer to home, taking the shape of a "Hello, I just found out the archives is a few blocks away and I'd like to stop by tomorrow." This summer brought a feeling of universal lesbian power—women united in the celebration and adventure of pursuing our identity.
>
> —Valerie

After Deborah and I separated, and Judith Schwarz, who had become part of the Archives collective in the late 1970s, moved out of the apartment, I was left alone with this huge collection of memory, in which the past and present sat cheek to cheek with each other. I felt this aloneness particularly after Thursday night work groups, when the many women who volunteered to work with the collection would take their leave, several rushing

off to the subways and buses that carried them to Brooklyn. I would walk through the apartment, past the boxes and piles of clippings, wondering at what my life had become. Could these gathered voices keep my own alive? Could these tales of resistance and desperation, of love and the loss of it, of gender construction and sexual adventuring, change forever the loneliness of our cultural exile? Of my own life?

From the visitors' book, 1983:

> I am here among women
> who breathe softly in my ear
> who speak gently
> in a voice that will not be stilled.
> I am here in a cradle
> or a womb,
> or a lap,
> on a knee that is shapely
> under my thigh
> leaving the impression
> that I will never be alone.
>
> I am here
> to remember faces
> I have never seen before
> and I do
> Love,

—Jewelle Gomez

Twenty-nine years have passed since I started this journey to find a public face for lesbian memory. When I look over the Archives' newsletters of the 1970s, I can see how the discourse has changed. The word *identity*, so popular in that decade,

is more complicated now, more challenged in its implications. Transgender and passing women's history is no longer an orphan child of the movement, and no one need apologize any longer for an interest in butch-fem or leather communities—at least within the confines of our own queer movement. Lesbian, gay, bisexual, and transfolk history are now thriving concerns, with both public and private institutions undertaking their own collections. The success of queer theory on college campuses has ensured, at least for now, a continuing flow of published and cultural discussion. When the New York Public Library opened its gay and lesbian history exhibit a few years ago in a cocktail-party atmosphere, I knew another time had come, and I feared for the life of my grassroots dream.

As I toured the exhibit, one to which the Lesbian Herstory Archives had contributed, I kept thinking of the first time I had ever tried to find out about my queer self. I was a high school senior, and I wanted to do a research paper on homosexuality. The year was 1957. My teacher had told us about the world-renowned library on Fifth Avenue, so I made my way to the institution guarded by its two ageless stone lions. Too ashamed to ask a librarian about my topic, I toured the endless rows of wooden card-catalog cabinets until I found the letter H. I pulled out the long narrow drawer and flipped through the timeworn cards. Finally, my heart beating, I found the word "Homo-sexual," followed by a dash and then the words "see Deviancy," and next to this "see Pathology," with suggested subcategories of prisons and mental institutions. I never wrote that paper. But years later, remembering that journey of self-hatred and strengthened by my marginalized culture, I helped to create in the same institution that had played such a powerful role in our cultural disenfranchisement another story of same-sex love, one that recognized not only our humanity but also our power of choice, of self-determination.

In 1993 the archives moved into a three-story limestone building in the Park Slope section of Brooklyn, New York. Over two hundred volunteers, including lesbian architects and carpenters, worked for a year to prepare the building for its new life. The core group of coordinators who are responsible for the daily life of the collection has expanded to include over twenty women, many of whom are archivists and librarians. In June of 1996, we celebrated with our larger communities the burning of our mortgage, the accomplishment of a grassroots miracle. I am no longer the caretaker of our collection; I no longer sit at the endless bimonthly meetings where women slosh through the grinding demands of tours, research questions, collection building, workdays. When I can, I take a car service to this Brooklyn home, and I sometimes have to ask a woman I do not know what she is doing or where something is. After giving a tour, when the house is silent, I walk through the collection. I look into closets to see if old friends are still there—like the army uniform worn by a lesbian woman who served in Vietnam as a medic or the ripped leather jacket with studs on the back spelling out "Dyketactics," the name of an early zap-protest group from Philadelphia. I push a book back into place, or stare into the face of a friend who now lives beyond her death in this home of memory. And I know that sometime I, too, will be returned to where I came from, to this place of cherished difference. When I close the door behind me, I often just stand on the stoop, marveling at the solidity of the home we have created.

And solid it had better be.

From the *New York Times*, July 7, 1998:

> Mr. Craig, the organizer of Greenville, South Carolina's Citizens for Traditional Family Values, said he believed that homosexuality was "demonic" and "a stench in the nostrils of God."

The Beauty of the Unarmed Human Body

My Right
To Live
To Choose
To Be
—These words, in Arabic and English, are on a
T-shirt produced by ASWAT, The Palestinian Gay
Women's Group

Translations are very special gifts to writers. They are acts of generosity that undertake the most difficult of things—to transpose moments of the imagination, so specific in history and language, in geography and culture, into another imaginative world with its own complex continuities. Translations are divine interruptions in the lives of texts. I do not think my work is divine an any way, but I do know that all who have struggled with the specifics of my language choices, who have helped to bring this volume into being, are the best friends a writer can have.

In May of 2007, my partner, Diane Otto, joined our new friends Dalia Sachs and Hannah Safran in their home in Haifa. This was our first visit to Israel—there is a direct line from the Women in Black vigils in New York City to us climbing up the worn Haifa steps, with the old port behind us and the sad complexities of this city, this land, above us. The twelve days we

spent in Israel-Palestine formed the most profound journey of my sixty-seven years of life. Our hosts, including Gila Svirsky in Jerusalem, forced us to see through their eyes, through their hearts, what peace activists in this country face every day—the wall, the checkpoints, the struggle to keep alive the best of the Israeli vision for another kind of nation. Like feminist peace activists back in New York and Melbourne, Australia, our other home, and around the world—where women stand on street corners calling for the end of occupations, armed conflict, the suffering of citizens at the hands of militaristic regimes—the women we met in Israel were both tired and generous, welcoming and questioning.

Dalia and Hannah had arranged for me to speak with the women of the Haifa feminist community at two events, a potluck in their home and a gathering at the Haifa Women's Center, Isha L'Isha. At the shared dinner, I met many of the wonderful women and David, the publisher who would become involved in this project. One of the conversations I had that night went right to the heart of me. Rouda, one of the founders of AS-WAT, told me she had never heard of my work—"What is it about, your work?"

Before this forthright question, we had been talking about the possible richness of the margins, the subversive force that comes from surviving the blows of power, and then even more, using the richness of that which is denigrated, hunted, to create another kind of strength—one that never ceases to call for liberation. My words staggered as I tried to depict a life's work. The deeper confusion was the question, Do my writings about lesbian-queer-fem bodies and histories, American, New York–marked social and racial struggles, about my Bronx-born working-class eroticized Jewish mother deserve to live in the face of Palestine's-Israel's struggle for existence? This transla-

tion will give each of you the chance to decide for yourselves: are my words of any use.

After a sleepless night pondering Rouda's question, I met with the women in the Haifa Women's Center, beginning my own act of translation—by reading "My Mother Liked to Fuck" and "The Bathroom Line." I needed to be as honest about what compels my writing as I could to begin our discussion. I can still see us, sitting in a very large circle, languages flying around the room as women with different histories translated my words to each other, trying to find common ground. I had learned from reading from reading *Sappho in the Holy Land* (edited by Chava Frankfort-Nachmias and Erella Shadmi, 2005) that women's centers such as Isha L'Isha had played a critical role in allowing women to explore their sexual and political selves. Earlier in the week, we had met with Nabila Espanioly, the director of the Nazareth Women's Center, and in these two sites of feminist yearning, I saw dynamic communities of women—Palestinian, Ethiopian, Jewish, Druid, Christian, old and young—working together. I saw hope.

The conversation next continued in a Tel Aviv classroom where I spoke about "History, Passion, and the Body," as part of a series of programs sponsored by Gay and Lesbian Studies, the Queer Theory Reading Group, and NCJW Studies Forum—thank you all—and it was here I met a young group of queer women, part of Israel's butch-fem community, many of whom had also been members of Black Laundry, a new generation's version of Women in Black. Because of my work with the Lesbian Herstory Archives, I am a carrier of voices from what I call our survival time, and I shared some of them that afternoon, including the story of Jul, a young Italian working-class butch woman who had spoken to me, many years ago now, about her erotic adventures in the early 1960s bars of Greenwich Village.

An older butch woman who had seemed to be enjoying our discussion was upset by my thanks yous to Women in Black and Black Laundry. "Why do you need to put politics into our story," she said. As I answered her, and she resisted, we met in some other place, the place where old comrades who over their lifetimes have fallen out can still, from time to time, remember the shared humiliations and the muted victories of their common histories. At the end of the two hours, a group of fem women came up to talk with me about the difficulties they face, the judgments from all sides that accompanied their lives. As they spoke and I comforted, I saw their beauty.

That night we spent in the Jerusalem home of Gila and her partner Judy; the following day we stood vigil with Women in Black against the Occupation in the roundabout trying not to flinch at the hatred shouted at us from passing cars, two ninety-year-old Israeli peace activists refusing to give ground. Gila took us through the streets of Jerusalem, letting us take in the settlers with their rifles slung over their shoulders, the mounds of spices in the old market. At one point we crossed over the green line, going into the West Bank, the pomegranate-juice vendor tipping his back to let the sweetness flow into the small cups of his customers. We traveled along the wall surrounding Bethlehem, stopping at the checkpoint controlling Palestinian entry and departure, and finally into the frantic histories of the old city. A long hard day.

In the evening, another communal sharing of food; many of the young people who had been present in Tel Aviv had made their way to Gila's house for this last shared dinner. Feeling a little tired, I sat in the backyard, taking in the scents of the warm night air, the night sounds of Jerusalem. One by one, the students and their friends came to sit around me. They wanted stories of the body, wanted tales of how we survived the bigotries

of the 1950s, how we found each other and tried to imagine another world. We leaned into each other and again I saw the beauty of the unarmed human body, their hopes for another kind of future held in their bare arms. "Come back to us," one of the young women said, "when the occupation is over."

I do not think I will be able to make this journey again, and so this book, brought into being by the generosity of so many, is the way I honor all those in Palestine and Israel who bare themselves in the face of history and ask for an end to dispossessions, walls, and exiles.

Voices from Lesbian Herstory

To live without history is to live like an infant, constantly amazed and challenged by a strange and unnamed world. There is deep wonder in this kind of existence, a vitality of curiosity and a sense of adventure that we do well to keep alive all of our lives. But a people who are struggling against a world that has decreed them obscene need a stronger bedrock beneath their feet.

We need to know that we are not accidental; that our culture has grown and changed with the currents of time; that we, like others, have a social history composed of individual lives, community struggles, and customs of language, dress, and behavior— in short, that we have the story of a people to tell. To live with history is to have a memory not just of our own lives but of the lives of others, people we have never met but whose voices and actions connect us to our collective selves.

Having a history may be harder than not having one: this reality of continuity in time carries with it its own burdens. We lesbians in the 1980s will be in trouble if we act as if the 1950s or the 1920s never existed. Because of the work of grassroots

This essay is adapted from a keynote speech I gave at the 6th Amazon Autumn Annual Conference in New Jersey in 1982, the first time I presented my ideas about lesbian history in this formal manner. It was reprinted in the now out-of-print Canadian gay newspaper, *Body Politic*, in September 1983. The debt my work owes to the Lesbian Herstory Archives is made particularly clear in this marshaling of pre-1970 lesbian history.

national and international lesbian and gay historians, we have found patterns both in our oppression and in our responses. We can begin to analyze what went wrong and what went right. We are able to record the birth of new ways and to watch the dying of old ones. History makes us alone, at one and the same time part of a community and alone as we watch the changes come. Having a history will certainly complicate the issues because simplistic positions will seldom do justice to it.

I am forty-two years old (1982), and I came out in 1958. I have made this statement many times before, but only now am I beginning to understand my own historical complexity. As I watch and participate in the lesbian community now, I have many echoes in my head. I hear the voices of other times, teaching me important lessons. I celebrate and mourn at the same time. I want to tell you about what my past has taught me and about the challenges facing us today.

The lesbian community is at a crossroads: we can either betray ourselves or carry our courage, culture, and intelligence into new territory. The recent raid on Blues, a Black lesbian and gay men's working-class bar in Manhattan; the harassment of Déjà Vu and the Duchess, two New York City lesbian bars; the police attacks on Black lesbians in Washington Square Park; the increased physical assaults on lesbians and gay men in all parts of the country; the renewed arrests on Long Island of men wearing women's clothing; the refusal to give S/M lesbian women space to talk and explore their sexuality; the hostility towards butch-fem lesbians—all of these bring back to me the first layer of my history: the memory of being a queer, my inheritance from the fifties.

This is the layer of memory that makes me feel most lonely. The word *queer* is seen as a male word, or is so removed from the liberating energies of lesbian feminism that it makes me feel like

a relic from another time just to use it. But I need the wisdom of that memory now. I need to remember what it was like to walk the streets as a young fem with my butch lover. I need to remember what it was like to fight for sexual territory in the time of Joseph McCarthy. I need to remember the humiliation and the courage of standing in the bathroom line. I need to remember the flashing red lights that signaled police visits and the closed faces of the vice squad, the police wagons carrying off my friends. I need to keep alive the memory of passing women and their wives, the memory of lesbians who because they "looked like men" were ridiculed, beaten, locked up, hidden away. These women presented gender challenges at a time when only deviants questioned gender destiny. I need to keep alive the memory that in the 1940s doctors measured the clitorises and nipples of lesbians to prove our biological strangeness. When transvestites and transsexuals are beaten by the police, as they were at Blues, this history calls me to action. I cannot turn away from it. My roots lie in the history of a people who were called freaks.

The 1980s, a more enlightened time, also bring a message about being different. In a 1980 article in the *Journal of Homosexuality*, "Sexual Preference or Personal Style? Why Lesbians Are Disliked," two well-meaning sociologists documented the anger of more than five hundred straight students, male and female, at lesbians who were clearly butch-fem identified. These are the lesbians found most objectionable by the survey's straight participants. The authors' closing advice is that if lesbians want greater heterosexual acceptance, they should adopt an androgynous style.[1] I know this bargain, and it is a killing one. We are offered respectability if we "tone down" our lesbian selves; we

1 Mary Riege Laner and Roy H. Laner, "Sexual Preference or Personal Style? Why Lesbians Are Disliked," *Journal of Homosexuality* 5, no. 4 (1980): 339–356.

are offered safety if we separate ourselves from the easily recognizable other. I feel the fear of being recognized as queer every time we use the word *woman* when we know we really mean *lesbian*. But I know queer women. I know their power and their courage, as well as their loneliness and their pain.

From "Memories" by Jeanne Flash Gray, who writes about Harlem gay life in the 1930s and forties in *The Other Black Woman*:

> Before it was discovered by others that black lesbians and gay men had money to spend, there were many places in Harlem run by and for black lesbians and gay men. When we were still bulldaggers and faggots . . . I am glad I had a chance to go to Blind Charlie's and Mr. Rivers and similar places in Harlem. I am glad I had a chance to be a bulldagger before it became fashionable to be a lesbian.[2]

From a letter to the Lesbian Herstory Archives documenting the early history of the Moody Garden Gang, a butch-fem working-class lesbian community in Lowell, Massachusetts. The words belong to Jean, the lead guitarist and singer of an all-women's band that entertained in the late 1950s and early 1960s:

> When I was asked to play at the Silver Star Café in the fifties, there wasn't a place around for gay people and the few friends you had found to get together, and there was always the fear of being asked to leave a bar or being physically hurt when you left the bar at night. But here was a chance to be myself and be accepted for what

2 Jeanne Flash Gray, "Memories," *The Other Black Woman* 1, no. 1 (1981).

I was. We started playing Friday, Saturday, and Sundays, all day, and within a short time, you had to be there early to get a seat. The kids poured in, and even though it still was a straight bar, we outnumbered the straights four to one, and sometimes more than that. They came from all around, some traveling for two or three hours just for an evening with us. It was our Mecca, we were family, and we had found a home. . . . So many of the new kids ask what's so special about Moody Gardens. To us it was our world, a small world, yes, but if you were starving you didn't refuse a slice of bread, and we were starving just for the feeling of having others around us. We were the kings of the hill. We were the Moody Gardens. And today the phrase "Moody Gardens" is as much a part of our lives as it was then. There isn't a person today that was part of that era that doesn't remember the good times and the bad, the friends that even after thirty years still take time to come together and remember. We are a small part of our history, and that's why I have to write and tell our sisters of today that if there hadn't been little Moody Gardens all over the world, we wouldn't even be allowed to get together as we do today and feel, in a small way, we are being accepted and we are not alone.

New York City, 1927: The first play on Broadway with a lesbian theme [now I know it to be the second, the first being a Yiddish play] is closed by the New York City vice squad for being immoral. Cast members and producers are arrested. A coalition of women's and church groups spearhead the campaign against this play and several others in New York and New Jersey that have gay sexuality as their themes.

New York City, 1962 (from *Beebo Brinker*, a lesbian paperback novel written by Ann Bannon):

A rash of raids was in progress on the homosexual bar hangouts at the moment, with cops . . . hustling old dykes who were Village fixtures for eons, off the streets so they wouldn't offend the deodorized young middle-class wives.

New York City, 1964: Forty-six lesbians are arrested in the largest raid on a lesbian bar in New York City.

December 1971: The United States Supreme Court rules that photographs showing explicit lesbian sexual activity, including embracing, are obscene and therefore pornographic.

Toward the middle of the 1960s I began to see clearly that besides being a queer, I was also a lesbian. I was part of that particular tradition and culture, a culture which often brought me into conflict with another history I shared, that of being a woman. It wasn't until the early seventies that I learned the vocabulary of feminism and recognized, in another way, what I had loved and admired in older lesbians: their audacity to be their own women, their brave dependence on no one but themselves for economic survival, their courage to have sexual expertise and to offer it to other women, their creation of women-loving communities in their homes and neighborhoods, their communal support of each other in times of illness, separation, and death. I had known a feminist community before I heard the clear enunciation of the ideology.

Feminism is now as essential to my history as is my lesbianism—it is a way of viewing the world that challenges every traditional assumption about women. I have watched language change as women refuse to be historically trapped in old paradigms, old schemes of life that limit and distrust the power of women. I have been healed by women who are in search of old wisdoms, who have learned to understand their need for new sources of spiritual strength. I am part of the concrete struggle

of feminists, lesbian and straight, to challenge the physical brutalization of women that haunts all societies. Rape crisis centers, battered women's shelters, information hotlines are all creations of the 1970s, when feminism and lesbianism joined hands.

All women's lives are precious, but histories are complicated things. While all lesbian history is women's history, not all women's history is lesbian history. These identities may be intertwined at times, but they are separate, distinct legacies, and at other times they may be in conflict.

From a letter dated January 10, 1927, written by a woman visitor to a meeting of the Heterodoxy Club, a group of feminists who met regularly in Greenwich Village:[3]

> One thing interested me or rather bothered me terribly in that meeting. I wonder whether you noticed it—or whether it was all my imagination. It was the woman who sat two places to the left of Dr. Hollingsworth. I think her name was Helen Hull. It seemed to me that she had gone through a hell of a life when she was younger. When Dr. Hollingsworth included in her definition of the perfect feminist a woman happily married and with children, it shattered all Miss Hull's defense mechanisms. Did you notice how she turned to the other psychoanalyst with white hair—Dr. Potter, wasn't it—and to one or two others and hoped they would back her up and when they did not, did you see her face and notice that she never spoke again? I wonder whether you know anything about her. I may be a fool, but I think there was a good deal of tragedy for her involved in that situation.

3 See *The Radical Feminists of Heterodoxy* by Judith Schwarz (Norwich, Vermont: New Victoria Publishers, 1986).

In our time, the debate over sexuality has opened historical wounds made even deeper by the fact that now it is other lesbians who are judging the acceptability of our sexuality. This is what history has taught me:

If we choose to involve ourselves in the antipornography movement, it would be helpful to keep in mind that many of us were the early victims of vice-squad raids, that some of us are lesbian prostitutes and sex workers, that we have a long history of surviving and finding each other in places other women were too frightened to walk through, that sexuality has always been our frontier.

If we sign the NOW resolution against, among other things, the public display of affection, we should remember that others, like myself, made love in public bathrooms, on public beaches, in parked cars, and on church pews, because we had no other place to go; that lesbians in the fifties were called obscene for holding hands in public.

My lesbian history tells me that the vice squad is never our friend even when it is called in by women; that when police rid a neighborhood of "undesirables," the undesirables also include street lesbians; that I must find another way to fight violence against women without doing violence to my lesbian self. I must find a way that does not cooperate with the state force against sexuality, forces that raided my bars, beat up my women, entrapped us in bathrooms, closed our plays, and banned our books.

Shame and guilt, censorship and oversimplified sexual judgments, the refusal to listen, and the inability to respect sexual difference are not the qualities of the world I have fought to create. The real challenge to all of us, lesbians and feminists, is whether we can eliminate violence against women without sacrificing women's erotic complexities. I do not want to become a

dictator of desire, not to other lesbians and not to gay men who have the courage to listen to their own voices.

From a letter to the Lesbian Herstory Archives Newsletter, written by Harriet Lane:

I lived at home in 1960. (I was nineteen.) So did my lover. Sometimes we went to cheap hotels in the Times Square area, but often even this was hard to arrange. Somehow we heard of a woman on Fourteenth Street who rented out rooms to lesbians by the hour or night (I no longer remember) and despite our terror of what we might find there, we went. The downstairs buzzer said "Amazon Ltd." on it. We were greeted at the door by a smiling woman who took us in the kitchen, made us some tea, and sat and talked with us for a while. Then she left us alone. The kitchen was at one end of a long hallway off of which there were several rooms. I guess these were the rooms she rented out, for we could sometimes hear muffled sounds coming from them. I don't remember ever actually seeing anyone else there. We never rented a room (still too afraid to acknowledge to someone else our erotic feelings), but we did go there frequently in that cold winter to sit and talk with her in the kitchen or by ourselves in the parlor room at the other end of the hallway. The woman, whose name I wonder if I ever knew, never asked for money, or pressured us in any way. It was for us a safe space, and now I wonder about that woman, and would certainly love to hear of anyone else who ever went there.

One of the lessons I have learned in trying to live with history is that for every repression, we have found a suitable form of resistance. Our history is the chronicle of our vitality, our passion, our cunning, and, at many times, our integrity. We

must now work out a way by which we can honor both the old and the new. We must look for connections rather than judgments.

As we strive to uncover matriarchal myths, we must also keep in our minds the "big-daddy tanks" of our jails into which lesbians who looked like men were thrown.

As we change our names to commemorate the earth, we must remember the women who changed their names to Frankie and Jo to commemorate their women-loving selves. And if we are tempted to dismiss them for being male-identified, we must reflect on how only the imprisoned know the kind of freedom they need the most.

While some of us may choose dress styles that clearly symbolize feminist fashion, we cannot judge the fem woman as either a victim or a traitor if she makes a visual gift of herself for the women she loves and for her own pleasure.

While we look for the rituals of the Amazons, we should also explore the customs of lesbian communities like the old Moody Garden Gang.

While we debate different sexual styles and their implications, we should never take from lesbian women their right to explore and champion the sexuality they have won for themselves. We must not become our own vice squad by replacing the old word *obscene* with the new phrase *corrupted by the patriarchy*.

We can honor the women who fight violence against women by our dedication to creating more rape crisis centers and battered women's shelters. We can also honor the women who struggle to find new ways for us to explore sexual desire and fantasies. The creation of safe, open, public sexual spaces for lesbians is a much-needed political action.

In these days of lesbian performers (or, as they call themselves, women performers) singing at Carnegie Hall, the wooing

of lesbians by national political parties, and big-budget gay civil rights organizations, remember that our battle is to be accepted in the fullness of our difference and not because we promise to be like everyone else.

As we explore women's culture and its connection to lesbian culture, we must realize that we no longer have to say that being a lesbian is more than a sexuality. Sexuality is not a limiting force but a whole world in itself that feeds the fires of all our other accomplishments. Many of us are just beginning to understand the possibilities of erotic choice and self-creation. It is this open declaration of our sexual selves that moralists and governments have tried to silence. They know that a lesbian celebrating her desire is a symbol of the possibility of social change for all women.

Is it turning forty that makes me see layers of identities? I see the queer 1950s, the lesbian 1960s, the feminist 1970s, and it becomes clear to me that memory is something that goes beyond sequential incidents. None of these years have gone away, and none of the experiences are outdated; they, the wonderful jumble of them all, are the source of my politics, my work, and my joy.

There are many other layers of our history that I have not touched on here: our individual ethnic and racial heritages, our class legacies, the community history of the differently abled, the history of lesbian parenting, the long lineage of cultural creators. They are all essential to our interpretation of our personal and communal experiences. They all may force painful choices at times, but with the conflict comes the glory—that we are all so many continuities at once.

Living with history may be burdensome, but the alternative is exile. We would never have the chance to embrace each other,

to urge each other on in telling the whole story. We should not use history to stifle the new or to institutionalize the old; rather, let it be a source of ideas, visions, tactics that constantly speak to us. The choices we make based on these voices and our own lives are the living gifts we bequeath to our lesbian daughters. Every present becomes a past, but caring enough to listen will keep us all alive.

Afterword: Homage to Joan Nestle

Susie Bright

Homage to Joan Nestle

Joan Nestle opened her heart, her lesbian hearth, and her perfect queer femme understanding to me, when I was very young. I was born in 1958. I came of age as a young political dyke, in high school, teetering on the cliff edge between the old-school gay veterans and the lesbian feminist generation. I knew how I loved women but was daunted by the exacting female critique of sexual style: what it meant erotically and politically.

Joan was a master of the dance! I laugh now, realizing that much of my slim confidence had to do with needing the time to grow up. —To have the quiver of lovers' trials. A girl needs role models. Joan was one of mine.

Joan was a lesbian femme, devoted to her butch lovers, and a sister and auntie to her femme comrades. She understood the profound ignorance of those who confused "heterosexuality" or "patriarchy" with our queer camp, our truly rare homosexual sex lives, and the rock, blood-rock, of gender-fuck. Joan had the character, writing acuity, and stage charisma to dig directly to the queer soul of the matter.

Joan wrote in "The Fem Question: We Will Not Go Away" her essay in *Pleasure and Danger: Exploring Female Sexuality,* "Politically correct sexuality is a paradoxical concept. One of the most deeply held opinions in feminism is that women should be autonomous and self-directed in defining their sexual desire, yet when a woman says, "This is my desire," feminists rush in to say, "No, no, it is the prick in your head; women should not desire

that act." She continued, "But we do not yet *know* enough about what women— any women— desire."[1]

Many lesbians of that era, prominent in academia, literature, or political leadership, were in two closets. One, they were not openly gay. Anywhere. And beyond that, they feared being discredited if more of their character was revealed. There was a sense that if you didn't fit a "Ms. Magazine" notion of the stoic cheerful Girl Scout sublimating her sexuality for feminism's unspecific future, you were letting down the side. (For what it's worth, the actual people at *Ms.* were far more complicated.)

Joan explained some of these dynamics in that essay:

> The real problem here is that we stopped asking questions too early in the lesbian and feminist movement and rushed to erect what appeared to be answers into the formidable and rigid edifice that we have now. Our lack of curiosity also affects our view of the past. We didn´t *ask* butch-femme women who they are; we told them. We didn´t explore the social life of working-class lesbian bars in the 1940s and 1950s; we simply asserted that all those women were victims. Our supposed answers closed our ears and stopped our analysis.
>
> If we close down exploration, we will be forcing some women once again to live their sexual lives in a land of shame and guilt. . . .

Joan would not put up with clichés and putdowns. She was relentlessly curious. Again, her words from "The Fem Question"—

1 This essay is not included in this collection but is available for further engagement with Joan's work.

Curiosity builds bridges between women and between the present and past; judgement builds the power if some over others.

Curiosity is not trivial; it is respect one life pays to another. It is a largeness of mind and heart that refuses to be bound by decorum or by desperation. It is hardest to keep alive in the times it is most needed, the times of hatred, of instability, of attack. Surely these are such times.

Joan was fearless; she could never be rocked back on her heels. Femme women didn't need to wipe their lipstick off, and butches didn't need to slap some on. We were not going to be stereotyped by squares and know-nothings. We presented ourselves, in our garments, our voices, and our sense of deep attraction to each other, with no apologies. We honored the women who came before us, who survived against ALL the odds. There would be no lesbian nation without us. Joan knew that, and she never backed down.

Susie Bright
Santa Cruz, California, September 2022

Best-selling author **Susie Bright** is a pioneering feminist sex writer, one of the world's most respected voices on sexual politics, as well as an award-winning author and editor who's produced and published many of the finest writers and journalists working in American literature and progressive activism today.

Joan Nestle: A Bibliography

Books

Nestle, Joan. *A Restricted Country: Essays and Short Stories.* Ithaca, NY: Firebrand Books, 1988.

———. *A Fragile Union: New and Selected Writings.* San Francisco: Cleis Press, 1998.

Edited Collections

Nestle, Joan, ed. *The Persistent Desire: A Femme-Butch Reader.* Boston: Alyson Publications, 1992.

Co-Edited Collections

Nestle, Joan, and Naomi Holoch, eds. *Women on Women: An Anthology of American Lesbian Short Fiction.* New York: Plume, 1990.

Nestle, Joan, and Naomi Holoch, eds. *Women on Women 2: An Anthology of American Lesbian Short Fiction.* New York: Plume, 1993.

Nestle, Joan, and John Preston, eds. *Sister and Brother: Lesbians and Gay Men Write about Their Lives Together.* San Francisco: HarperSanFrancisco, 1994.

Nestle, Joan, and Naomi Holoch, eds. *Women on Women 3: An Anthology of American Lesbian Short Fiction.* New York: Plume, 1996.

Nestle, Joan, and Naomi Holoch, eds. *The Vintage Book of International Lesbian Fiction.* New York: Vintage, 1999.

Nestle, Joan, Clare Howell, and Riki Wilchins, eds. *Genderqueer: Voices from beyond the Sexual Binary.* New York: Alyson Books, 2002.

Nestle, Joan, and Yasmin Tambiah, eds. *Sinister Wisdom* 94: *Lesbians and Exile*. Berkeley: Sinister Wisdom, 2014.

Translations

Nestle, Joan. *Restricted Countries and Fragile Bodies: Selective Writings*. Translated by Il-il Kofler Kofler, Shirly Tal, Mariana Bar, Yasmin Piamenta, Haya Shalom, Nuphar Lipkin, Efrat Rotem, Talma Bar-Din, and Hannah Saffran. Haifa, Israel: Pardes, 2008.

———. *Prepovedana Dežela*. Translated by Tatjana Greif, Suzana Tratnik, and Nataša Velikonja. Ljubljana: Škuc, 2016.

Nestle, Joan. *Osvajanje Slobode: Zivot I Aktivizam*. Translated by Danijela Zivkovic, Lepa Mladenovic, Nina Durdevic Filipovic, and Zorica Mrsevic. Belgrade: Konsultacije Za Lezbejke, Labris: 2017.

Essays, Stories, Talks, and Poems

Nestle, Joan. "Foreword." In *Eye to Eye: Portraits of Lesbians*, by Joan E. Biren. Washington, DC: Glad Hag Books, 1979.

———. "Notes on Radical Archiving from a Lesbian Feminist Perspective." *Gay Insurgent* 4/5 (Spring 1979). Reprinted as "Voice 2: Radical Archiving from a Lesbian Feminist Perspective, 1979" on OutHistory.org. https://www.outhistory.org/exhibits/show/an-early-conversation-about-ga/voice-2-joan-nestle.

———. "The Lesbian Herstory Archives—One Woman's View." *Focus*, 1979.

———. "Dear Sisters: I Went Back to Reread Fran Winant's Dyke Jacket after Reading Judith McDaniel's Review, Looking for the Poems." *The New Women's Times*. 1980, 12th edition.

———. "Marcia's Room." *Focus* (March–April 1980).

——. "The Bathroom Line." *Gay Community News*, October 4, 1980. Reprinted in *Lesbian Connection* 5, no. 3 (September 1981).

——. "Joan: Another Way to Be a Lesbian." *off our backs* 11, no. 5 (1981): 10.

——. "Esther's Story." *B.A.D. News*, August 1981. Reprinted in *The Penguin Book of Lesbian Short Stories*, edited by Margaret Reynolds (New York: Penguin, 1994), and *An Intimate Wilderness: Lesbian Writers on Sexuality*, edited by Judith Barrington (Portland, OR: Eighth Mountain Press, 1991).

——. "Stone Butch, Drag Butch, Baby Butch." *B.A.D. News*, August 1981.

——. "Butch-Fem Relationships: Sexual Courage in the Fifties." *Heresies #12* vol. 3, no. 4 (1981). Reprinted in *The Body Politic* 76 (September 1981); *Sapphic Touch* 1 (1981); *Emma*, 1982 (German), *Diva*, 1982 (Dutch), *Sexualidat* 1982/3 (German).

——. "A Restricted Country." *Sinister Wisdom* 20 (Summer 1982).

——. "My Mother Liked to Fuck." *Womannews*, December–January, 1981–2. Reprinted in *The Eight Technologies of Otherness*, edited by Sue Golding (London: Routledge, 1997), and *Powers of Desire: The Politics of Sexuality.* edited by Ann Snitow and Christine Stansell (New York: Monthly Review Press, 1983).

——. "Liberties Not Taken." *B.A.D. News*, January 1982.

——. "Lesbian Memories 1: Riis Park, New York City, ca. 1960." *Common Lives/Lesbian Lives* (Summer 1983).

——. "Living with Herstory." *Lesbian Insider, Insighter, Inciter* (March 1983). Reprinted as "Voices from Lesbian Herstory" in *Body Politic* 96 (September 1983). Keynote address

presented at Amazon Autumn Sixth Annual Conference, November 1982.

——. "Two Women of Difference." *13th Moon* 7, no. 1–2 (September 1983).

——. "The Fem Question: We Will Not Go Away." In *Pleasure and Danger: Exploring Female Sexuality*, edited by Carole S. Vance. Boston: Routledge, 1984. Reprinted in Spanish as "Nosotras que nos queremos tanto . . . ," *Revista Feminista*, no. 6 (February 1988); and in *We Are Everywhere*, edited by Mark Blasius and Shane Phelan (New York: Routledge, 1997).

——. "Introduction." *Common Lives/Lesbian Lives* 8 (1984).

——. "The Gift of Taking." *On Our Backs* (1984). Reprinted in *Diva Lesbisch*, July 1985 (Dutch).

——. "An Old Story." In *The Lesbian Path*, edited by Margaret Cruikshank. San Francisco: Grey Fox Press, 1985.

——. "Proud to Be Passionate: Lesbian Sex and Censorship." In *Pride Guide '85* June 1985: 25–26.

——. "My History with Censorship." *Bad Attitude* (Spring 1985). Reprinted in *Slechte Meiden* Nr 5, 1986 (Dutch).

——. "A Change of Life." *Bad Attitude* (Winter 1985). Reprinted in *Diva*, 1985 (Dutch).

——. "Wet Words." *Bad Attitude* (Winter 1985). Reprinted *in Wanting Women: An Anthology of Erotic Lesbian Poetry*, edited by Jan Hardy. Pittsburgh: Sidewalk Revolution Press, 1990.

——. "Pat's Story." *Bad Attitude* (1986).

Nestle, Joan and Deborah Edel. "Preface: In the Beginning." In *The Lesbian Periodicals Index*, edited by Clare Potter. Tallahassee: Naiad Press, 1986.

——. "The Three." *On Our Backs* (Spring 1986).

——. "Lesbians and Prostitutes: An Historical Sisterhood." In *Sex Work: Writings by Women in the Sex Industry*, edited by Frédérique Delacoste and Priscilla Alexander. San Francisco: Cleis Press, 1987. Reprinted in *Good Girls/Bad Girls: Feminists and Sex Trade Workers, Face to Face*, edited by Laurie Bell (Seattle: Seal Press, 1987).

——. "Hope." *Bad Attitude* (Summer 1987).

——. "Margaret." *Bad Attitude* (Summer 1987).

——. "A Feeling Comes." *Homologies*, June 1988 (Dutch). Reprinted in *Lesbian Love Stories Volume 2*, edited by Irene Zahava. Freedom, CA: The Crossing Press, 1989.

——. "Those Who Were Ridiculed the Most Risked the Most." *Gay Community News* 16, no. 46 (1989).

——. "This Illness Is No Figment of Our Imaginations." *Gay Community News* 16 (May 21–27, 1989): 12ff.

——. "Woman Poppa." *On Our Backs* (1988). Reprinted in *Lesbian Love Stories*, edited by Irene Zahava. Freedom, CA: The Crossing Press, 1989.

——. "Our Gift of Touch." *Conditions* 17 (1990).

——. "Woman of Muscle, Woman of Bone." *Bad Attitude* 6 (1990). Reprinted in *Tangled Sheets: Stories and Poems of Lesbian Lust*, edited by Rosamund Elwin and Karen X. Tulchinsky. Toronto: Women's Press, 1995.

——. "Desire Perfected: Lesbian Sex After Forty." In *Lesbians at Midlife: The Creative Transition*, edited by Barbara Sang, Joyce Warshow, and Adrienne J. Smith. San Francisco: Spinsters Ink, 1991.

——. "Books." *The Wisconsin Light*, 1992, 5 edition, sec. 15.

——. "Understanding an Erotic Identity." *The Front Page (Carolinas)*, 13 (13), p. 17. 1992.

——. "A Sturdy Yes of a People: An Open Letter to My Community." *Gay Community News* (June 1993).

——. "Oral History with Gabi." In *Lesbiot: Israeli Lesbians Talk About Sexuality, Feminism, Judaism, and Their Lives*, edited by Tracy Moore. London: Cassell, 1994.

——. "Lesbians," "Lesbian Herstory Archives," and "African American Women United for Social Change." In *The Encyclopedia of New York City*, edited by Kenneth T. Jackson. New Haven: Yale University Press, 1995.

——. "The Uses of Strength." In *Heatwave: Women in Love and Lust*, edited by Lucy Jane Bledsoe. Los Angeles: Alyson Press, 1995.

——. "Writing Sex for John." In *Looking for Mr. Preston: A Celebration of the Writer's Life*, edited by Laura Antoniou. New York: Masquerade Books, 1995.

——. "Afterword." In *Creating a Place for Ourselves: Lesbian, Gay, and Bisexual Community Histories*, edited by Genny Beemyn. New York: Routledge, 1997.

——. "Beaches and Bars: Places of Restriction and Reclamation." In *Queers in Space: Communities, Public Places, Sites of Resistance*, edited by Anne-Marie Bouthillette, Gordon Brent Ingram, and Yolanda Retter. Seattle: Bay Press, 1997.

——. "Early Words on Living with Cancer." *New York City Lesbian Health Fair Journal* (May 3, 1997): 13–17.

——. "I Lift My Eyes to the Hill: The Life of Mabel Hampton as Told by a White Woman." In *Queer Representations: Reading Lives, Reading Cultures*, edited by Martin Duberman. New York: New York University Press, 1997.

——. "I Wanted to Live Long Enough to Kiss a Woman: The Life of Lesbian Literature." In *Particular Voices: Por-*

traits of Gay and Lesbian Writers, edited by Robert Giard. Cambridge, MA: MIT Press, 1997.

———. "Two Women: Regina Nestle, 1910–1978, and Her Daughter, Joan." In *Every Woman I've Ever Loved: Lesbian Writers on Their Mothers*, edited by Catherine Reid and Holly Iglesias. San Francisco: Cleis Press, 1997.

———. "The Will to Remember: The Lesbian Herstory Archives of New York." *Journal of Homosexuality* 34, no. 3 (1997): 225.

———. "A Different Place." In *Hot & Bothered: Short Short Fiction on Lesbian Desire*, edited by Karen X. Tulchinsky. Vancouver, BC: Arsenal Pulp Press, 1998.

———. "A Fem's Feminist History." In *Live, from Feminism: Memoirs of Women's Liberation*, edited by Rachel Blau DuPlessis and Ann Snitow. New York: Crown Publishers, 1998.

———. "Many Days of Courage." 20th Anniversary gay pride rally in Central Park on June 24, 1989, *OutWeek 3* (July 10, 1998): 28.

———. "Herstory—Womyn Speak." *Voice Magazine* 1, no. 6, 1999.

———. "March Women's History Month." *Woman's Monthly (Washington DC)*, 8 (7), p. 3, 2000

———. "How a 'Liberationist' Fem Understands Being a Queer Jew, or How Taking Advice from a Prophet, Even a Jewish One, Is (Un)Transformative." In *Queer Jews*, edited by David Shneer and Caryn Aviv. New York: Routledge, 2002.

———. "Wars and Thinking." *Journal of Women's History* 15, no. 3 (2003): 49-57.

———. "Passion is Our Politics, Jan 24, 1984" in *Speaking for Our Lives: Historic Speeches and Rhetoric for Gay and Lesbian Rights (1892–2000)*, edited by Robert B. Ridinger. New York: Harrington Press, 2004.

———. "Surveillance and Yearning: The Art of Henry von Doussa." *Traffic* 6 (2005).

———. "Aging in a Time of War." Talk for *SAGE*. New York. March 16, 2006. In papers.

———. "It All Began with an Insult." Talk for Art of Difference International Conference on Art and Disability. Speech, May 19, 2006.

———. "Historical Musings: Tropes of Erotic Memory—I Wanted to Live Long Enough to Kiss a Woman"; "Dexter and Diana: Voices in the Wind, 1950s–1990s"; "Women's House of Detention, 1931–1974"; "The Kiss, 1950s–1990s"; "Thank You, Del Martin, 1921–2008." OutHistory.org. 2008.

———.. Talk given In the Loop Bar, Melbourne, Australia on the 40th Anniversary of Stonewall, USA, June 2009. *Don't Stop Talking* (blog).

———. "Words for the Woman in the Hat, Rosa Luxemburg," in *Milk and Honey: A Celebration of Jewish Lesbian Poetry*, edited by Julie Enszer. New York: A Midsummer Night's Press, 2010.

———. "Archives in Times of Need, in Times of Change." *Australian Lesbian and Gay Archives Yearly Meeting*. November 16, 2011. In papers.

———. "The Bodies I Have Lived With: Keynote for the 18th Lesbian Lives Conference, Brighton, England, 2011." *Journal of Lesbian Studies* 17, no. 3–4 (2013): 215–39.

———. "For Lois: Femme Glorious." In *The Only Way Home Is through the Show: Performance Work of Lois Weaver*, edited by Jen Harvie and Lois Weaver, 109. London: Live Art Development Agency, 2015.

———. "Who Were We to Do Such a Thing? Grassroots Necessities, Grassroots Dreaming," *Radical History Review* 122 (May 2015): 233–242.

———. "Reflections on Legacies and Solidarities from the Perspective of a 50s Fem: Fragments of Stories, Encounters, Perils and Cries of Possibilities." *Hecate* 44, no. 1 and 2 (2018): 17–26.

———. "Lesbian Memories 2: The Lower East Side, 1966." In *The Stonewall Reader*, edited by The New York Public Library. New York: Penguin Books, 2019.

———. "My Letter of Appreciation," in *Meet Me There: Normal Sex and Home in Three Days* by Samuel Ace/Linda Smuckler. Brooklyn: Belladonna Press, 2019.

———. " 'Don't Worry, I Will Find the Room': An Appreciation of Deborah Edel" and "Archival Fragments." In *Sinister Wisdom 118 / Forty-Five Years: A Tribute to the Lesbian Herstory Archives*, edited by Elvis Bakaitis, Shawn(ta) Smith-Cruz, and Red Washburn. Dover, FL: Sinister Wisdom, 2020.

———. "Polemics and a Dream, Thirty-Two Years Later, 2010." OutHistory.org. https://www.outhistory.org/exhibits/show/an-early-conversation-about-ga/polemics-and-a-dream-thirty-tw.

———. "Grassroots Archives: Sites of Gratitude, Intrusion, Uncertainty." Talk for 30th Anniversary of Victorian Women's Liberation and Lesbian Feminist Archives, Melbourne, May 24, 2013. *Don't Stop Talking* (blog). http://joannestle2.blogspot.com/2013/03/.

———. "Homophobia and Private Courage." Essay in the catalog for the City Hall exhibit "Prejudice and Pride: The NYC Lesbian and Gay Community, World War II to the Present, June 1988."

———. "Writing Differences," Talk given at Brunswick Public Library, Melbourne, Australia, January 25, 2006. *Don't Stop Talking* (blog).

Smith-Cruz, Shawn(ta), Flavia Rando, Rachel Corbman, Deborah Edel, Morgan Gwenwald, Joan Nestle & Polly Thistlethwaite. "Sustaining the Lesbian Herstory Archives as a Lesbian Organization." *Journal of Lesbian Studies* 20, no. 2 (2016): 213-233.

Interviews

Untitled, *Sinister Wisdom*, 1979.

"Taking Pride in Lesbian Herstory," with Susie Day. *Sojourner* 14 (June 1989): 17–19.

Untitled, *Feminist Collections*, 1981.

"A Fem's Own Story," with Margaret Hunt. *Gay Community News* (October 4–10, 1987): 16ff.

"Our Favorite Femme," with Sue George. *Square Peg* (1988): 10–11.

"Pleasure, Guilt and Other Slippery Territory," with Robin Podolsky. *Forward Motion* (September 1989): 56–62.

"Lesbian Writer Fights Feminist Censors," with Holly Metz. *The Progressive* (August 1989): 16.

"Joan Nestle: Keep Flaunting It," with Lissette Chang. *Womannews* (June 1990): 1ff.

"Interview with Joan Nestle," with Holly Metz. *American Voices* (Winter 1990): 73–84.

"Interview." *Sphere* 1, no. 4 (1991): 6.

"Joan Nestle; A fem reflects on four decades of lesbian self-expression" with Amy Hamilton, *off our backs* 23, no. 8 (1993): 2.

"Queen Mother: Archivist Joan Nestle Is a Voice Against Forgetting," with Liz Galst. *The Worcester Phoenix* (May 13, 1994): 8–9.

"Stonewall: A Gift to the World. An Interview with Joan Nestle and Tony Kushner." *Found Object* 4 (Fall 1994): 94–107.

"We Are All Part of This Circle of Difference: An Interview with Joan Nestle," with Isa Leshko. *Sojourner* 20 (June 1995): 9ff.

"I'll Be the Girl: Generations of Fem," with Barbara Cruikshank. In *Femme: Feminists, Lesbians, and Bad Girls*, edited by Laura Harris and Elizabeth Crocker. New York: Routledge, 1997.

"Interview with Joan Nestle," with Kate Horgan. *Antithesis* 13 (2002): 110.

Interview transcript, Queens College Library and Archives, 2010, New York. Preface to edited transcript, 2012. On Queens College Archives site.

Articles About Joan Nestle

Whatling, Claire. "Reading Awry: Joan Nestle and the Recontextualization of Heterosexuality." In *Sexual Sameness: Textual Differences in Lesbian and Gay Writing*, edited by Joseph Bristow. New York: Routledge, 1992.

Rochman, Susan. "Joan Nestle." In *Contemporary Lesbian Writers of the United States: A Bio-Bibliographical Critical Sourcebook*, edited by Sandra Pollack and Denise D. Knight. Westport, CT: Greenwood Press, 1993.

Stanley, Deborah. "Joan Nestle." In *Gay and Lesbian Literature*, edited by Wayne R. Dynes, Barbara G. Grier, Sharon Malinowski. Detroit: St. James Press, 1994.

Davidson, Cathy, and Linda Wagner-Martin, eds. "Joan Nestle." In *The Oxford Companion to Women's Writing in the United States*. New York: Oxford University Press, 1995.

Szymczak, Jerome. "Joan Nestle: American Archivist and Writer." In *Outstanding Lives: Profiles of Lesbians and Gay Men*, eds. Michael Bronski, Christa Brelin, and Michael J. Tyrkus. New York: Visible Ink Press, 1997.

Martindale, Kathleen. "Toward a Butch-Femme Reading Practice: Reading Joan Nestle." In *Un/popular Culture: Lesbian Writing After the Sex Wars*. Albany: SUNY Press, 1997.

Hogan, Steve, and Lee Hudson, eds. "Joan Nestle." In *Completely Queer: The Gay and Lesbian Encyclopedia*. New York: Henry Holt, 1998.

Film and Video

Neighborhood Voices: Greenwich Village. Produced by B. Kerr and Amber Hollibaugh. WNYC Foundation, 1986.

Just Because of Who We Are. Heramedia, 1988.

Lesbian Voices: Currents. PBS, June 1988.

Hand on the Pulse. Directed by Joyce Warshow. Activa Productions, 2002.

The Archivettes. Directed by Megan Rossman. San Francisco: Women Make Movies, 2018.